Iconography of Religions: *An Introduction*

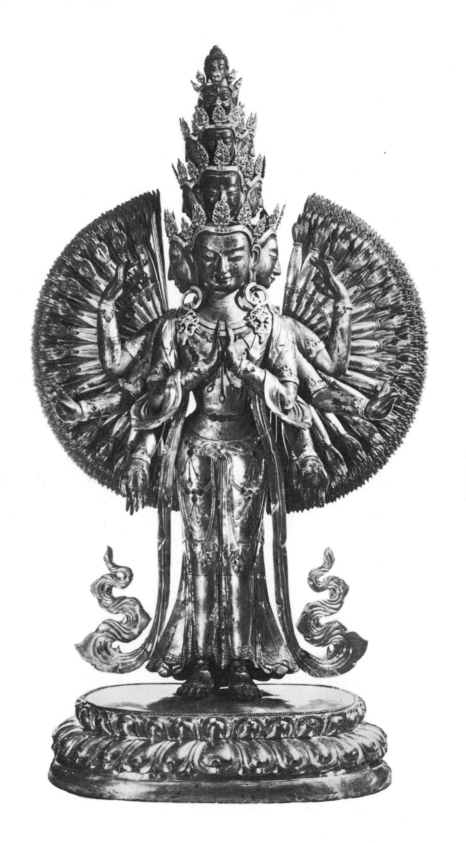

ICON

Albert C. Moore

RAPHY OF RELIGIONS

An Introduction

FORTRESS PRESS · PHILADELPHIA

First American Edition 1977,
Fortress Press, Philadelphia

© 1977 by SCM Press Limited, London
and Fortress Press, Philadelphia

Library of Congress Catalog Card Number 76-62598
ISBN 0-8006-0488-1

Printed in Great Britain 1-489

Contents

Preface

THIS BOOK is intended as an introduction to the iconography of religions. Within the covers of a single volume it seeks to provide a systematic approach to the types and the meaning of the images used in a representative range of the religious traditions of mankind. It is not a popular 'pictorial' lavishly illustrated in colour, nor is it a specialist work dealing with the iconography of one religion or with one period or area of development of religious images. There are many fine examples of scholarship of this sort and a many-volumed work of encyclopaedic scope is in progress.[1] But in bringing together a variety of religious iconographies in a short compass, this book seeks to be comprehensive. The underlying concern here is to lead the reader increasingly to understand and, if possible, to empathize with various alien ways of religious thought and worship through their expression in visual images. The study of iconography can help us imaginatively to 'switch' to other religious worlds.

Within this general aim it is hoped that the book will be an aid to students in presenting the main lines of the subject clearly, enabling them to make more effective use of the many fine studies now available on religious art and symbolism. If this book can mediate some of these contributions to a wider body of students and general readers it will have proved well worthwhile. The justification for a book of such wide-ranging coverage is that there is a need to relate the researches of several overlapping disciplines which have achieved much over the past hundred years – archaeology, anthropology, art history and phenomenology of religion. My impression is that whereas students working in any one of these disciplines know all too little about the others, much could be fruitfully shared at certain points.

It is not only knowledge that we need to share but also our interests and enthusiasms. My own interest in the subject is coloured by my own enjoyment of the visual arts and by being helped to find a way of understanding religions of the world through the visual approach. The experience of teaching the history and phenomenology of religion has given me the opportunity to explore this over recent years and the desire to gain a more systematic understanding of iconography. Again, I shall feel rewarded if others can share something of this interest and enthusiasm.

The following features are deserving of mention for the general guidance of the reader:

1. The problem of selection is great indeed in a book of this scope. Many religions of the world are not dealt with, especially among primal and ancient religions. Some readers again might have expected more on the rich heritage of medieval Western Europe. The aim, however, is not to be encyclopaedic but to cover a representative selection of religions in which some features are unique and distinctive and yet other more typical features overlap and recur. On this basis the reader can apply the study to similar areas not dealt with in this book. Within the book the treatment is intended to be cumulative; for instance, what is said in chapter 3 about animal-headed deities in Egypt and the anthropomorphism of Greek statues need not be repeated but can be related by the reader to materials in subsequent chapters. Another problem of selection is that of bias. While Christianity is not given favoured treatment over other religions, inevitably the selection of material and of interpretative questions is coloured by the interests of the Christian and 'post-Christian' West. Yet the intention throughout is to understand the use of images from the viewpoint of the religion concerned.

2. The illustrations have been chosen as an integral part of the book and are included in the systematic discussion of iconographic features as a means of teaching. 'Coffee-table' books have undoubted charms but this book cannot indulge in the luxuries which they offer. Where relevant, books rich in pictures are recommended in the notes.

3. The notes are intended as a source of bibliography, taking their starting point from specific points in the text. Apart from the short reading-list which is general, students are referred to the notes on particular issues.

4. In a work covering such a wide sweep of religious cultures, it has been decided not to use the full diacritical marks in transliterating words from Asian languages. This is the position taken by a number of comprehensive works on art and religion.[2]

5. The term 'primal' is used in chapter 2 where an explanation is given for its being chosen in preference to 'primitive'. I am well aware of the problems of finding the 'least unacceptable term'. If anyone has a better term than 'primal' let him use it, rather than argue at length about the merits of such terms.

The overall emphasis of the book is on understanding the themes and forms of religious iconography. The very richness and diversity of the material precludes any single theory of interpretation being adopted as the 'explanation' or the key to unlock all doors. The Conclusion does not seek to offer these. A comprehensive theory of iconography is beyond the scope of this introductory work and must be deferred to a subsequent study concerned with the 'dynamics' of iconography – the various factors leading man to make, to use and to circumscribe images for religious purposes. Such a study will also be concerned with hermeneutics – with the principles of interpretation which we bring to focus on iconographies in order to discern their various levels of meaning and changes of meaning. Above all, it is man's very ability to *interpret* his world with the aid of symbols that has led to the rich complexity of meanings in his art and religion.

Interpretation is unavoidable in this study but meanwhile our first step must be a more descriptive approach. What we now need is a deeper appreciation of those traditions of religious iconography already partly familiar to us and a sympathetic exposure to a range of less familiar traditions. In this spirit the reader is invited to explore the field.

Acknowledgments

IN WRITING a book of this wide coverage of religious iconography one becomes aware of the many influences underlying one's work. Among the persons and ideas leaving a deep sense of indebtedness for my own understanding of religion and the arts, I should mention two associated with Dunedin and the University of Otago – the Very Rev. Dr J. M. Bates and the late Professor Helmut Rex – and also Professor Mircea Eliade of the University of Chicago.[3] In my recent teaching work at the University of Otago I have enjoyed the stimulus of students and teachers in the faculties of Arts and Theology – including my colleague Dr Kosuke Koyama, Dr R. D. J. Collins, Professor W. H. McLeod and Professor Peter McKellar. I have also profited from discussions with Professor R. W. Medlicott, Mrs Shona McTavish and Associate Professor T. Esplin who represent various facets of lively practice and interpretation of the arts. I am grateful to the university for a year of study leave which made possible the writing of this book. I am also grateful to the department of Religious Studies at the University of Aberdeen where I happily spent two terms as visiting research fellow while drafting and working on the manuscript.

On specific matters in the course of writing this book I was fortunate to be able to meet with and discuss suggestions from some writers in the field of religion and iconography whose works have been illuminating to me – Dr Gilbert Cope (University of Birmingham), Dr Richard Gombrich (University of Oxford), Mr Philip Rawson (Gulbenkian Museum, University of Durham), and Professor Dietrich Seckel (University of Heidelberg). I am also indebted to Dr Peter R. McKenzie (University of Leicester) and above all to Dr Harold W. Turner (University of Aberdeen) for stimulus, criticism, tireless help and friendly encouragement.

Acknowledgments 6 For permission concerning the use of photographs which are duly credited in the List of Illustrations, I acknowledge the assistance of the following: the National Gallery of Victoria (Felton bequest), Melbourne; the Trustees of the British Museum, London; the Gulbenkian Museum, Durham; the National Gallery of Scotland, Edinburgh; the Rijksmuseum, Amsterdam; also the Hirmer Verlag, Munich; the Oxford University Press; the United Society for the Propagation of the Gospel; the Henry Moore Estate and Lord Clark, and Mr Nikolaus Barlach. Mr Alan K. Palmer of Dunedin has taken some fine photographs of works in my possession. Messrs Ian Cargill and Victor Davidson of Aberdeen have used artistic skill and imagination in dealing with the many figure drawings which are essential to the book.

 I must acknowledge the guidance and encouragement given by the editor and staff of the SCM Press. And, finally, I am also grateful for the support given by my wife and children who have shared in some of these iconographical adventures at home and abroad.

University of Otago Albert C. Moore
Dunedin
New Zealand
June 1975

List of Illustrations

Chapter 9 Conclusion: The End of Iconography?

1 Introduction

Theories date rapidly, but documents, like diamonds, are forever.

E. H. Gombrich[1]

ICONOGRAPHY deals with the documents which man has created in the visual arts. Literally it means 'writing in images', so that to study iconography is to begin to 'read' the meaning of these images. It is concerned with the subject matter, with the content rather than the form of art. In the case of the iconography of religions the content consists of images, symbols, teachings and narratives related to religious belief and practice; it is our task in this book to describe these and to understand their meaning.

While this chapter must deal by way of introduction with definitions, principles, methods and theories, the emphasis is not on theoretical explanation but on the subject-matter. So let us begin with a concrete example.

Why does Moses have horns on his head? Many people have been puzzled by this odd feature of Michelangelo's great statue of Moses. It appears earlier in medieval art and in the interpretations of both Christian and Jewish scholars of the Bible and Jewish Law given by Moses. The motif has been attributed to an 'error' of the early church father Jerome in translating Ex. 34. 29; after Moses communes with God at Mount Sinai he is marked by rays of light – or by 'horns' in Jerome's translation of the ambiguous Hebrew word *qeren* by the Latin *cornuta*. Yet Jerome appears to have consciously chosen this interpretation. It is enigmatic to modern readers for whom horns sprouting from the head signify, if anything, association with the Devil! To ancient and medieval minds

this was not so; horns were symbols of honour, not of dishonour. The history of ancient religions is full of horned gods and goddesses, and in the Bible 'horn' is a metaphor of strength, victory, divinity and kingship. The horned helmet was the mask of the Anglo-Saxon-Scandinavian warrior, and this was probably the bridge to the interpretation of Moses as an epic warrior-chief and great commander. It was in eleventh-century England that the horned Moses first took visual form; this was related also to horns on the medieval bishop's mitre.

Both the horns of Moses and the horns of the mitre were generally interpreted by the Church scholars as symbols of honour, station and power.[2]

The evidence is set out in the detailed text and illustrations of Ruth Mellinkoff's recent careful and illuminating study. The story has a fascination in itself. But for the study of iconography it is a valuable example of the way in which the history of art and religion are related, drawing on folklore, liturgy and drama in an interdisciplinary study.

The Study of Iconography

The subject may still appear to some as having rather specialized, anti-quarian appeal – 'very interesting, if you're interested'. In its patient work of describing, classifying and relating motifs it may seem a very circum-scribed discipline. 'Iconography is a dull topic': this from a writer whose own work on Buddhist iconography is far from dull.[3] But the same writer goes on to state that people looking at Buddhist images want to know how to distinguish the different types of figures. They are puzzled by certain symbols which would be meaningful to the Buddhist but leave them with the feeling that the images are a 'closed book'. Iconography can help the viewer or reader by making identifications, bringing certain satisfactions in its train:

Pleasure in a piece of sculpture depends indirectly perhaps, on knowing what it represents. Knowledge, in this sense, offers no bar to appreciation; whereas unsatisfied intellectual curiosity may greatly reduce one's capacity for aesthetic response.[4]

This holds true equally for the Buddhist who seeks to understand the Christian symbolism of European cathedrals – or for that matter for the British visitor to the old parish churches of his country, full of imagery designed to teach medieval worshippers by their picture-book of the faith. This requires more than tourist curiosity (although tourism is not to be despised as a starting-point) and goes deeper than the identification

of an art object; it involves the effort to understand the lives and thoughts of people:

> Thus, all too often, the visitors to our old churches pass on with a merely aesthetic appraisal and so miss the deeper significance which these battered, faded images reveal to those who love and understand them.[5]

The study of iconography and in particular of the iconography of religions can therefore be of much more than peripheral significance. Its contribution is valuable for three reasons.

First it is evident that most religions have found expression in some way in visual imagery. In the history of mankind man could draw long before he could write;[6] and in the history of ancient religions there were images, visual symbols and pictographs before written texts were produced. Even in religions with a large corpus of scriptures, such as Buddhism, the use of images developed as a parallel tradition only partly related to the texts. The Eastern Orthodox Church is a good example within Christianity of how the visual complements the verbal, reverence being accorded to both the gospels and the icons as means of communicating the holy. The modern Western world in its emphasis on the written word predisposes scholars to study religions through their texts to the neglect of religious art and other media. Because of the technological bias of Western culture in favour of material that can be mastered and examined, the visual arts are kept on the periphery of educational curricula. Yet today the impact of the visual picture and symbol is no less powerful, as seen in the mass media; in religion as elsewhere there are some things which can best be said pictorially and 'visual aids' help people to gain knowledge and focus their thinking.

Secondly, these visual expressions challenge the observer of another religious and cultural tradition to understand them. Despite his initial puzzlement and ignorance, the tourist, the reader, the visitor to a church or an art museum may find himself drawn into a deeper quest for the meaning of the images. As we have seen, the study of iconography helps to equip him for this quest by identifying typical features and symbols. The student must learn to 'read' the images by looking and discerning. Indeed, one of the educational values here lies in teaching the student to *look*. This goes far beyond the use of colour-slides and pictures as visual aids to illustrate a lecture.

Thirdly, the study of iconography provides a mode of understanding not only one religious tradition but the many which are accessible now to modern man through travel, study and the mass media. These are now part of his horizon and even on his doorstep, but he may remain sadly lacking in knowledge and sympathy towards the various religious tradi-

tions, lacking even in the will to understand them. Often the visible art, architecture and ritual are the most immediate aspects to be encountered in all their strangeness; they are therefore suitable avenues of approach to the religious meanings which they express. Modern man has to live in a pluralistic international community where there are many 'worlds of the sacred'. He must learn to come to terms with them, to seek to understand them by switching imaginatively from his own world-view to others. Thus he can empathize with some at least of the religions on his horizon, as well as the ways of life and thought in religions of the past. Art and iconography help him in this venture.

We must now inquire more exactly into the term 'iconography'. Its derivation from the Greek words *eikon*, image, and *graphein*, to write, indicates that it refers to the act of creating pictures and thus 'writing in images'. This implies a system and a tradition which man develops so that his writing, either in words or in pictures, can be understood by others. In this sense one can describe the complex of symbols and images used by an Australian aboriginal group in their rituals and story-telling as 'an iconography, a systematically elaborated representational tradition, materialized in two- or three-dimensional artefacts'.[7] Because there is a system to be discerned in the images they can be understood by students of the iconography, so that there is an easy transition to talking of iconography as an academic subject, a writing *about* images – as in the following definitions:

. . . the study of images, their formation, transmission and transformation in the various cultures and civilizations . . . a descriptive discipline based on the systematic grouping of particular themes.
. . . a descriptive and classificatory study of images with the aim of understanding the direct or indirect meaning of the subject matter represented.[8]

This usage now seems to be accepted in the history of art; nevertheless it is well to remember the more active connotations of that 'writing in images' which is the real subject of our study.

If we turn to the other half of the term, the 'image', we are confronted with a very general term for a representation or 'likeness' of something. There is the problem also that in modern psychological usage it refers to a perception of forms, colours, etc. in the absence of an external stimulus – separate representations of sensuous and perceptual experience which provide each of us with a store of raw material for the imagination.[9] It is out of this that we create symbols and art. Imagery in this sense, if very complex, is prevalent and powerful in the life of man.[10] However, our concern is with the tangible expressions resulting from such psychological images – with representations in the form of statues, reliefs, paint-

ings and photographs. These need not be regarded as 'works of art'; but the images are so constructed as to make vivid the object or person they represent.

The human figure in particular has been represented in sculptured form from very ancient times. Greek mythology hints at the deep-seated human impulse to create images – for instance, the story of Narcissus who fell in love with his own reflection in a spring of water but pined away and died because he could not give it substance. Pygmalion, by contrast, fell in love with the marble statue he had made, and married her (Galatea) after Aphrodite, the goddess of love, had granted her life. Sculpture here answers man's need for establishing a sense of real existence. Herbert Read comments:

It is perhaps significant that both these legends have retained a powerful hold on the human imagination, even into our own time. They illustrate the deep-seated longing that man has to project an icon, a material counterpart of his mental image of himself. . . . Only by conceiving an *image* of the body can we situate the *idea* of ourselves in the external world.[11]

Drawing on sight, touch and other sense impressions we represent ourselves in some bodily likeness.

The two key notions here are of a 'likeness', in some sense, and of mediating the impression that the reality is actually present. Thus Rembrandt's etching of Jesus healing the sick makes us aware that Jesus was a person 2000 years ago who preached and healed; the picture confronts us with what convinces us as being his likeness (although in fact neither Rembrandt nor anyone else can be sure of what Jesus looked like). At the same time we are drawn into the picture as a present reality for it represents (makes present again) to our mind's eye the situation of Jesus meeting a group of people who might have seen him thus. The image has been taken from the original time and place – or at least from Rembrandt's time and place – and made available to us. This can be experienced in images of any sort; but where religious conviction and devotion are involved the sense of reality is more than just a fleeting recognition in the presence of the image.

A further key notion is that of 'seeing', for every image embodies a way of seeing. As the art critic John Berger points out, seeing comes before words and it establishes our place in the world. Our gaze is always roving as we look at the relation between things and ourselves:

Soon after we can see, we are aware that we can also be seen. The eye of the other combines with our own eye to make it fully credible that we are part of the visible world. . . . The reciprocal nature of vision is more important than that of spoken dialogue.[12]

This becomes evident as we grow involved in the succession of images from famous paintings and modern advertisements in John Berger's book. It is also relevant to religious images, in which the eyes usually play an important part in establishing the sense of living reciprocity between worshipper and image. For man the eye is the bridge between outer and inner reality; it is the 'window of the soul'.[13] Attributed to a god it signifies his power and omniscience – the dangerous 'third eye' of Shiva, or the biblical 'eye of the Lord' which sees all, both good and evil. E. H. Gombrich has noted the apparent magic of eyes in evoking a response; we look for meaning in eyes to know how to respond to looks; we are unhappy with a drawing which shows a face with no eyes and we are relieved to have the eyes filled in. An artist creating an image of the human form can never simulate the actual power of the eyes to see and to be continually mobile. But he can use his skill in detail to convey the illusion that the eye is 'looking' at the viewer. (Here one might instance Byzantine icons of Christ and the saints with their fixed commanding gaze, or the half-closed eyes of an Amida Buddha with his mysterious meditative benevolence.)

The task of the artist therefore is not necessarily to fashion a facsimile eye. It is to find a way of stimulating the response to a living gaze.[14]

Already the discussion of the eye has brought us from the image in general to the icon, meaning here an image used in worship. This is our concern in a book on the 'iconography of religions'; it is the religious context of worship (though not implying that the image itself is actually worshipped) which provides a criterion. Sometimes it is difficult to be sure whether to label an image as 'religious', either for lack of information or because the whole culture of the people concerned is interwoven with symbols of varying degrees of sacredness. The latter may be more true of Asian religions and the pervasive Hindu tradition; on this basis Banerjea draws attention to the religious origins of iconography, which 'really signifies the interpretative aspect of the religious art of a country, which becomes manifest in diverse ways'.[15] But in most cultures the people themselves will make some distinctions so that it is permissible to write about the 'iconography of profane art' in depictions of scenes and themes from daily life and non-religious allegories and symbols.[16] In the religions of prophetic monotheism such as Islam the distinction can be made more clearly. Secular art finds its purpose and inspiration 'in social and individual terms rather than in spiritual or cultural ones'; its functions (but not necessarily its forms) are much more similar in various cultures than those of religious art in differing religions. In the many needs and activities

common to the social life of peoples, of princes and of ordinary citizens, secular art and craft could be shared by Muslim and non-Muslim.[17]

What then is 'religious'? If we define religion in an open-ended way as 'ultimate concern' it makes the field hard to pin down. A well thought-out definition in this vein is of religion as man's way of valuing most intensively and comprehensively.[18] But if this is to help us relate to concrete expressions of religion in their historic forms, the 'valuing' must take the form of man's response to what he recognizes as of ultimate worth, unity and power.[19] Religions have some supreme goal, which may be a personal God or an impersonal transcendent state such as the Buddhist *nirvana*, and they use a variety of media to bring men into contact with transforming supernatural power. Rather than seek to define religion in general, we may do better to recognize its complexity: 'it is a six-dimensional organism, typically containing doctrines, myths, ethical teachings, rituals, and social institutions, and animated by religious experiences of various kinds'.[20]

Applying this to the realm of art and iconography we regard as 'religious' those works which are known to be related to a transcendent religious goal by people using these media of belief and practice. This is sufficiently clear in the case of the traditional religions, for their long-established conventional symbols readily identify the religious goal of a Hindu temple image or the biblical heroes in a Jewish illuminated Haggadah book for use at home. But what of pictures and images with a religious concern which are outside the conventional area of belief and practice? For Paul Tillich some conventional religious art was far less religious in the ultimate sense than Picasso's 'Guernica' which he called a great Protestant painting. This is an individual judgment, of course, but it may be that Picasso was also drawing on the religious power of such ancient symbols as the bull, the horse and the sun to confront man with the ultimate depths of existence.[21] Perhaps the best we can do is to recognize it as implicitly religious in its evocation of awe; but to become explicitly religious it would require conventional symbols linking it to a tradition in which men participate by worship and overt responses.[22] It is with the explicitly religious image in this sense that we are concerned in this book.

Having delimited the field of iconography of religions we should make it clear that this study of iconography here must follow the same basic rules of historical method and classification of material as have been developed in the general discipline in modern times.[23] The methodological schema of Erwin Panofsky has been influential in giving a new meaning to the term 'iconology' to signify a synthetic study and interpretation of

images. Iconography deals with the form of visual symbols by first describing and then classifying them according to the subject matter; this is a task of analysis. Iconology goes beyond this to interpret the meaning of the symbols and images in relation to the culture where they appear, placing them in the history of tradition; this is a task of synthesis involving the art historian and others in an interdisciplinary enterprise. Of particular importance here is the process of development and change in the 'life of images'; some images fade away, others persist (as in the case of classical Greece and its influence on the Christian West), others are transformed by conflation and reinterpretation. The iconography of religions is a rich field for the study of such changes.[24]

The successive tasks involved can be arranged in three stages in Panofsky's schema.[25] First comes pre-iconographic description of the subject-matter, requiring practical experience and familiarity with objects and events. Secondly, iconographical analysis deals with the conventions of images, stories and allegories; in order to discern and relate these the researcher requires knowledge of the literary sources and familiarity with the themes and concepts involved. Thirdly, iconographical interpretation seeks to uncover the intrinsic meaning or content, the symbolic values underlying a work of art; this involves 'synthetic intuition' and some sense of how the human mind works. Here the grand scheme reaches its climax in a unified interpretation of art. If the stage of synthesis seems to leave the door open for fanciful interpretation of symbols and high-flying speculations, Panofsky's answer is to persist with the use of historical methods tempered by common sense.[26] Art criticism and surveys of religions can all too easily make generalizations about the 'spirit of the age' to interpret an image or practice about which little is known. The only corrective against hasty assumptions and wishful thinking being read into the phenomenon is to seek more exact knowledge of the context. A parallel is at hand in the exegesis of a passage from a book such as the Bible. We approach the text with some interest and questions of our own which start to involve us in the meaning; but we must be prepared to check this against the meaning of that particular passage in its historical setting. The more we can know of the immediate context and of the wider contexts for comparison, the better based will be our understanding of the original. Scholarship has the ongoing task of correcting and refining our knowledge towards this end.

Man's ability to construct images which represent other things may be regarded as an aspect of man's ability to symbolize. By making something stand for something else man is able to transcend the immediate limits of his life; he is able to adapt himself to his environment in new ways and through language and other symbolic systems which make up his culture. Man is the symbolizing animal.[27] In this general sense it is almost a truism to say that religion too is a 'system of symbols'.[28] But it is true, in that religion uses forms in the empirical world to symbolize what is ultimate and to lead men into a relationship with what is beyond. Some religions have an abundance of symbolism, as in the liturgy of Catholic Christianity, whereas others such as Islam have little. But certain symbols will be central in providing a unifying focus for the varied experiences, values and emotions of followers of that religion; for Mahayana Buddhism the elusive 'Void' or 'Emptiness' serves thus as a master-symbol.[29] For Islam it is the God-given book of the *Qur'an*. Lesser symbols are nourished by the master-symbol. They are based on a wide variety of phenomena; but certain basic features of man's life provide widely prevalent symbols such as the sun, sky, trees, water, fire and parts of the human body such as the head or hand.[30] Some of these (such as the tree symbol) are linked directly in religious symbolism with images involving a human figure (such as a crucifix of Christ or the Buddha's enlightenment under the Bodhi-tree).

In view of the wealth of general and specific studies of symbolism[31] we need do little more than refer to characteristics of symbols which relate to the theme of iconography. There is a certain elusiveness about religious symbols which is important. In contrast to signs which are intended to signify a specific empirical thing or experience (such as a warning-signal in case of fire), symbols refer to a reality which would otherwise elude one's grasp. They do not indicate or denote so much as evoke. This is evident with national symbols such as flags, and in the case of religious symbols the specific earth-bound object touches off a transcendent dimension in the person's experience. Along with this goes the multi-valence of symbols; they are apparently inexhaustible reservoirs of meaning and in the history of religions one can see that the great master-symbols and the natural symbols (such as stones, trees and light) have acquired many facets.

Images, in the sense of overt representations of something are more definite than symbols. However, they share the basic character of symbols and often have subordinate symbols associated with them (as in the case

of a Hindu image with many hands each holding an attribute with symbolic meaning). Here it is important to note that images are not automatically self-explanatory; they are given a human interpretation – usually in the form of another symbol system, that of language.

Without words and labels you don't know what you're looking at. As clothes make the man, language makes the picture. . . . Is the painted lady a saint? A queen? A courtesan? Or not a lady at all?[32]

This is forcefully put and is a corrective to the assumption that visual images have an independent life of their own. We have already mentioned the fact that prehistoric man could draw and use visual symbols long before he could write. This has been taken further in the thesis that, in the development of human consciousness, the image always precedes the idea, giving historical priority to art.[33] While the power of visual images is undeniable, there is the equally undeniable fact of the primacy of language in human experience; a developed system of speech is the possession of all peoples however 'under-developed' they may be in technology or artistic culture. Language underlies our interpretation of the world and makes possible the transmission of culture by oral tradition if not by writing; this includes iconographic conventions which may vary from one culture to another and can be explained by means of language.

Two points emerge here. First, images and the visual arts are not to be detached from the rest of culture and from language in particular with a much more precise form of symbolism in most instances. (Readers will doubtless be able to recall occasions when pictures or colour-slides were puzzling and meaningless until a verbal explanation was forthcoming.) Word and image are complementary in everyday life and also in religious practice and iconography.[34] Secondly, the range of symbols is much wider than these two forms. Audile symbols include musical sounds; and visual symbols include ritual actions, gestures, the dance and drama as well as objects such as tangible emblems and images. Religions draw on these varied avenues of symbolism in worship, so that the image will be reverenced in the context of a specially enclosed temple or perhaps in a natural grove; it will be accompanied by visual ornaments, perhaps sweet smelling incense and the accompaniment of rituals and words of adoration.

In turning now to consider specifically religious images we have a further distinction to make – between the iconic (literally 'with a like-ness') and the aniconic ('without a likeness'). The distinction between a plain cross and a crucifix depicting the image of the suffering Christ is a familiar example of the contrast in Christianity. In the religions

discussed in the following chapters the aniconic form is often encountered, as in the empty throne for the Buddha's presence or a simple smooth stone for Lord Vishnu. When the Buddha is represented in human form on the throne or in the meditation posture a transition has been made to the iconic. When the icon is treated with reverence in the context of worship, this attitude can be described as 'iconolatry', veneration of the icon. This term should be used in preference to the term 'idolatry' which has so many censorious and pejorative associations in Western usage, typified by the now obsolete hymn lines:

> The heathen in his blindness
> Bows down to wood and stone.

The implication here is that the 'heathen', the ignorant followers of inferior religions, bow down to worship 'idols' carved out of materials from the natural world. To offer such worship is not only ignorance but an offence against God who cannot be identified with any creature or earthly object; it is self-deception on the part of the worshipper who knows very well that his idol is only of wood and stone; it is corrupting because it makes the god a pawn in the hands of the worshipper and by worshipping what is less than God (i.e. a false god) destroys the possibility for him of true religion – it becomes demonic instead of ultimate.

So run the objections to idolatry. But it must be asked whether these objections are relevant to what actually occurs in the use of images. In many cases at least there are good grounds for refraining from the assumption that it must be 'idolatry' in the sense described. As a preliminary caution one must ask what is the source of the information concerning the alleged idolators; in the past it has often come from foreign observers with only limited knowledge of the religions employing the 'idols' and from former worshippers disillusioned with their ignorant beliefs about the images of the gods. It is indeed extraordinarily difficult to secure agreement as to when the elusive term 'idolatry' can be applied. For instance, at the Reformation both Catholics and Protestants agreed that idolatry was forbidden to Christians by the Bible; but they disagreed over the question as to when an image became idolatrous:

At no time was it possible to prove that idolatry was taking place, since the worship of a created thing in place of God occurs in the mind of the worshipper rather than in the image addressed.[35]

A further caution is necessary concerning the easy assumption that 'idols' are found among the so-called 'primitive' peoples with a low level of technology. It is evident on the contrary that image-making flourished far more in cultures with advanced skills, as in Egypt, Greece and India,

while in Africa there are cases of peoples whose traditional religion had no place for images, preferring ritual action instead. Nor should it be assumed that where images of a very rough unfinished nature are used (often described in Western literature as 'crude' or 'rude' images) they are the work of culturally inferior people. A telling example is the village god made by a priest of Bush Negro people in Surinam. It is described as a crude anthropomorphic figure, a repository of magic strength coated in sacred white clay; but the power resides in the charm about its neck, and the image itself is not worshipped. Yet in secular art the people are capable of producing wood-carvings and ornamented paddles and combs of a high standard of craftsmanship. The sacred art is deliberately of a different sort, strikingly crude.[36] What is important is the relation to the sacred power which it mediates. This point can be illustrated again from many images venerated in the churches and temples of 'higher' religions. Some of the elaborately decorated pilgrimage churches of Europe enshrine images which are much inferior artistically but which are believed to be special vehicles of the divine power. For instance, the dazzling German rococo-style church, '*Die Wies*', in southern Bavaria was built in the eighteenth century by the Zimmermann brothers to house a crudely executed and painted image of Christ scourged.[37] Sometimes this crudity achieves an elemental simplicity that makes the image almost aniconic, giving it a semi-abstract stylized appearance that appeals to the modern Westerner. The female figurine in this style from the third millennium BC in Sardinia is, along with many other such prehistoric Mediterranean images, thought to represent the Great Mother, the source of life and death, sexuality and power. Despite our lack of information as to the specific religious context we can sense that the image need not be more representational to achieve this effect.[38]

If we now ask more positively what such images mean when used for worship we may consider the following points. First, the image is not thought of as a mere block of stone but always as something significantly more than this. Of course it is known that most of the images have been made by local craftsmen and are vulnerable to fire and woodworm, in which case they can be discarded and replaced. Usually there is some act of consecration or ritual or setting up the image in a special house or sacred place, or of completing the image by endowing it with eyes; henceforth the image has some indwelling 'life' and spiritual power, if only for certain occasions. Secondly, the god is not tied to this one image or sacred place. There may be many images of the god in the country of the religion; yet in all of them the god is believed to be present, in some way overarching them and accessible through them all. (In contrast to

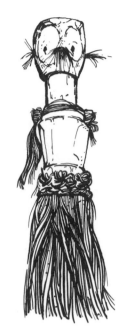

3. Bush Negro art: a village god.

2. 'The Great Mother'.

the religious use of images, the practice of magic and the use of so-called 'fetish' objects is for local circumstances and requiring unique manufactures.) Thirdly, the worshipper is concerned to participate in the power of the god whom he regards as ultimate; he may be tempted to identify that power with the particular image confronting him, but this need not be so. He knows that there are other images and that the god is more than the image. All that is required from the image is that it should mediate or reflect the divine power, (rather like a mirror, which is indeed an 'image' but not the reality). Finally, images are felt to be necessary because man needs some mediating channel through which to receive the sacred power: God is too great for man to meet directly, and he cannot be totally revealed. Hence images are experienced as a mode of 'revelation' of the hidden God, partly revealing and partly concealing. Men may feel awed by images but also they experience a certain joy in devotion which restores them to wholeness in the manner of a sacrament.

The above considerations present a more favourable view of images in order to counter the premature judgments concerning 'idolatry'. Our concern is to allow for the authentic religious intention which may be expressed through the use of these images. It certainly is not easy to decide when an authentic religious intention is misdirected and turned into something else – a magical manipulation for instance. What considerations would lead to this judgment? Perhaps the discovery of trickery and deception, as in the case of a priest in Spain earlier this century who used to press his foot on a secret mechanism causing an image to raise its arms, the people being allowed to regard this as miraculous.[39] Yet on other grounds the devotion might be genuine enough. The crux of the issue of idolatry comes when the image is so much identified with the deity and its power that it is regarded not merely as a mediator or reflector of the holy but becomes itself intrinsically holy. One's doubts are aroused by hearing that a certain image at one centre is said to be more effective than another image, as if the sacred power behind the image were limited to it as a medium.

That ancient images continued to retain some of their 'magic' in popular belief can be well illustrated from medieval Europe where most of the free-standing statues of pagan antiquity had been destroyed as 'idols' and as 'the seats of demons'. In the Italian city of Siena around AD 1300 the citizens were delighted to unearth a nude Venus sculpted by Lysippus which they placed in an honoured position on the fountain in front of the city hall. Apparently it was expected to serve as a sort of protective deity; but when Siena suffered misfortunes such as the plague of 1348, popular feeling turned against the image. The city government pronounced the

Venus 'inhonestum' (indecent) and disposed of it. A later account states that the image was broken in pieces and buried on Florentine soil so that the evil qualities might be transferred to the enemy.[40]

As a reaction to such 'degenerations' and abuses in religions down the ages there have been periodic outbreaks of iconoclasm when sacred images were literally broken by those who saw them as idols in opposition to true religion. The illustration from Antwerp in 1588 shows how Catholics regarded Protestants at the Reformation period – as despoilers and pillagers of their sacred images, committing sacrilege against Christ himself. Deep feelings were aroused concerning images on both sides.

In view of the great variety of images and of attitudes to them (both iconic and aniconic may be objects of reverence), it is impossible to make any blanket generalizations about their legitimacy. One may gain a fairer assessment of the use of any image by looking for its context first in the ritual use and secondly in the attitude of the worshippers. The image may turn out to be more of a decorative background for some, of quasi-magical significance to others and a helpful religious reminder in other cases again. We have to persist in asking what the image means to worshippers.

One further caution against an over-readiness to identify an icon with the deity it represents comes from E. H. Gombrich in describing Van Eyck's altar-piece. The artist has here used gold to suggest the divine

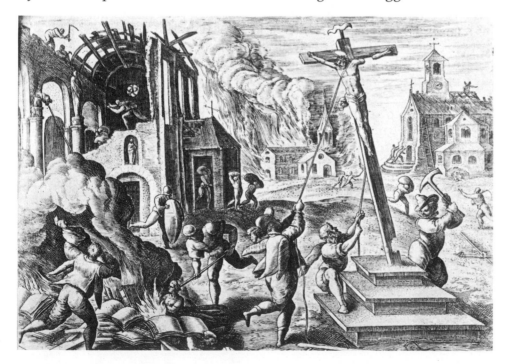

4. Iconoclasm directed against Catholic images following the Reformation.

goodness and radiant holiness and he shows God in regal and priestly splendour as a dignified man with a papal crown. Writing simply as an art-historian, Gombrich reminds us that all artists create illusion and that the images they produce for religious purposes are not intended as literal iconic likenesses.

> To Van Eyck and his sponsors the doctrine was clear that God is not a man with a beard, but that among all sensible things of which man can have experience on earth, a beautiful and dignified fatherly ruler of infinite splendour is the most fitting metaphor our mind can grasp. . . . The Church warns the faithful not to take any of these symbols literally but only as sensible analogies to higher meanings.[41]

Understanding Man's Use of Images

Having discussed some of the crucial issues in this use of religious images we can now inquire about the methods appropriate to deepening our understanding. To begin with, it can be helpful to survey the main types of human response to images in religion, for which purpose a brief typology is offered. Of the six types along the continuum, three are more positive and three more negative in orientation.

Type 1 is the thoroughgoing image-worshipper. As he enters the temple he sees the central icon as a living embodiment of god whom he envisages as looming behind the image but also addressing him in it as his bodily home.

Type 2 also venerates the image but he regards the god's presence as a temporary manifestation during the period of ritual and worship when the image comes 'alive' for the purpose; the god is above his and all other images.

Type 3 venerates the image as a reminder of the god's presence and of his character available to worshippers in other places besides the temple and its icons. But the images are a valued aid to devotion and he can pray to the god while concentrating on the visible image.

Type 4 would not go to a temple with images in the belief that the images could confer any special benefit. They are part of the tradition which helps many people; but as a mystically minded person he is able to do without such mental crutches and achieve oneness with God. In prayer and meditation he may begin with the image only to transcend it.

Type 5 would not go at all to a temple with images if he could help it. The temple of his choice has no such trappings and any pictures used are regarded as works of art or illustrations for educational purposes. When he prays he turns away from any thought of a visual image.

Type 6 would not need a temple at all for worship; God has no need of a house, being so much beyond man's understanding as not to be confused with his creation. When he prays he communicates directly to God with no need for intermediaries. As for images, if he could lay hands on them he would smash them up.

It is necessary to keep in mind that these are 'ideal types' in the sense of artificial abstractions from reality ranging from one extreme to another. In actuality one person may experience more than one of these attitudes in an occasion of worship – for instance, switching from type 3 to type 4 in a mystical moment and also making didactic use of images sometimes. There is a certain amount of oscillation between types and also of carry-over from one type to another. Also there appears to be no simple line of evolutionary development in attitudes to icons. The variety of attitudes above is evidenced in ancient times in scriptures and testimonies of religious experiences from sages, prophets and mystics. It may well be that these are perennially recurring types existing side by side in human experience.

There is a great deal more to be discovered about people's attitudes to images and various disciplines are able to assist in this task of research. The study of religion owes much to the work of anthropologists over the past century; and recently some fruitful studies have been published concerning the visual arts among primal peoples and relating to their traditional religions.[42] From the standpoint of religious iconography it is the effort to get inside the meaning of the art of specific cultural groups that is helpful and often admirable, so that one can only hope for more of such studies describing human behaviour with sympathy and insight. Art is sometimes classified by anthropologists as cultural tradition and as communication – to convey ideas and emotions by means of conventions and formal symbols and to reinforce beliefs, customs and values.[43] Leaving aside the implicit functional approach, one could develop the suggestions on art as religious communication in the light of inter-disciplinary studies of the mass media. That this is not just a modern phenomenon is indicated by the propagandist aspect of ancient Roman monuments used as meaningful visual images in a mass society linked by a rapid and effective communication system:

The first rationalized application of these techniques to the calculated persuasion of a disparate mass audience occurred under the Romans, and their works of art were its primary agents.[44]

Within the discipline of sociology questions could be raised concerning the social base of iconography of religions, the social factors underlying

changes in iconography (the social history of art)[45] and how images are used in groups. And psychological researches in the field of imagery[46] could be applied to inquiries into the diversity of types of images experienced by different people in relation to religious activities and the use of icons in worship.

From these suggestions for inter-disciplinary work we turn to the task of religious studies in studying the iconography of religions. This is understood here in terms of the history and phenomenology of religions. First the material has to be described on the basis of our knowledge of religions as they have developed in history. But having done this one seeks to understand the material as far as possible on its own terms, without prejudging its truth or imposing alien categories on it. In discussing the use of images it is all too easy to be moved by sympathies and prejudices, or to explain away the use of images as the result of superstition, projection of human wishes or of some other proposed 'origin of religion'. This fruitless procedure is left aside here, on the grounds that both art and religion are complex forms of human activity and experience and that there is no possibility of reducing all art or all religion to a single 'origin'. Instead of seeking to judge or explain in this way we are concerned first and foremost to *understand* the phenomena of religious worship and images. This requires empathy for the religious intentions of worshippers and knowledge of their activities from historical and disruptive disciplines. More specifically the history and phenomenology of religion as exemplified in the work of modern scholars directs our attention to images in the following five directions.

First, following the lead of Rudolf Otto,[47] we would see images as a means of evoking man's experience of the 'numinous'. For instance, the apse of Byzantine churches may be dominated by an awe-inspiring mosaic of Christ as Pantocrator whose stern gaze fixes on the worshipper; or at Torcello near Venice a thin hieratic figure of the Virgin 'Mother of God' stands out in majestic splendour against the gold background of the apse, a figure of both commanding otherness and magnetic attraction.

Secondly, the image captures a religious experience which is valued as a continuing reality so that in confronting the image it can be deliberately repeated, ever anew.[48] Just as masked ceremonies ritually enact past events and myths and ritually perpetuate the past, so the image captures the action of the holy and 'freezes' its motion.[49] Movement of course is the one thing that an image cannot supply; but it can simulate and suggest it, as in the Hindu image of Shiva dancing. An image can express the vitality and power of the Sacred, but in freezing it for eternity it also illustrates the conservative aspect of religion. The great Yün-Kang

caves of northern China in the late fifth century resulted from the resolve of an emperor, converted to Buddhism, to build a monument to Buddhism that could not be destroyed by the ravages of time and persecution.[50] In such massive sculpture a religious vision is expressed in outward form and perpetuated. Iconography then becomes a means of handing on the established pattern.

Thirdly, the image embodies a manifestation of the sacred power and presence which is celebrated in myth and ritual, in sacred space and time.[51] Thus Apollo had one of his great shrines at Delphi, a place hallowed by his deeds which are represented in festival and myth.

Fourthly, the image offers the worshipper an ideal archetype or sacred model to follow, so that confronting the image periodically renews and transforms the person. In the early Christian centuries the figure of Christ was not represented visually so that the experience of renewal took place through the word and sacraments of the church based on the crucified and risen Jesus. But the male cult of Mithras had as its focus the heroic image of a bull-conqueror who could transmit life and courage to his soldier followers.

Finally, the image enables man to relate himself to the cosmos, because the harmonious body of the divine image is a microcosm with which he can identify; in the warm life-like figure depicted in visible form he has access to the infinite majestic power of the microcosm. Being a creature of body and spirit, man seeks to relate his body to the divine 'body'. This is very evident in the beautiful anthropomorphic statues of deities developed in ancient Greece and India; but it is also a motif latent in most religions and icons. The twelfth-century German abbess saint Hildegard of Bingen had a vision which vividly expressed the microcosmic principle, illustrated in the thirteenth-century *Codex of the Book of Divine Works*. Man is shown as the world in miniature, the measure of the macrocosm and microcosm. The four elements (air, earth, fire and water) appear in him, and the fiery power of life embraces man and his world (shown as a black disc behind him). Beyond this, supporting the world, is a person representing Christ with the stigmata (marks from the crucifixion) on his feet and a head of Apollo crowned by that of God. This outer figure may also be understood as Nature, with the upper patriarchal face representing the divine Wisdom. Here then is one of the few pictorial expressions of what was a fundamental conception of medieval Europe.[52] As a principle of correspondence between man and the universe it is found in Asian religious thought in such systems as Hindu Tantra, and it may well prove to be a principle implicit in a great deal of religious iconography based on anthropomorphic forms. In a discussion of the

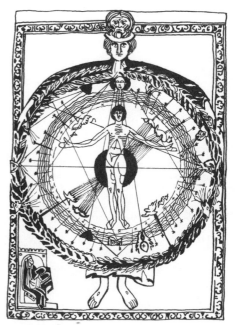

5. Man, the microcosm at the centre of the universe.

Buddha-image Titus Burckhardt writes thus of the reciprocal relation between the worshipper and the icon:

> The icon penetrates the bodily consciousness of the man and the man as it were projects himself into the image having found in himself that of which the image is an expression, he transmits back to it a subtle power which then shines forth on others.[53]

In the following chapters the approach just outlined will be implemented by describing images and their meaning in some major and representative religious traditions. In each case the following questions can be profitably asked, and although they are not applied formally in an identical way to each chapter they do shape the presentation of the material. The reader is therefore recommended to keep these questions in mind as he works through the iconography of various religions.

1. What are the *gods or sacred powers* who are worshipped and believed in? What theology (or Buddhology!) is expressed in the cultic images?

2. What is the *iconography* of the images? (Images may include carved icons, flat Byzantine icons and frescoes, mosaics and pictures such as Indian 'bazaar prints'.)
 How do we 'read' the iconography? i.e. What recurring themes and features tell the story which the religion seeks to hand on?
 How did the iconography develop? e.g. from aniconic to iconic forms.
 How did the forms become fixed (as in an authorized iconographic 'canon')? Or how did they proliferate and diversify (as in the spread of Buddhist images over Asia)?
 What opposition was faced from iconoclasm?

3. What is the *context* of the image in its *religious setting*? (i.e. not just as an exhibit in an art museum or a link in the chain of history of religions).
 (*a*) Who makes the images on the basis of religious traditions?
 (*b*) After the making, how are they consecrated?
 (*c*) What ritual accompanies their worship? (e.g. lamps lit, chanting, music, circumambulation, offerings).
 (*d*) What is the spatial setting? (e.g. temple complex, domestic shelf).

4. *What is the experience of the worshipper?*
 Who confronts the image and participates in worship?
 (*a*) How is the image related to other images which he may worship in the temple and village?

(*b*) How does the worshipper relate himself to the god or sacred power? (e.g. as a suppliant – seeking mercy, benefits).

(*c*) How does this experience transform the worshipper's understanding or reinforce his religious stance personally?

How does his own body relate to the 'ideal body' of the god?

<div style="text-align: right">2</div>

Primal Religions

Questions of Prehistoric and 'Primitive' Religion

What we like to call our thinking may be as much conditioned by the fears and prejudices of the mammoth-hunter or the neolithic peasant as by the religious aspirations of the early Semites or the speculative thoughts of the Greeks.

Stuart Piggott[1]

6. Wall painting showing hand imprint.

7. Palaeolithic engraving probably of vulva as a fertility symbol.

SHOULD WE LOOK to prehistory for the beginnings of religious iconography? To answer this we must at least be aware of the main subjects of prehistoric art works that have come down to us from a period of some 30,000 years. Following the richly illustrated survey by Siegfried Giedion we list them as follows:[2]

1. Under the category of *'symbols'* we place various markings and finger-drawings of lines and abstractions, rectangles, dots, circular forms and hollows (cupules). Among the earliest are imprints of human hands which are themselves significant of man's distinctive powers of control and expression. While the meaning of such 'symbols' is far from clear, an emphasis on fertility and procreation is evident in the sexual symbols[3] of the vulva, phallus, female breast and bisexual or androgynous symbols.

2. *Animals* provide the chief subject-matter of Upper Palaeolithic art (i.e. the later period of the Old Stone Age, approximately 30,000 to 10,000 BC). Cave-drawings depict large mammals of this period such as bison, horse, deer, mammoth, woolly rhinoceros, cave lion and brown bear. As art works these are the most impressive, and the powerful representations in colour at Altamira (in northern Spain) and Lascaux (southern France) have aroused modern men to astonished admiration.

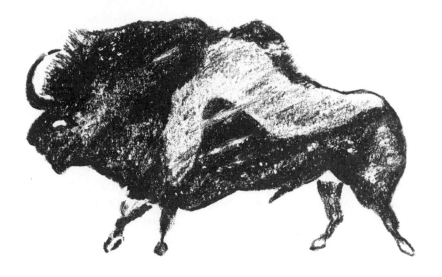

8. Wall painting of a bison, from the Lascaux caves.

10. 'Bison-man' behind herd of animals, from Trois Frères.

11. 'Venus' of Laussel.

The art expresses a deep involvement with the animal world. Palaeolithic man hunted these animals yet felt a bond with them – perhaps admiring them for their superior speed and power. If this was the age of the supremacy of the animal, the 'zoomorphic' age[4] which continued through prehistory, the situation changed with the neolithic period. Man then domesticated animals and in dethroning the animal took his own place as lord of nature.

3. The *human figure* is less represented in palaeolithic art than the animal, and much more crudely and clumsily – perhaps a further sign of man's sense of inferiority in relation to the animal. In these representations facial features and even the head may be lacking or depicted as an animal head. The latter is the case with some intriguing hybrid figures combining animal and human features, such as those in the Trois Frères cave where one may be performing a dance masked in animal skin and another perhaps musically charming a herd of animals. The female body is strongly featured in carved figurines and in cave reliefs such as the so-called 'Venus' of Laussel. The face is lacking but the exaggerated female features of the human body indicate a predominant concern for fertility.

Already in outlining these simple types of prehistoric art we find it difficult to avoid interpretation. Even the external forms and materials of these works can be viewed as having a deeper significance. For instance, Giedion notes that the relief-sculpture on a cave wall is attached to its background and thus expresses 'the inseparable oneness of all that exists'; also the wall paintings, being without a spatial frame, express the oneness of the world, 'a world of unbroken continuity'.[5] This hints at some cosmic and hence religious significance. But our initial query remains: In what sense can this prehistoric art provide us with religious iconography? If iconography deals with the content of art, one can readily enough discern some of the basic life-concerns of palaeolithic man which supplied the content of his art – birth and fertility, death and the hunt for food. Granted this, in what respects were these *religious* concerns giving rise to a religious iconography?

There has been no lack of interpretations of prehistoric art as an early expression of man's religions, of his artistic and spiritual creativity, of his anxious concern to control the unknown factors so crucial to his survival. Thus the 'Venus' of Laussel may have been the focus for fertility-rites in a rock-sanctuary and 'the oldest representation of a deity in the form of a Mother Goddess'; the paintings of animals in the recesses of caves may be part of a 'hunting magic' accompanied by a masked dancing shaman who may even have been venerated as a supernatural 'Lord of the Beasts'.[6] The artist himself may be viewed as 'a magician whose drawing had all the virtue of a magic spell, an incantation', an artist-magician who in a state of ritual trance 'evoked the supernatural powers which identified him with the bison, the mammoth, horse or deer, until he was possessed by the soul of the animal itself and could then portray its image on the wall of his cave'.[7]

However suggestive and attractive such speculations might be, it is necessary to re-emphasize what the writers usually acknowledge by way of preface – that these are speculations, or at best hypotheses. For instance, it is tempting to interpret the human-animal figure in the Trois-Frères cave as a dancing sorcerer or shaman; this accords with the evidence for the widespread practice of shamanism which may be the earliest form of religious specialism and leadership.[8] The 'Lord of the Beasts' identification is taken a step further by those who see this figure as man's first god – a dancing magician who constitutes the real, human, origin of the gods and religion.[9] But when one looks critically at the much-published drawing by Breuil of this 'sorcerer' alongside of the cave photographs, one can scarcely feel confident about the evidence on which such hypotheses are based.[10] The great variety of possible interpretations

9. So-called 'Sorcerer' from 'sanctuary' recess, Trois Frères.

in this prehistoric material is itself a reminder that caution and perhaps a self-denying ordinance are called for here, for no single interpretation is adequate to cover all the evidence.[11]

A key issue here is the lack of criteria for checking such interpretations of prehistoric material. This is a problem which must be considered in any study of the past, including the study of the iconography of religions. All history is an interpretation of evidence from the past using certain models relevant to the material. In the case of iconography the model must be based on some known systematic tradition of symbols and visual representation; and if it is religious iconography it must be able to be related to a sacred context of worship and religious meaning. It is possible, for instance, to relate a crucifix to Christian worship and to observe the role of masks in the religion of a contemporary African tribe. But these requirements are almost impossible to meet in the case of prehistoric cave paintings and figurines. Granted, we can sense the importance of animal and mother figures for hunting peoples; but we do not know their context of ritual use nor the religious experience to which they could be related. It is not enough to say, 'Prehistoric man must have felt the need for a shaman and fertility cults'. We would require some testimony from participants in the ritual and from the artists who made these works, in order to show the context and tradition in which they might have shared. Without such testimony one cannot speak legitimately of a prehistoric religious iconography.

Prehistoric works of art express themes which, in some cases at least, may be interpreted as religious. Further, we can say that their main types of content – symbols, animal and human figures – are those which recur in the developed iconographies of the historical period of mankind. These types provide a basis but do not yet constitute a discernible tradition of religious meanings; they are expressive signs but not yet a system of 'writing in pictures' which can be 'read' as in the case of a true iconography. It appears impossible, both in principle and in practice, to bridge this gap.

Because of this crucial gap some writers in the fields of anthropology and the history of religion have, during the past hundred years, sought to interpret prehistoric evidences in the light of existing 'primitive' peoples who might be studied as living fossils from prehistory surviving to tell the tale. The ambiguity of the word 'primitive' can cover both the primeval or prehistoric and the present-day pre-literate tribal peoples with simple technology. This ambiguity makes it easier to link cultures of both sorts, to switch between them and to treat them as 'the single, and in a certain sense, timeless subject that the modern anthropologist can see

them to be'.[12] On these lines Lommel proceeds to study the diffusion of art-motifs, such as the 'animal style' or prehistoric hunters, over wide areas of space and time and thus seeks to penetrate 'the mental world of early man'. The art of the early hunters died out in Europe but has survived into our own time among Arctic peoples, the South African Bushmen and the isolated Australian aborigines.[13] This wide-ranging approach imparts a certain excitement and a synoptic vision of mankind; it may help us to appreciate the common human qualities and possibilities of men in all places and periods. It is nevertheless open to a recurring objection – that it tends to equate prehistoric with modern 'primitive' peoples, the latter being viewed as a rather static form of the more dynamic original.

Despite all the intriguing parallels and continuities we are not entitled to make this assumption. First, because all societies change. For instance, the Australian aborigines with probably 30,000 years on their continent have been cited as arch-conservatives; but with all their alleged conservatism they have still been influenced in the north from Papua and Indonesia. They certainly cannot be identified as ossified 'survivals' of palaeolithic man. Secondly, there is the allied misleading assumption that similar economic activity (i.e. hunting) provides a common determinant of the art, religion and kinship system. This is not true for existing hunting cultures which may be compared, such as the Australian and Eskimo; the complexity of Australian religious thought and kinship system makes it far from typical and no clear guide to a supposed palaeolithic original. 'To know that a people live by hunting and gathering does not, therefore, enable one to generalize about many other features of their culture.'[14] The chief value of such comparisons may lie rather in adducing a wider range of analogies than provided by the limited, culture-bound experience of the researcher and thus enabling him to be more clear-sighted in his interpretations and speculations.

Rather than add to such speculations we should direct our efforts to the study of existing cultures and religions in their own right and learn what we can of their religious and artistic expressions as modern studies have made these known.

Further, instead of the ambiguous and often misleading term 'primitive', we prefer to use the term 'primal' to indicate the traditional cultures usually found among tribal, pre-literate peoples. The last-named terms are too restrictive, the term 'traditional' is too general, and 'primitive' has implications of inferiority and backwardness (with overtones of misplaced evolutionism, as in the term 'animist'). The term 'primal' means that the religions so described 'both anteceded the great historic

religions and continue to reveal many of the basic or primary features of religion'.[15] Even when the overt religious system declines, the structure of beliefs and values involved in the primal 'world-view' may continue to guide the way of life. While there are many such primal world-views, broad similarities in their attitudes to nature, society and the life-crises of man have been widely noted in discussions of 'primitive religions'.[16]

Whatever be the term used, it should be made quite clear that there is no intention of imposing an evolutionist interpretation of progression from some dark 'primal' stage to a superior stage of 'high' religion. Quite on the contrary, such religions should be seen as primal in the sense of basic, expressing elemental forms of human behaviour that continue to be powerful and important in the life of modern societies. One indication of this is the modern response to the power of so-called 'primitive art'.[17] The fact that they can often be studied in small-scale pre-literate cultures highlights their position as 'nuclear' religions – primal (not primitive), elemental (not elementary), nuclear (not peripheral).

Out of the many religions of primal peoples which have been studied in detail in recent times, we choose three adjacent areas with distinctively different traditions – Australia, Melanesia and Polynesia. By choosing examples from these areas, we cannot, of course, expect to have covered all types of iconography among primal religions. But at least some of the basic issues will be thereby raised to view, and these can subsequently be related to other areas than the Pacific, such as Africa and the Americas, according to the interest of the student.

The Australian Aborigines

With Australian aboriginal art we can rightly speak of a religious iconography. It supplies a good starting-point, not because it is a 'prehistoric survival' (an interpretation we have rejected) but because it shows how a simple technology may be accompanied by a rich and complex world of symbolism.

Here is the aboriginal in his traditional way of life, a nomadic hunter and gatherer over vast and often inhospitable territories. He wears few if any clothes, his material possessions and shelter seem pitifully small. To the white settlers who first saw him he was a creature little above the animals, with ridiculous childish customs and no sign of religion. Such art as could be seen on rock-carvings seemed of little interest, and the symbolism of aboriginal drawings and designs baffled even the few who sought to understand them sympathetically. In actual fact much of

'The Dreaming'

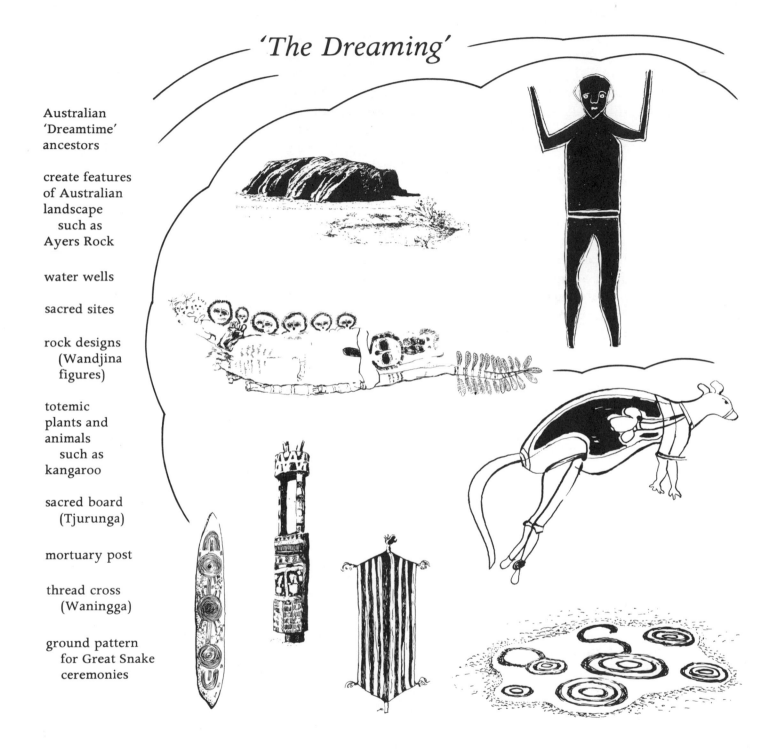

Australian 'Dreamtime' ancestors

create features of Australian landscape such as Ayers Rock

water wells

sacred sites

rock designs (Wandjina figures)

totemic plants and animals such as kangaroo

sacred board (Tjurunga)

mortuary post

thread cross (Waningga)

ground pattern for Great Snake ceremonies

12. Expressions of the Australian aboriginal 'symbolic universe'

'The Dreaming'

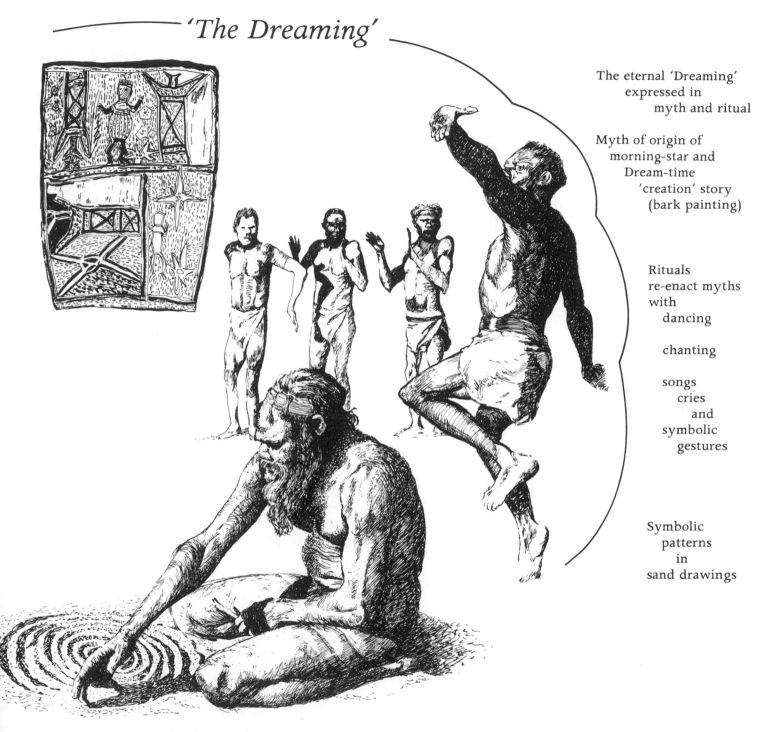

The eternal 'Dreaming'
expressed in
myth and ritual

Myth of origin of
morning-star and
Dream-time
'creation' story
(bark painting)

Rituals
re-enact myths
with
dancing

chanting

songs
cries
and
symbolic
gestures

Symbolic
patterns
in
sand drawings

. . . Australian aboriginal 'symbolic universe'

the art, lore and ritual was of a sacred and secret nature and hence not easily accessible to Europeans. Although the traditional culture is fast vanishing, effective studies of the remaining aborigines, especially in central and northern Australia[18] have done much to remedy European ignorance and reveal the religious roots of aboriginal life and art.

The foundation of this view is the 'Dream Time' (or, better, 'Dreaming'[19] for the term *altjira* from the Aranda of central Australia, with equivalents in other areas). This refers to the 'seeing of eternal things', as in a dream, things which constituted life 'in the beginning'. This primordial Dream Time or eternity is what constitutes the universe and provides the order under which men must live and forever find renewal. Myths tell of the earth as eternal and uncreated but needing to be awakened from its barren featureless state. This happened when the totemic ancestors awoke and burst through the earth's crust to wander over its surface. It was these ancestors (not high gods or 'sky-dwellers') who were responsible for filling the earth with animals and plants of their totems. Although they sank back into the earth their Dream Time lives on as an eternal order, an 'everywhen' in which man lives. Their mark is upon the Australian landscape and indeed upon all things; it is felt especially at sacred sites and in the myths and rituals which are reminders of what the ancestors did.

We can see first the implications of this view for the life of man. The aboriginal lives in a symbol-laden universe where all things are linked in a primeval unity of man, society and nature. He is deeply rooted in the land with its sacred sites and Dream Time ancestors. His distinctive life comes from these ancestors who provide each child with a second, immortal, soul during its mother's pregnancy. At initiation he receives a secret name and a special stone or other token linking him with the ancestors; he belongs to one of the many totemic groups which relate human society to natural objects, plants and species (such as the snake, emu, kangaroo and witchetty-grub). The term 'Dreaming' can be variously used to designate also a man's cult-totem and himself as an initiate, because all are linked together in one continuous eternal order. Totems endure as unifying social bonds and, together with the sacred places of their origin, they are signs which link living men to the marvels of the ancestral Dream Time. (See diagram of 'Australian symbolic universe'.) The symbolic nature of the Australian aboriginal's world is summed up by Stanner with the aid of Bishop Berkeley's quaint phrase:

But most of the choir and furniture of heaven and earth are regarded by the aborigines as a vast sign-system. . . . He moves, not in a landscape, but in a humanized realm saturated with significations.[20]

The outward expression of this view is found in a variety of symbolic forms. At one level the Dreaming is an unseen, spiritually apprehended and eternal state, so that one may refer to the doctrine as 'a sort of eschatology', a doctrine of final things which were also the first things, or again as an ontology concerned with man's being. But this abstraction is always mediated by 'symbolizing means', vehicles which convey the basic symbolism of the Dreaming. Ritual activities bring these together most vividly, including a whole range of symbolic gestures, cries, songs and chants, myths and rituals, stylized acts using such elemental powers as fire, blood and semen. In this setting, aboriginal art is actively correlated with chanting, dancing and acting – for instance, chanting while actors are painted to become Dreaming heroes, or painting mythological designs on bark to make the Dreaming present. If acting recreates the founding drama as a dramatic sign, chanting is the audible sign and painting the visible sign of the Dreaming.[21]

Aboriginal art is not all 'sacred art'; there is secular decorative art and a variety of art works which can be enjoyed aesthetically by the modern European public. There are also degrees of what is 'sacred' and 'secret', so that sacred designs can sometimes be used on secular objects such as weapons, implements and ornaments. But sacred tradition and ritual use provide the norms for group and artist. These can be expressed in diverse media, art forms and regional styles. Painting is done on rock, bark, earth, artifacts and the human body. There are engravings on stone and wood sculptures of men and animals. Some of these may be only temporary symbols such as decorated poles and frameworks erected for a particular totemic ceremony. Others are permanent, treasured objects kept in a secret place or carried around to impart strength and success. Particularly important here is the *tjurunga* (*churinga*), the flat wooden sacred emblem of the Aranda; its length may vary from a few inches to three feet or more. Because the designs incised on the wood relate to the ancestors it is treated with great reverence by the individual owner and the group meeting in a secret ground to chant the myths.

To illustrate the religious iconography of different areas of Australia let us consider the cave paintings found in the north-west region (north Kimberleys) depicting the Wandjina, creative beings who bring the seasons, rain, fertility and spirit-children. At the end of their Dream Time exploits they went to caves and shelters to 'die' and become paintings.[22] Their power remains in their paintings and is available through ritual renewal; for instance to 're-touch' them by sacramental painting will bring rain. Their faces have eyes and nose but no mouth, for which there are various explanations. When a visiting ethnologist asked for the reason

an aboriginal replied, 'They can't have mouths! If they did it would never stop raining and everybody and all nature would die!'[23]

The Arnhem Land 'reserve' in the far north is still productive of traditional forms of art, typically more representational than the formalized style of central Australia (although the Tiwi of Melville Island show more affinity with the latter[24]). Forces are working for both continuity and change. During the 1960s the two major myths of north-east Arnhem Land were depicted on panels in the Yirrkala church, thereby recognizing the importance of the aboriginal heritage.[25] In this region again the Elcho Island Mission station has a public memorial made up of traditional sacred-secret emblems such as the submerged log, crowned with a cross and suggesting a mythical personage – 'a deliberate attempt at syncretism' suggests Berndt.[26] In east Arnhem Land the myth-cycle of Djanngawul is accompanied by bark paintings of this Dream Time figure who arrived with his sister by canoe and bestowed fertility on the country by creating waterholes, vegetation and especially human beings.[27] A more ambivalent source of fertility is the rock python Julunggul who was once coiled up with eggs in his sacred waterhole; when the Wawalag sisters disturbed him he swallowed and regurgitated them repeatedly. This 'Great Snake' appears under different names in other areas. He is feared because of his power; but in order to renew ties with this power aboriginals may run their fingers along his wavy snake-image on a rock.

Because there are variations on the myths and because different symbols are used to express them, the understanding of a picture may be confined within the territorial limits of the tribe and taught to initiates. But within these limits it is a genuine iconography, a form of writing in images. 'Thanks to the line and colour that speak to the eye and so keep the word fresh in the aural memory, the Aborigines' "oral literature" becomes also "painted literature".'[28]

This process has been studied more exactly in relation to the graphic signs used in social and ritual communication among the Walbiri of central Australia, (north-west of Alice Springs). In the course of anthropological field-work Nancy Munn[29] was able to collect many totemic designs painted in the course of rituals in public 'camp' ceremonies and men's ceremonies. The designs were used on various forms such as the ceremonial regalia worn or carried by dancers, including headdresses of mulga branches, painted shields and poles, string crosses carried on the head or in the mouth. Body designs to aid the impersonation of ancestor-figures were done in red and yellow ochre, white paste and charcoal; bird or vegetable fluff was stuck on with blood drawn from the arm.

Ground designs were painted in red or white fluff, to be obliterated in dancing. Information on the iconography and myths was gained by encouraging men to draw 'visual texts' in the form of diagrams with pencil crayons on paper. A further most important source was the observation of sand drawings which both men and women used to accompany their story-telling and general conversation; women typically recounted everyday experiences and dreams, men the more exclusively masculine accounts and ancestral myths. They expressed pride in their sand drawings as a way of talking, with the saying, 'We Walbiri live on the ground'.

These sources revealed a basic repertoire of graphic signs which could be used in different contexts and combinations to create many designs. The Walbiri themselves distinguish several categories of representation. Munn was particularly concerned with the symbolic functions of the iconography in Walbiri cosmology and society; subsequently she came to a structural analysis to interpret the relation of the graphic system to the sociocultural order.

A key example of the graphic signs is the circle-line notation used in men's designs. The circle form, drawn also as concentric circles and a spiral, represents a place, particularly a campsite, a circular path and other meanings in context such as a hole, fire, fruit and hill. The straight line represents a path between the places, a means of going out and coming in. But they also relate to sexual differences – the circle to digging-stick holes, women's breasts and vagina, the body of the mother as container of life; the straight line to leafy poles, spear and penis, the male life-principle, the son emerging from his mother. Here can be seen the basic polarities which are complementary within an over-all unity of society. The circle-line model applies to the major experiences of life. It refers to the interplay of male and female – the son coming out of his mother but returning to the female centre in sexual intercourse and to the earth in death. It refers spatially to the local Walbiri country made up of life-centres linked by paths which the ancestors trod and hallowed. It refers temporally to continuity between the past ancestors, whose power from the Dreaming (*djugurba*) resides at these centres, and the present expression of this power as it comes out from these centres into the landscape and life of the present. The circle-line model is thus a 'spatio-temporal icon' which images the Walbiri world theory built on the notion of coming out and going in.[30]

The conclusions reached in Munn's study are of interest for the wider study of iconography of religions in other societies, literate and pre-literate. The study seeks to analyse the internal structure of visual

forms as parts of larger visual systems within a culture. The study also illustrates beautifully the part played by the designs in temporal activities and bodily behaviour. For instance, the circle patterns are drawn by hand in the sand and acted out by the dancers in ceremonies.[31] The body makes contact with the sacred objects or designs, even being identified with them in body-painting. This leads to a third important consideration – the role of iconography in relating the social order to the individual's experience. A verbal code is a cognitive device, but a visual code is able to regulate experience by drawing on the senses of sight and touch. Iconic symbolism is thus a bridging mechanism between the macrocosm expressed in notions of a world-order, and the microcosm which is the individual.[32]

Melanesia and Masks

To the north and north-east of Australia lies Melanesia (literally 'black islands') extending from the large island of New Guinea to the Solomons and out to Fiji in the south-west Pacific ocean. The Oceanic Negroid population is the result of waves of Neolithic peoples and cultures reflected in very diverse languages, customs and religions of which no single one can be called typical. Hence Melanesia has no dominant religious theme to compare with the Australian 'Dreaming'. A parallel to the latter appears among one group in southern New Guinea, the Marind-anim, who honour the *Dema,* the mythical creative ancestral beings who disappeared into the ground but mysteriously continue to affect the present.[33]

Throughout Melanesia generally reverence for the ancestors and for an intermediate range of ghosts and spirits is of more practical concern than any creator god or cosmology. The social lack of stratification and of hereditary chieftainship is reflected in a religious lack of a supernatural hierarchy and pantheon. Magic and religion are interwoven.[34] There is a strong materialistic bent in Melanesian rituals which are regarded as a means to earthly welfare based on fertility and the increase of yams, pigs and fish; feasts and exchange of produce are a common means of enhancing prestige. 'Power' in material affairs is the aim and may be obtained from those who were powerful in the past through charms and skulls of ancestors; the many-sided term *mana* is associated with this supernatural power.[35] These are very general features of Melanesian religions which are expressed in a wide and dazzling variety of activities such as masked dances, secret societies, initiations reflecting the tension of male and female and (in remote areas) ritual cannibalism.

The art forms associated with these practices are equally varied and spectacular, inspired by ancestral cults and showing great richness of form and colour.[36] The cathedral-like *Tambaram* houses of the Sepik river area in north-east New Guinea are outstanding examples. These great ceremonial houses signifying the mystery of the male cult link the whole community with the ancestors. It is the spirits of the dead who give strength and vitality to the community, so it is under their eyes in the men's house, surrounded by impressive masks, shields and cult-images, that the powerful elders confer and the young men are instructed for initiation. Skulls of slain enemies are also preserved there; but despite this male warlike tradition, 'the house as a whole is considered female, a dark, safe container'.[37] Even when the traditional cults have died out the ancestral influence is felt. It is expressed powerfully in other Melanesian art-forms such as the *Korwar* figures of north-west New Guinea, wooden images in which the head is a receptacle for an ancestral skull, thus safeguarding its vital force. East of New Guinea in New Ireland the *Malanggan* figures and masks commemorate clan ancestors, mythological scenes and totemic rituals; these intricate open-work wood carvings are arranged in tableaux for death and initiation rituals. Houses in New Caledonia traditionally featured protective door-posts with carved images of an ancestor to whom the dweller would make sacrificial offerings for help. In Malekula in the New Hebrides the ancestors were depicted in the form of huge drums with large saucer-like eyes. However rich in decoration such art is directed towards gaining supernatural power and, along with this, social prestige.

We now turn to examine the meaning of masks – an art form found widely in Melanesia and linked with the various activities mentioned above. Sometimes masks are used for social entertainment and buffoonery such as scaring people 'for fun'[38] or clowning in totemic religious rites with a comical fish-mask. For a large-scale sacred use of masks, the Orokolo Bay area in the Gulf of Papua provides the example of the spectacular *Hevehe* festival which was enacted until the late 1930s.[39] Its purpose was ultimately a practical one of gaining protection and fertility from the spirits, and the making of high masks to represent them was a way of attracting their attention, honouring and entertaining them. It was consequently a suitable time for initiation ceremonies when the power of these spirits was near at hand. Each clan carefully prepared its masks in the secrecy of its men's house and when they appeared at last in public they were the focus of protracted singing and dancing for days on end. The power thus generated was beneficent but could be dangerous if the masks were left in their highly charged state. Therefore when the

14. Ancestor face; house painting from New Guinea.

18. Korwar figure from New Guinea.

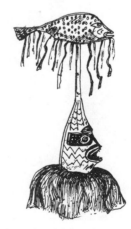

15. Fish mask used for clowning, from the Papuan Gulf.

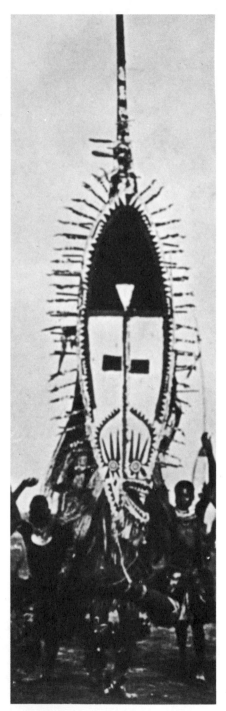

13. A Nabo Hevehe dancing on the beach with its escort.

time was completed the *Hevehe* spirits were driven back to the house, thanked for their stay and their masks 'killed' with an arrow and ceremonially burned, their ashes being thrown into the sea to join the great spirit of all *Hevehes*.

A native Papuan, Albert Maori Kiki, describes the making and iconography of the *Hevehe* mask.[40] Each mask had to be an exact copy of the one destroyed after the previous festival; a consensus of opinion among the older people was necessary to ensure that this was so. The more experienced men 'with a skilful hand' actually made the masks, but it was not an art taught via formal apprenticeship – it was a clan tradition. Using a cane frame up to fifteen or twenty feet high they painted significant clan designs on the bark cloth covering shaped like a flat oval shield. The lower half represented the face of the clan ancestor. The upper was decorated with various geometric patterns which, however similar to those on another clan's mask, could convey quite different meanings. A long line down the centre symbolized a magic rope. The spatial ordering of the world was indicated by such patterns as zigzags round the edge for clouds on the horizon; a painted area at the top stood for land which the clan hoped to find and settle in the future, and a series of rectangles below this for the land held at present. The *Hevehe* mask typically shows the face of the clan ancestor with eyes consisting of concentric circles; they are surrounded by a star-like pattern which, as Kiki explains, can mean a variety of things according to the clan that uses it:

For example: the tail of the *maria* fish; a *lakatoi* sail; a firefly, which stands for lovemaking, and is the symbol of a particular ancestor; 'jelly fish feet', which is a metaphor for the twinkling of the star, the symbol for Malara, the protector of the Kauri clan.[41]

This example makes it clear that in dealing with primal religions one can know the detailed iconography only from knowledge of the local tribe or clan. Moreover, in situations not guided by strict ceremonial requirements, the Western ethnographer may make the mistake of expecting every painting to 'represent something'. In fact in the artistically rich Sepik area of north-east New Guinea, Abelam artists may not know exactly 'what' they are painting, rather starting with a few forms to see what they suggest. They deny that the great white circles staring mesmerically down from the house-façade are literally the eyes of the ancestors; but it appears that this association is latent in the link-up between eyes and stars and fireflies and ancestors, in a sort of visual pun. Anthony Forge concludes from this that a Sepik painting should not be regarded as a representation but as a relationship, with meanings at several levels including the unconscious; these are part of a 'grammar

of painting', a traditional communication system learned by those who prepare and participate in the ancestral ceremonies. 'Abelam art acts directly on its beholders, properly socialized and initiated Abelam'.[42]

From the Sepik area a whole range of mask-forms can be seen. Reverence for the skull as the abode of the ancestors vital powers results in a skull being overmodelled with resin and wax to make a mask, sometimes decorated with the ancestor's lifetime ornaments. Another type may incorporate weird animal or bird-like forms with a fantastic beak or nose, evoking some totemic ancestor.[43] The 'orator's stool'[44] featured the mask of an ancestor to whom the speaker appealed for support as he announced his plan of warfare and beat the seat to gain strength. For initiation purposes the Iatmul of the middle Sepik area had a huge mask six feet across and sixteen feet long worn collectively by initiates who crowded underneath.[45] The mask is here the means of a group participating in the over-arching world of the spirits; it seems a perfect illustration of Durkheim's 'collective Sacred'.

Because of their potential for inspiring awe, masks have been used as a means of social control – sometimes deliberately in the case of secret societies.[46] Members of the *Dukduk* society among the Baining of New Britain wore a conical mask with large round eyes and a long leafy cloak masking the whole body.[47] Arriving on floats from the sea under the aspect of awesome spirits they would abduct and beat the young men and terrorize the people at large from whom they extracted piles of food. This male hostility may have been a degeneration from more benevolent initiations and rites associated with Tumbuan, the mother of masks. The Baining were otherwise noted for towering *Hariecha* effigies representing friendly spirits akin to the *Hevehe*.

Who makes these masks? We have noted the role of tradition in perpetuating forms through a consensus of older members of the community. Besides corporate work there is room for the individual artist to use his creative talent, though still within the traditional repertoire of forms. Among the Kilenge of New Britain, such a man is employed by the powerful leader, the 'big man' who takes the credit for 'making' the mask.[48] The artist may still have the reward of seeing the crowd appreciate his work at a festive 'sing-song'. An interesting parallel may be drawn from Africa where professional artists are often highly esteemed.[49] In western Liberia remarkable masks of ancestral guardians are made for the men's and women's societies, by highly skilled woodcarvers; but this fact is not publicly acknowledged – people are to believe that no human hands but only the distant ancestors could make them. The carver himself privately claims to receive inspiration through a tutelary spirit; it is

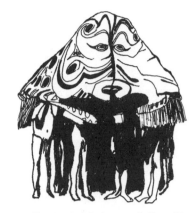

17. Collective initiation mask from New Guinea.

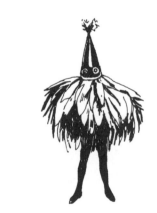

16. Duk Duk society mask and costume.

like a loving union of which the masks are his children. So he is rewarded by a deep sense of fulfilment when he sees the masks perform and 'come to life'. One described it thus:

> . . . all the people wonder about this beautiful and terrible thing. To me, it is like what I see when I am dreaming. I say to myself, this is what my *neme* has brought into my mind. I say, I have made this. How can a man make such a thing? It is a fearful thing I can do. No other man can do it unless he has the right knowledge. No woman can do it. I feel that I have borne children.[50]

Perhaps this testimony speaks for many anonymous artists from the primal religions.

Enough has now been said of the many-sided functions of masks to show how they reflect the major interests of a local culture such as initiation, fertility and war; religion is interlinked with the network of relations of a traditional society. We are concerned to ask further how masks are seen specifically as 'sacred' and relate men to a sacred cosmos of spiritual powers. First, in the preparation of masks for rituals such as have been described, painting itself is regarded as a sacred activity. In the Sepik area paint is the 'essentially powerful magical substance of the yam cult',[51] the yam being a major food bound up with gardening magic and male virility. Under ritual conditions the hitherto mundane paint becomes charged by the ceremony; it is both a positive means of transferring the benefits of the ceremony to initiates and villagers and a negative source of danger requiring ritual precautions when paint applied to the body is removed. The mountain Papuans of Wantoat valley, also in the north-east, celebrate a *kap ngaman* festival for fertility of the fields in which enormous pole frames carry mask-like coverings. These remain 'secular' constructions that may be seen by anybody until the last night before the ceremony. Then occurs the solemn moment when heads of families paint on the designs; only then do they become charged with the all-important *taakwan*, sacred power.[52]

Secondly, the mask evokes an attitude of awe and wonder in the viewers, mediating to them the overpowering reality of the sacred world. Even in a museum a mask may convey something of this atmosphere of mystery, beauty and terror. The astonishing shapes of some masks, the grotesque combination of animal and human forms, the elemental simplicity of a mask which may be little more than an oval with eye-slits – these exemplify the power of so-called 'primitive' artists to address people of other cultures. But the atmosphere of a mask is experienced fully only in a living context, not in a museum or drawing-room. Masks are usually seen in movement: shaking, dancing, emerging from a forest or out of the darkness; contrasts of light and shadow continually change before a

flickering fire. Eyes move and flash through the perforated slits, imparting vitality to the mask.[53] Above all, the sense of vitality is derived from belief in the sacred power infusing the mask from its ancestral origins and continuing through its ritual construction and painting and its part in the living drama with the spirit world. The Sacred is experienced as a numinous happening and the mask is not only a dynamic art-form but a sacramental mediator of the sacred event.

This leads, finally, to an understanding of the mask as a means of transformation. In the most general sense a mask is a disguise which covers the wearer and thereby conceals or transforms his identity.[54] This is its function in much traditional drama, as in the classical Greek drama, the Noh plays of medieval Japan and the Balinese dance-dramas (such as 'Rangda and Barong'). The mask is still a source of child-like fun, of creativity and adult festivity. A modern city festival appealed in these terms to all comers: 'Wear a mask for a Dream Day. . . . Wear a mask to the Ball. . . . Be someone you dream of! Be something you dream about!'[55] Here the individual is being called to project himself into some ideal form or personality, to clothe himself with a vision of what is other than himself yet related to his hopes and yearnings. In the religious sphere one can see the classical death-mask as a means of conferring an enduring divine status on the dead person; the gold mask of Tutankhamen arrests time and covers mortality with eternity. Priestly robes in 'high' religions serve as a form of mask to conceal the human personality, transforming the priest into a fit instrument and mediator of the Sacred. In the dynamic rituals of primal religions the mask serves likewise to transform the wearer to a plane where he can share the power of a sacred cosmos. On the one hand, as a profane man he needs protection from the dangerous potency of the spirit world; on the other, he can participate in that potency with the aid of ritual and mask. The awesome otherness of the Sacred need not destroy him, for the mask is a bridge by which he crosses over and unites with it. Barriers of death and time are overcome, and the mythical ancestors live again in him as he re-enacts their myths. In all this he becomes other than his profane self; he transcends himself.

The masks which effect this transfer may depict a great variety of beings other than ancestors and deities, for a sacred cosmos includes the whole realm of nature, animals and even demonic beings. The mask may serve as a means of catharsis and control of their power. Vivid examples of this come from the north-west American Indians whose masks depict the wind, the moon, birds and animals in semi-humanized form.[56] The Kwakiutl dance-societies used the 'wild man' mask to evoke frenzy and violent behaviour from the initiates until their irrationality was purged

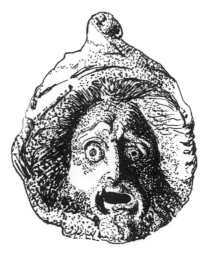

23. Terracotta copy of dramatic mask in Greek tragedy.

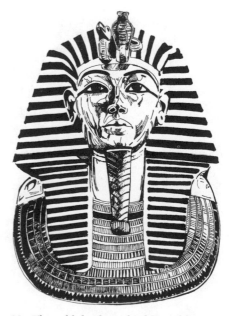

22. The gold death mask of Tutankhamen.

or tamed. The Bella Coola and Kwakiutl both used transformation masks[57] with hinged flaps that could be manipulated by string-pulling; so what had been the head of an eagle or raven would suddenly fly open to reveal a human face. While this could be a theatrical device to entertain an audience in fireside stories, a more profound meaning is involved – the interplay between nature, animal and man which we have seen to be basic to primal peoples. The same holds true for the Siberian shaman who has a skilled knowledge and command of animal noises and whose dress features the figures of animals important to his people. Above all, these transformations relate man to the powerful unseen world. The terrifying Night Society masks from western Cameroons symbolize the worldly and supernatural power of the chiefs, transforming them into leopards, elephants, rainbows and chameleons.

Bared teeth, blown-out cheeks, overhanging brows – all transform the human being into a supernatural one, its features distorted with lust or fury.[58]

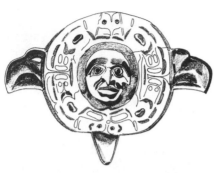

20. North American hinged double mask combining images of man and an eagle.

The cultic use of masks brings man into intimate contact with the Sacred; his body and spirit become one with the spirit of the mask. For this reason, if one were to speculate on the 'origins' of religious iconography, the mask would be a key link in the chain of beginnings. Masks appear almost universally.[59] However, one must recognize that even in the artistically prolific region of New Guinea not all societies use masks. In the populous Central Highlands area of Mount Hagen there is a conspicuous lack of the elaborate carving and cult-art of the Sepik area, perhaps linked to the lack also of graded societies, initiations and danced enactment of myths. Instead of making masks and paintings they take actual parts of animals and feathers of birds to adorn their bodies for elaborate festivals of ceremonial exchange celebrating prosperity and wealth. 'Self-decoration here expresses what cult-objects of ancestors express elsewhere.'[60] For spirit-cults concerned with fertility and clan solidarity, simple objects such as stakes and stones are used; but for transforming oneself into the ideal state of the ancestors finery and paint are applied to the body – dark and aggressive tonings for men, bright and fertile for women. Here the painted face becomes a mask, with the added power of being actually one with the skin and responding to the mobility of the face. The result may be felt to carry an added degree of sacredness compared to the mask. In many parts of New Guinea both forms are used, the mask playing a more public, half-buffooning role, 'while the painted performer, although he may appear in public at the peak of a ceremony, partakes of the order of the tambaram, the most sacred and secret foci of the ceremonies.'[61]

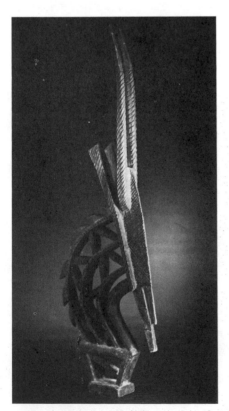

21. Bambara antelope 'mask' or headpiece from West Africa.

Bodily decoration or 'personal art' is important because it is a universal art, possible for even the poorest and most transient of wandering peoples. The motive may be primarily to enhance the body aesthetically, to celebrate the strength, prowess and beauty of the healthy body; this is the case with the naked Nuba of the Sudan who paint their bodies with bold designs, in striped, dotted, pictorial and asymmetrical patches.[62] Some is associated with functions such as disguising oneself for the hunt, or with mourning rituals such as smearing the body with mud and ashes, or with protection of the body against sickness and spells. The more permanent forms of personal art may include an element of deformation such as scarification and tattooing; these are to confer prestige, status, and identity by imprinting an indelible mark on the person's body, branding him for his lifetime with an identity recognized in his society.

Such markings, like the more ephemeral painting used in sacred ceremonies, usually belong to a religious tradition, whether of a totemic ancestor or of a deity, to remind the wearer of his allegiance and participation. Thus they relate him to the sacred powers who protect him and give him guidance for his life. Personal art may be both a source and a derivative of religious iconography. Its importance is all too easily neglected because it is not the sort of art that can be put in a museum, unless in the form of a preserved head. But it is no less powerful for being ephemeral.[63] It makes the body of man the bearer of the Sacred.

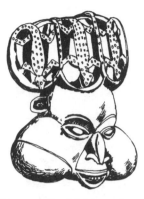

19. African mask with blown out cheeks.

Polynesia: the Maori

Polynesia (literally 'many islands') covers a vast area of the Pacific Ocean from Hawaii in the north to New Zealand in the south and Easter Island far to the east. The triangle which this makes on a map includes at the centre the well-known groups of Samoa, Tonga and the Society Islands (Tahiti) from which the brown-skinned Polynesians migrated outwards, after earlier journeys had brought them most probably from south-east Asia.[64] Despite the great distances between the island groups Polynesia displays much more homogeneity than Melanesia in its language, art and mythology; the regional variations rest on a fundamental unity. These cultural achievements are all the more noteworthy in view of the limited resources of the scattered islands and also the rarity of contacts with other cultures which might have added stimulus.[65] Polynesian religion was less dominated by material concerns for prestigious wealth than was Melanesia; instead it developed an imaginative mythology and elaborate genealogies to link present status in the tribe to the prestige of the ances-

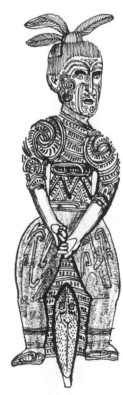

32. Maui, the Polynesian culture hero and trickster, fishing up New Zealand.

tors. The system of tribal chiefs and hierarchies was associated with a high valuation of social ranking which is reflected in the hierarchies of gods and ancestral beings.[66] The importance of *mana* and *tapu* (taboo) led to the specialization of roles; hence in the realms of art, craft and religion there were many 'experts' (*tohunga* in Maori, *kahuna* in Hawaiian, *tufunga* in Samoan) who had been trained through long apprenticeship in their skills and traditions. This ensured the careful use and control of sacred power and the avoidance of danger through observing the detailed *tapu* regulations. The priestly *tohunga* was both a professional in matters of ritual and a medium for the voice of a god on occasion.

Throughout Polynesia there was a common pattern of degrees of supernatural beings (*atua*) linked to a chain of human ancestors, with a variety of inferior spirits and guardians, and local deities such as Pele the volcano-goddess in Hawaii.[67] Polynesian mythology recounted stories of a basic pantheon of gods ruling the major departments of life such as war (Tu), agriculture (Rongo) and the ocean (Tangaroa); there were also the exploits of the great culture-heroes such as Tawhaki and the Promethean trickster-figure Maui, who were non-sacred but much revered.

Despite this common basis in mythology, one can scarcely speak of a common religious iconography of Polynesia. Few images have survived from the earlier period since European contact began some two hundred years ago with the consequent advent of Christianity and the abandoning of traditional religions. The Tongan converts, for instance, desecrated their old gods and destroyed them, apart from a few which the missionary John Williams was permitted to take away (*c.* 1830). Polynesian religions ceased to be practised as a living system, surviving only in certain folk-beliefs and social practices alongside Christianity; so there was no continuing tradition to explain the meaning of such images as were preserved. Even the names of the gods are uncertain in the case of a number of wooden images in museums or the mysterious huge stone images on Easter Island.

A further difficulty comes from the uneven distribution of families of images. The Maoris of New Zealand had elaborate carvings of ancestors but rarely of gods. In Tikopia, a Polynesian 'outlier', there were no figure sculptures at all but only a craft tradition applied to such objects as head-rests. Puzzling over this fact Raymond Firth suggests that such groups, long isolated as in Polynesia, may develop their aesthetic traditions selectively and differentially.[68] In the case of Hawaii, the war god Ku was represented by a variety of fiercely grimacing images in wood or in basketry and feathers, but elsewhere other deities appear to have

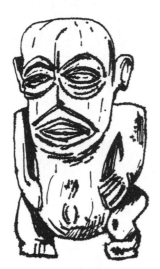

25. Fisherman's god from the Cook Islands.

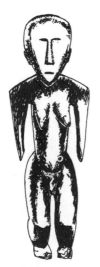

27. Female deity from Tonga.

become dominant. For instance, the sea-god Tangaroa, though assigned to the underworld in Hawaii, was in central Polynesia regarded as a supreme deity (Ta'aroa in Tahiti); probably for political reasons he was elevated over other gods to become their 'creator'. This is expressed in a four-foot wooden image from Rurutu in the Austral Islands, the body being covered with small images of gods and men and having a cavity in the back where further images could be stored. A similar iconographic convention appears in the striking Rarotongan ironwood image which is called 'Rongo and his three sons' but which is possibly again Ta'aroa in the act of producing lesser gods. If it be objected that Polynesian gods are not created but begotten, the phallic aspects of these images would certainly indicate a begetting.[69] There are also Tahitian myths of creation which attribute the origin of all things to Ta'aroa who was once alone in his shell but emerged to make earth and sky out of its two halves and to supply the features of the world from the parts of his body.[70] But this has no iconographic expression and may again be a product of the late supremacy of the god. One should be cautious in regard to other claims for a supreme Creator or high god in Polynesia. For instance, the late nineteenth-century disclosure of teachings about Io, the supreme god of the highest heaven said to have been secretly worshipped in an esoteric Maori cult has no assured support; the teachings could well have arisen as the sophisticated response of Maori thinkers to Christian teachings of one God.[71]

A more likely source of common ground concerning origins and gods in Polynesian mythology, while allowing for variations, is the myth of Rangi and Papa as recounted by the New Zealand Maoris.[72] Rangi and Papa, representing heaven and earth, were not creator gods but themselves were the products of long cycles of emergence from primeval darkness in which aeons of nothing and night led on to the dawn of light and extension of space, then to heaven and earth. The primal pair clinging together gave birth to a series of sons who then wanted to free themselves and reach the light. They separated the parents under the leadership of Tane (who was to be lord of forests); Tane stood with his hands, like roots, on mother earth while his legs, forked like branches, thrust upwards and forced Rangi to the heavens. Rangi and Papa were thereby sundered forever and their sorrow is shown in rain and mist.

This beautiful and imaginative myth relates man and all realms of life to one family derived from these common parents. The myth presents a primeval genealogy along these lines:

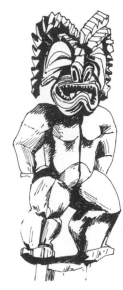

24. Hawaiian wooden image of the war god Ku.

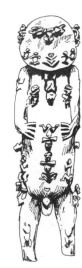

26. The ocean god Tangaroa as the supreme god creating other gods and men.

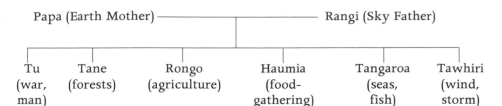

Papa (Earth Mother)			Rangi (Sky Father)		
Tu (war, man)	Tane (forests)	Rongo (agriculture)	Haumia (food-gathering)	Tangaroa (seas, fish)	Tawhiri (wind, storm)

When these six sons fell into dissension it was Tu, the god of war, who overcame his brothers and used their produce – all except the intractable wind. Now Tu is also regarded as the ancestor of man; and here we have a picture of man subduing nature to live from its fruits (forest, ferns, fish and agriculture) and yet of man still at the mercy of the storms of nature and human conflict. The myth gives an exemplary model for man as a being who is humanly powerful yet also dependent on powers which establish him in a sacred cosmos. The sacred quality is manifested in a variety of ways in the world – in the whole of life and not in a restricted sacred sphere of gods and religious rituals. The sacred is diffused through man's relations with nature, human society and the mystery of his own self.

This cosmic picture helps to explain why the Maoris of New Zealand had few cultic images and sacred places. We can study the implications of this by turning more specifically now to the art and religion of the Maori.

The supernatural powers (*atua*) at the highest level of the gods were rarely depicted in the rich wood-carving work of the Maoris. When it was necessary to make a sacrifice or to recite an incantation to the gods, this was done at the relevant place, on the spot. The heart of the first victim on the battlefield would be offered there to Tu as god of war, and a freshly dug sweet potato (*kumara*) to Rongo. If images were used there they took the form of portable god-sticks about a foot in length with a sharpened peg which could be thrust into the ground.[73] They were vehicles for the temporary presence of the god whom the *tohunga* called upon after he had prepared the god-stick by painting it with red ochre, binding it with flax cord and dressing it with feathers. Such god-sticks were not worshipped and probably had no fixed iconographic identity, an individual god being named only for the ceremony.

Why this reticence in depicting the gods when Maori carving could produce skilled and imaginative figures and designs elsewhere? Sometimes it has been claimed that the Maoris displayed a 'higher' type of spirituality, personifying their gods but not needing the support of visual images of them. However, the sporadic appearance of images (such as carvings of Rangi and Papa on a ridge-board inside the porch of a

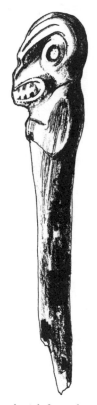

30. Maori god stick from the Wanganui district.

meeting-house, or the god-sticks, not to mention the wider Polynesian scene) suggests that this was not a matter of principle. Rather did they see the great gods as sacred powers identified with their departments of life in the forest, field and ocean and not with separate cultic places; it was therefore more appropriate to make offerings and prayers at the site of relevant activities. This relates to modern Maori attitudes to religion as seen at funerals and social celebrations which provide an occasion and centre for worship on the public *marae*; here 'the Maori does not meet to worship but worships when he meets'.[74]

If the question is raised as to why the Maoris did not build temples, various reasons might be offered concerning the conditions of life in New Zealand. Whereas the Hawaiian priesthood developed impressive temple complexes (*heiau*) with the institutional support of the king, his palace and hierarchy,[75] the Maoris came to New Zealand from around AD 1000 and lived in scattered tribes, moving their village sites. Even in Hawaii, and in Tahiti where the sacred *marae* was built as a stone platform,[76] elaborate building seems to have been a late development. Probably the Polynesians at first used simple natural sites marked out as sacred by stones, and the Maoris continued to use something of this sort in the *tuaahu*, the sacred site outside the village, and the sacred pool for purifications and the dedication of children. But as the centuries advanced they developed increasingly impressive carved houses for the chief of the tribe at a focal point behind the *marae*, the village 'square' where the people gathered. Ceremonies enacted there for social, political and military concerns also had religious overtones because of the pervasive, diffused sacredness of the land with its tribal centre – hallowed by the chief, the tribal traditions and, above all, the ancestors. Through these came the all-important power of *mana* which was ultimately a spiritual power from the gods and the chain of ancestors giving life and success to the tribe, especially through its chief.[77] It was on the village *marae* that the Maori visibly participated in this power of the tribe and sensed his belonging to the land with his 'place on which to stand' (*turanga-waewae*). And by recounting detailed genealogies and seeing carvings of the ancestors he was continually reminded of his tribal origins and the models he was to emulate.

The central carved house (*whare whakairo*)[78] was a living embodiment of this for its parts were interpreted as the body of the ancestor. At the apex of the façade was a mask-head of the ancestor or chief (usually surmounted by a full-body figure, the *teko-teko*); the sloping barge-boards were his arms with carved 'fingers' at the ends; the ridge-pole of the roof was his spine and the rafters his ribs (which could be used to

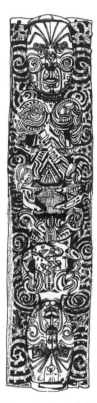

29. Maori ridge carving of the primal pair Rangi and Papa.

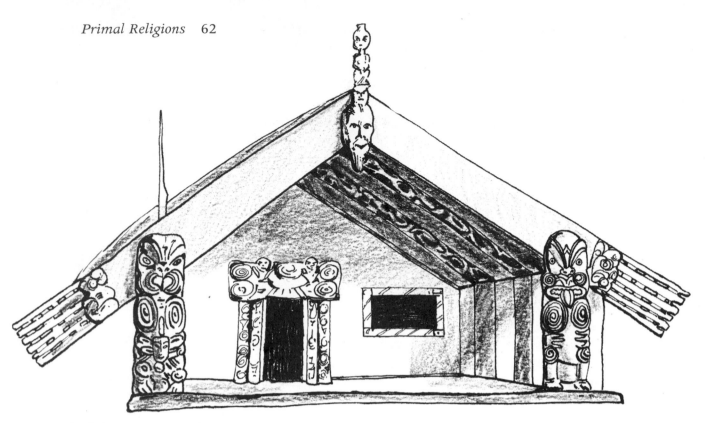

28. Maori chief's house as the body of the tribal ancestor.

depict genealogies in the interior). At the porch the door was the mouth of the ancestor, a window his eye and the whole interior his bosom. The traditional mode of address used on the *marae* still expresses this reverence for the meeting-house as an ancestral person whom one approaches with such words as: 'O house! O *marae* of the father! O people gathered!'

The construction of the house is surrounded by *tapu* restrictions which are removed only by the *tapu*-lifting at the opening ceremony. For the traditional Maori rituals hallowed every stage. The workman chanted over his stone adze before use since it possessed a personal spirit. When felling a tree it was necessary first to placate the forest-god Tane. The art of carving was believed to have come from the gods, and especially the carving of images required the expertise of a *tohunga* who had much personal *mana*.[79] The best known story of the origin of carving attributes it to Rua, a great ancestor who had dealings with the gods. Before his time men had only painted patterns in their houses. But in the house of Tangaroa at the bottom of the sea Rua discovered images which talked. Although he took away only non-talking images, these amazed men by

their verisimilitude when Rua copied them on his own house; these became the models of the sacred art for subsequent generations. Another myth attributes it to Rongo who visited a carved house in the heavens where he learned the art; he also used the personified form of the owl (*Kouturu*) whose staring eyes are seen in many carvings to this day.

The carved house is rich in symbolism. Meanings were given to even the apparently minor decorations covering the interior, such as the spiral and curvilinear patterns associated with men and the women's geometric patterns woven on wall-panels. The figure carvings are primarily of the human image or *tiki* and represent the ancestors who, while not gods, are ultimately descended from them. (The word *tiki* may refer to the myth of Tiki, the first man; the well-known Maori greenstone *hei-tiki* [neck-pendant] seems to have become a female figure associated with fertility and the magical powers of an amulet.) The great carvings of ancestors are often aggressive, holding a club in warlike stance and thrusting the tongue defiantly from an enormous mouth. The head is disproportionately large because it is the important centre of one's *mana*; it also helps to fill the shape of the panel. The penis indicates the tribal connection with virility of the ancestor, and children between the legs of an ancestress also show the continuity of the generations. The three-fingered hand is a claw-like convention; while various explanations have been offered, note should be taken of Barrow's interesting suggestion linking it to a hybrid 'bird-man' in Polynesian art; this is supported by other avian features such as webbed feet, elongated lips and slanting eyes.[80] Other creatures depicted are the beaked *manaia,* the lizard and fish-monsters such as the *taniwha* and the merman *marakihau.* As in other primal religions such forms link man with the animal world. Among the most popular guardians in the Maori pantheon were the hybrid ancestors in animal form who advised and warned their descendants through omens and apparitions.[81]

Images of the ancestors were the chief iconographic expression of religious tradition in the present life of the tribe. In addition to the meeting-house or carved house of the chief, the chief's food-storehouse and prominent posts and gateways were dominant places where ancestor figures were depicted, their protective power confronting daily all who came to the village. It remains to mention one other important medium – that of tattooing or *moko*. Here is a form of 'personal art' such as we have discussed earlier in relation to Melanesian body-painting. By means of elaborate facial designs the individual Maori had the imprint of the ancestors on him for the rest of his life. The same basic designs were used, though with infinite variation, as on the wood-carvings of the ancestors.

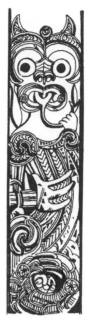

33. Marakihau, the Maori water monster and mythical fish-man.

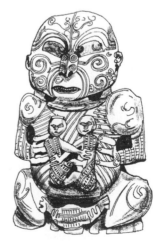

31. Gateway figure of an ancestral chief (Maori).

Tattooing was indeed a form of carving, performed with a small chisel and blue-black dye by a skilled craftsman. The face which resulted, as can be seen from preserved heads, paintings and photographs of old-time chiefs, shows a combination of 'determination, ferocity and dignity'.[82] All men with the self-respect of a warrior would submit to the long and painful operation on the face and also on the thighs and buttocks. (Women's facial tattoo was confined to the chin and lips; slaves and tohungas had none at all.) The designs followed certain family traditions but were used to create a unique *moko* pattern for each individual – like an enlarged fingerprint, but far more personal since it gave him a sense of history and identity which others could recognize. Indeed it was used as an actual signature in the early days of European contact when some Maori chiefs would draw their *moko* on documents as their mark of personal commitment.[83]

Although tattooing can be viewed as simply a rich form of bodily adornment, in the case of the Maori it clearly goes deeper into matters of one's identity in the socio-religious order. The Maoris did not use masks in ritual dancing as did the Melanesians; and the reason may be that already in *moko* each man had the mask he needed for a lifetime, one which should not be concealed or altered further. Eric Schwimmer writes:

Moko emphasised the sacredness of man. During the time of carving, the patient was strictly *tapu*, and was fed through a funnel. It would be absurd to suppose that the tattoo was 'just a decoration', concealing the real face underneath. On the contrary, a Maori of rank did not get his real face until he was tattooed; thenceforth the tribal self engraved upon him became his permanent mask. The bold convolutions of the tattoo expressed the tribal spirit and indeed the world order, for the two almost symmetrical profiles facing each other, separated by the split in the middle of the design, were a reflection of the cosmic dualism – left and right, earth and sky.[84]

Maori religion had its main focus on the power of the ancestors, and the Maori arts of wood-carving and *moko* both served to make the ancestral world living and visible.

Summary

In this chapter we have looked at some basic elements in religious iconography. Prehistoric remains provide a basis in the symbols and animal and human forms depicted; but we cannot yet discern a specific iconographic tradition as we can through contact with primal religions in recent times.

Within the symbolic universe of the Australian aboriginal myth, ritual and image relate the individual to his social group and to the whole natural order as founded by the Dream Time ancestors. Among the diverse expressions of Melanesian religions, masks and body-painting are means of transforming the individual and tribe seeking access to the power of the spirit world. In Polynesia we see the sacred power of the ancestors revered in myth and genealogy and diffused through the chief and the tribe; in New Zealand, with few representations of the greater gods, the ancestors are embodied in the Maori meeting-house and wood-carvings and recalled in the individual's tattoo.

These religious expressions are primal in the sense that they are basic and persist in a variety of forms in the iconography of religions found in the great civilizations of world history.

3 Polytheism in Ancient Religions

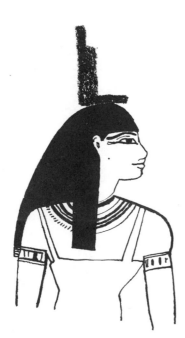

34. Isis with throne attributes, from the tomb of Haremhab, Thebes.

Egypt: 'Images and Eternity'

'ART FOR ETERNITY' is the title of the chapter dealing with ancient Egypt, Mesopotamia and Crete in a well-known history of art.[1] In face of the passage of centuries we recognize in the monuments and ruins, art and artifacts from the Ancient Near East and Mediterranean something which seems to defy time. A hunger for order, stability and permanence may be found in all human cultures, but these are given more evident and effective form in the first 'high' civilizations which emerged in the fourth millennium BC. Egypt is an outstanding example of a religious tradition pervading a civilization continuously for well over 3000 years, the inner cohesion being supported by the geography and by long periods of relative isolation. This has served to make Egypt a mystery to other peoples and has made it equally a source of fascination down the ages. The pyramids and the tombs of the Pharaohs bring to our attention two great emphases in Egyptian religion – the quest for eternity in preoccupation with the cult of the dead, and the veneration of the Pharaoh as a god-king: 'Egypt's divine catalyst . . . a celestial sparking plug',[2] representing divine power for the welfare of the nation.

In this setting we are concerned with the great variety of gods in Egypt. What we categorize as polytheism was for the ancients a way of seeing all forms of life and nature as sacred, 'sustained by man's experience of a universe alive from end to end'.[3] Especially the daily rising of the sun and the annual flooding of the Nile were for Egyptians miracles of rebirth. Since nature manifested the divine, many gods and religious

symbols could be imaged from the world around to ensure the continual integration of man, society and nature in a sacred cosmos. Whether or not the Egyptians were the most religious of peoples, as Herodotus observed, they were prolific in gods and iconography. The result is almost an embarrassment of iconographic riches, from colossal statues in stone to gilded miniatures and paintings, a profusion of human, animal and inanimate forms. Problems arise because of the complexity and ambiguity of many figures; the reasons for this lie probably in the fact that the ancient local deities were preserved and combined quite unsystematically from the time of the early political unification of the country (*c*. 3200 BC); further, rival religious centres continued to develop, such as those at Heliopolis, Memphis and Thebes with their differing pantheons and theologies. The decipherment of hieroglyphic texts, while opening up many possibilities in the understanding of ancient Egypt, has not provided an adequate account of the nature of the deities named, much less the accompanying myth and ritual, so that in many cases these have to be inferred from better-known examples. Accepting these limitations we shall consider three important issues in Egyptian religious iconography – the use of symbolism, the place of the animal form and the cultic significance of images of the gods such as Osiris and Amon-Ra.

Many of the Egyptian symbols have familiar parallels in other religious cultures – the sun, earth, water, the bird, the serpent, the lotus and the tree of life. But these are all woven into a complex mythology which in turn is expressed in the life-giving round of ritual. Visual symbolism pervades Egyptian art and religion, so that in the tremendous temples which they produced architecture and decoration became 'a kind of mythical landscape' in which 'everything had a meaning or could be made to have one'.[4] For instance, when the goddess Isis is depicted with a throne on her head as her distinctive attribute, we recall that the Pharaoh from the first dynasty called himself 'son of Isis'. Because in mythopoeic thought there is reciprocal identity between gods and such royal insignia as thrones, we can interpret the symbolism thus: Throne = Isis = 'mother' of the king.[5] Her husband Osiris wears the white crown of Upper Egypt and carries the royal symbols of the crook-sceptre and flail which go back to similar depictions of kings such as Udimu in the Archaic period.[6] Osiris may also be symbolized by an ancient wooden object, the *Ded* (*Djed*), the 'stability column' and cosmic pillar. This seems to have derived from the upright sheaf in peasant rituals at harvest. As Osiris was associated not only with kingship and fertility but with the rising of the soul from death, the uprightness of the *Ded* expresses 'the victory of the vertical as the manifestation of eternal life'.[7]

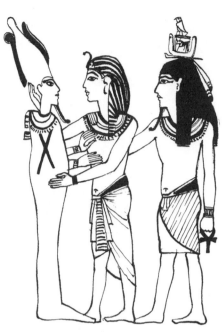

38. Osiris embraced by Tutankhamen and his divine spirit (Ka).

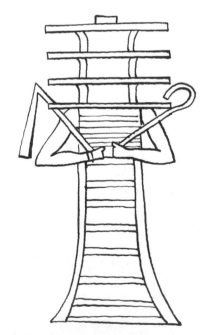

35. Ded (Tjed) symbol holding the royal insignia, sceptre and whip of Osiris.

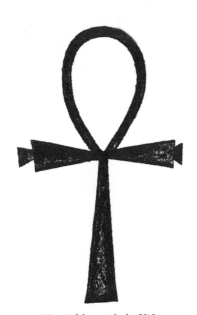

36. Ankh, symbol of life.

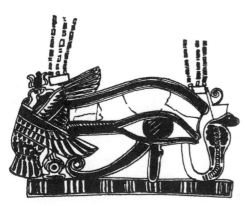

37. 'Wedjat' Eye from Thebes.

The *ankh* is a distinctive Egyptian symbol of life – a loop-headed cross used as an ideogram and shown frequently in iconography as an object which the gods present to the Pharaohs. As an amulet in tombs it was meant to indicate the triumph of life over death; and in the papyrus of Ani (New Kingdom, *c.* fourteenth century BC) it was depicted with arms raised from the 'neck' to support the solar disc of Ra. The Eye is another distinctive Egyptian symbol in the form and function it was given, clothed in a bewildering mythology. The Eye is the daughter of the High God sent out over the primeval waters; and it appears to retain femininity in its links with the Great Goddess and the Moon.[8] In the myth concerning the eye of Horus which Seth threw away, the parts of the eye are re-assembled to constitute the reassuring full moon.

The religious symbolism of monuments is evident in the pyramids and the sphinxes for which Egypt is famous. The sphinx, a mysterious tomb-guardian, brings us more into the realm of iconography, being a hybrid of man and animal whose many-sided aspects have provided a perennial riddle. The sphinx of Giza is the greatest of these, hewn from the living rock ('a sculptured mountain'[9]); originally it represented King Chephren wearing the royal headdress and beard, facing east as the necropolis guardian and sun-god which he became after his death. Here the god-king and sun-cult motifs merge in the ancient hybrid form of a lion with a human head. What does this mean? The philosopher Hegel interpreted it as a symbol of Egypt and its religion (a 'hieroglyph of human thought'): 'The human head that bursts from the animal body represents Mind as it begins to raise itself above Nature . . . without, however, being able to liberate itself wholly from its fetters'.[10] But of course this comment does nothing to resolve the problem posed by the reverse case of an animal head on a human body and this is what we must consider in the Egyptian gods.

The animal- or bird-headed body characterizes many of the Egyptian deities. Some examples of this are: Thoth, the ibis-headed god of wisdom; Horus, the falcon-headed god of sky and royalty; Anubis, the jackal-headed god of the dead and embalmer; and Khnum, the ram-headed god who is shown creating man on a pottery-wheel. From the Archaic period the bull Apis was worshipped, and likewise the cow as the goddesses Hathor and Isis. Not only 'useful' animals but frogs, serpents, scorpions, and crocodiles were held to be sacred. Cemeteries of mummified cats, dogs and other animals have been unearthed, testifying to the ancient reverence for animals and animal-gods. This continued throughout the whole period of ancient Egyptian history and provides a source of amazement to foreign visitors in the Greco-Roman period. Although

were scornful. The Jew Philo (first century AD) and St John Chrysostom
(fourth century AD) expressed their derision of the animal cult, for it
contrasted fundamentally with the Jewish-Christian view of God as
creator and man as spiritually transcending the animal world. Meanwhile,
how are we to understand this aspect of Egyptian worship and
iconography?

One facile explanation has been 'totemism'. But if this term is given
the usual connotations of tribal unity based on descent from the totem-
animal, it does not apply. Nor do the connections with laws of exogramy
and sacrifice for a clan feast. Another explanation might follow an
evolutionary development based on a succession of historical stages.[11]
Thus an original pure animal-worship would be followed by animal-
headed gods, then by human and cosmic gods, including more abstract
ones, with foreign gods imported towards the end. However convenient
such a classification might be, the proliferation of Egyptian deities
upsets it. As early as the first dynasty we find *both* animal and human
forms – for instance, the goddess Hathor as human with cow's ears and
horns, and wholly anthropomorphic statues of Min, a god of sexual
fertility and storms. It is likely that the Egyptians worshipped gods in a
variety of forms from the first and continued to worship and harmonize
them in increasingly ingenious and complex ways.

If we ask how such animal cults arose at all, they are most readily
understood as a continuation of prehistoric reverence for the animal as a
creature of superior power and beauty participating in the unity of all
life in the cosmos. This is one of the 'eggshells of prehistory' which the
Egyptians, with their conservative mentality, did not throw away.[12]
But the Egyptians went further than this by divinizing the animal, by
seeing a god incarnating himself in its form. This brings us to the question,
far more significant than that of origins, as to what the worship of therio-
morphic (animal-formed) gods meant religiously to the Egyptians.

First, the animal is a symbol of life and power and is venerated for the
special capacities which it embodies – 'the keen nose of a dog, the sharp
sight of a bird . . . the capacity of the skin-shedding snake to renew
itself. . . . Men saw in the animal something inexplicable, something
inscrutable.'[13] Kristensen rightly draws attention here to the spiritual
and cosmic dimensions of the material basis of life; the bull and ram
express fertility, life and the foundation of human existence; the bird is
an atmospheric being which can give form to the human soul. Man is
limited in his capacities but the animal with its heightened powers
represents a universal principle of life.

Secondly, the animal's strangeness and otherness evoke a response of awe from men. 'It is precisely in the strange behaviour of the animal, its irrational and unethical actions, that the believer sees something that lies beyond human finitude: the superhuman in the religious sense, the absolute.'[14] The Egyptians do not appear to have felt this otherness as something savage and wild. In comparison with the dynamism of much of the animal art of ancient Mesopotamia, Persia and central Asia, the Egyptian animal is calm, dignified, mysterious.[15] The animal world reproduces itself in species which do not change, whereas human beings display a variety of changing individual characteristics. It is just this unchanging order which the Egyptian valued in his ideal of an eternal world order. 'Thus animal life would appear superhuman to the Egyptian in that it shared directly, patently, in the static life of the universe. For that reason recognition of the animal's *otherness* would be, for the Egyptian, recognition of the divine.'[16]

The animal could thus be a fitting vehicle for a god. Indeed, gods could be incarnated in more than one animal while the same animal could be linked with several gods. We have already noted that the merging of communities and their cults provides some historical explanation for this. But religiously this interchangeability was understood as in keeping with the nature of the god. He was not confined to one personality or limited to certain forms. The very multiplicity and puzzling ambiguity of these forms express the power of the god; he is able to assume a variety of human, animal and symbolic incarnations within the interwoven texture of the cosmic order.

When we turn to the specifically human, anthropomorphic, forms of the gods, examples of these are found from the first dynasty. No doubt the establishment of the state and divine kingship furthered the representation of gods as humans; on the one hand they were elevated as cosmic deities yet they were also like rulers with earthly authority and family relationships. The Pharaoh was from earliest times identified with the sky-god as the falcon Horus and became the focus of a complex cult at Heliopolis with the title 'Son of Ra'. Because he was physically the son of the sun-god, the ceremonies of purification each morning renewed his identity with the rising sun and the symbols of royalty; and it was therefore appropriate to treat the gods with similar rites in subsequent temple worship. Ra was at first represented by an obelisk in a court open to the sun, the god residing at its apex; later he was represented in various forms, especially as a man with a falcon's head and the sun disc on it. In the combined form of Amon-Ra at Thebes he was represented as human with a distinctive cap and two upright plumes. If one can generalize

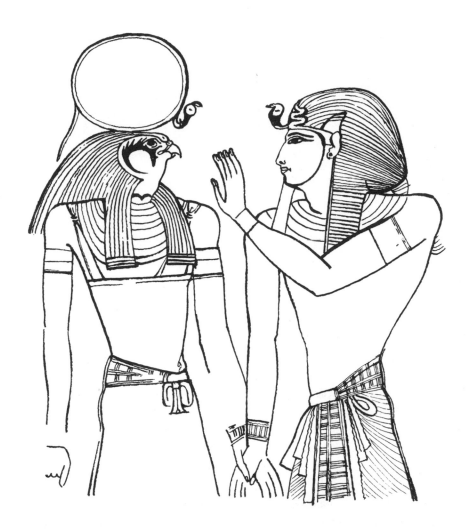

39. King Seti I worshipping the sun god Ra.

about the iconography of the gods, whether fully or partly anthro-
pomorphic, one can note the archaic style of their dress – the male loin-
cloth and female long narrow robe, the artificial plaited beards of the gods
recalling the faces depicted on the earliest monuments. They usually
carry a symbol such as the *ankh* and a sceptre.

The great god Osiris was depicted in human form from the first, appar-
ently because of his link with the mortuary ritual at the king's death and
the worship of the dead king as Osiris. The myth of Osiris may be derived
from historical events of the murder of the king by his brother (Set);
the outcome of the myth is that the body of Osiris is reassembled by Isis
and others and resurrected to become the ruler of the Kingdom of the
Dead while his son Horus founds the line of divine kings, the Pharaohs
on earth. Osiris is shown in the form of a mummy with his hand folded on
his chest holding the sceptre and whip, his face painted green or black.

41. Rameses II receiving emblems of office from the great god Amon.

The death and resurrection of Osiris thus provide a model for the mummification of the Pharaoh who is 'Osirified' as he is preserved for eternal life. The ancient cult also symbolized the vegetation cycle of death and growth. But as a cult of hope for the after-life it became increasingly universalized, so that by the time of the New Kingdom (1575–1085 BC) it was a popular hope open to all. With these developments the same figure of Osiris was worshipped in Egypt for well over 3000 years.[17]

Also uniting the royal cult of the nation with popular piety was the great god Amon who, however, did not rise to full ascendancy until the New Kingdom period at its capital and sacred city of Thebes. Favoured by a time of national triumph and priestly zeal, Amon became the state god and was identified with the sun-god as Amon-Ra. Later he came to be sought after as an oracle by visitors to Thebes, including Alexander the Great. But at the same time Amon retained the popular appeal which he had enjoyed in his humbler origins as lord of air and winds and patron of mariners; he was a friend of the common man, a saviour and consoler in time of need and sickness. Amon could also be popularly worshipped in the form of the ram, the Nile goose and the bull, but he was given a universal status as Lord of the gods, as creator of the world, as an invisible and omnipresent 'Enduring One' in the priestly theology.[18] 'Amon is the god who, more than any other, personifies the profound oneness of religious phenomena.'[19]

Mention should be made of one iconoclastic attempt to depose Amon at the height of his power. This was the work of the so-called 'heretic' Pharaoh Akhenaten (1364–47 BC) who broke with the age-long tradition of polytheism, erased the name of Amon from monuments and focused all worship on Aten the supreme universal creator, represented by the solar disc and its rays with himself as mediator.[20] It is sufficient to say that this 'solar monotheism' proved to be ephemeral and on the death of its propagator Egypt and her Pharaohs reverted to her manifold gods and long-hallowed iconographic forms.[21]

How were all these images used in Egyptian religion? In a multitude of forms the gods were visibly active at all levels of the nation's religious life. But the high point and focus of worship was the temple cult. The power of the god was cosmic in scope, but his earthly house was the temple where he 'lived'. It was the duty of the king to serve him daily, but the increasingly elaborate rituals came to be delegated to a priestly body, at first lay priests then developing into a sacred-segregated official class of priests and priestesses by the New Kingdom period. The original simple wooden structure of the earliest temples was probably retained in the Archaic period long after much grander buildings were possible; and Egyptian traditionalism retained this design for the inner sanctuary when the massive temple-structures of later times were erected round it.[22] While sheer size could be impressive here, the significance lay in the temple as a sacred centre, as an image of the world and as an earthly reproduction of the transcendent heavenly model; the shrine of the deity could be called 'heaven' or 'the doors of heaven'.[23] The sacred enclosure was resistant to earthly corruption and potent to re-sanctify the world around.

At the heart of the sacred centre, behind bolted and sealed doors in the 'holy of holies' where all was dark, stood the cultic image of the god. It rested in a little ark which could be carried around for processions and for this reason was unpretentious in size – smaller than life-size and perhaps little more than a foot in height. It was usually of painted wood with inlaid eyes. The perishable nature of the image probably accounts for the fact that no identifiable examples of the central cultic image have survived. Further, the image as such is not depicted in paintings and reliefs of scenes where the Pharaoh is engaging in cultic practice; the god is here shown in some other form. The sanctity of the image was emphasized by its normal seclusion in the sealed chamber, where it stood on an enormous block of stone, and by the elaborate ritual which in the case of the priest of Amon at Thebes could amount to sixty separate ceremonies performed each day. The early morning ritual began typically

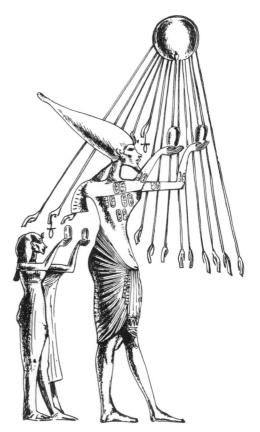

40. The god Aten, shown as a solar disc, receives gifts.

with the purified priest breaking the door seals and repeating ritual phrases such as 'I come and I bring thee the eye of Horus' and 'The gates of heaven open'. The god is revealed and the priest prostrates himself while exalting the majesty of the god on his throne: 'Thy beauty belongs to thee. . . . Thou naked one, clothe thyself'. The priest has brought incense and vessels of water with which he begins the daily toilet of the god, outlined as follows: 'He sprinkled water on the image twice from four jugs, clothed it with linen wrappings of white, green, red and brown, and painted it with green and black paint. Finally he fed the image, by laying before it bread, beef, geese, wine and water, and decorated its table with flowers'.[24]

The meaning of this central ceremony is important. First it is clearly linked with the cult of divine kingship. What is done to the Pharaoh in his daily purification and anointing as god-king is done here to the image of the god, by priests acting on behalf of the Pharaoh in service of the god. As an earthly image it is cleansed, perfumed, adorned, and even beautified with cosmetic, but all this is done to the accompaniment of words which interpret it in its mythological meaning. What the priest does in this dark inner sanctum is of national and cosmic significance. 'What transpires in private nevertheless serves the general well-being and is actually done on behalf of the community. We are told, although only briefly: God, the Distant One, is made present in the image by the daily service.'[25] The segregated nature of the sacred ritual testifies to the mystery and hidden nature of God – 'The Hidden One, whose nature nobody knows', as is also proclaimed in hymns used in public ritual.[26]

The cosmic dimensions implied here raise the question of how the image was understood in relation to the deity who 'lived' in the temple as his 'house'. Could he be identified with the cult image there? Could that image embody the majesty and diversity of his being? These questions were of concern to thoughtful Egyptians such as the Memphite theologians.[27] On the one hand we have the prevalence of icons, virtually every god having an image and accompanying ritual. Supporting this was the widespread ancient belief that an image or word was identical with what it represented and that, being alive, it was vulnerable to dangerous actions such as the operations of magic. On the other hand, at least the educated came to draw distinctions between image and object, between the god as the sun on the horizon and his images upon the earth (as in the saying of the sage Ani of the New Kingdom). This could lead to the idea of the image as a temporary habitation for the god who comes down to receive offerings and worship; and a passage in the Memphite theology suggests that the gods enter their 'earthly bodies' time and time again.

Such a distinction is at least implied in the ceremony of 'opening the mouth' as applied to statues while they were still in the sculptor's workshop. Here the image is presumed to be lifeless while being fashioned, until it is 'vitalized' by the special ritual. When applied to mummies the ritual similarly animates the body and its organs; indeed, this parallel mortuary ritual gives us a way of appreciating the change of the image from lifelessness to life. Morenz expresses the Egyptian view thus: 'We believe that in what appear to be statues not endowed with life we do in fact worship the power of the gods present in them, who are endowed with life'.[28]

In dwelling on the central image of the temple cult we have not mentioned other religious activities more directly connected with popular worship. There were joyous temple festivals in which abundant offerings of food and drink were made; the cult image was said to receive also singing, dancing and incense as his 'food'. The image was made further accessible to the people by processions in which priests carried the image from the shrine on a barque, perhaps stopping at designated way-stations for people to worship and even to glimpse the image momentarily. Such images became renowned also as oracles and for magical powers of healing. In addition to the central icon temples would accumulate a variety of votive images, statues given by grateful or hopeful worshippers. The representations of the gods as found in museums today are primarily from this source – not only gilded and glazed statuettes but colossal statues in granite, basalt and sandstone (which in some cases are hard to distinguish from god-kings). There were also small domestic images, probably of minor tutelary deities for protection of the house.

The making of such a variety of images required artists of a high degree of skill and specialization, acquired by a long apprenticeship. A large stone statue required successively a quarryman, a sculptor, a hieroglyph cutter, a metal-worker to insert the eyes and other details, a painter for colouring the statue – all part of 'a well-paid production team'.[29] While there was room for genuine artistry and ingenuity in execution, the symbolism of the religious images was strictly laid down to ensure the 'identity' of the god. A grid system of scale plus careful training in draughtsmanship ensured that the artist portrayed the figures realistically within certain conventions, to manifest that assured Egyptian 'presence' of dignity and tranquillity. Colour symbolism prescribed green or black for Osiris, blue for Amon-Ra and yellow for the gold flesh of other gods. The sculptor's workshop was also known as the 'gold house' where the divine images were vitalized, as already mentioned. The art of calligraphy was important in conveying, by means of hieroglyphics, the reality and

identity of a name, divine or human and many paintings and models made for tombs served as inventories of possessions for transfer to the next world.[30] Their art thus served, directly or indirectly, the all-pervasive national religion of the ancient Egyptians.

Other ancient religions of the Near Eastern area reveal points of similarity to Egypt, but the iconography of each must be understood in the light of its own development and pantheon. In Mesopotamia the anthropomorphic representation of Sumerian deities goes back to 3000 BC; but it is of interest that the two supreme gods Anu (sky) and Enlil (earth) are not represented anthropomorphically but their presence indicated by a tiara, the symbol of divinity, placed on a throne.[31] In western Iran an earlier aniconic phase may have preceded the representation of deities in human and animal forms which developed after 400 BC in the Achaemenid, Parthian and Sassanian periods until the advent of Islam. But even before this the supreme god of Zoroastrianism, Ahura Mazda, 'was represented in a half-symbolic, half-anthropomorphic form as a winged solar disc containing the figure of a deity holding a wreath. This symbol, derived from Egypt and passed on to the Assyrians and subsequently to the Medes, was finally inherited by the Persians and survived the downfall of the Achaemenian empire'.[32] Cultural contact with Greece stimulated the Iranian portrayals of kings and gods renewed in Sassanian iconography (third to seventh century AD) of kings triumphing over enemies and being invested with authority from the gods. In return the Romans imported Iranian figures such as Mithras, as well as the Mesopotamian deities Tammuz and Ishtar and the Egyptian Isis, adding to the cults of the Roman Empire.

Greece: 'Gods and Men'

> Great God! I'd rather be
> A Pagan suckled in a creed outworn, . . .
> Have sight of Proteus rising from the sea;
> Or hear old Triton blow his wreathe'd horn.[33]

The famous lines of Wordsworth's sonnet express a nostalgia of Western man for the world of the ancient Greeks. It is a world where all aspects of life and Nature are hallowed by the presence of gods – even the minor sea-god Proteus who can readily change form, or the Triton blowing his conch-shell. If we could recapture the personal power of each phenomenon of nature, Nature would be 'ours' once more. Ancient polytheism has

this religious sense of nature, which is part of its charm for modern
men. It acknowledges the mystery of each phenomenon in itself. 'Poly-
theism is the conception of the divine which corresponds to the infinite
variety of the mystery of being.'[34] In Egypt we have seen this variety
expressed in many forms related to animals and divine kingship, but in
Greece the forms are virtually all human. What did the ancient Greeks
mean by this anthropomorphism in depicting their gods? We shall look
into this question, giving special attention to the great gods Zeus, Athena
and Apollo and their iconography in the first millennium BC.

First let us note the importance of ancient Greece in its legacy of
mythology and art which has inspired so much of European culture. This
legacy has helped to shape the religious iconography not only of the
Mediterranean and Christendom but of religions in Asia. In Hellenistic
and Roman times it spread through the Near East and Iran where Greek
anthropomorphism further shaped the deities. After Alexander reached
north-west India in the late fourth century BC, Hellenistic and Roman art
eventually contributed to the formation of the Buddha image which was
diffused over south and east Asia. In Europe and the Mediterranean area
the Roman Empire inherited the Greek legacy and became a carrier of
Greek art and iconography. When Christianity emerged in this milieu it
could not avoid using the moulds of Greco-Roman art and thought-forms
for its own expression. And throughout the history of European Christi-
anity their influence has recurred, especially in the Renaissance and
Baroque periods. Even though the Greek gods officially 'died' at the end
of antiquity, they continued their influence in the half-world of astrology
and the imaginative worlds of art and literature.[35] The ideals of naturalism,
order and bodily beauty have been recurring influences flowing out from
the Greek source into subsequent religious iconography.

The 'Greek' source here refers to the great Classical period (*c.* 500–323
BC) and the following Hellenistic period which continued and diffused
these influences in religious art. But scholarship of the past hundred
years has also been concerned to explore the antecedent periods of Greek
history with the aid of archaeology, philology and other disciplines. The
age which produced the Homeric poems (*c.* ninth century) was preceded
by Mycenae and the Minoan civilization of Crete in the second millennium
BC and it was in this period that the Greeks came from the north imposing
their Indo-European language, their culture and religion on the earlier
Mediterranean culture with its archetypal Great Mother goddess and
animal cults. Going back further into the pre-Hellenic ages, studies of
south-east Europe suggest a naturalistic pantheon in the millennia of the
Neolithic period, perhaps carried over from the Palaeolithic.[36] Much of

this ancient past remained as a substratum of popular and rural religion when the Greeks came, but the ancient nature deities were subordinated or absorbed under the anthropomorphic Olympian gods described by Homer. Even after this, when these gods were given iconographic form, Greek art was not an isolated development but received inspiration from the Aegean area, Egypt and the Near East.[37] The influence of neighbouring cultures and the memory of animal cults from the remote past may account for some Greek composite animal sculptures as well as winged goddesses such as the winged Victory (*Nike*).[38] Also Homer refers to the 'owl-faced' Athena and 'cow-faced' Hera. But the actual depiction of the gods in mythology and art is decisively anthropomorphic in the historical period of ancient Greece and it is with this that we are primarily concerned.

Aniconic and anthropomorphic

In seeking to understand the religion and iconography of the first millennium BC we have many references to religion and myth in ancient Greek literature beginning with Homer and Hesiod (ninth to eighth centuries) and including the great classical writers of tragic drama, philosophy and history; of ancient treatises concerning the gods and their worship various fragments survive from late Hellenistic and Roman writers as well as the reports of early Christians.[39] There are also inscriptions on monuments describing the public rituals and sacrifices although there is a lack of texts to show the hymns, prayers and liturgies of the temples. Something of the feeling of ancient Greek worship is conveyed by their religious art. Here we must regret that so little has survived from the Classical and Hellenistic periods for which we must rely mostly on Roman copies of cultic images, while their setting has to be imagined from the ruins which remain from the temples. There is also the problem of the diversity of Greek religion, due to the vicissitudes of history and to the political divisions of Greece; in the separate city states and even within one city such as Athens the same god might be represented and worshipped in differing cultic forms.

Despite this local diversity and the Greek tolerance of a variety of religious expressions, Greek religion acknowledged a common pantheon of gods; these hallowed the forces of life and represented the characteristic virtues and ideals of Greek society. The city-states took pride in standing for law and order and freedom, and the religious duties of its citizens were bound up with support of the civic religion. Local heroes exemplified the civic virtues and became venerated as protectors of the city or even semi-divine heroes in the stories of Achilles, Herakles and Jason. Human

greatness could not aspire too high without incurring divine vengeance, *nemesis*. The Greeks showed awareness of tragedy and 'fate'. But on the whole one may say that Greek religion was life-affirming and linked with daily life; it was in the festival, above all, that the cycle of life found its creative peak in the joyful celebration of sacrifices, feasts and games.[40]

The basic ritual of service to the god was sacrifice and this was performed at an altar where offerings of fruit cereal and animal-sacrifice could be made. This seems to have originated in prehistoric times from the *temenos* which was a fenced clearing in a grove containing emblems of the god's presence such as a tree trunk, a holy pillar or a heap of stones.[41] Cultic centres developed from this, including oracles and priests at such specially endowed places as Delphi. Temples date from as early as the ninth century, as distinct from the royal chapels of Minoan and Mycenean times, but they were not essential for the altar-sacrifice which continued to be performed outside in the open, offering the worshippers more direct access to the god. It was only as images of the gods became more important that an impressive temple was thought necessary as a 'house' for the god where appropriate ceremonies were performed for his image.[42]

These developments do not mean that a simple line of evolution can be traced from aniconic forms to iconic. Such a scheme was indeed developed by later Greek thinkers, based on a 'Democritean evolutionary concept',[43] but in Greece as elsewhere, a variety of forms probably existed from earliest times. Certainly the gods are thought of in anthropomorphic terms in Homer – as 'real personages humanly conceived with distinct form and independent action'[44] and this basis in mythology and literature influenced the iconography in its full flowering. But in the preceding period it is far from clear how far images were used and worshipped as icons. The trees and stones may not have been identified with their deities but rather venerated as aniconic tokens, perhaps magnets, of their presence. Weapons and pillars were venerated also.

We should like to know more about the *xoana,* the ancient wooden images briefly mentioned by later writers such as Pausanias (second century AD) who lists the various trees used for carving images of gods in days of old. Their origin could be attributed to heroes and the legendary craftsman Daedalus and treasured alongside marble and bronze cult-images; an example of an aniconic *xoanon* is the log which fell from heaven to be adorned with bronze and worshipped as Dionysos.[45] No such wooden images survived into modern times except a small wooden relief statue of Zeus embracing Hera in holy marriage, from the late seventh-century BC sanctuary of Hera on Samos.[46] But there must have

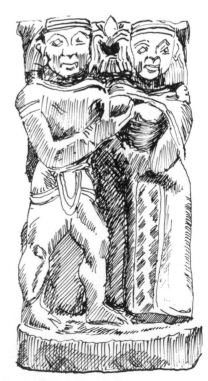

43. Wooden relief of Zeus and Hera from the Hera Temple, Samos.

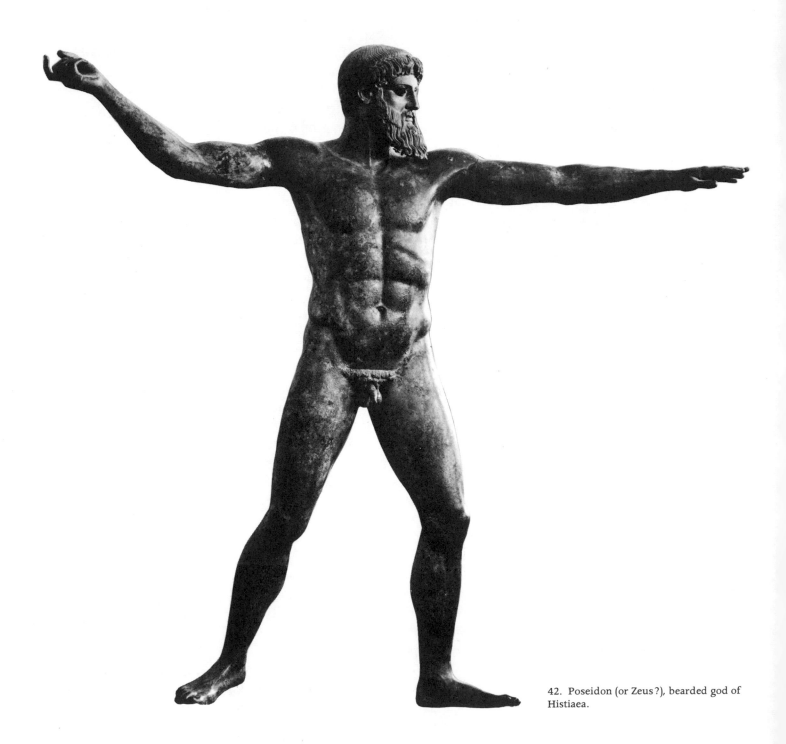

42. Poseidon (or Zeus?), bearded god of
Histiaea.

been a wide variety of simple cult-images ranging from figurehead deities from ships to aniconic forms. Some appear to have been a half-way house between the iconic and aniconic, suggesting the human figure without having any clear arms, legs or head; garments and decorations may have been hung on them, as at the Athens Acropolis where an image of Athena, perhaps a type of sacred clothes-dummy, was draped with a fine new robe for her great four-yearly festival, the Panathenaea. The most sacred object in the wealthy temple of Artemis in Ephesus was a small stone believed from remotest times to have fallen from Zeus as a heavenly, not a man-made, gift; this *diopet* representing the infant Artemis was probably kept on top of the head of the much-decorated sixth-century wooden statue of the goddess. Such ancient ritual objects were revered and preserved; sometimes they were coloured and gilded to enhance their magical power. Their sanctity persisted into late times alongside fully human sculptures.

Among similar forms of image, the *Hermai* were marble or bronze pillars showing the head and phallus of Hermes and other gods; these stood in the streets or by gates and were revered by citizens as protectors of the welfare of their city. They may have been a continuation of earlier pillar-worship. Some of the stumpy-armed terracotta votive statuettes found in sanctuaries and tombs[47] may represent deities. There was also the legacy of cults and images from the predecessors of the Greeks.[48] The Greek use of masks is a further catalyst in the development of expressively human images.

However crude the earliest images may have been, the Archaic period (*c.* 700–500 BC) saw the rapid development of artistic expression of the human figure with its climax in the fully anthropomorphic images of the gods for which classical Greece is famous. The combination of Greek ideals of harmony with divine majesty and power is splendidly shown in the fifth-century large bronze statue of the 'god of Histiaea' (Zeus or Poseidon), a copy of which stands in the entrance of the United Nations building in New York. Since its human form is the focus of our interest we should ask what factors underlie such a striking development in Greek iconography.

First there is the anthropomorphic conception of the gods which had already long been part of the mythology and religion of Greece, as attested by Homer. In this Greek view of the cosmos the gods are akin to men and men can feel kinship with the gods. Both men and gods are part of the cosmic order and ultimately subject to Fate. Of course the gods are immensely more powerful and in contrast to mere mortals are possessed of immortality; they are 'imperishable men' with power over mortal men

and the forces of nature. If this means a lessening of otherness and remoteness in the gods, it means also that nature is more comprehensible in so far as it is governed by powers similar to man. Implicit in this is the ancient belief that in essence man is a microcosm – the cosmos in a capsule – and that therefore he has an inner affinity with the cosmos and can understand something of its powers. On the macrocosmic back-drop the gods live out their super-human existence. 'This transformation of the gods into the likeness of men was a prodigious stroke of emancipating thought. It means that the Greeks were so impressed by the range and possibility of human gifts that they could not conceive of the gods in any other shape.'[49]

Secondly, as a consequence of this conception in Greek religious practice there is the belief that the gods are active in the world and that man can communicate with them through his human activities. Because they are gods they have an unfading life and beauty which man can only long for as an ideal; but they have divine resources of power and knowledge which man can to some extent contact for his own enrichment. Their knowledge of the future was exploited through reading the signs, as in the oracle of Delphi, and their power over the forces of nature through sacrifices and rituals directed to the appropriate gods. The gods might prove enigmatic and capricious in their answers, perhaps all too human; but this very humanity was a means of access to them in gaining their favours. Since the gods were amenable to human pleasures they could take delight in both solemn ritual and joyous celebrations of human life in the arts, sports and festivals. The Pan-Hellenic games at Olympia, Delphi and other centres were in this way religious festivals.

This leads, thirdly, to the Greek cult of physical perfection which provided in the athlete a model of the divine perfection. The four-yearly games at Olympia by the sanctuary of Zeus were held in an atmosphere of religious dedication. At the Olympiad in 720 BC an athlete who discarded his loin cloth won the foot-race and thereby established the convention of athletic nakedness which the Greeks maintained for a thousand years, 'because it seemed to them to be consistent with their principles of liberty, moderation and good breeding'.[50] In contrast here to the Romans, the Greeks were proud of the nude body and saw in it a mark of their superiority over barbarians.[51] Out of this situation came the emotional and artistic concentration on the human body. Kenneth Clark compares the Greek athletes to medieval knights competing in a poetical and chivalrous spirit, with the difference that here religious solemnity and rapture elevate the individual body in a cult of physical perfection and with passionate scrutiny: 'No wonder that it has never again been looked

at with such a keen sense of the qualities, its proportion, symmetry, elasticity and aplomb'.[52] Many statues were made of victors at the athletic games. By the fifth century BC Greek sculptors were able to portray the mature male athlete with these qualities and thus to attribute them to the gods. The superb statue already referred to as the bearded 'god of Histiaea' has the balance, strength and tension (if not the movement) of a human athlete, but his size and bearing have the majesty of a god. The commanding and indeed threatening posture is very similar to some images of Zeus as Saviour casting a thunderbolt at his enemies; but the now empty hand was probably meant to grasp the long trident of Poseidon, the sea-god and brother of Zeus. The now empty eye-sockets once held coloured eyes, adding to the life-like effect of this powerful image. The Greeks felt it appropriate thus to express the perfection of the god as a perfect 'divine athlete' and prototype of mankind, because athletics in the service of religion had come closest to the divine. As Seltman observes: 'That Greek art operated in the service of anthropomorphic religion is obvious, but it was an exceptionally high standard of anthropomorphism'.[53]

Finally we may note the close relationship between art and religion in Greek life – the setting in which sculptors could unite the divine and the human, as Hegel and others observed.[54] The earliest word for the statue is *agalma*, literally 'delight', signifying a beautiful ideal such as the body of an athlete or a beautifully clothed woman and hence the gods in all their youth and vigour. The common word *eikon*, 'likeness, image' implies the view of the sculptor's art as *mimesis,* an 'imitation' of the human body. But this was not merely external naturalism and realism, however skilful the Greek artists were in depicting life movement and power. As Sir Maurice Bowra points out, 'the Greeks delighted in works of art, but saw in them not so much an extension of the living scene for its own sake as a connexion between it and something else'.[55] Behind and through the appearances known to the senses lay the world of abiding reality, the essential nature of things. The artist then is building a bridge between the seen and the unseen, the familiar world of everyday and the ideal world of divine glory and beauty. Within the Greek view of the one cosmos including Gods and men, the immortals are rightly portrayed through the ennobled vision of the artist.

The outcome of these movements in Greek thought, art and religion was the triumphant anthropomorphic art of the classical period, from the more severe style of the early fifth century to the age of Alexander (338 BC). Inspiration for a century was given by Pheidias, the famous sculptor whom Pericles commissioned to work on the Parthenon (448–432

BC) but whose most celebrated individual images are known only through late copies or by verbal descriptions. His work can be seen as the culmination of Greek anthropomorphism as expressed both in the mythology of Homer and in popular worship. Pheidias can also be seen as a creative religious influence who enabled the people to imagine their deities more nobly, combining physical beauty and perfection with that more awesome ethical-spiritual strength and solemnity, *semnotes,* that shows the tranquil reserves of power possessed by the gods.[56] The gods were shown as majestic but also as benign and gracious, avoiding both sentimental or voluptuous dilutions and the extremes of the terrifying and macabre. In this light Farnell argues convincingly that the effect of this classical art was not to weaken but to strengthen popular faith in the gods, despite the periodic criticism of anthropomorphism by Greek thinkers. By deepening the aesthetic-religious emotions of the people, Pheidias and his successors helped to fortify and ennoble Greek polytheism. Their iconography established the individuality of the gods more clearly.[57] To three of these gods we now turn our attention.

Zeus, Athena, Apollo

Zeus has a dominating position as the great sky-god of the Indo-Europeans. Replacing the ancient mother-goddesses of the Aegean civilizations, Zeus became the leading national deity of the Greeks, the father of gods and men, lord of nature and guardian of law and justice. But in the process of extending his religious sway he appears to have absorbed aspects of ancient and local deities such as Cretan fertility spirits[58] and gods of the underworld; the pre-Hellenic goddesses Hera and Athena were linked with him as wife and daughter. Zeus became guardian of home and storehouse, clans and city-states and the father of kings and heroes. His complex story fills several large volumes.[59] Eventually Zeus was elevated not only as ruler of the universe but as its embodiment when in the early fifth century. Aeschylus could call him the 'unknown, unnamed god', identified with air, earth and sky, while Epimenides could say 'In him we live and move and have our being'.

In view of his elevated status as sky-god it is not surprising that Zeus was later than the other gods to be worshipped iconically. He was identified with mountain-tops such as Olympus (the mythical home of the twelve Olympian deities in northern Greece) and other mountains such as Lycaeus in Arcadia, southern Greece, where the sanctuary on the summit was a mound of earth flanked by two columns engraved with eagles. As the high god of the upper air Zeus was originally worshipped with altar

and sacrifice only, perhaps associated with aniconic emblems such as a meteoric stone or a pyramid.[60] But the anthropomorphic conception of Zeus in the ancient myths is of a despotic ruler over fighting chiefs similar to the early Greeks; he is all too human in his behaviour with Hera and other goddesses and women and is characterized not by morality but by power and will. Hence some of the earliest iconic representations of Zeus show him as a warrior-figure striding out to hurl a thunderbolt – the expression of his thundering power, his command over the sky, weather and lightning. When combined with the athletic ideal in sculpture this produced the dynamic effect seen in the small fifth-century bronze from Dodona (the ancient grove of the sacred oak tree in north-west Greece where the oracle of Zeus spoke). A more intimate and friendly aspect of Zeus is seen in representations of his marriage with Hera.

A new level was reached in the colossal image of Zeus at the sanctuary of Olympia in southern Greece. Completed by Pheidias around 430 BC it was regarded as the masterpiece of Greek religious sculpture and became the subject of detailed and ecstatic descriptions. These, along with some coins, give us some picture of the now lost statue in all its majesty. About eight times life-size, it reached up thirty-nine feet almost to the ceiling of the temple interior. Zeus was seated on a richly carved throne of bronze, gold, ivory and ebony. His face and flesh were of ivory, his mantle and sandals of gold, the mantle being decorated with animals and flowers, especially the lily as symbol of immortality.[61] He wore a golden olive wreath, the victor's crown of the Olympic games thus expressing his role as guardian of the games and of the unity of Greece. The idea of victory

46. Colossal statue of the enthroned Zeus by Pheidias.

45. Zeus hurling a thunderbolt.

44. Hera unveiling herself before Zeus.

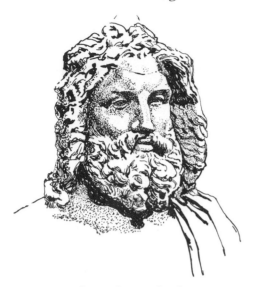

47. Bust of Zeus showing fixed iconographic type.

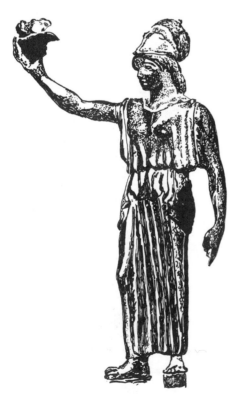

49. Athena as girl with an owl.

was also expressed in the winged figure of victory which Pheidias introduced in the right hand of Zeus holding up a garland for him; there were further relief-carvings of groups of victories on the lower part of the throne. The eagle took a less prominent place, perched at the top of the sceptre in his left hand.

The significance of this work during the nine hundred years of its existence did not lie simply in its magnificence and beauty as one of the seven wonders of the world. Writers of the Roman period praised its beauty as expressing the divine majesty. For instance, Quintilian (*c.* AD 95): 'The beauty of the Olympian Zeus is thought actually to have added something to the received religion: so far did the majesty of the work go towards equality with the godhead'.[62] Pheidias had left behind the thunderbolt of Zeus (which is absent from his statue) and drawn on those aspects of Homer which represented Zeus as 'enthroned in lofty calm'.[63] The imagery of physical terror was replaced by the ideals of peace and benevolence, a saving god ruling by spiritual power. Subsequent iconography shows the influence of this conception by Pheidias. Zeus comes to be depicted as a powerful mature man wearing a long mantle but bare on the chest and right arm. Sceptre, eagle and sometimes still the thunderbolt appear as his attributes. He has thick wavy hair and curled beard and may be crowned by a wreath. The solemnity of his posture is matched by his grave countenance and strong lined forehead.

It was from the head of Zeus that the goddess Athena was born, without a mother, springing forth fully armed and with the vigour appropriate to a virgin goddess protecting the city. Her femininity is clothed with traditionally masculine qualities, though not in any savage fighting spirit; her world of action is 'reasonable action which through her clear awareness will most surely lead to victory. . . . She is spirited immediacy, redeeming spiritual presence, swift action. She is the *ever-near*'.[64]

Like her father, Athena had a complex history of many-sided development, becoming one of the leading Greek deities; but unlike him she was of pre-Hellenic origin. She preserved attributes from earlier figures such as the Minoan snake-goddess and the ancient Aegean 'Mountain-mother' as manifested on the Acropolis rock in Athens with its snakes, owls and olive-trees.[65] The owl remained her favourite bird, being shown on Athenian coins and vases, and Athena herself was credited with the bright piercing eyes of the owl.[66] When the Acropolis was a Mycenean palace she was a goddess carrying a shield, a household protectress in martial dress. When the invading Greeks took over she became Pallas Athena, a maiden goddess and *parthenos*, virgin instead of mother. While she was worshipped in various ways throughout Greece as goddess

of victory, skill and health, in Athens she had a special place as protectress of the city, heroically 'in the frontline' as Athena Promachos, holding a shield and spear. Her popularity was enhanced by the famous Athenian politician Pesistratus of the mid-sixth century who instituted the four-yearly festival of the Greater Panathenaea. Here she became the patroness of work, *Ergane,* in the sense of the skills of the city-dweller, the political man and 'member of the prosperous proletariat'. Coming from the brain of Zeus she embodies the divine wisdom in the sense of skilful knowingness; so her true Christian successor is not the Virgin Mother but Hagia Sophia, the Holy Wisdom of God.[67]

The earliest emblems of Athena may have been aniconic, in the form of stones from heaven, leading on to the simple wooden *xoana.* The sacred Palladion of Athena seems to have been a cult image of this sort; it was treasured in the Erechtheum, one of Athena's three temples on the Acropolis. Artistic developments in the Archaic period led to more polished images of the girlish goddess or powerful protectress. In the fifth century Pheidias made several statues of Athena, but the two on the Acropolis have not survived. The colossal bronze Athena Promachos could be seen from afar by sailors approaching Athens. The other colossal image of Athena was inside the Parthenon (the house of the Virgin goddess). It was completed by Pheidias around 438 BC and this is known to

48. Archaic-period bronze of Athena.

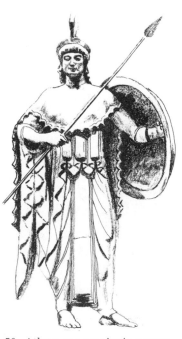

50. Athena as a warrior in armour.

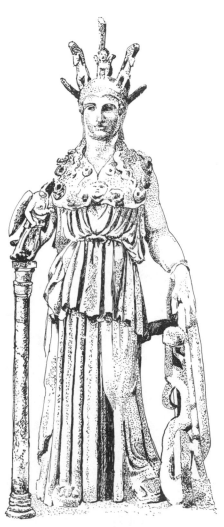

51. Athena Parthenos: statue by Pheidias.

us not only by descriptions but by a faithful if uninspired Roman copy in marble, about three feet high, from the second century AD. The original was some thirty-seven feet high – a standing figure of Athena clad in a peplos, a full-length garment made of gold; her flesh was of ivory and her eyes were of jewels which flashed out to the viewer far below. Her helmet had a sphinx in the centre and winged horses on each side with griffin decorations. At her right hand stood a column supporting the winged goddess of victory. Her left arm supported a spear as she held her shield, alongside which was coiled a legendary snake; snakes also decorated her dress. She stood on a base depicting the adornment of Pandora in the presence of twenty gods.

If this image was overladen with symbolism from the traditional attributes of Athena, this was probably because Pheidias was conforming to tradition within the complete programme of sculptural decorations he designed for the Parthenon.[68] Even if the image lacked the numinous power of his Zeus at Olympia, it must have been awe-inspiring in its majesty as one came into the semi-darkness of the Parthenon. Modern reconstructions, while hypothetical, help us to envisage something of its power.[69] As a votive image on the grand scale it would signify to Athenians the greatness of their state under their divine protectress. The more

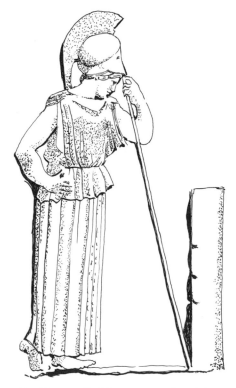

52. The so-called 'mourning Athena' from the Acropolis.

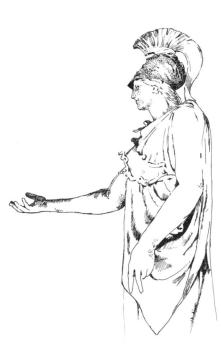

53. Bronze of Athena from Piraeus.

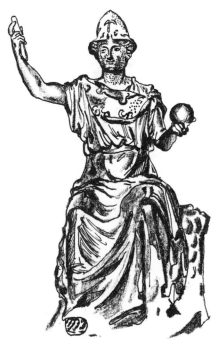

54. Minerva, Roman goddess of crafts, wisdom and war.

warlike qualities of earlier images are here softened and given something of maternal peace and security. The influence of this famous statue led to further beautiful and elegant representations of the helmeted Athena; in later ages this provided a model for national emblems such as Roma and Britannia. In another direction the practical wisdom of Athena became increasingly understood as intellectual wisdom. In Rome the ancient Etruscan winged goddess Minerva (who also held a screech-owl) was merged with Athena to become the patron of crafts, industry and learning; her warrior-character followed later. Meanwhile, as free city life in Greece decayed during the Hellenistic period, the face of Athena in sculpture became 'charged with sentiment or with excess of thought'.[70]

Apollo is regarded as the mightiest of the gods, next to Zeus, the very embodiment of fine style, manly beauty and noble superiority. He is the bright and beautiful god, renowned for his many loves. He is the lyre-playing god of music, representing art, moderation, sanity and law. For these qualities he is renowned as the most Greek of all the gods, popular in worship and as a subject of Greek art. But originally he was non-Hellenic, coming either from the Hyperborean north or from Asia Minor – both Apollo and his twin-sister Artemis, the huntress goddess favoured the Trojans.[71] Among the Greeks he was worshipped under some two hundred names, indicating that he had absorbed various other deities; thus he became a god of flocks and herds, of archery, of purity, of healing and atonement; one title, Phoebus, 'the bright one', was taken popularly to refer to him as a sun-god. He was the god of young men who dedicated their long hair to him on attaining manhood. Two great shrines in Greece were devoted to him – an Ionian shrine at Delos in the Aegean sea, and his temple at Delphi with its famous oracle at the place where he killed the Python and became god of prophecy.

Despite his many-sided nature Apollo has the unifying feature of harmonious beauty. This is expressed in the lyre which is one of his chief attributes, the tones of which keep the universe in harmonious movement. In contrast to Dionysos with his wildness and excess, the Apollonian ideal seeks clarity and unerring rightness. W. F. Otto sees this expressed in Apollo's best-known attribute, the bow which he shoots from afar, with distance and stately objectivity:

In Apollo there greets us the spirit of clear-eyed cognition which confronts existence and the world with unparalleled freedom – the truly Greek spirit which was destined to produce not only the arts but eventually even science.[72]

This ideal, as well as the attributes, are found in the iconography of Apollo. He is depicted as a young man of idealized beauty, with broad

chest and slim hips, generally nude with a garment over his shoulder. Surmounting the beardless face and high forehead is thick long hair knotted on top with curls hanging or in long locks falling to the shoulders. This typically vigorous young man appears in the quaint Archaic bronze of the seventh century, 'Apollo of Manticlus'; a dedication on the thighs reads 'Phoebus of the silver bow' and the left hand is stretched forward, presumably to hold a bow. As the stiffness of the early figures was modified, Apollo was represented with full power and nobility in the fifth-century classical sculptures. These include a striking bronze figure discovered in 1959[73] and a marble replica of a statue by Pheidias. Perhaps the most powerful representation is the large figure of Apollo on the west gable of the Zeus temple at Olympia (*c.* 460 BC). In the midst of a scene of conflict between lapiths and centaurs, representing civilization and barbarity, he raises his right arm to quell the strife; his bow is idle because as god of law and right he can overcome lawlessness with the weapons of the spirit.[74] This serene gesture of command puts him above the

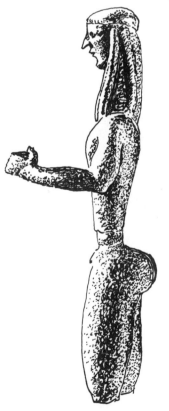

55. Archaic bronze of Apollo of Manticlus.

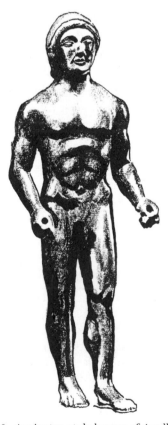

56. Aeginetan-style bronze of Apollo.

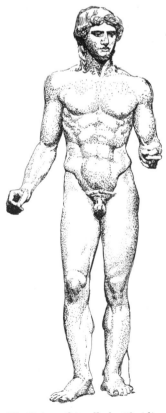

58. Statue of Apollo by Pheidias.

battle and gives him the air of calm confident divinity. While his pose is
poised and majestic, his face is particularly expressive with the fullness
of the eyes marking him as a god. A worshipper of Apollo would be
assured that law and right must prevail over conflict and he would be
inspired to follow Apollo's exemplary qualities of moderation, clear-
sighted courage and wholeness.

Later representations of Apollo tended to beautify him further as a
graceful youth. The most famous of these is the 'Apollo Belvedere' by
the popular Athenian sculptor Leochares (*c.* 330 BC) whose bronze
original survives only in a smooth Roman marble replica. There is a
magical lightness in the young god's stride: 'This is the antique epiphany,
the god come to earth, alighting with the radiance of his celestial journey
still about him'.[75] At the same time one senses a self-consciousness in his
graceful movement and signs of over-refinement in the sculptor's
representation of the god. A further development along these lines made
Apollo into an indolent effeminate youth with the loss of that divine

57. Apollo quelling the strife, from the
Temple of Zeus at Olympia.

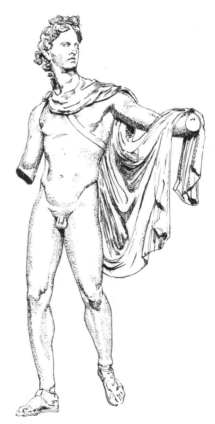

59. Apollo of Belvedere by Leochares.

majesty expressed in the great fifth-century images. The fourth century is transitional in this respect. The masterful Praxiteles was able to put warmth and life into his charming statues – as evidenced in the only original to survive, the 'Hermes' of Olympia (*c.* 350–340 BC) where the messenger of the gods smilingly holds Dionysos, his infant half-brother, on his arm.[76] Praxiteles was renowned for his statues at Cnidos of the goddesses Demeter and Aphrodite, the latter as a mature young woman, about to enter the bath. These larger-than-life images identify the gods with supreme human beauty, feeling and love; they are divine yet more on the earthly side of human experience. The statues of Praxiteles look towards the earth rather than towards the distant horizon where the classical divine images directed their gaze. His favourite subjects were Eros, Aphrodite and Dionysos – deities of life and propagation – as well as satyrs and demons, but he did not depict Athena. Noting this, Pierre Grimal contrasts the earlier classical reflection on the universe and its workings with the more earth-centred awareness of the present life and affairs of the moment:

Ultimately the very perfection of this classical representation of the gods in human terms caused the image itself to become 'too human'. The inspiration for a statue of Aphrodite is no longer an ideal of the divine but rather the body of a specific woman, as if each artist or each man were evolving the divine from his own human experience.[77]

Anthropomorphism criticized

How are we to understand this humanizing trend? As a nemesis of anthropomorphism which leads to a weakening of the sense of divine 'otherness'? As a loss of artistic vitality when the classical masters were copied by lesser admirers? As Hellenistic decadence creating images of male and female deities for 'a sensual and pleasure-worshipping people'?[78] We should understand this first of all in terms of the changing life of ancient Greece with the decline of the rival city-states and the loss of the political and cultural basis for the civic religion. In the Hellenistic era following Alexander's empire, religion was less local and corporate but more cosmopolitan and personal, as in the growth of mystery-religions with their healing and saviour cults drawing on the deities of Egypt and the Near East. Art expressed more intense striving and drama. Gods such as Hermes and Dionysos could be adapted to meet the new needs; but the stately Athena and Apollo tended to become Olympian abstractions and the city festivals reduced to pageants. The great anthropomorphic images of the gods which so fittingly expressed the Greek ideals of human life and the divine in the fifth century no longer did so. Human life and

culture are subject to change; and anthropomorphic images which depict the gods in terms of human culture are especially vulnerable to change, including distortion and devaluation of the divine. On the other hand this very vulnerability offers fertile opportunities for new developments, renewals and influences on other ages and civilizations. The Greek 'Apollonian' ideal found new soil in the Buddhist art of Asia as well as in Christian Europe and in Greece itself the traditional shrines continued their popularity well into the Roman period.

This is to understand the images of the gods as phenomena of cultural history, but when we seek to understand them as phenomena of Greek religious experience it is not easy to give any single definite answer. We should like to know especially how the ancient Greek worshipper at a shrine or temple regarded the anthropomorphic image of the god – was it an idol embodying the actual nature and power of the god, or was it more of a symbol to bring home visibly to the worshipper the intangible qualities of an invisible god? The latter view is expressed by Seltman when he writes that

the Greeks were *never* idolaters in the sense of worshipping actual images which they had made. Rather was the ancient statue a statement of praise about a god, no more and no less than a hymn was a song of praise about a god, but human language was requisite for the song and human likeness for the statue.[79]

On this view the image was there to suggest divinity, not to receive worship directly; the beautiful image in the temple made one aware of the holy presence of the god who had come down from his heavenly mansions on Olympus to make a temporary abode with men. But this view is probably too ideal and rarified for the popular mind. Passages in classical Greek literature imply that the statue was in the most intimate sense the shrine of the divinity and often animated by its presence – as, for instance, in Euripides' *Iphigenia* where the image of Artemis turns aside at the approach of the matricide Orestes. Again, statues were sometimes chained to prevent them leaving their votaries.[80] While no passages explicitly equate the image with the god, it is clear that ancient 'paganism' showed a more than symbolic reverence for images, especially the ancient and sacred *xoana*.

Further evidence for the prevalence of image-worship is afforded by the protests against it by Greek thinkers. Just as Hesiod in his *Theogony* (*c.* 700 BC) had sought to tidy up the scandals and inconsistencies of ancient myths in the interests of morality and theology, a subsequent critical movement was directed against the multiplicity of anthropomorphic deities in the interests of a purer understanding of divine power. Thus

Xenophanes, an epic reciter (*c.* 500 BC), attacked polytheism and the all-too-human versions of the gods in Hesiod and Homer; he maintained that the greatest god was not at all like a man but controlled the universe by pure effortless thought. In a famous passage Xenophanes exposed the anthropomorphic fallacy of mortals who think that the gods are begotten, wear clothes and speak in human form. If oxen, horses or lions could make works of art they too would depict the gods like themselves in their own animal form. Each people projects its own image on the gods – the Ethiopians as black and flat-nosed, the Thracians as blue-eyed and red-haired.[81] Among the pre-Socratic philosophers of this period Heraclitus criticized the irrationality of religious rituals and prayer to idols: 'Also they talk to statues as one might talk with houses, in ignorance of the nature of gods and heroes.'[82] Zeno criticized the use of temples and idols. There were also more rationalistic attempts to explain the origin of the Greek gods as derived from Homer and Hesiod (the view of the historian Herodotus) or as the result of divinizing great men (the view of the fourth-century Euhemerus). Such criticisms have provoked perennial interest among scholars; but it cannot be said that they altered religious attitudes in their own time, nor did any movement of iconoclasm develop. In so far as traditional values were undermined they were replaced among the populace not by philosophies of a 'classical enlightenment' but rather by new forms of cults and mystery-religions. Greek religion continued to be deeply bound to its vivid and beautiful forms of expression in anthropomorphic images.

It is a temptation for modern readers to echo the criticisms made by Xenophanes and others as forerunners of Feuerbach and Freud and to dismiss the ancient images as 'mere anthropomorphism'. But it is not our task so to judge this anthropomorphism as so evidently inferior or erroneous. Kristensen reminds us that we have to learn the 'language' of these ancient conceptions; and within the Greek view of the cosmos in which gods and men are related their humanized deities make sense in a reciprocal way: 'Anthropomorphic ideas of deity signify theomorphic ideas of man'.[83] Instead of reducing such ideas to the common human factor we should see how the accent falls on the divine factor. On the one hand, the anthropomorphic god is not a man but a god and is worshipped as such. And on the other hand, the human qualities are never purely and simply human, for in them mysterious uncomprehended factors are revealed; 'even that which is human is an uncomprehended reality, a revelation of self-subsistent energy, and as such it is divine'.[84] Thus the myths and images of the gods fighting and making love, or acting in ways that may be often benevolent but also arbitrary and enigmatic, all attest

this interplay of the divine and human. The more mysterious and super-human aspects are expressed in a special way in the greatly revered *xoana*. The greater simplicity, even crudity, of such ancient images drew them out of the orbit of naturalistic art to their spiritual function; they represented the otherness of a god from beyond the visible world and his divine freedom beyond human norms.[85] The Greek gods are then really gods, immortals, whose link with humanity yet enables them to understand the lot of mortals.

Since it was the Roman Empire which mediated the heritage of Greece to European civilization, it is appropriate to mention the iconography of Roman religion. The use of images was a comparatively late development and not integrally bound to religious expression as it became in Greece. In the early centuries of Latium there were no myths and images of personal gods but rather a practical religion of prayer, sacrifice and divination which related the various requirements of life to the super-natural potency, *numen*. By the sixth century BC the influence of Etruscans nearby and Greek expansion in southern Italy led to the use of images. Greek art was used to provide the Roman gods with visible form and Greek gods were subsequently added, thus transforming the ancient piety. A modified form of the twelve Olympian gods emerged as the *Consentes Di,* the six pairs of gilded gods in the forum in which were matched Jupiter and Juno, Neptune and Minerva, Mars and Venus, Apollo and Diana, Volcanus and Vesta, Mercury and Ceres.[86] This pantheon was officially sanctioned in 217 BC as part of the Roman state religion. From this time also there came a further influx of foreign deities in the oriental cults of the Hellenistic period such as Cybele the Great Mother from Asia Minor, Isis and Serapis from Egypt and Mithra the sun-cult deity originally from Persia. Oriental ideas of divine kingship also contributed to the Roman cult of the emperors before whose images sacrifices were offered as an act of allegiance to the Empire.[87] The expansion of Rome led to an ever growing syncretism of cults in the conquered territories. Even though there was Roman persecution of the druidic religion of the pagan Celts, Roman toleration resulted in a mixture of Romano-Celtic deities and heroes in the temples and popular religion of Roman Britain.[88] The many gods and cults of the Roman Empire provided the religious setting in which Christianity emerged – not only as a contrast and foil to Christianity but also as part of the Roman-Hellenistic civilization which shaped early Christian iconography and European Christendom.

Summary

In the polytheistic religions of ancient Egypt and Greece we can study two rich but very different developments in iconography. Egypt enjoyed a long-lasting national tradition which included representations of the gods with animal and human (especially royal) features. Its quest for eternity leaves an impression of majestic otherness, enduring, static and rooted in Egypt. The Greek gods by contrast are conceived and portrayed anthropomorphically; they are therefore more involved in and dependent upon the changing ideals of human culture. Just as the surviving Greek images have come through the vicissitudes of history mainly in broken or derivative form, so their anthropomorphic vision itself has been more vulnerable to change. The Greek iconography flourished for a much shorter period in its own land than did the Egyptian, but it proved ultimately to be more widely influential in other civilizations.

4 The Hindu Tradition

What differences in the countless iconographic variants of the Buddhist, Hindu and Jainistic pantheon! What differences in the interpretations among the individual sects! What scale of dimensions – from figures of several millimetres to sculptures of life size! What diversity of technique, workmanship and material which only for the lack of an appropriate vocabulary are called bronze, copper or brass. And what spectrum of styles, changing from province to province and from century to century.[1]

WHAT IS HERE being said about the diversity of 'the bronze deities of India' applies to the whole range of Indian religious iconography. This covers a sub-continent for a period of over 2000 years – perhaps for 5000 years if we go back to the pre-Aryan civilization of the Indus valley. Despite the obscurity of the ancient period and the profusion and diversity of the subsequent periods of Indian religion and art, a certain continuity of symbols and themes can be traced even from the pre-Aryan remains through to the later Hindu depiction of such deities as Shiva and the Mother goddess. This justifies our talk of a 'Hindu tradition' in the literal sense of the religious tradition of the Indian people.

This tradition is something wider than 'Hinduism', the orthodox heritage rooted in the Vedas; it can include the heterodox systems of Jainism and Buddhism which are discussed in this and the following chapter. Again, it is wider than the geographical bounds of India, as we shall observe in the Hinduization of south-east Asia. What we have is a living religious tradition which Hindus prefer to call 'the eternal religion' (*sanatana dharma*), the universal truth manifested in India. Historically there are interesting parallels with the ancient religions already discussed.

The iconography of India like that of Egypt depicts a variety of animal and human forms; and like that of ancient Greece it results from the invasion of Aryan peoples whose civilization absorbed an older indigenous one. But the special interest of India for us is that it is a *living* tradition, with an iconography proliferating in many forms through to the present day. The meaning of Hindu images can be studied in the prescriptions of medieval texts and the interpretations of modern scholars, while the use of images in worship can be observed in the temples, homes and village shrines of the Indian people.

61. Swastika – the symbol of fortune.

Indian Religious Symbolic Themes

Ancient religious symbols link the present to an all-but-forgotten past. For instance, a perennial symbol of fortune is the swastika, found at Harappa in the Indus Valley of the second millennium BC. This symbol has solar and cosmic significance because the arms of the cross expand outwards from the centre in four directions but, being 'crooked', represent the transcendent which escapes human power and logic and cannot be brought back to the centre. 'Used everywhere as an auspicious sign, the *svastika* is meant to remind man that the Supreme Reality is not within the reach of the human mind nor within man's control.'[2]

60. Bull found on a seal from Mohenjo-Daro.

Also from this period, around 2000 BC, are various Indus Valley stone seals and clay figurines depicting animals, especially the humped bull, as well as tigers, elephants and mythical 'unicorns'. The emphasis on male rather than female animals indicates a predominantly male religious cult of fertility,[3] expressed again in polished stone phallic images of varying sizes – predecessors of the Hindu *lingam*. The theme appears in a clearly cultic setting in three seals dating from the third millennium BC at Mohenjo-Daro; they depict a seated figure with erect phallus, horned headdress and retinue of votive animals, all of which suggest the title 'Lord of the Beasts', a fertility deity conveying power through animal life. But this figure is notable for being seated firmly in the yogic posture with heels together which, along with his nudity and apparently piled-up matted hair, associates him with the ancient ascetic tradition of Indian religion. This combination of sexual fertility and asceticism is an important and recurring theme in the Hindu tradition, especially in the great deity Shiva as 'Lord of the Beasts' and 'Prince of Yogis'. The further fact that the figure on the seal has faces at the sides of his head marks him as a precursor of the three-faced Shiva depicted in Hindu sculptures 3000 years later (fig. 91, p. 116).

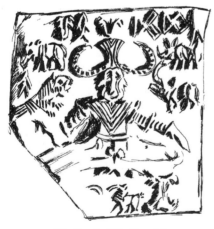

87. 'Lord of the Beasts'.

If the Indus Valley civilization did not accord such cultic significance to the cow, the female side is still represented in clay figurines of what may be a fertility goddess of household cults. There are also seals depicting a horned goddess with a sacred tree. These indicate 'the worship of a mother goddess who presided over fertility and birth and who may have acted as guardian and protector of the dead'.[4] The terracotta figurine from Sari Dheri (south of the Khyber Pass) is 'fish-eyed' and bears a lotus-flower or rosette type of ornament on the head, while the harness of scarves crossing between the breasts is a fertility symbol and charm found also in representations of the mother-goddess from Mesopotamia and Iran.[5] In view of the widespread appeal of such a cult in the ancient world it is scarcely surprising to see similar figurines appearing 2000 years later in Bengal, second century BC. The worship of Devi, the great goddess, found richly varied forms at the village level and in the developed Hindu pantheon.

Popular worship found a further focus of devotion in the many nature spirits and genii, both male and female (*yaksha* and *yakshi*). These two derived from pre-Aryan religious cults which continued as the 'Dravidian' religion under the Aryan conquerors. Yakshas represented the wealth and abundance of the earth's treasures which they guarded. Although there must have been many images of them, the earliest one that has survived is the imposing (over eight feet high) stone statue from Parkham,

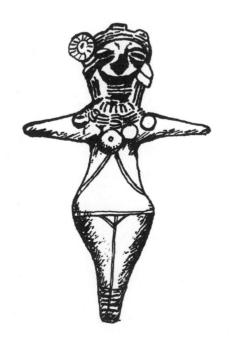

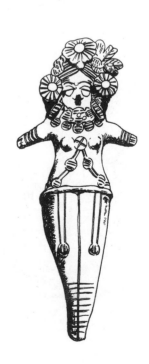

68. Terracotta statuette of female deity from the Indus valley.

69. (*far right*) Fertility goddess from Bengal.

north India, from the third century BC. With its prosperous stomach it conveys the promise of abundance to those who propitiate the yaksha with offerings. It is interesting to note that the image retained its cultic appeal into modern times; despite its damaged condition it was still included in daily ritual worship in the village until its removal to the nearby museum at Mathura.[6] In Hindu mythology the fat figure of Kubera came to be honoured as king of the yakshas and 'Guardian of the North' (i.e. of the Himalayas) although originally he had been a shady leader of demons; he could also be represented in a more slender and dignified form. Likewise the general of the army of yakshas was the corpulent Pancika, husband of the protective mother-goddess Hariti who herself had been earlier feared as an evil yakshi.[7] The yakshis were associated with the ancient Indian cult of trees which were regarded as the dwelling-place of nature-spirits and protective deities of villages. When they came to be assimilated as guardian on fertility figures in the official cults of Buddhism and Hinduism they were still depicted as buxom females entwined in trees. The stone image from the railing of the Buddhist stupa at Bharhut, second century BC, expresses the belief that when the young woman embraces the tree or touches it with her foot it flowers instantly; here are themes of sex, fertility and the union of human and plant life.

66. Pillar relief from Bharhut stupa of Yakshi and tree.

65. Sandstone Yaksha.

A host of spirits and minor deities peoples the cosmos of popular religion and finds a place in iconography. For instance the *gandharva* is a divinity of the sky and air, a heavenly musician, who may be depicted with his consort flying around one of the great Hindu gods. The *apsaras* is a sky nymph associated with Indra's heaven who may appear as a seductive courtesan on temple walls. There are evil forces such as *asuras* (anti-gods) and *rakshasas* (demons) represented with varying degrees of ugliness and deformity.[8] An ambivalent honour is given to the *nagas,* serpent-gods who are feared as evil yet also linked with gods and the creative fertilizing power of water. Cobras are featured cultically on Indus Valley seals and snake-worship has continued in many forms in India up to the present.[9] A medieval image shows the male and female forms intertwined: 'Backed and surmounted by their cobra hoods, the nagas, denizens of the waters and symbols of the primordial generative power, are royal in their dignity and human in their tenderness. They meet and flow together, their serpent bodies interlace'.[10] A small mutilated figure below the naga and nagini represented a worshipper.

Already we have observed a number of basic themes and symbols recurring over the millennia of the Hindu tradition. Stella Kramrisch emphasizes three recurrent configurations of Indian sculpture.[11] The man-animal shape is found explicitly in a few deities such as the elephant-headed Ganesha, a pot-bellied yaksha-type (fig. 97, p. 121). It appears also in the traditional animal mounts of the gods and the various animal incarnations of Vishnu. The effect, as in Egyptian deities, is an impression of supernatural power. The configuration of woman and tree relates man to the unity of nature and fertility, as we have seen. The third configuration, the *mithuna* or 'state of being a couple', depicts a man and woman in union as the symbol of wholeness regained. This widespread theme does not always have such an elevated spiritual meaning, and controversy surrounds the interpretation of erotic art found on Hindu temples such as those at Konarak and Khajuraho. Nevertheless their place on temple walls has been justified on the grounds, first, of providing an 'attraction' to the devotee in terms of the primary human drives and senses, so that he is led to concentrate without distraction on the divine beings in union. If he can then proceed to dwell on the erotic *mithuna* with detachment, without being enslaved by desire, the second purpose is achieved – of attaining spiritual self-mastery and the bliss of liberation and union with the divine. Here again is the confluence of sex and asceticism in the Hindu tradition.

Among the many religious symbols of this tradition some of the most important are expressed most clearly in ancient Buddhist monuments,

67. Naga and Nagini, snake deities.

while actually belonging to the wider body of Indian religion. For instance the sun-medallion from Bharhut depicts the fiery rays with a worshipper at the centre; the sun's rays could also be assimilated to the spokes of a wheel (*chakra*) in the famous Buddhist symbol. The lotus-medallion, also from Bharhut, shows a turbanned noble or king at its centre, fore-shadowing the iconography of Buddha-figures and Hindu deities seated on the lotus. As the flower arising from water the lotus (*padma*) symbol-izes purity and detachment, as in the attainment of the Buddha, and self-creation, as in the Hindu creator-deity Brahma. The symmetry of the eightfold petals and the lotus centre are also identified with the directions and centre of the universe, and again with the female principle, the creative womb. Another cosmic symbol is the pillar regarded as the *axis mundi*. This seems to be the meaning of the great pillars set up by the Buddhist emperor Ashoka in his Mauryan empire of the third century BC. The well-preserved pillar at Lauriya Nandangarh near Nepal is sur-mounted by a lion, possibly a symbol of the Buddha or of the sun.[12] Others were more ornate, such as the pillar at Sarnath with its four lions originally crowned by a great stone wheel. Despite theories of Persian and Hellenistic influences it is likely that the pillars represent a very ancient Indian religious cosmology in which the axis linked the waters below with the sun-god above.[13]

Less monumental but no less important for Hindu and Buddhist iconography is the detailed language of gesture. Mention has already

62. Medallion showing sun with worshipper at the centre.

63. Medallion showing lotus with turbanned noble or king at the centre.

64. Lion column of the Emperor Ashoka.

been made of the importance of sign and gesture in primal religions. In India this was brought to a fine art with the wealth of hand-poses (*mudras*) and arm-postures (*hastas*) used in traditional Indian dancing as well as in priestly rituals.[14] To the initiated a mere flick of the finger may convey instantly a series of ideas. Banerjea observes that man with his powers of reasoning and speech still finds such communication necessary: 'How absolutely necessary will it be for him to endow his mute gods with such suggestive action-poses in order that the idea or ideas which he wants to be symbolized by his deities may be correctly explained!'.[15] Thus the raised hand of the *abhaya* mudra expresses protection by the deity: 'Have no fear'. The simple gesture of the worshipper is obeisance, with the hands together in the *anjali* mudra, is seen in an early sculpture from Orissa, first century BC. Of the many highly technical mudras developed in art, meditation and ritual, only a few are used for Hindu deities, but the basic ones were apparently already familiar in ancient India and may well go back to pre-Aryan times as suggested by the poses on seals and figurines. The main bodily postures are three: standing, seated and recumbent. These are used for depictions of the Buddha and Vishnu; but Shiva may also dance and minor deities may fly (though denied the aid of wings in Indian iconography). Postures are further subdivided according to the flexions (*bhangas*), symmetrical or curved, of standing figures, and include up to eleven types of seated postures (*asanas*) for gods as well as yogis.[16]

The rich variety of symbols in ancient Indian religions proliferated further in the subsequent development of a specific Hindu iconography. The whole range of nature and human behaviour was drawn upon to give each of the gods a recognizable form and character. Not only postures and types of dress and ornamentation but consorts, animal mounts or vehicles and symbolic objects held in the hand became distinctive attributes; and to display these the gods are given multiple arms and heads, showing the various aspects of their nature, wisdom and power to help. All these have been listed and classified in manuals of Hindu iconography,[17] the rules of which guided the medieval makers of Hindu images and the information of which helps us to identify and understand the images. But these descriptions and iconographic canons derive from Sanskrit texts which cannot be dated much earlier than the sixth century AD, even if they derive from more ancient traditions. We are thus made aware that the iconography was not a static system but the result of successive developments within the Hindu tradition. To understand this further we now turn to the historical changes and factors leading to the making and worship of images of the Hindu gods.

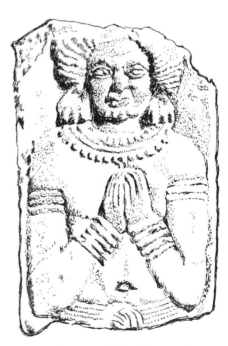

74. Worshipper with hands in anjali mudra of obeisance.

In view of the obscurity of our knowledge of prehistoric India we can only surmise that cultic images were made corresponding to the figures depicted on seals from the Indus Valley civilization (*c.* 3000–1500 BC). When the Aryan invaders poured through north-west India in the second millennium BC such religious practices were displaced or subordinated as the 'Dravidian' element. They persisted at a popular level, especially in the south, and eventually affected the Aryan religion by a process of mutual interaction and absorption. The veneration of *yaksha* images is one instance of this which we have already noted. But it might be asked why we do not have examples of at least some images from the centuries preceding the Buddhist monuments depicting these popular deities. Iconoclasm is certainly a factor in the destruction of images by invaders throughout Indian history. But as Banerjea points out[18] much loss has occurred through the utilitarian motives of people who shared the same religion; they used ancient monuments for new buildings or even for ballast and could burn down beautiful statues to obtain lime. Above all, the reason for the non-survival of buildings and images from the ancient period is that they were in perishable materials such as wood and clay. 'In India everything not fashioned of brick, stone or metal is ultimately crumbled by the climate or the unremitting labor of white ants.'[19] To this day many images in popular worship are still made of clay with no intention of their lasting longer than a single occasion or a few months.

The religion of the dominant Aryans was not concerned with such images. They worshipped a pantheon of gods (*devas*) conventionally numbered at thirty-three and representing the powers of nature – such as Indra the thunder-god who became the head of the pantheon, Agni, the fire-god and Soma the god of the sacrificial plant and libation. In accordance with the Indo-European heritage these gods were conceived of anthropomorphically; hymns and sacrifices were offered to them, as written in the Vedas (*c.* 1200 BC onwards). But the Vedic tradition was aniconic. Its basis was ritual sacrifice (*yajna*) performed by the ritually purified priestly caste. In the central fire sacrifice the element of fire could be compared to a visual image in so far as Agni was the mediator between the sacrificer and the gods. It has further been suggested that in the Vedic altar there was immured an image of the 'golden man' symbolizing Purusha, the primordial essence of man and sacrificial victim, and linking the altar sacrifice with the cosmic power.[20] However this may have been, the Vedic sacrifice was concerned with the power, not the appearance, of the gods; and this power was most characteristically

channelled through Sanskrit words in the special speech of sacrifice, in hymns and in *mantras*, ritual formulas such as the holy syllable OM or AUM embodying the very truth of reality in sound. 'The overwhelming interest of the Vedas was in sound, not visual representation, and Brahmanical religion made no use of anthropomorphic images.'[21]

But the Vedic sacrifices and priestly authority failed to satisfy either the broader religious needs or the more profound quest for transcendent meaning seen in the developing monism and theistic tendencies of the Upanishads. The sixth and fifth centuries BC saw the rise of non-Vedic religious movements which offered more personal and practical ways of salvation in Jainism and Buddhism. The powerful challenge of these movements was eventually answered by developments in the following centuries when yogic practice, theism and caste duties were brought into a new synthesis; thus the Brahmanical tradition led on to medieval Hinduism. At the popular level the Vedic aniconism had to accommodate to the persistent worship of anthropomorphic images. In the fourth century BC the grammarian Panini refers to images of Shiva and Skanda and to Vasudeva, an early form of Vishnu, while other texts indicate that 'houses of the gods' or some forms of temples were now being built for such images.[22] It is significant that these hitherto minor deities, Shiva and Vishnu, were now on their way to their supreme places in the Hindu pantheon. The old Vedic gods faded out of active worship or became accessories within the main Shiva and Vishnu groups[23] in the rich storehouse of Indian mythology and iconography. The factors in this transition are of great importance for the cultic use of images.

First and foremost is the emergence of *bhakti* as a popular mode of piety, that of loving devotion to a personal deity. This relation between the god Krishna and his worshipper is a constant refrain of the *Bhagavadgita*: 'Dear to me is the man who is thus devoted to me' (ch. 12). The popular appeal is evident in the god's proclamation to Arjuna – and to all future devotees – 'He who offers me with devotion a leaf, a flower, a fruit or water, that devout offering of a pure-minded one I accept' (ch. 9.26). But if the *Gita* was written around 200 BC the Bhakti movement must already have gathered strength in the centuries immediately preceding. The thought of the Upanishads provided a basis in the concept of *Ishvara* as the personal form of God manifesting the otherwise impersonal Brahman. At the level of popular worship rendered wholeheartedly to a single god, this now required images to mediate the gracious presence of the god and help the devotee to visualize him. Thus developed the form of worship (*puja*) by means of offerings and ritual honouring of the image, expressing personal devotion.

Secondly, the changes in the dominant pantheon and the increased number of gods required a more explicit iconography. Instead of the limited number of Vedic gods each with a fairly straightforward meaning or characteristic, a complex new network of deities emerged with an elaborate mythology. As the Brahmanic tradition accommodated to the popular local religious traditions, it absorbed many of the village deities by giving them new names or attaching them to the great gods. Thus Vasudeva-Vishnu found a succession of incarnations (*avatars*) in such lesser deities, and Shiva's consorts were mother-goddess figures who became alternative forms of his *Shakti* or female essence. All this was subject matter for vividly expressed myths and images. Furthermore, the enthusiastic devotion to these deities led to the development of theistic sects devoted particularly to Shiva (*Shaivites*) or to Vishnu (*Vaishnavites*). Sectarian rivalry is seen in their respective popular religious literature, the Puranas; it also stimulated the production of images, one sect seeking to outshine the other and to depict the superior power of its chosen deity.

These factors are within the Brahmanical tradition of emergent Hinduism, but a third factor might be seen in the stimulus of outside influences. The heterodox movements of Jainism and Buddhism are relevant here. Their presence and survival provided a challenge and example. Although they confined themselves to aniconic forms of their supreme guides until the turn of the era, they had earlier begun to use stone for religious monuments. Hence the earliest surviving religious monuments in India are Buddhist, as in the examples cited above from the third to first centuries BC. The use of stone instead of wood for such sculpture was probably due to Persian and Hellenistic influences at this period. In addition, Hellenistic style and features helped to shape the anthropomorphic image of the Buddha when it was developed in the Gandhara school of north-west India from the first century AD. The growing importance of Buddhist iconography from then onwards stimulated the efforts of the Hindu sects to produce images of their gods.

Royal patronage is the fourth factor to be considered. The importance of political power for developments in religion and art is already evident in the encouragement which the Buddhist emperor Ashoka gave to the spread of Buddhism and its monuments in the third century BC. Support for sectarian religions is seen in the second-century Kushan emperors, some of whom were devotees of Shiva and his lingam. The Gupta rulers of the fourth to fifth centuries were devout *Bhagavatas*, i.e. devotees of Vishnu in his form as Krishna, while other incarnations of Vishnu such as the Boar were worshipped, as in the case of an invading Hun king

c. AD 500.[24] The effect of this was to give official support and legitimation to the popular theistic religion and to give it practical expression in the form of costly temples and images. The Gupta period (which may be extended chronologically from AD 320 through to the seventh century) gave stability to northern India and led to a 'golden age', a flowering of Indian arts.[25] Instead of mud huts for the poor and wooden houses for the wealthy, temples built of stone were now required as the indestructible home of the god. Rulers made it a matter of prestige to build great temples and funerary shrines and to endow monastic establishments. All these now had images in the inner sanctum and subsidiary paintings and sculptures decorating the walls. The rulers themselves were increasingly identified with the power of the gods symbolized in their images. This resulted from the alliance of kings and priests by which medieval Hindu rulers were accorded the religious aura of being agents of the state deity within an aristocratic-theocratic complex.[26] 'When a king has a statue made of himself, he has the attributes of the god he worships, for he is his representative on earth. If he assumes the form of a worshipper, he expresses the feeling the believer should have towards the All-Powerful.'[27] Images of gods and kings in the Hinduized medieval kingdoms of south-east Asia illustrate this (fig. 101, p. 134). Meanwhile royal patronage was greatly reduced by the Muslim conquest of northern India, but in the south it was able to continue; hence much more lavish and magnificent Hindu temple-complexes were built in south India up to the eighteenth century.

Fifthly, the characteristic Hindu worship of images in temple or home, the rite of *puja*, brings together the factors of devotional piety and royal influence. Originating as a hospitality ritual for honoured guests such as Brahmins at family ceremonies, it is a 'sequence of acts of service and respect' rendered to the deity as if honouring a person.[28] Thus the deity is invoked and farewelled, he is offered a seat, bathed, anointed, given a fresh garment and sacred thread. In addition to offerings of incense, flowers and food (which may be shared by worshippers as a free gift of the deity's meal) the deity is praised in verse and by circumambulation. These are external acts involving purification of the worshipper as well as of the image, but the spirit is intended to be the Bhaktic pure-minded devotion. Temple worship of the image brings out the kingly aspects, for many aspects of the temple reproduce the life of a king's palace. The temple tank comes from the miniature lake providing a cool place for the king; and the umbrella to shade him, the royal palanquin to transport him, the finery to clothe him and the retinue of servants to tend him are all transferred to the care of the deity's image. In the temple he graciously

makes himself available for viewing (*darshana*) by his worshippers, and this is extended to a wider public when at festivals the image carried through the streets in his car or palanquin. It is a 'spectacle' in both the devotional and king-celebrating senses. 'Thousands of pilgrims flock to have a look at the form of the Lord on such occasions when it is royally attired, for it is really an achievement in the art of decoration with flowers, clothes, and jewels: a lovely figure kingly and saintly.'[29]

The sixth and final factor leading to a definitive Hindu iconography is the influence of Tantra. This terms is generally associated with esoteric teachings and practices of a non-Vedic type dealing with spiritual disciplines and the cult of Shakti, the Mother goddess. The latter element has certainly pervaded Indian popular religion; and Tantra may well have been a widespread form of religious practice that has not been sufficiently acknowledged in the writings of Hindu orthodoxy. In its developed forms Tantra can be seen as 'a special manifestation of Indian feeling, art and religion . . . a cult of ecstasy, founded on a vision of cosmic sexuality'.[30] Meanwhile the contribution of the earliest Tantric texts from the sixth century AD, the *Agamas*, was to teach ritual practice (*Sadhana*) that pointed inward. The Tantric initiate who could be a man or woman of any caste, conformed to the basic worship activities obligatory in *puja*; but he used mantras, meditation and images to apply the symbolism to himself as the deity within. Where *puja* was directed outward, 'Tantra emphasized internalization of the image and identification of the worshipper with the divine powers represented by the image and its symbols'.[31] The basic Tantric principle here is one that recurs in much religious iconography – that man is a microcosm of the universe and therefore has cosmic powers that can be awakened inside himself if his body and mind can be disciplined aright. To this end yogic meditation, which could already be associated with the use of images in ordinary *puja*, was developed on the basis of Tantric Kundalini yoga to release these powers; they are latent in the six lotus-shaped *chakras* located in the invisible 'subtle body' along the spine to the forehead. Man's energy-charged body is thus a microcosm which can be related to its model in the cosmic man (*Purusha*) mediated through cosmic diagrams, mandalas and images of the gods (fig. 185, p. 198).[32]

The Tantric initiate may concentrate on more abstract symbols of the deity such as mantras, representing the 'subtle form' of thought and sound. He may also use *yantras*, geometrical diagrams which are given esoteric meaning through ritual to represent the energies of the deities – 'they are the visual equivalents of the *mantras*'.[33] But Tantra, in accord with the Hindu tradition, values 'gross form' meditation on an image with

hands and feet. It enjoins the worshipper to concentrate his mind gradually on all parts of the body of his chosen deity, from the sole of the foot to the face, or vice versa. Thus he will 'acquire such concentration as will during unperturbed meditation reveal to his mind's eye the whole body of the Devata at one and the same time. If this be done, meditation on the Deity with form will gradually become both profound and steady'.[34] The ultimate goal is for the worshipper to install the deity in himself, in his pure spiritual body.

Leaving aside the more esoteric developments of Tantra, its special significance for iconography lay in the formal consequences of such meditation on an image. If one sought to realize identity with the deity, the image representing him had to be exact, showing his true nature, attributes and activities. 'An image, if it accurately stated the truth about a god, gave access to the god and to his power. It was an expression of the truth in visual symbols, as a mantra was an expression of the truth in sound.'[35] The spread of Tantric rituals among sectarian theists required that a safeguard be found in the standardization of images. Each of the principal gods was identified by his proper symbols, mudras and poses. All these iconographic details and prescriptions for the making of images in wood, stone or metal according to fixed proportions were codified in the Shilpa Shastras, texts for the guidance of craftsmen which cut across sectarian lines. Such elaboration of the canons of icon-making did not necessarily produce a slavish or lifeless uniformity, for they arose from the work of master-craftsmen at the great art centres of ancient India whose standards they continued. Sages praised images which followed the correct proportions to avoid excess and the texts, while recommending the craftsman to follow the rules, commonly advised him to make the image as beautiful as possible, 'for have not the gods a special liking for beautiful images?'.[36] The sculptor must be dedicated. Astrological guidance and rituals accompany the various stages of the image, but it is not finally fit for worship until consecrated by a priest who chants mantras, anoints the image, touches its limbs and breathes in its mouth to convey the breath of life. (The eyes are also traditionally given to the image near this time, being chiselled or painted in last of all.) It is now not only an image in the sense of an imitation (*pratikriti*) or a symbolic reflection (*pratima*) but a duly consecrated image for worship (*arcca*). As such it becomes an embodiment of the deity in his representative personal form (*murti*). It is a living material image.

The iconographic traditions which resulted from the factors described are seen today not only in temple images but in popular prints of the Hindu deities. No doubt these owe something to the heritage of colourful

yet delicate miniature paintings of Hindu mythological scenes from the Moghul period in north India. Then in nineteenth-century Calcutta there emerged a blend of boldly styled and coloured scroll-paintings by Bengal village artists with British water-colours; the resultant 'Kali-ghat' paintings were sold to pilgrims visiting the Kali temple and this 'bazaar painting' style continued until about 1930.[37] Mass production of the chromo-lithograph has made possible the cheap distribution of modern glossy colour prints, somewhat in the style of gaudy 'calendar art' yet with a charm of their own. Most Hindu homes have one or more such prints of the popular deities and they may be used to accompany worship in homes, shops and shrines. Included in the repertoire of these prints are pictures of Gandhi, Indian saints, Sikh Gurus, the Buddha and Jesus Christ. The classic Hindu iconography continues to flourish in this form, just as the Hindu tradition is expressed in other mass media such as the cinema.

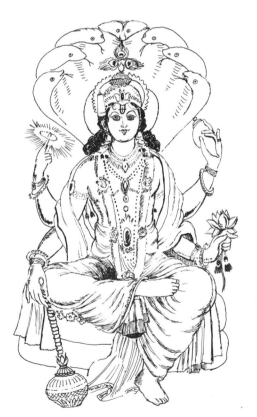

81. Lord Vishnu and his attributes.

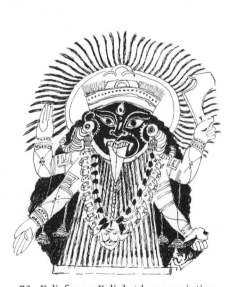

73. Kali, from a Kalighat bazaar painting.

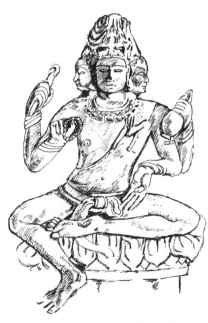

76. Brahma, Creator facing four directions.

Hindu art depicts a tremendous range of deities and symbolic and mythological beings from the animal to the heavenly realms of the cosmos. The gods are mainly shown anthropomorphically, but with multitudes of local variants and under different names and forms. Even the larger works on Hindu iconography cannot include all the variations and the thousands of village deities.[38] Here we can do no more than sample the iconography of the major Hindu deities as depicted in some of their classic forms in sculpture and painting. Primarily we shall be concerned with Brahma, Vishnu and Shiva who are often grouped schematically – but somewhat deceptively – as a triad representing the divine energies as Creator, Preserver and Destroyer. Also of importance is the mother-goddess figure Devi in her forms as divine consort.

Brahma is the creator of the world and father of gods of men; he is shown with four heads facing the four directions. Yet his actual position in Hindu mythology and devotional practice does not live up to this exalted original status. He is subordinated to Vishnu and Shiva in myth and art, for instance being shown seated in a lotus which springs from the navel of Vishnu, while a Shaivite myth tells of Brahma's fifth head being burnt up by the fire from Shiva's third eye! Perhaps his lessened popular appeal is due to his being a less dramatic figure, a personified form of Brahman, the impersonal Absolute and supreme reality. He also stands for the Aryan supremacy of Brahmin learning; the four castes sprang from parts of his body – above all the Brahmin's from his mouth – and his four heads represent the four Vedas. He is thus lord of wisdom and his wife Sarasvati is goddess of music and wisdom, mother of the Vedas and inventor of the Devanagari alphabet. Brahma is depicted in the famous Aihole stone relief of AD 500 as seated on a lotus throne, happily meditating. His four arms represent the four directions and he holds a water-vase (symbolizing the water from which the universe evolved), a rosary (for counting time) and a sacrificial spoon (of the Brahmins). His attributes may also include a disc, an alms-dish and the four Vedas. He may be shown wearing a black or white garment and is often bearded. His mount is the swan or goose.

Far more influential in the Hindu tradition is the great god Vishnu. His name means 'the Pervader', the inner cohesion through which everything exists. Originating as a minor solar deity in the Vedic period he became an all-pervasive divinity whose many-sided powers of protection were listed in Sanskrit texts as 'the twenty-four icons of Vishnu'.[39] As the primordial God-head he has the form of Vishnu-

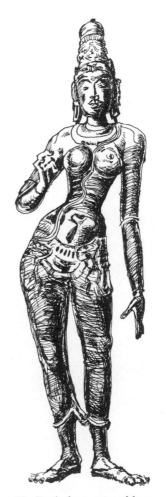

70. Devi, the great goddess.

Narayana (the universal abode), as depicted in the Gupta-style relief from the temple at Deogarh. Here he is shown reclining on the serpent of eternity; Brahma above in the lotus derives from him, while his consort Lakshmi massages his feet with the archetypal Hindu wife's devotion. The mythology underlying this is from the Puranas. Vishnu rests on the serpent coils, sheltered by his hood of nine (or even a thousand) heads representing the endless revolutions of nature. When Vishnu sleeps creation is withdrawn in the 'night of Brahma'; but the serpent is a remainder (*Shesha*) of creation ready to begin again and he provides a couch on the ocean of the universe. This is a fundamental cosmic image; it is 'the Vaishnavite equivalent of the *lingam* of Shiva as an expression of cosmic creative power in its potential form, the iconographic equivalent of the creative cosmic sound syllable *om*'.[40]

The rival sectarian claims made for Shiva and Vishnu as supreme god led to an attempt to unite the two in one composite deity Hari-Hara (Vishnu-Shiva). This process of fusion was a well-established feature of the developing Hindu pantheon, as it had been in ancient Egypt. The cult of Hari-Hara flourished around the ninth century AD but failed to reconcile the antagonism of the sects, perhaps because of economic conflicts with the large land-holders among the Shaivites.[41] An earlier image from Hinduized Cambodia in the sixth century shows clearly the two halves, with Shiva's matted hair and trident on the proper right and Vishnu's characteristic tall mitre-headdress and his discus on his left side.

As 'Hari' Vishnu is the divine 'remover' of sorrow. His great work is to preserve the world in times of distress and for this purpose he appears in specific incarnations (*avatars*) from age to age. This is the thread on

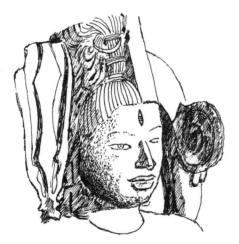

78. (*above*) Hari-hara, combining Shiva and Vishnu.

77. (*right*) Vishnu-Narayana on world serpent with consort Lakshmi, and Brahma above.

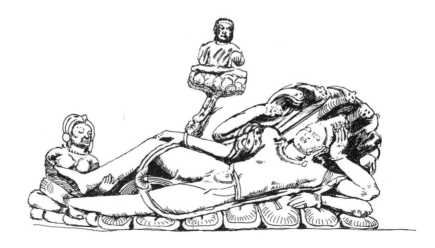

which are joined various myths and gods under the name of Vishnu. In the myth of the primeval churning of the ocean there was a tug-of-war between the gods and Titans using the serpent Vasuki coiled round the world-mountain Mandara, thus producing the precious Dew of Immortality. When the mountain began to sink, Vishnu came to the rescue as the tortoise Kurna to support it. In the Khmer bas-relief from Angkor Wat, twelfth century, he is shown both as the tortoise and in anthropomorphic form above directing operations. So Vishnu is victorious and restores the balance of good and evil. He is again renowned for his 'three strides' as Trivikrama. In his earlier form of a solar deity this may have referred to the three stages of the sun, or to the forms of light manifested in sun, fire and lightning. The seventh-century relief from Mahabalipuram depicts the incarnation of Vishnu as a dwarf, Vamana, a ruse by which he won back the territory of the gods from the demon-hordes; accepting their leader's challenge he covered the three worlds in three giant strides (depicted with the left leg raised) and pushed the demons down.

Vishnu combines compassion with strength, as shown in the attributes given him in traditional iconography. When shown with four arms he manifests absolute power over the four directions of space, as well as the schematic four arms of life and four stages of development in Hindu teaching. His four standard symbols are the conch-shell (symbolizing water and the primeval sound of creation), the lotus (the unfolding universe), the mace (the power of knowledge conquering time) and the discus-wheel (the weapon conquering evil and ignorance). His hands may be in the mudras of protection and boon-granting. The face and body of Vishnu are coloured black or dark blue; this has been interpreted as the colour of ether pervading the universe like Vishnu, but is probably to be accepted as a conventional colour. He may have a yellow veil around his hips, a sacred thread and jewel-treasure on his chest, a tall mitre on his head and the vertical V-shaped lines on the forehead which are the mark of the Vaishnavite. Vishnu's consort is Lakshmi, the goddess of prosperity and good fortune, but their progeny are not mentioned. Their mount is the partly-human eagle Garuda, king of the birds and powerful opponent of evil (especially of hostile nagas). These features recur in various combinations in ancient sculptures and in modern popular prints of Lord Vishnu. They also appear in the conventional ten avatars of Vishnu who are the subjects of detailed mythology and iconography.[42]

Lord Krishna is the eighth – and probably most famous – avatar of Vishnu. In the ancient epic of the Mahabharata he is the divine charioteer through whom the way of Bhakti is revealed in *Bhagavadgita*, but in the

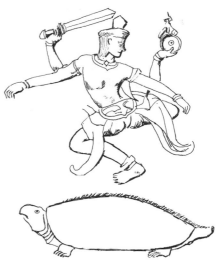

79. Vishnu with his tortoise avatar at the churning of the ocean.

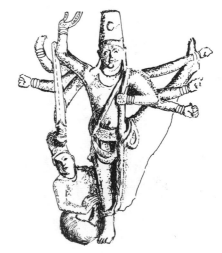

80. Vishnu's three strides and his dwarf avatar.

popular Puranas ('ancient stories') of the following centuries he appears in the very different form of the cowherd, Krishna Gopala. In the Vishnu-Purana, traditions of his royal birth and his adventurous infancy are blended with demonstrations of his divine powers as an incarnation of Vishnu. He is a mischievous but appealing infant who steals butter and prances with delight. In his boyhood at Vrindaban (north India) he subdued the greatly-feared serpent-king Kaliya and danced upon his hooded heads. The south Indian processional image from *c.* AD 900 shows him giving protection from fear (*abhaya mudra*) and the serpent saluting the vibrantly dancing victor. Countless images and pictures up to the present day depict Krishna Gopala as the amorous young cowherd playing his flute; his body is in the triple-bend (*tribhanga*) pose, his right leg slung carelessly in front of the left. This refers to the episode when, under the autumn moon, he charmed the cow-girls (*gopis*) and danced the *rasa-lila* with them as they responded with erotic passion. The scene has been given further elaboration in story, song, dance and illustration over the centuries, and the erotic desire interpreted devotionally as the longing for that blissful release which can come only through giving oneself to Krishna. Medieval poetry and devotion made much of the loves of Krishna and of his special love for Radha. In addition to the Sanskrit poem Gitagovinda these themes are expressed visually in the fine Rajput miniature paintings from the Hindu courts of western and north-western India in the seventeenth to eighteenth centuries.[43] Krishna and Radha in the grove are models, as divine lovers, of human love but especially of the soul's devotion to God.

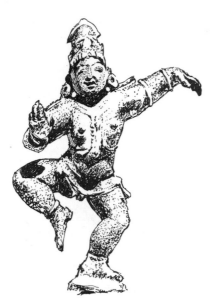

82. Infant Balakrishna.

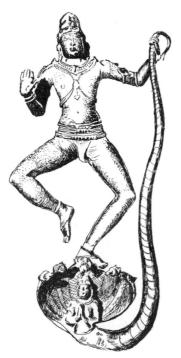

83. Krishna dancing on the defeated serpent Kaliya.

84. Krishna Gopala playing his flute.

85. Krishna with his beloved Radha.

However, it is the Krishna's years of maturity that he achieves his primary task as an avatar of Vishnu, that of conquering evil. This he does as the warrior and hero, supreme statesman and religious teacher in the *Gita*. In this aspect as supreme Lord he appears richly ornamented, clothed in red and crowned. He has the blue colour of Vishnu. Illustrations in modern popular books illustrating the *Gita* may show Krishna framed in the traditional *chakra* (wheel) on which is inscribed the perennial message of the incarnation of Vishnu:

> For the protection of the good,
> For the destruction of the wicked,
> For the establishment of righteousness,
> I am born from age to age (*Gita*, 4:8).

The great god Shiva is like Vishnu in being a universal deity, omnipresent with diverse aspects and activities; the Shiva Purana gives him 1008 names such as 'Three-eyed', 'Lord of the Universe'. In both cases there appears to have been a process of development by which lesser deities were incorporated in the major one. For Vishnu this is achieved by the doctrine of avatars so that the boar, dwarf, Rama and Krishna are successive manifestations of the Lord. This is not the case with Shiva whose different aspects are held together simultaneously, even in apparent contradiction. We have already observed this in the three-headed proto-Shiva figure of the ancient Indus Valley the 'Lord of the Beasts' and the fertility-figure who is also a seated yogi-ascetic. 'Permanently ithyphallic, yet perpetually chaste: how is one to explain such a phenomenon?'[44] In posing this fruitful question Zachner rightly notes the superhuman contradictions in Shiva, at once terrifying and fascinating, which make him more mysterious and less humanly tender than Vishnu.

Contradictions likewise co-exist in another predecessor of Shiva, the Vedic storm-god Rudra. He was much feared as a terrible god to whom offerings were made outside the town limits; but after the sixth century BC he gathered more benevolent and auspicious aspects, conferring prosperity and freedom from disease. The later sculpture from Ellora, eighth century AD, depicts Rudra with many arms trampling on enemies. The developed figure of Lord Shiva, drawing on both Dravidian and Aryan elements, includes all these aspects. The classic aniconic symbol for Shiva is the *lingam*, a stylized phallus which represents not only ancient fertility-worship but also the Supreme Man (the cosmic Purusha) who is worshipped through the 'sign' of the lingam. For ritual purposes it is often set in a circular *yoni*, symbolizing union with the universal female element of Nature. It may stand in a shrine in front of an anthropomorphic figure

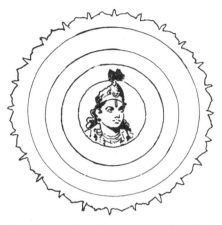

86. Modern devotional picture of Lord Krishna, in Gita Chakra.

88. Rudra, storm god of the Vedas.

75. Lingam and Yoni, fertility symbols as cult images.

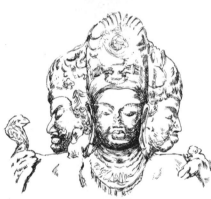

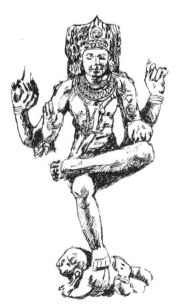

of Shiva, as in a sculptured relief, or the two types may be combined in a 'lingam with face' (*Mukhalinga*). The example from the twelfth century depicts Shiva in his terrible form (*Bhairava*) crowned with skulls and his hair merging with the lingam. In the *Caturmukha* (four-faced) lingam Shiva covers the four directions like Brahma but with a transcendent fifth face, symbolized by the lingam, looking upward. A further variant is the *Lingodbhava*, a pillar-like lingam in which Shiva appears majestically standing in an oval opening. He is here revealed as the primal creative source in his fiery lingam which extends into cosmic space and awes even Vishnu and Brahma into submission – according to the myth reflecting sectarian disputes.

A classic Shiva synthesis in threefold form (*trimurti*) is seen in the colossal Mahadeva image in the Elephanta cave, Bombay, *c*. AD 700. The tall headdress is reminiscent of the lingam and the central face, serenely contemplating, expresses the universal aspect of Shiva. The face on the viewer's left shows the masculine wrathful aspect of Bhairava, with a skull above and a hissing snake below. The face on the right is fuller and gentler, expressing the feminine qualities of the goddess Vamadeva-Uma: bliss, beauty and benevolence. These active creative polar opposites are united by the silent eternal Shiva in the centre.

The yogic aspect of Shiva is seen in his teaching work as master of all wisdom, represented as a handsome youth sitting under a tree on Kailasanath, his mountain home; his long hair is spread into an aureole, one foot rests across the knee and the other foot tramples the demon of ignorance. He can also be shown as the great yogi who is master of austerity, penance and meditation, so that he is naked and emaciated, with matted hair and his body smeared with white ashes. For Shiva is not only the teacher of yoga techniques to mankind; he is the perfect ascetic and patron of ascetic orders. The psychic energy (*tapas*) generated by his austerities is the source of life, fertility and the Ganges water which comes from his hair to purify all things. This is part of the meaning of the 'Descent of the Ganges', depicted in the great rock-wall sculpture at Mahabalipuram, south India, in the seventh-century Pallava times; here all the profusion of gods and creation surround the beneficent river, giving thanks to Shiva. For this reason also a small figure of the goddess Ganga is sometimes shown on Shiva's headdress.

89. (*top*) Mukhalinga: Shiva as Bhairava with skulls.

91. (*middle*) Mahadeva: triune image of Shiva as the great god (Mahesvarimurti).

92. (*bottom*) Shiva contemplating as master of all wisdom.

A number of the customary marks of Shiva appear in the fine Javanese image of Mahadeva. Foremost is the 'third eye' set vertically in his forehead which is the source of knowledge and spiritual 'vision'; it is the eye of higher perception and mainly directed inward, but it can be directed outward – it was thus that Shiva's eye burnt up at a glance the lord of lust, Kama.[45] His hair is matted and in the chignon is a crescent moon and a skull (which can become a garland of skulls) symbolizing recreation and destruction. He has a snake cord across his chest, showing the power of Shiva to deal with death but also to hold the sexual energy of Kundalini, the yogic serpent power. The four arms of Shiva express his mastery of the four directions of the universe. Here his hands hold a fly whisk and water jug, but sometimes he uses as weapons the spear, axe, bow and club. The trident (*trisula*) is his most characteristic weapon and may be carried by his followers. Its three prongs have been interpreted as Shiva's three functions as Creator, Preserver and Destroyer, based on the three *gunas* or qualities of Nature; the mark of a Shaivite is the *tripundram*, three horizontal lines on the forehead. Other attributes of Shiva are the tiger-skin and the little hour-glass type of drum with which he constitutes the rhythm of the universe. The white bull Nandi is his mount, for he is master of the bull's fertile power.

93. Shiva Mahadeva with four arms and attributes.

Some Shiva images portray a single aspect such as the horrifying Bhairava, a figure popular among both Hindus and Buddhists in Nepal.[46] But more characteristic is the fusion of both destructive and creative aspects in a single image, as other aspects are combined in some of the Shiva images already noted. A classic synthesis was reached with the type of 'dancing Shiva' developed in the bronze images of south India from the tenth century. It may well be that this, along with other features of Shiva, derives from ancient pre-Aryan cultic and sculptural forms which re-emerged in the Dravidian south. The dance itself is the most elemental form of religious expression, requiring only the movement of the human body, and represents the primal unity of religion and the arts.[47] We have already seen its importance in association with the masks of primal religions where dancing can be a means of religious ecstasy and transformation. In India dancing and music were valued as sacred arts which could make deeper truths accessible to the people. Dancing became a sophisticated art form with a rich repertoire and complex gestures classified in the ancient rules of the *Bharata Natyashastra*. These affected religious iconography – not only through the use of the mudras but through the consciousness of the body which the sacred dance enhances. Hindu sculpture is rightly seen as related to two different but basic arts: architecture which fixes an image statically in the space of the temple,

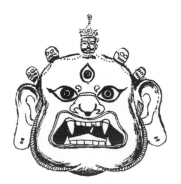

90. Bhairava: Shiva in his terrible form.

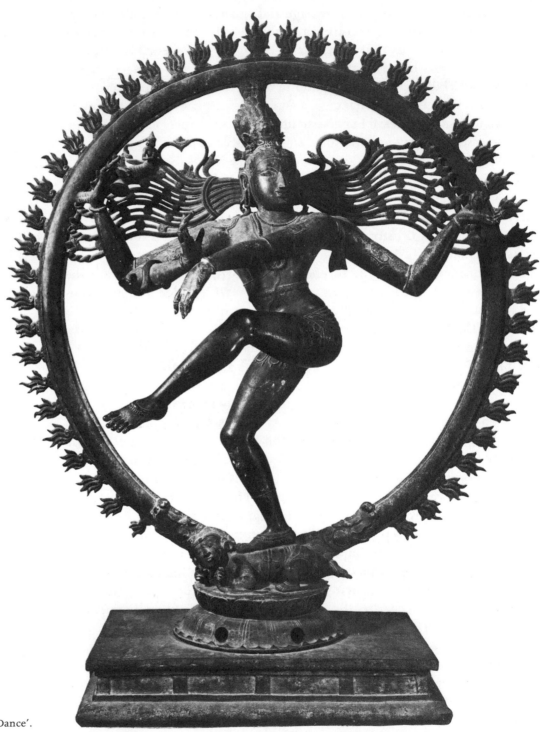

94. Shiva Nataraja – 'Lord of the Dance'.

and the dance which 'transforms space into time, by absorbing it into the continuity of the rhythm.'[48] The dance of Shiva combines these wonderfully in this image which expresses the dynamic rhythm of the cosmos – the creation, conservation and destruction of the world as his divine activity. Shiva is *Nataraja*, the Lord of the Dance, both in this cosmic sense and as revealer of the rules of sacred dance to men, the patron of temple dance-halls.

While variant forms have been produced of the *Nataraja* image they treat the human body in a realistic way and show a south Indian fondness for theatrical, exalted gesture. Even the multiplicity of limbs does not seem unnatural, for their theatrical poses and voluminous hair-styles are woven harmoniously into a waving, rippling movement. Just as in actual dancing the human body uses the dimensions of space for a temporal activity, so this image captures the dancing motion of the cosmos as a cycle in time round the axis of Shiva himself in perfect equilibrium, like a tree in space. Some images convey such a feeling of pin-point balance that Shiva no longer seems fixed to the base but hovering in the air, a figure of lightness, volatility and freedom.[49] The *Nataraja* image has been justly praised on such aesthetic grounds and is the subject of some lyrical interpretations.[50]

Details of the religious iconography are already partly familiar. Shiva's hair is long and matted, in a crowning form above but also with some tresses streaming out in the agitation of the dance, diffusing his super-human yogic energy. In his upper right hand is the little drum whose rhythm is associated with sound and ether, the divine substance of creation; the rhythmic dance of Shiva is thus beating out the constant creation of the universe. The upper left hand, however, carries a tongue of flame on the palm and this symbolizes the periodic destruction of the world. The great circle around Shiva is the cosmos which he sets on fire with the ring of flames; his dance is one of Dionysian frenzy on the last night of the world. Yet this disintegration is only part of the process which includes renewal in the eternal rhythm. The other hands convey assurance to the beholder – one is uplifted in the *abhaya* mudra of protection and the other points down to the uplifted left foot which signifies release and salvation. Underneath the right foot is a dwarf-like demon symbolizing forgetfulness and ignorance. The furious *Tandava* dance by which Shiva tramples him under is to be read as a victory for spiritual wisdom. The image stands on a lotus base. All this makes the image an allegory of release of the soul; at the macrocosmic level it presents Shiva as the central axis of the flux of creation and destruction, but at the microcosmic level it centres on the heart of man.

The final important feature is the face of Shiva which retains its mask-like countenance of sovereign calm, (as may be the case in a real masked dance with its contrast of fixed face and moving body). Zimmer perceptively compares this to the earlier image of Shiva in his threefold form where the vital male and female polarities in the profile faces are resolved in the central head signifying the quiescence of the Absolute. Here eternity and time are reconciled; 'the reposeful ocean and the racing stream are not finally distinct; the indestructible Self and the mortal being are in essence the same'.[51] The same lesson is to be learned from the balance and calm of the face of Shiva midway between his hands working for creation and destruction as he dances. It is the age-old

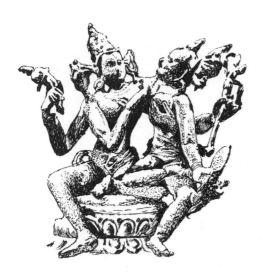

95. Shiva and his consort Parvati on a lotus flower.

96. Somaskanda: Shiva, Uma (Sa-Uma) and Karttikeya (Skanda).

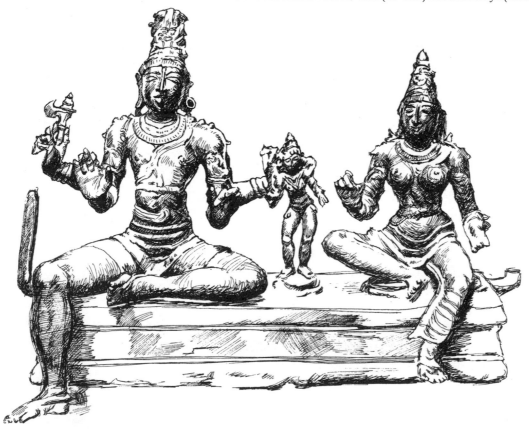

paradox of the god Shiva 'who sets everything in motion and who, absorbed in Yoga and the highest bliss, is always dancing'.[52]

These aspects are reconciled within the single figure of Shiva. There are even hermaphrodite images of Shiva (*Ardhanari*) in which his right side is male with the Shiva attributes and the left side female; this expresses the union of the two halves on the principle that Shiva can unite only with himself. However, other images of Shiva may be accompanied by his wife and progeny, in which case the complementary aspects of the divine nature are differentiated and contained within the pair or group – the family life of Shiva. As male deity he is paired with the great Mother goddess Devi under various names. As his sweet and gentle wife she is Parvati or Uma, daughter of a Himalayan mountain. Sometimes they are depicted as a royal couple, enthroned at Kailasanath, in 'happy union', or seated on their bull-mount Nandi. In medieval north-east India the couple were shown more intimately on a lotus cushion with Parvati seated on Shiva's knee and holding a mirror symbolizing her power. The small bronze from Bengal shows them in loving embrace on a lotus flower. They are often accompanied by their children, as in the serious 'family portrait' sculpture from medieval south India, the Somaskanda. The name is an abbreviation for Shiva together with Uma (Sa-uma) plus Skanda or Karttikeya, their son, who was born to be a god of war and to overcome the Titans. As a developed warrior Karttikeya remains the eternal adolescent, forever single. He is depicted with six heads, twelve arms and mounted on the peacock Paravani who is the enemy of serpents. One story attributes the six heads to his infancy when his mother squeezed her original six children a little too closely. He is also known by the name of Kumara and, in south India, as the popular Subramanya. Paintings of the seventeenth to eighteenth centuries show various scenes of Shiva with Parvati, happy family picnics and more gruesome family activities such as threading skulls at the cremation-ground.[53]

Their son Ganesha or Ganapati was given his elephant head by Shiva as a replacement for his decapitated head; he has a large pot-belly; he may be shown with a consort and with a mouse as his vehicle. But these incongruous features do not prevent him from being a very popular deity, worshipped as the god of wisdom, prudence and 'remover of obstacles'; he has four arms and is associated with the swastika as a luck-bringer. Indeed, his elephant-human body shares something of the mystery of Shiva in linking the macrocosm with the human microcosm as in the sacred formula 'Thou art That'. He is obese because so many universes were born from his belly.[54]

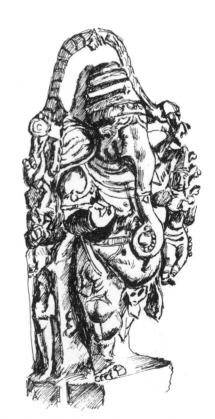

97. Ganesha, elephant-headed with his shakti (consort).

Parvati is only one of many forms of the great Goddess who is believed to have been manifested to overcome evil at times, like the incarnations of Vishnu. And just as Shiva's aspects include the fierce and terrible forms, so do his consorts, especially Durga and Kali. Durga is above all a figure of power, 'a sort of feminine St George',[55] who emerges from fire to slay the buffalo-headed demon. She may have eight or ten arms holding various weapons such as the sword, bow and shield. She is accompanied by her vehicle, the lion. In the form of Kali the power of the goddess takes on a more terrifying and destructive colour. Her name means 'the dark one' and paintings depict her as black. In the Kalighat picture her stylized face has the fierce 'third eye' of her consort Shiva. Between her bared teeth protrudes a long tongue. Her four arms bear weapons and a human head while a garland of heads or skulls hangs around her neck. Her hands are blood-stained, yet one is raised in the *abhaya mudra* to assure her devotees of protection and even grace in the midst of destruction. She is an ambivalent destroyer, like Shiva himself.

This ambivalence derives from the ancient popular worship of the great goddess as an Earth Mother whose power was manifested both in life and death – in the fertility of the earth and the receiving of the dead.

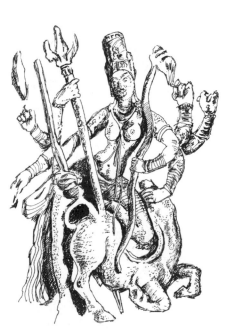

71. Durga slaying buffalo demon.

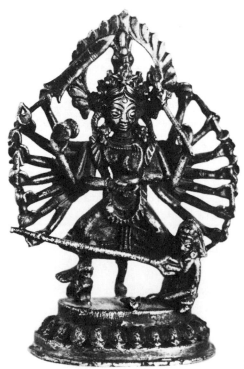

72. Hindu goddess (Bhagwati): Durga slaying demon.

Within the Hindu tradition in the form of the consorts of Shiva she could be worshipped as his *Shakti,* the active female energy which complements his nature as absolute but passive intelligence. She is thus the real creative power that activates the material universe, inspires the passing world of illusion and (as time) destroys it. Because she is so intimately bound up with human life it is understandable that Shakti is worshipped as the creative Divine Mother present in all things and that her devotees, the Shaktas, constitute the third great sectarian group of Hinduism.[56] 'This is the focus of Tantra in which the Goddess may be worshipped in almost any object – an image, a sex emblem, a diagram, a book, water or a stone. For the energies which fill the universe, which are all the different Shaktis radiating from the original seed through the cosmic anatomy of the Goddess, are parts of Her. . . . It is, of course, She who must be worshipped in the objects, not the objects themselves.'[57]

In this light it is more understandable that the destructive figure of Kali could be fervently worshipped as the Divine Mother by the great Shaivite philosopher Shankara and by the modern saint Ramakrishna. At the popular level Shaktism has flourished in parts of northern India such as Bengal and Rajputana. Paintings and popular prints of recent times depict Kali dancing on her consort Shiva as if he were a corpse; yet here again there is that mysterious interplay of life and death, of creative animation and destruction:

She is black with death and her tongue is out to lick up the world; her teeth are hideous fangs. Her body is lithe and beautiful, and her breasts are big with milk. Paradoxical and gruesome, she is today the most cherished and widespread of the personalization of Indian cult.[58]

She is India's Mother, at once caressing and murdering; but she may be symbolized also in calm and abstract forms. At the more esoteric level of Tantric yoga the aim is to harness her female energy, the Kundalini in the spinal column, so that Shakti is roused and reunited with Shiva in the human body itself. This interplay of sexual forces in the microcosm is aided by contemplating the *yantra* (instrument), the diagram which serves to focus these powers and suggest them as three-dimensional living forces. In the archetypal Shri Yantra a square outer frame, representing a sanctuary with four gates leading from the earth to the world beyond, encloses a series of concentric circles and lotus petals. Within are two sets of overlapping triangles – the female pointing downward and the male pointing upward. They meet at the invisible centre, the seminal 'drop' (*bindu*) which is the creative point of origin and the focus of the Absolute. Here again are the energies of Shiva and Shakti, the sexual opposites which continually interact and co-operate in all life.[59]

We have dwelt at length on Shiva and his relation to Shakti because they typify that paradoxical union of opposites which is basic to Hindu iconography. Shiva may be seen as a prototype of conflicting values in Hindu goals of life – that it is best to be a holy man and give up sensual pleasures, but that on the other hand it is best to beget sons and to fulfil one's duties to society.[60] Shiva combines these goals as the 'erotic ascetic', the meditating yogi who exemplifies also fertility and dynamic action. For the Hindu tradition these need not be opposed since ascetic energy (*tapas*) is related to the heat of sexual desire (*kama*), as we have noted; but whereas a mortal must alternate between the phases of energy – sexual activity and yogic restoration – the two are able to co-exist simultaneously in the figure of Shiva as a single divine image.[61] His eternal calm is able to hold in balanced tension the extremes of sexuality and asceticism, matter and spirit, and the other polarities and oppositions which man experiences in his cosmos.

The Meaning of Hindu Images and 'Idolatry'

Having surveyed some of the classic forms of Hindu iconography we proceed to ask about the meaning which image-worship has for Hindus. To understand this we turn first to the classic tradition represented by temples, sculptures and the authority of Sanskrit texts concerning the use of images appropriate for different levels of life and worship. Next we look at the practice of the villages with their deeply-rooted traditions of local deities; for India is still predominantly rural. Finally we listen to the arguments concerning 'idolatry' which have been voiced on both sides by Hindus in the modern period.

In their connection with temples it is well to guard against an 'over-spiritual' interpretation of the sculptures there, as if all were 'sermons in stone' expressing profound religious experience. Granted that most of the artistic remains of ancient India reflect the pervasive Hindu tradition, they equally reflect the full and active life of the times, a delight in sensual vitality and a feeling of growth, and movement.[62] The swarming figures on Hindu temple façades suggest to us 'the warm bustle of the Indian city and the turbulent pullulation of the Indian forest'. In arguing thus, Basham points out that the gods and demigods are young and handsome and that even the ascetic figures are usually well fed and cheerful. Their feet, like the Hindu temples, are solidly fixed on the earth. All this accords with the traditional Hindu cosmology in which the gods are related to the earth by dwelling in the upper reaches of Mount Meru

(*Sumeru*), the central peak and axis of the world. Though their cities may be fantastically high the gods live in one cosmos with mankind and can descend to the foothills when needed. Corresponding to this, man may relate himself to the macrocosm in his temples. The great Hindu temples at Khajuraho and Bhuvaneshvar (*c.* AD 1000) are symbols of the world-mountain or, analogically, of the universal man (*Purusha*) whose body comprehends the universe.[63] The image of the central deity is housed in a small inner sanctum built in the universe-form of the square; above it rises the high tower, a microcosm of Mount Meru with its vertical thrust leading eye and heart to union with the divine. In south India the temple courts and precincts were vastly expanded to constitute temple cities, replicas of the heavenly which included all the activities of religion and daily life.

The sculptures likewise express this commerce between the human and divine. Stella Kramrisch writes:

The divine visage confronts the worshipper in the cast of his own features, and those of the people around him, perfected in an ideal norm. The gods, in their stone and metal images, remind the worshippers of their own perfectibility, in accordance with their own natures.[64]

Hindu images are meant to convey the living quality of nature which mediates life by the breath (*prana*) and the sap (*rasa*) pulsating through the organism. The sculptor knows this inner sense of movement and lets it pervade the figure as a plastic vessel, 'a vehicle of life itself, holding in its volume the weightless power of breath and in its outlines the tangible flux of its sap'.[65] The female figures, images of the goddess, exemplify the sap-filled body with emphasis on the breasts and hips to make them symbols of motherhood. The male figures are characterized more by the discipline of yoga which is intended to perfect the man's body like the body of the gods especially by controlling the rhythm of breathing. The sculptures of the seventh to thirteenth centuries show this breath-inflated power upholding the yoga body as if almost weightless. Images of the gods for this reason seem to be effortlessly self-supporting as they rest on their lotus-base. The chest is here the centre of focus and images of the gods are therefore meant to be seen from the front; 'In the fulness of their splendour they confront the devotee as if with bated breath. It fills the expanse of their shoulders and chest.'[66] This yoga body of the gods provides a pattern for man to copy by will and discipline, thus overcoming the time-bound flow of life seen in the female form. Our first observation, then, is that the Hindu gods are involved in the living world of man, though they stand for cosmic laws at a higher level of that world.

This leads, secondly, to a recognition of the various levels of religious life. Men have not all the same capacities, nor are they all at the same stage of development. Therefore everyone should worship the god suitable for him at his particular level. Hinduism accepts polytheism as a reality of human experience, in so far as man can never reach the unmanifest One God but must approach one of the particular manifest aspects of God. These are the gods of the pantheon, each of which has an affinity with some particular form, colour, body or energy in the visible universe.[67] Since these affinities exist, it is possible and proper for man to worship particular gods through their particular symbols; this is how the divine and human world meet. In representing the deities there are three levels of abstraction – the level of the spiritual body; the subtle body where emotions and the senses hold sway; and the gross or physical body in the phenomenal world. The most abstract of these includes the thought-forms and symbolic sounds of the mantras, also the diagrammatic yantras; by virtue of being abstract they are held to be more accurate than an image.[68] An intermediate position is occupied by conventional gesture and musical notes – the arts of dancing and music – which are 'subtle' representations helping lesser minds to grasp the abstract. The lowest level would include the 'gross' representations seen in myths and images, but these forms are none the less valued as symbols of the god to help not only the 'less evolved' common man but also the more profoundly spiritual man familiar with the higher levels.

This leads, thirdly, to the positive meaning of the *murti*, the living image (literally 'materialization' or embodiment) in which the god becomes real. Its supreme place is in the innermost sanctuary of the temple which one approaches in a straight line from the entrance rooms and finally may circumambulate, as in the case of a centrally placed Shiva lingam. The secondary images such as the avatars of Vishnu or the family of Shiva may be featured on the outer walls orientated to the main directions, flanked by lesser deities. The worshipper goes to the temple to see the central cult image and it is this 'seeing' (*darshana*) which bestows grace if done with understanding induced by the proper ritual of approach.[69] No doubt a deep impression is made psychologically on the worshipper as he presses through the crowd to his place where he can glimpse the image as he makes his offering; there in the semi-darkness with the glow of oil lamps and the flickering light reflected in the eyes of the image, the devotee feels he has seen the face of God – or at least as much as one may hope to see on earth in the image of a particular deity. This experience is traditionally justified by the analogy between the dark cave of the heart and the dark space of the shrine where the image appears. It is in the heart,

in the worshipper's inner field of vision, that one faces God and creates
this image; the concrete image functions as a support of his contemplation
of the divinity whose presence he can read into all the parts of the image.
The unity of the worshipper and the image is here well brought out by
Kramrisch:[70]

Such seeing with the eye of knowledge requires and brings detachment from
everything whatever but the presence of the image. Towards it the devotee
has the most intense attachment, for he ritually touches with his gaze the part
of the image on which he concentrates, and he touches with his hands his own
body at those same places, affecting a magic transfer of his living self, whereby
he is one with the deity. Man becomes what he worships.

The importance of the image lies in providing a bridge between the
body of the worshipper and the god represented by the image's body so
that the vision of the deity arises in him. After this he does not need the
image, until the next time the eternal vision is renewed in his heart by
this creative 'seeing' with the look of knowledge and devotion. The
image is valued, yet it is a disposable means and may be thrown away
once it has achieved its purpose – as happens regularly with clay images
carefully prepared for domestic and seasonal rites and also with permanent
images which have become broken. The *murti* is a concrete but ultimately
symbolic medium. This conclusion applies not only to temple worship
of the 'great tradition' but also to popular village worship, to which we
now turn.

Useful studies have been made of Indian villages relating religion to
social factors[71] and communication of religious mythology through
such media as festivals,[72] but while religious images and practices
have often been described it is rare to find a sensitive enquiry into the
meaning of the image in village worship. We now draw from Ursula
Sharma's helpful account of this based on her year's stay in a north
Indian hill village in Himachal Pradesh.[73] In this setting popular Hinduism
is concerned with the propitiation of many gods (*devatas*). There is also
a higher reality, the Supreme Spirit (Paramatma or Bhagwan) who is
immanent in all living things and reached by unuttered prayer without
specific ritual; he is personal and loving, unlike the impersonal Brahman
of Vedantic doctrine (of which the villager knows little). But since the
devatas are the divine beings nearer to the specific activities of man in the
world they are of more immediate concern in day-to-day living; it is to
them that the rituals are addressed for material blessings; and it is their
distinct attributes that enable them to be portrayed and identified in
popular iconography. Their images are used in the two main kinds of

ritual activity – the individual acts of worship directed to particular gods for their benefits, and the more complex rites requiring the services of a Brahmin priest to chant Sanskrit mantras and conduct especially the 'rites of passage'. In both cases, after proper preparations and purification, the culmination of the ritual is a sacrificial offering to propitiate the god and establish communion between him and the devotee. Usually this consists of food which may be pressed against the mouth of the image or – in the case of the Brahmin ritual – offered to the deities represented in a sacred diagram drawn on the ground.

A variety of images may be found in homes and village shrines. Since not all own a carved image of a god they may borrow one or instead use one of the framed popular prints which brighten the interiors of most village houses. Even in the cruder forms of image used the main lines of traditional iconography are followed. This is based on the conviction that the gods do really involve themselves in the affairs of men and reveal themselves in physical form. People may experience their presence very vividly in dreams or in apparitions in waking state; some will fall into trance at festivals under the influence of drumming and singing and excitedly announce the coming of the deity and describe his attributes.

In short, the deities are regarded as, if not at all times visible, then essentially seeable, hence portrayable and essentially accessible to human experience. They do not manifest themselves to randomly chosen forms but are seen as mixing in human affairs in regular guises by which they can also be depicted in images and prints.[74]

In addition to the images carved from wood and stone or made in metal or clay, aniconic forms are used. These include the Shiva lingam and the small polished elliptical stones (*banalingas*) from sacred river-beds revered by Shaivites. For the worship of Vishnu likewise there are the sacred *salagramas*, small river-worn ammonite stones with holes and spiral grooves likened to the discus of Vishnu. Yet other stones are sacred to Ganesha and Surya, while Sarasvati the goddess of learning may be worshipped through books.[75] The yantra and mandala diagrams are also aniconic expressions of the deities. In village shrines worship may be focused on quite unpretentious objects and sometimes there is no image or symbol of any kind. An individual worshipper might choose any convenient spot to make his offering and address the deity without an image. Clearly, then, it is not essential to use a physical cult image. On the other hand villagers prefer to use an image, doubtless because it does 'lend coherence and direction to the ritual sequence of sacrifice and is a logical desideration'.[76]

What is this logic of the image in popular worship? It is not that the image is a focus for meditation nor is it designed to 'remind' the devotee of some aspect of the divine, although these may be secondary functions. Its primary function is in ritual, where it acts as an intermediary for man's sacrificial worship directed to the god. Its role is instrumental and it is sacred by virtue of being used as a focus for worship. 'It is the ritual which converts it from a profane to a sacred object and as such it is regarded in a fairly literal fashion.'[77] When the devotee makes his offering, the tangible cult image is there to 'receive' it; so for the purpose of the ritual there is a sense in which the image actually represents and 'is' the deity it represents. Outside of this living ritual situation the image does not have a permanent sanctity as if it were identified with the god in his being. This is shown by the way in which disused images or shrines are treated; they may be then regarded with respect, at best as valuable and interesting objects, but no longer revered for their sacred use. The images are ritual instruments justified by their part in a living relation between man and his gods.

But does this view of the Hindu use of images take into account the abuses to which they lead? It will appear altogether too tolerant and idealistic to those who have stigmatized it as 'idolatry' and therefore as something to be rejected forthwith. Islam with its uncompromising monotheism and hostility to idols led to the destruction of many Hindu images and temples in northern India from the first Muslim invasions of India, *c*. AD 1000. Subsequently the representatives of Christendom also were repelled by the idolatry of Hinduism. For instance the French traveller Bernier wrote of it as a trickery of prayers and rituals and did not accept the explanation sincerely given by the learned pandits of Banaras with whom he argued in 1665. They affirmed that God alone was absolute and that their images of Brahma or Vishnu were aids to devotion: 'We show them deference only for the sake of the deity whom they represent, and when we pray it is not to the statue but to that deity'.[78] In contrast to such enlightened views it is chiefly as a list of superstitions and depravities that Hindu idolatry is presented – though along with much interesting information – in the account by Abbé Dubois, the Christian missionary who worked in India for some thirty years in the early nineteenth century.[79]

One can find criticism of the use of images within the long tradition of Hinduism itself. We have already mentioned the recognition of different levels. Tantric texts can be cited to the effect that mental worship (perceiving Brahman in all things) is the highest stage and external worship the very lowest.[80] The Jabala Upanishad says: 'Yogis should find god

within their own selves, and not in images; the latter are meant only as aids to meditation for the ignorant'.[81] The Shilpa Shastra warns that external worship of images will lead the world-renouncer back into the cycle of rebirth instead of to liberation.[82]

Arising within the Hindu tradition some devotional and reforming movements have rejected all use of images. The Sikh religion opposes idolatry on the grounds that God has no form nor substance and that he is to be worshipped as the True Name; veneration goes to his revelation in the Guru Granth Sahib, the sacred scriptures and source of prayer and wisdom, placed centrally in the Sikh temple (*gurdwara*). Nanak, the first Guru (*c.* AD 1500) affirmed: 'There is one God. He is the supreme truth'. The teaching and piety of Nanak here have their origin within the Hindu tradition which includes theism, Bhakti and the religious movements of medieval northern India. Islamic monotheism and Sufism were not primary influences.[83] The surrounding Hindu way of life has continued to exert a pull on the Sikhs who have nevertheless maintained their distinctive principles and organization. In the early eighteenth century there emerged the first Sikh paintings of such figures as the ten Sikh Gurus.[84] Since then certain iconographic conventions have developed to depict the Gurus and their teaching in popular illustrations and paintings of the Sikh heroes and martyrs. For instance, the haloed figure of Guru Nanak is shown, following Indian tradition, seated on a pink lotus; rosary beads crown his turban and his eyes are mystically half-closed. Beside his head are the first letters of the Granth signifying 'One God', as with raised hand he gives the teaching of God as the true name (Nam); the title of the picture is 'Nam helps all'. Other popular calendar pictures and 'bazaar prints' show the influence not only of Indian but also of Western-Christian art styles. But the subject-matter concerns the themes of Sikhism and incidents in the life of Guru Nanak and such pictures are not intended as 'images' for worship but simply as illustrations to inspire piety and good works.

During the nineteenth century the matter of 'idolatry' became an offence not only to Christian missionaries and other Western critics but to educated Hindus who responded to foreign criticisms by seeking reforms within Hinduism. Rammohun Roy (1772–1833), founder of the Brahmo Samaj, saw idol-worship as a degeneration from the ancient faith in one Supreme Being taught in the Upanishads. If taught in the purity of its simple theism Hinduism would not be inferior to Christianity; but current Hindu practice of idolatry was destructive – here Rammohun did not attempt to soften and justify popular propitiation of the gods in their images.[85] One of his successors, Keshab Chandra Sen, expressed a

98. Guru Nanak on lotus: 'Nam helps all'.

more allegorical and syncretistic view of the worship of images: 'Idolatry represents millions of broken payments of god. Collect them together and you get the Indivisible Divinity'.[86] A more aggressive and iconoclastic reforming zeal was voiced by Dayananda Sarasvati, founder of the Arya Samaj in 1875. He appealed to the Vedas as the fount of Hindu truth, especially in teaching that one God is All-Truth (polytheism being only apparently taught in the Vedas). His hostility to the use of images resulted from his boyhood disillusionment at a midnight vigil in the local temple of Shiva. A mouse ran about the image and ate the sacrificial food without raising the slightest protest at this pollution,

Is it possible, I asked myself, that this semblance of man, the idol of a Personal God that I see bestriding his bull before me, and who, according to all religious accounts walks about, eats, sleeps and drinks . . . is it possible that he can be the Mahadeva, the great Deity . . . ?[87]

His father explained that the Brahmins had consecrated this mouse to become the living representative of Shiva himself; but this did not satisfy the lad who later in adulthood engaged in great disputes with Brahmin leaders on this and allied issues. The traditional Hindu position reasserted itself in the homely teaching of the saint Ramakrishna (1836–1886). His own experience led him to advocate belief in 'the Divine Presence infilling the Images of the Deity'. In ecstasy he could see the forms of Krishna or the Divine Mother in people around, in himself, in everything. As a priest devoted to Kali he believed that her image lived, breathed and took food from his hand.[88] His disciple Vivekananda gave a further rationale and defence of images. God could be seen in man and in all things, so it was right to depict God in various forms. Even if the external worship of images were classified as the lowest form of worship this would not require its condemnation; it could still help many, despite the abuses. To reformers Vivekananda said: 'Brothers! If you are fit to worship God-without-Form discarding any external help to do so, why do you condemn others who cannot do the same?'[89] Reform did not mean abolition and iconoclasm. Hinduism was a large house, comprehensive enough to contain conflicting viewpoints as complementary within the whole.

Generally speaking, these latter arguments have prevailed in modern Hinduism with its cheerful tolerance of images as a harmless aid to worship – a view accepted by Gandhi. Icons and aniconic forms can co-exist, as they have already done for several millennia. To justify this against the would-be-iconoclasts appeal is made to various popular analogies. For instance, outer worship is an elementary but no less essential stage like learning *Ka-Kha,* the Sanskrit 'ABC'. Or the image is to be understood as a mirror of the divine image within, which cannot be

broken by misguided efforts of iconoclasm: 'The agitation of the water does not cause the moon's reflection to disappear'.[90]

A more profound and philosophical defence is implied in arguing that idolatry can arise not only with cultic images but with human categories of thought imposed on God as a personal being:

The error of the iconoclasts is to believe that a mental image is less an idol than a physical one. In fact, the external form of the image is rather a help to the understanding of its relative value. It is among the most violent iconoclastic religious groups that we find the most material, childish anthropomorphic conceptions of God.[91]

This argument brings us back to the question which recurs in our examination of image-worship: to what extent do worshippers regard the images of gods only as symbols of realities beyond rather than identifying them with the divine being? We have seen how both these attitudes are present in the ritual use of images. The argument from relativism asserts that the very multiplicity of images leads the worshipper to 'see through them', to acknowledge that they are symbols pointing beyond themselves to their ground in ultimate reality, the non-symbolic God or impersonal Brahman. John G. Arapura interprets the Vedantic contribution in this way – as pointing to the God who cannot be described and who therefore truly liberates. The images cancel one another out to this end, in a process of 'symbols swallowing symbols':

This accounts for the grotesqueness of Hindu idols as against the perfection of beauty of Greek gods. In this sense Hindu and Buddhist images are the repudiation of idolatry. Raising that which is apparently insignificant and irrelevant to the mock status of ultimacy is the inverse way of signifying transcendence.[92]

The argument is over-subtle, almost a *tour de force*. Yet it has the great merit of seeing that interplay of opposites in the use of images which characterizes the Hindu tradition of iconography. Shiva is both sexual and ascetic; Vishnu is both absolute and incarnate; Indian sculpture exudes earthly life yet is basically spiritual. Likewise the icon is worshipped as a representative of the divine, yet it is a disposable earthly symbol of the divine. The Hindu tradition holds to its images – and it transcends them.

'Farther India': South-East Asia

We cannot conclude this chapter on the Hindu tradition of iconography without mention of its impact beyond the Indian sub-continent. For some of the greatest monuments of Hinduism and Buddhism were built in Cambodia (the temples of Angkor)[93] and in Java (Borobudhur and

Prambanan).[94] Not only this, but the whole area of south-east Asia – including Ceylon, Burma, Thailand, Indochina, Malaysia and Indonesia – has been marked by the legacy of Hinduization which occurred during the first millenium AD. The process was not the result of a deliberate missionary programme of Hinduism nor of Indian colonial expansion; it was an expansion of Indian culture and religion brought about by traders and Brahmin priests in the area. Its appeal was to the aristocracy rather than to the common people who retained their traditional culture; above all it gave cultural prestige and religious legitimation to the powerful rulers. Hence the process of Hinduization brought Hindu ideas of kingship to a further stage in the *devaraja* (god-king), associated with Hindu gods and rituals; subsequently Buddhism also was adopted, riding on the wave of the Hindu tradition. It also involved the observances of the treatises of canonized common law (*dharmashastras*) and the use of Sanskrit.[95] Of lasting importance in popular acceptance, even with the later dominance of Buddhism and Islam in the area, has been the Hindu mythology of the Puranas, above all the great epics of the Mahabharata and Ramayana which inspire much entertainment and culture. These influences can best be illustrated from some iconographic examples.

The Cambodian head of Shiva could well be an idealized portrait of a mid-tenth-century Khmer monarch, a *devaraja* who is identified with Shiva. This was the purport of rites conducted by Brahmin priests at the lingam placed at the top of a stone temple-mountain. Likewise the twelfth-century Khmer king Suryavarman II was identified with Vishnu in the great complex of Angkor Wat, his sepulchre probably being under the central 'Meru' tower. The mythology of Vishnu was abundantly depicted, and his mount Garuda is to this day a popular figure, being the national emblem of Buddhist Thailand. In the eleventh-century Javanese sculpture Garuda is ferocious of visage as he tramples a snake, his traditional enemy; but the divine figure whom he carries has a special interest

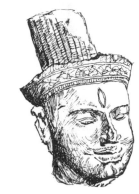

99. Cambodian head of Shiva (Devaraja god-king?).

100. Garuda mount of Vishnu.

102. Arjuna as Javanese wayang (shadow play) puppet.

– the body and attributes are those of Vishnu, but the face is realistically human, that of the famous King Airlangga (Erlanga) in whose time the Hindu epics were translated into the classic Javanese. In this period also the shadow-play, which had probably been a priestly re-enactment of the exploits of Javanese ancestors absorbed Hindu mythology from these epics; thus the heroic warrior Arjuna of the Mahabharata became the slender and charming hero of the Javanese *wayang*. In the process of syncretism the Hindu themes were given a new form and style. In the case of the Shiva-devaraja we can discern Cambodian features and head-dress. The seven-headed Nagas, ambivalent as snakes, are at Angkor sources of protection and fertility and line the balustrades of the approaches. The dancing *apsaras* from the Bayon is recognizably different from the heavenly nymphs on Indian temple walls.

Indonesia provides many examples of the syncretism of Hinduism, Buddhism and (from about the fifteenth century) Islam with indigenous Indonesian traditions.[96] The first wave of Hinduization in Java led to the magnificent ninth-century temples at Prambanan, central Java, dedicated to Brahma, Vishnu and above all Shiva. The influence of the Indian Gupta style in representing deities later receded as more florid Javanese art and ancient Javanese concepts of ancestor worship were emphasized. The small neighbouring island of Bali is of interest because

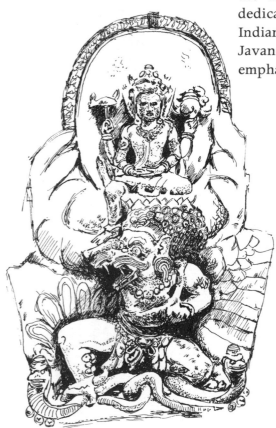

101. King Airlangga as Vishnu on Garuda.

103. Naga with seven heads.

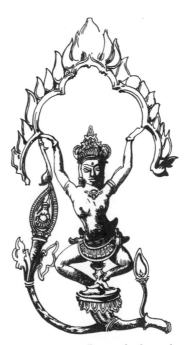

104. Apsaras (heavenly dancer).

the Hindu influences which came from Java were not subsequently subordinated to Islam; instead there developed a unique blend of Hinduism, Buddhism and Balinese traditional religion called '*agama* Hindu Bali'.[97] This is richly expressed in the arts of dance, drama and temple sculpture. But the principal gods, for whom elaborate offerings are constantly prepared, are not normally depicted by cult images in the temples: 'These remain free-floating, and only descend to earth temporarily when invoked to be worshipped, feasted with offerings, and entertained with music and dances'.[98] They remain invisible, but small effigies and stone lotus-thrones are provided for their presence during the ritual. While the gods are represented in sculptures outside, the Balinese preference is for the bold, sometimes grotesque, depiction of mythological animals, monsters and demons. This is seen in the decorated cave entrance at Goa Gadjah in the monstrous head and gaping mouth of Kala, the evil Lord of Demons. The Kala-makara mask (with makara-monsters at the mouth) is a Hindu archway figure elaborated in Java and south-east Asia. This suggests another horrific Balinese figure – the evil witch Rangda who struggles with Barong in the unending conflict of good and evil. This pervasive theme of Balinese religion and life is portrayed in the ever-popular dance-dramas and the vivid masks of Rangda and Barong.[99] It also underlies the constant attempt to ward off the many forces of evil by the use of magical drawings prepared by Balinese priests – for instance, of the figure of Yama-Raja, the judge in the hereafter.[100] Hindu and Buddhist themes have here been adapted to the indigenous religion of Bali.

105. Carved mask of evil Kala or witch Rangda.

Summary

The Hindu tradition goes back to pre-Aryan times and blends Dravidian with Aryan elements in a long-lasting and still living tradition. Ancient Indian symbols and themes recur in the varied religious movements in India as well as in the Hinduized legacy of south-east Asia. The iconography of the major sectarian gods, Shiva, Vishnu and the goddess Devi received classic definition after a process of merging with local deities, along with the influence on worship of bhakti, puja and tantra and the building of temples under royal patronage. Characteristic of Hindu images of the gods is the synthesis of the worldly and the ascetic, body and spirit. The cultic use of the images shows a corresponding ambivalence – the material image is worshipped as the presence of the god in ritual, yet it is not indispensable and can be spiritually transcended.

106. Witch Rangda in Balinese dance drama of Rangda and Barong.

Sages and Saints from India: Buddhism and Jainism

Bloomin' idol made o' mud –
Wot they called the Great Gawd Budd –
Kipling[1]

THE WORSHIP OF idols of the Buddha as a great god, as ascribed by Kipling's British soldier, would certainly have been rejected by the Buddha himself. As the 'Enlightened One', Siddhartha Gautama was a sage, saint and reformer within the ancient Indian tradition, living in the sixth century BC which also produced the Jain saint Mahavira. Subsequently he became the exemplar of the Buddhists, as a heterodox sect within India, and the founder of Buddhism as a pan-Asian and universal religion. Images then became an accepted feature of most forms of Buddhism, resulting in a rich and systematically ordered iconography. Included in this are the images of the Buddha, bodhisattvas, monks and other sacred personages; stories and symbols representing a 'sacred history'; a vocabulary of symbols to convey the main religious ideas and images of the structure of the cosmos; and religious edifices for ritual purposes and the monastic life.[2]

There are good reasons for paying close attention to the iconography of Buddhism. First, especially in Mahayana Buddhism, much can be learned of its mythology and ritual through images and art works. The images were made with care according to traditional rules, for they were intended for use in meditation and also came to be revered as reservoirs of supernatural power; they therefore 'express the spirit of the doctrine accurately and impressively'.[3] Secondly, they tell the story of the development of Buddhism in India and Asia, especially during the major period

of expansion during the first millennium AD. It is a story of unity and
diversity. On the one hand there is a recognizable continuity in the varied
art of Buddhism based on the subjects and iconographic types but more
profoundly on the spiritual consciousness of the Buddhist way as a
universal community. On the other hand Buddhism has been renowned
for its tolerance of differing schools of thought and its peaceful spread
which enabled it to adapt to new religious cultures and fertilize other
traditions – 'with a vital many-sidedness that enabled it to avoid rigidity
and ossification'.[4] Thirdly, the appeal of Buddhist art is for 'Westerners'
a valuable approach towards understanding the teachings of Buddhism.
As Hendrik Kraemer also shrewdly observes 'art is a great winner of
souls' and many images of the Buddha express winsomely his wisdom,
gentleness and compassion.[5] The importance of art as the expression of
a religious culture is still evident in Buddhism in Asia, for instance in
Japan where aestheticism, viewing beauty as spiritual nourishment, can
find in the Buddhist heritage a great 'national treasure'.

Turning back to the origins of Buddhism in ancient India we look first
at a cognate religious movement which remained small and confined to
India but which is none the less important – Jainism.

Jainism

Like early Buddhism, Jainism is an atheistic, rationalistic, ascetic and anti-
Brahmanical doctrine but with a 'scientific' (physical) rather than psychological
emphasis. . . . Buddhist figural art is characterized by a warm humanity and that
of the Hindus by dynamism and sensuality, whereas Jain art is cold and in-
tellectual, the result of Jain doctrine, of the history of the sect, and of the social
position of its members.[6]

In rejecting the authority of the Vedas and the rules of caste both move-
ments were heterodox by Hindu standards. Both Buddhism and Jainism
were systems of moral and spiritual training to achieve salvation, above
all by the renunciation of all attachments as typified in their saints and
monks. But the way of Mahavira was more ascetic and pessimistic than
that of the Buddha, being based on a thoroughgoing denial of the world
in order to free the eternal soul-monad from the entanglements of matter.
The one who achieved this ultimate release was a 'victor' (*jina*) and the
followers or sons of the victor were the Jains. Mahavira (literally 'Great
Hero') in the sixth century BC was such a one, but by no means the first;
he was the last in a series of twenty-four Tirthankaras ('ford-makers' or
guides over the ocean of worldly Samsara). His predecessor Parshvanatha
may have been an historical proto-Jain leader about 200 years earlier,

but the line goes back into aeons of time when the Tirthankaras enjoyed immense size and age.[7] These are the real objects of adoration, for in their perfect victory they have gone beyond the world whereas the Hindu gods remain part of it and may be ignored as inferior. This means of course that the Tirthankaras have gone beyond the reach of prayer also and are not worshipped anthropomorphically like Hindu deities: 'the worship of the Jina image is said to be adoration of the aggregate of qualities which the pious worshipper strives to acquire himself'.[8]

Despite these distinctive teachings, Jainism shares much of the outlook and symbolism of the wider Hindu tradition so that it is not easy to distinguish Jain images in the ancient period. The earliest extant image of a jina, from Lohanipur near Patna, is from the third century BC and shows similarities to ancient Yaksha images and even to pre-Aryan forms. There are suggestions of a jina image being made by the sympathetic monarch Nandas of the fourth century BC. Jain art may have been a creative source and model for Buddhist images; but time and persecutions appear to have destroyed the earliest Jain monuments. For the rest, Jain reliefs and images appear distinctly at the same period as the Buddhist, in the first to second centuries AD, and share the same heritage of Indian symbols as Buddhism – the wheel, the tree, yakshas, animals, yogic posture, even the stupa. This will be clear from two ancient examples.

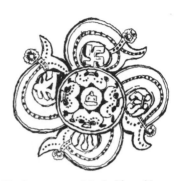

107. Ayagapata, Jain 'tablet of homage' showing symbols.

The Jain 'tablet of homage' (*ayagapata*) comes from the first century AD at Mathura, the north Indian centre which was famous in the following centuries for both Jain and Buddhist art works. It is a clay tablet about three feet square and the importance of the reliefs depicted lie in their use then in temple worship as the basic Jain symbols to be adored. The great auspicious symbol of the *svastika* in ornamental form is enclosed in an outer circle; its four hooked arms frame a small svastika (upper), a curl of hair, the *srivatsa* which is a distinctive Jain symbol on the chest of a Tirthankara (right), a pair of fish (lower) and a throne-symbol (left). In the centre sits a meditating jina surrounded by 'three-shaped' *ratnas* or jewel symbols. These appear also on the base along with a lotus and water jar. The outer circle contains figures of male and female worshippers, a cultic tree enclosed in a square railing and a stupa.[9] Here then is an array of familiar Indian symbols, mainly aniconic.

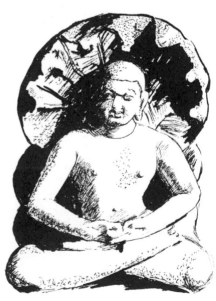

108. Parshvanatha protected by cobra.

The icon of Parshvanatha, also from Mathura, dates from the first to second century AD. The simple red sandstone image depicts the twenty-third Tirthankara meditating under the ascetic discipline of 'exposure to all weathers'. It is based on the story of the cloud prince attacking him with a great storm whereupon a serpent king, the Naga Dharanendra, spread his hoods to protect him as shown here. A very similar story is

told in Buddhist texts concerning the Naga Mucalinda and is depicted in Buddhist art subsequently (fig. 132, p. 154). The similarity of Parshva to the Buddha here illustrates once more the common ground shared by the two religions in the early period.[10]

The characteristic Jain image did not emerge fully until the artistic flowering of the Gupta period (fourth to seventh centuries AD). As in the case of Hindu iconography, the building of temples and then the influence of Tantra led to a proliferation of images and attention to detail. Conventional forms were established for icons of the twenty-four Tirthankaras, each with his distinctive colour, tree, emblem and attendant yaksha figures.[11] He is shown in the centre in a rigid standing or in yogic seated posture. For instance, the very first Tirthankara, Rishabhanatha, has the banyan tree above him and the symbols of the wheel and the bull, symbolizing the law and the earth, at his feet; at his proper right is his attendant yaksha with a bull as vehicle and at his left the yakshini with her eagle. It is noteworthy that these 'attendants' are frequently the ancient gods of the Hindu tradition, major and minor, perhaps with a change of name; thus Matanga the guardian of Mahavira seems to be Indra on his elephant. Although Jainism was 'atheistic' in denying ultimacy to the gods, it included them in its lower levels. Worshippers might invoke the Hindu deities for earthly benefits while seeking higher purification of the mind by contemplating the perfection of the jinas.

By the Middle Ages this worship approximated to that of the Hindus, with offerings of flowers, incense, lamps and so on . . . and though there was no real compromise with theism the sect easily fitted into the Hindu order, its members forming distinct castes.[12]

Medieval Jain temples resembled Hindu ones (as at Khajuraho, *c.* AD 1000) although they showed distinctive features in planning and decoration. The centre of gravity of the scattered Jain community moved westward and Jain wealth created remarkable temple-cities in Gujarat and Rajasthan. There also emerged from the eleventh century onwards stylized illustrations of Jain manuscripts,[13] influenced later by the Rajput styles.

Jain worship made early use of the stupa, an aniconic memorial which was venerated as in Buddhism, as indicated in plaques. This was developed into the more elaborate model of the *samavasarana*, a traditional Jain preaching-hall for the Tirthankara whose images at the top faced the four directions; a bronze model from the eleventh century is constructed as a mountain city with three circular tiers and a square base and summit.[14] Various other diagrams and plaques depict the Jain cosmography and geography with mountains, temples and places of pilgrimage. The influ-

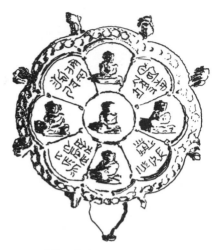

109. Siddha-chakra, Jain meditation circle of the 'Five Supreme Ones'.

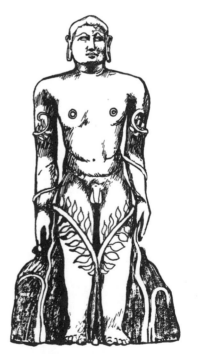

110. Colossal granite monolith of the Jain saint Gommatesvara.

ence of medieval Tantric texts led to the cult of the saint-wheel (*siddha-chakra*) which is still used in daily veneration and twice-yearly weeks of worship and washing of the tablet. The bronze example is in the familiar form of an eight-petalled lotus in which the five types of supreme or 'worthy' ones are arranged for veneration. At the centre is the meditating *arahat,* the emancipated soul of which the Tirthankara is the highest example. In the surrounding four sections are the next highest, the *siddhas* or sacred ones who reside at the top of the universe, then the head-monks, teaching monks (*sadhus*). The formula of obeisance directs the worshipper to invoke their abstract qualities of right knowledge, faith, conduct and penance, and there are altogether one hundred and eight listed qualities for meditation.

One exemplary arahat is celebrated in colossal stone images in south India, the largest being a fifty-seven foot monolith at the summit of a hill at Shravana Belgola in Mysore, *c.* AD 983. This depicts Gommatesvara, the second son of the first Tirthankara, originally called Bahubali ('strong of arm'). Realizing the futility of fighting he renounced the world to become a Jain monk and as penance stood rigid and motionless for long ages enduring the elements. He remained undisturbed by wild animals, serpents, birds and ants; and the sculpture shows this literally in the form of the anthills built at his feet and the vines creeping up his limbs. Standing firmly, unclothed, with calm and serene expression, he is the very personification of the Jain ascetic who practises renunciation and becomes a true 'conqueror'.[15] In his lofty eminence he deserves to be revered. Popular ritual expresses this in pilgrimages up the hill and ceremonies of anointing the image every twelve years. Being too large for an ordinary Jain temple (*basti*) the colossus stands in a cloistered open courtyard (*betta*) visible from afar.

There is much in this image that is instructive concerning the iconography and teachings of Jainism. Though not actually one of the twenty-four Tirthankaras, Gommatesvara is represented in the same mould. The exaggerated shoulders, long arms and powerful chest are all meant to display the ideal physique of the jina as one who conquers in the tradition of yogic meditation and breath-control. The rigid symmetry and immobility express a spiritual aloofness which can transcend the body, and the medium of stone brings out the quality of unchanging otherness. Later Jain images sometimes were carved in alabaster as the preferred material because its sublime translucency showed a body purified of the dross of tangible matter. The Tirthankaras do not have coloured flesh and blood but are said to be milk-white like alabaster, glowing with the light of their supreme clarified state.[16]

This removal from the life of warm-blooded human body appears surprising in view of the characteristic nudity of the Tirthankaras. The issue of nudity is an important one in the history of Jainism which suffered a schism in the first century AD between the southern sect of the Digambaras ('sky-clad', insisting on the renunciation of clothing by monks) and the northern Svetambaras ('white-clad', permitting it). This affected iconography in later centuries when the Svetambaras represented the Tirthankaras more modestly with a loin-cloth or folded hands covering the genitalia. But originally this was a burning issue for Mahavira who had found his predecessors too lax in wearing clothes; after meditating for thirteen months in the forests of Bihar, he abandoned clothes completely. Several reasons can be given for this action. First it accords with Mahavira's rejection of caste; costume would symbolize bondage to particular masks and distinctions between groups. Secondly, a true ascetic should have conquered all his emotions, including that of shame. Thirdly, he should be in a state beyond the consciousness of being naked and of common notions of what is right and proper. The Digambara sect maintained that only by leaving behind all property, including clothing, could a monk finally attain the release of nirvana. The stark aloofness of the Jain Tirthankara thus offers a very different view of nudity from that seen in classical Greek images of heroes and gods. There the human body is represented as healthy and beautiful, a worthy expression of supreme divinity. The modern Western world retains something of that view along with a spectrum of attitudes towards the nude as something rude or shocking, as erotic, as natural, as honest or as merely hygienic. In contrast to all these expressions of bodily awareness, Jainism has a spiritual, ascetic purpose in representing its archetypal guides as nude figures. This is a clinically pure form of spirituality which renounces the material body.

Here we come to the essential contrast with Buddhism. After an initial effort to achieve release by self-mortification, Gautama Buddha rejected the way of thoroughgoing asceticism. His was the 'Middle Way'. The iconography of Buddhism did not represent the Buddha as starkly nude but as lightly clothed and with the gentle expression of human warmth in his realization of peace and enlightenment. Historically this resulted in very different careers for the two cognate religions. Jainism has maintained its place as a heretodox sect of the Hindu tradition, its monastic core having the support of a well-to-do lay community. Despite its small following numerically (less than two million today) Jainism has made a remarkable contribution to the culture of India.[17] But it has remained confined to India. Buddhism has had a much more dynamic and outgoing

career, flourishing for over a thousand years in India before its decline
and re-absorption into the Hindu tradition; meanwhile as a missionary
religion it has found its greatest span of influence in other lands of Asia.

Early Buddhism: from Aniconic to Iconic

Buddha-images did not appear until the first century AD. For five centuries
after the historical Buddha (who lived *c.* 563–483 BC) only symbolic
forms were used to indicate his presence in veneration and sacred
memory. This was not due to an explicit prohibition of images during these
centuries of 'primitive Buddhism'[18] nor to any backwardness in means of
artistic expression. It is due to the nature of early Buddhism and its Indian
background. The Buddha was essentially a reforming sage who taught
truths about existence and a discipline, embodied in his community, the
Sangha, leading to release from the wordly cycle of *samsara*. Like a
prophet he was embodied in his message and to 'see' his word was to see
him. Homage to him was not homage to his earthly human form. In its
aniconic basis Buddhism here followed the ancient Hindu tradition of
not representing the Vedic deities in personalized form. We have already
noted the more elevated stream of thought in India which saw external
worship or interior spirituality as the highest level. This elevation of the
aniconic continued both in Buddhism and Hinduism even when the use
of icons had long been an established and religiously justified practice.
Throughout the subsequent developments in Buddhist iconography
there was a recurrent emphasis on the aniconic as the original and
superior form.

The special problem presented by the Buddha-figure, was that at his
death he attained complete extinction in *nirvana*. If this was the real
attainment of the Buddha it could not be brought down to the level of
human vision. 'To suggest the transcendent nature of the Buddha a
form had to be evolved that was visually impressive, yet spiritualized
to an extreme, which in itself transcended the limits of the finite world
and passed into the realm of the "Without Shape".'[19] Since all forms of
expression, including words, must fail to describe his essence, one could
use at best the symbolic image (*pratika*) which did not claim to present
a likeness to the eye but only an idea. The Buddha could be expressed
just as well – or just as inadequately – by means of vegetable, animal or
geometrical forms as by anthropomorphic images. It can even be argued
that the aniconic presents *more* of a likeness than the too limiting human
likeness, 'insofar as it reminds us of the relative unimportance of the

human mode, as merely a particular case among the possibilities of existence'.[20]

The major Buddhist symbols appear in the ancient phase on the monuments dating from the reign of the Mauryan emperor Ashoka, *c*. 250 BC, onwards. Among the pillars which had been erected throughout his empire, the one at Sarnath, near Banaras, features the famous lion-capital which is the national symbol of the Republic of India. In addition to the four lions surveying the four directions from the world-pillar, the plinth on which they stand depicts four solar wheels alternating with a lion, an elephant, a bull and a horse, all surmounting a lotiform bell. The four wheels may represent four great planets, but essentially they are ancient solar symbols showing the sun in its daily path of birth and re-birth; with this the sovereign identifies himself, as a world-ruler (*chakravartin*) and the cosmic pillar is thus an emblem of Mauryan imperialism. But the wheel is analogically the eternal Law (*Dharma*) which the Buddha 'turned' when he began teaching with his first sermon at Sarnath. It is therefore appropriate that the emperor Ashoka, as a convert to Buddhism, should have displayed this symbol at Sarnath

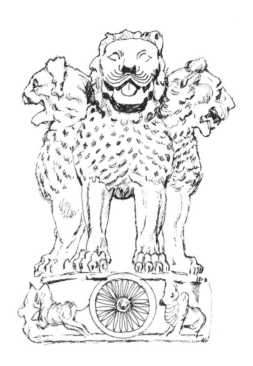

111. Wheel on Ashoka's lion capital.

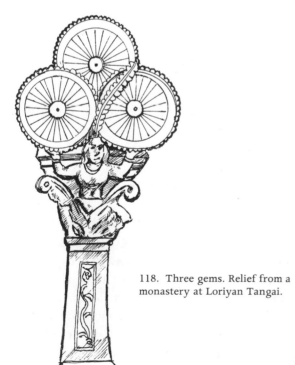

118. Three gems. Relief from a monastery at Loriyan Tangai.

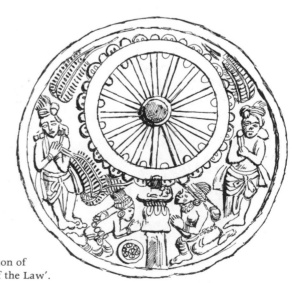

112. Dharmachakra: Veneration of Buddha turning the 'Wheel of the Law'.

and thus also reinforced his own sovereignty by the Buddha's Dharma. Thereafter the Wheel of the Law (*Dharmachakra*) becomes an established symbol (with spokes of the wheel numbering 8, 24, 36 or even 64), and is venerated in aniconic worship of the Buddha in his teaching, as depicted on the Bharhut relief, second century BC. The wheel could also be tripled to represent the 'three gems' (*triratna*) which are confessed as the ground of the Buddhist's 'refuge' – the Buddha, the Dharma and the Sangha. This symbol is the object of veneration in a relief from a monastery in the north-west, Loriyan Tangai, from the Kushan period, *c.* second century AD, but earlier the threefold formula was symbolized at Sanchi in much the same way as on the Jain tablet, as a three-shaped trident.

Associated with the Buddha's teaching is his missionary journeying, for which an appropriate symbol is the footprint of the Buddha, marked with the Wheel of the Law. As in Hinduism the footprint of Vishnu could be worshipped, this ancient symbol was used in Buddhism to indicate the presence of the Buddha; in the Sanchi relief of the second century BC the footprints are accompanied by honorific palms and garlands. Most Buddhist countries claim to have an impression of the Buddha's foot, copies of which are venerated in temples as next to actual relics in importance. Enormous footprints are found in Thailand and at Adam's Peak in Sri Lanka, a pilgrim site.

One of the richest and most evocative Buddhist symbols is the lotus (*padma*) which is found not only in India and east Asia but also as a symbol for emergence from the primeval waters in creation and in royal contexts in Egypt and the Middle East.[21] The reliefs on the north gate at Sanchi, first century BC, conveniently depict the lotus in two ways. Viewed from above it is a circular symbol of total manifestation, a petalled mandala with its heart representing the centre of the universe and the true essence of all. Viewed from the side it is the aquatic flower opening out only above the water, miraculously sprouting from slime below to purity above. It is thus a symbol of birth and creation, as when the Hindu god Brahma emerges in a lotus from Vishnu's navel, but in the Buddhist interpretation it is a symbol of spiritual rebirth, above all the Buddha's enlightenment as he rises above the muddy world of gross matter and delusion to the transcendent state of nirvana. The lotus can therefore serve as a throne for the Buddha in later iconography; as the world-lotus it provides a universal ground for birth and manifestation, but as it leads upwards on its stalk (a cosmic axis) it symbolizes detachment from this world.[22] The lotus also suggests the womb and has esoteric sexual overtones in the Tibetan use of the Buddhist formula: 'The Jewel is in the Lotus' (*Om mani padme hum!*).

113. The footprints of Buddha.

114. Lotus symbols from the north gate of Sanchi.

Another important symbol of the Buddha is the Bodhi-tree, the tree under which he sat when he attained enlightenment and wisdom in his Great Awakening. The relief from Amaravati, a famous Buddhist centre in south-east India showed attendants worshipping this aniconic symbol; but by this period (second century AD) the Buddha was also depicted in human form, and on the same slab shows on its upper frieze the seated Buddha being tempted by the daughters of Mara, the evil one, prior to his Awakening. Such a powerful symbol as the tree with its connotations of strength and life could easily be identified with this central event of the Buddha's earthly existence. This has led to the suggestion that tree-worship was the ancient source of Buddha-worship, that both the yakshas of ancient Indian popular cults and the later Buddha images were anthropomorphized human trunks from the stem of the tree.[23] However, the other basic symbols of the ancient Hindu tradition and Buddhism are too well established in their own right to be all subsumed under vegetal origins; it is preferable to see the tree as only one motif among these. The blazing pillar stands for the world axis as a symbol of the Buddha's cosmic centrality. Other aniconic symbols suggest the Buddha's absence rather than his presence – the empty throne, with cushions, in front of the Bodhi tree; the riderless horse; the honorific parasol covering no one; or even a floating plank to indicate the Buddha's miracle of walking on the waters.

Such aniconic forms as these could be knit together to represent the body of the Buddha. For instance a pillar of the north gate at Sanchi, first century BC, shows the Buddha's feet at the bottom and the lotus and 'three gems' symbol at the top, linked by a column of lotus palmettes.[24] At Amaravati pillars dating from c. AD 200 show the sun-wheel surmounting a column; also a stone medallion depicting Rahula being brought before his father, the Buddha, focuses the attention of the crowd of worshippers on a variant combination: a stool with footprints, an empty throne, a pillar as the Buddha's backbone, a wheel as his head crowned by the 'three gems'.[25] The aniconic is here moving towards the iconic.

The most important and long-lasting Buddhist symbol of all is the *stupa* which in one form or another (such as the east Asian *pagoda*) is a sepulchral and reliquary monument to the Buddha.[26] It represents the supreme event of the Buddha's *parinirvana* – his death and attainment of the absolute state of nirvana. But its origins appear to lie in the pre-Buddhist cults and burial practices of ancient India, in the mounds which

115. Bodhi tree: detail of marble relief from Amaravati.

116. Blazing pillar: detail of relief on a stupa at Amaravati.

117. Empty throne: detail from Amaravati relief.

were raised over dead bodies to prevent their escape to terrorize the living. More positively such mounds could be revered as a tomb embodying the presence of the dead – especially if they contained the remains of princes and holy men – and could be hallowed in popular cults as sacred sites associated with yakshas and tree-worship. These origins are largely a matter of speculation, but Buddhist texts refer to the ashes of the Buddha being interred in this manner. The first tangible evidence for the actual veneration of the stupa appears in the time of Ashoka who is said to have distributed relics of the Buddha to all the main towns of his empire so that stupas could be built (the symbolic number of 84,000 is given). One of these third-century BC stupas survives as the core of the great (No. 1) stupa at Sanchi in north-central India, although it was enlarged and decorated in the following centuries and restored in modern times. It is a solid hemispherical dome, a massive impenetrable structure fifty feet high, surmounted by a reliquary box and mast with an honorific triple umbrella. Later legends attributed this design to the Buddha's own instructions to his first lay disciples – he folded his garments, inverted his begging bowl and placed his staff on top to show them how to make a stupa to enshrine his relics. However, there is clearly a great deal of cosmic symbolism in the dome or 'egg' (*anda*) and the mast-axis as well as the gateways orientated precisely to the four directions. In the traditional Indian rite of circumambulation (*pradakshina*) the worshipper walks round the processional paths three times, keeping the stupa to his right as in following the journey of the sun. He cannot scale the sacred dome or cosmic mountain.[27]

Veneration of the stupa is clearly depicted in a number of reliefs – for instance on the north gate at Sanchi itself where both human and divine worshippers give joyful adoration to the Buddha by marching round with garlands, banners and musical accompaniment. Representations on tablets from Amaravati and Nagarjunakonda in the second century AD begin to depict the aniconic symbol along with impressive figures of the Buddha as a person. The significance of this for iconography is that the stupa itself is seen as the body of the Buddha. In principle the Buddha is dead and the stupa can only symbolize his absence, like other aniconic symbols; but because there are still relics of his mortal body in the stupa it is somehow animated with his continuing presence. On the one hand the overtones of royal burials helped to identify the Buddha with the World Ruler (*chakravartin*), dominating the cosmos in all directions as symbolized by the monument. On the other hand the popular veneration of

119. Stupa: relief on tablet at Amaravati.

stupas encouraged by Ashoka helped the worshipper to conceive of the
Buddha as still an immanent reality, made visible in the stupa with its
various levels standing for the head and body of the Buddha.[28]

Early Buddhist art was thus able to express the presence of the Buddha
through his 'traces' in the form of symbols, sometimes in the midst of
human figures portraying narratives of the Buddha's life. His own life
could be summed up in four major symbols – the lotus for his birth, the
Bodhi-tree for his enlightenment, the wheel for his teaching and the
stupa for his death and achievement of nirvana.

The Buddha-image

The emergence of the fully personal image (*Buddha-rupa*) is interwoven
with the development of Mahayana Buddhism in the crucial two centuries
from the first century BC to the first century AD. The Mahayana system
will be more fully discussed later in this chapter; meanwhile it can be
seen as the 'Great Vehicle', the Buddhist way accessible to the multitude
and open to more varied forms of popular piety than the austere simplicity
of the earlier period. This proved of lasting importance for the use of the
Buddha-image by the major schools of Buddhism all over Asia. We can
note the factors leading up to this.

First, as in the development of Hindu images, is the popular piety of
devotion, *bhakti*, now directed towards the person of the Buddha wor-
shipped as Lord and redeemer, as the *bhagavata* who elicits total
surrender, love and adoration. This has roots in ancient Indian popular
religion in the cults of yakshas, images of which probably influenced
the standing Buddha figures. Also reverence for the Great Man (*Maha-
purusha*) and the use of distinctive signs (*lakshanas*) of greatness on his
body were easily carried over when the Buddha was identified with the
World Ruler as a spiritual conqueror. Already at Sanchi the third- to
first-century BC decorated gateways express popular piety related to these
figures; but they remain guardians and conveyors of material blessings,
fertility and power. As accessory figures they are at the edge of the sanc-
tuary which centres on the plain aniconic stupa representing the
transcendent power and liberation of the Buddha.

Secondly, Buddhist cultic centres came to provide a more permanent
home to receive images. Buddhism was distinctive in its social emphasis,
leading to well-organized monastic orders and lay support for their
maintenance. As monasteries grew larger to house the *sangha* more
permanent buildings were erected, at first in wood but later hewn from

rock as cave temples modelled on the earlier wooden structures.[29] In the second to first centuries BC such monasteries were excavated at Bhaja and Karli near Bombay. Typically the monastic cells were gathered round a central rectangular hall for worship which was not as yet focused on an image. As with the ancient sacred place (*chaitya*) which Buddhists had hallowed with the symbol of the great open-air stupa, so these chaitya-halls now had their stupa inside for solemn circumambulation by the monks. In later centuries images of the Buddha were carved on the front of such stupas, as seen in caves at Ajanta and Ellura; this parallels the Hindu affixing of a Shiva image to the aniconic lingam form (fig. 89, p. 116). And the monks' assembly-hall became the typical Buddhist temple (*vihara*), the 'dwelling place' where the Buddha-image is housed.

Thirdly, the contribution of Mahayana Buddhism meant the harnessing of these tendencies in Hindu bhakti and Buddhist veneration to a new concept of the Buddha: 'He was now seen as the embodiment of an absolute world principle, a personification of highest truth, wisdom and goodness'.[30] Not only was he the great sage and teacher whose way transcended the gods; he now became a sacred person, a merciful redeemer whom his ardent followers wanted to see and revere with personal devotion. In one sense this was a return of Buddhism to its origins in the Hindu tradition, a process of 'conventionalization' which eventually led to absorption into Hindu theism.[31] From the viewpoint of Mahayana apologetics, however, there was need for more accessible ways of attaining salvation than had been provided by the Old Wisdom school with its austere doctrine and conditions. According to Buddhist cosmology there had been a decline since the time of the Buddha, following the periodic cycles of improvement and degeneration, and only a few monks could now become Arahats and attain nirvana.[32] The Mahayana claimed to meet the situation with a more positive and comprehensive way which made the Buddha and other saintly figures available to help in time of need, restoring lost teachings from the past and giving new hopes for the future. In iconography the result was to release the Buddha figure for depiction in personal form and to relate this comprehensively to all levels of the Buddhist cosmos – from earthly life to the heights of a proliferating Buddhist 'pantheon'. Through the Mahayana, then, Buddhism came to welcome the Buddha-image as a means of grace for monks and all worshippers.

All these factors were native to the scene of Buddhism in India, but a fourth element which came into play was foreign – the influence of Hellenistic and Roman art in north-west India where the 'Gandhara' school flourished from the end of the first to the fifth century AD. This

120. Head of Buddha.

was long after Alexander had brought Hellenism to the area, so that any classical Greek and Hellenistic influences were mediated now through provincial Roman style from Syria blended with Parthian elements.[33] The period of Kushan rule of northern India from the first to third centuries AD encouraged cosmopolitan culture and religious syncretism; hence the fruitful blend of Greco-Roman form and Indian iconography in the 'Romano-Buddhist' art of Gandhara.[34] It was a hybrid and eclectic style not remarkable for works of powerful originality. Nevertheless it contributed features of great importance in the history of Buddhist art because Gandhara was geographically at the cross-roads of India and Central Asia via which Buddhism entered China and Japan ultimately. One feature is the Westernized 'Apollonian' beauty given to the face of the Buddha to express his calm and benevolent humanity. This is evident in a stylized head from the fourth to fifth centuries, a period when Gandhara artists were returning to the great Hellenistic masterpieces for inspiration. Earlier works are less refined and sometimes stiffly conventional. This is due partly to the rhythmically draped garments derived from Roman statues; also the face is given a mask-like tranquillity to express the spiritual elevation of the Buddha. The combination of stylized form and spiritual beauty has become a recognizable feature of the Buddha-image throughout Asia.

As an example of the standard Buddha image we take the seated figure of the Preaching Buddha from the second to third century AD. This illustrates the blending of Roman-Hellenistic and Indian Buddhist features. The symmetry and perfection of the body is an attribute of the Buddha as an ideal world-ruler; it is both enhanced and offset by the formal but asymmetrical robe which typically leaves the right shoulder bare. (In standing Gandhara Buddhas the body is almost completely draped.) Here the Buddha is seated on the thalamus of a lotus which was developed a century later at Gandhara into the full lotus-throne with its rich implications in Indian symbolism. (The two other main forms of throne were also developed later – the lion throne, expressing spiritual victory, and the stepped recessed cosmic symbol of Mount Meru.) Moving upward in the image we note its posture: the Buddha is seated in the ancient yogic 'lotus posture' with upturned soles. And like the yogi his body is powerful and well-disciplined, perfect in breathing and meditation. Here the Buddha is teaching, as indicated by the hand-mudra (see further below). Behind the head is a halo symbolizing the 'Buddha Light' radiating from his supreme wisdom, sometimes depicted later in the more vivid form of rays and flames from the head and body. It cannot be determined whether this has Indian origins or was borrowed in the Kushan syncretism

121. Preaching Buddha, Gandhara style.

from Hellenistic images of Helios, deified Roman emperors or Iranian deities such as Mithra radiating light.

The head displays the distinctive marks of the Buddha as the Great Man. Long ear-lobes are a mark of nobility, presumably distended by heavy jewellery in Indian custom; but the Buddha had discarded all such material ornament. Between his eyes is the *urna,* a small crystal or white curl of hair symbolizing wisdom; it is not to be confused with the 'third eye' of Shiva, although this assimilation did occur in later Tantric Buddhism. Finally we come to the distinctive protuberance at the top of the Buddha's head, the *ushnisha.* The fact that this term originally meant a 'turban' makes it likely that it originated as the top-knot of hair on which the Indian princely turban was worn.[35] Here the hair is shown as abundant and wavy in a Gandharan style, perhaps influenced by the *krobylos* (top-knot of hair) of Hellenistic statues of Apollo. Whatever be the origin of this curious mark, the bump is interpreted as a receptacle of supernatural wisdom and power. In Thailand it was further developed into a lotus bud and even a flame pointing upwards. As for the hair style of the Buddha, this should have been short, for after Gautama cut his hair at the great renunciation it never grew longer than the short locks depicted later in 'peppercorn' or 'nail-shell' form curling to the right.

These iconographic details were derived from the traditional lakshanas on the body of the Great Man, listed in early Buddhist scriptures as thirty-two major signs and eighty minor signs. Naturally only a few of these could be depicted on a particular image, but the main features became standardized.

The hand-mudras are important because they appear in all images and indicate the activity of the Buddha. While many variants were developed

122. Dhyana-mudra.

123. Bhumisparsha-mudra.

124. Dharmachakra-mudra.

in the schools of Buddhism,[36] at least six basic ones should be described. The posture of concentration in yogic meditation is shown by the *Dhyana-mudra* in which the hands lie overlapping, palms upwards on the lap. When after arduous meditation Gautama attained 'enlightenment', he called the earth to witness his good achievement by touching the earth with the fingertips of his right hand, usually shown hanging over his right knee; this is the *Bhumisparsha-mudra*. Next, the Buddha taught the Dharma, and this 'turning the Wheel of the Law' in the *Dharmachakra-mudra* is shown by the fingers imitating the motion of a wheel, the hands being raised to the breast and the forefinger and thumb making a circle. The latter gesture is also used in the upraised hand of the *Vitarka-mudra* expressing exposition of doctrine and reasoning; it can also include appeasement, as when the Buddha quietened a maddened elephant. Protection and assurance to his hearers find expression in the raised right hand of the *Abhaya-mudra*; the left hand is usually held with palm upward, but sometimes both hands are raised in Thailand. Vow-fulfilling and the compassionate granting of favours are shown by the *Vara-mudra* with the hand held down, palm outwards. These mudras belong to the Hindu tradition originally but they have become pan-Asian features of the Buddha-image.

All that has been said points overwhelmingly to the Indian basis of Buddhist iconography. The Western elements in the formation of Gandhara art were important as additional factors in stimulating the development and shaping the widely-dispersed form of the Buddha-image. This is evident in the interplay of the Gandhara with other Indian styles, especially that which flourished in Mathura during the same period under the Kushan empire in northern India.[37] The seated Buddha from Mathura,

125. Vitarka-mudra.

126. Abhaya-mudra.

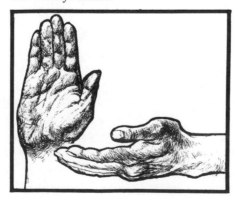

127. Vara-mudra.

second century AD, is a much more natively Indian figure, less 'beautiful' than the Gandhara but more vigorous and expressive of the spiritual and physical power of the yogi. His strongly-built body expresses the confidence and victory of the Buddha, recalling the early Jain images from the Mathura area. Distinctive features are the wheel-marks of the Buddha on both the soles of the feet and the head raised in the *abhaya-mudra*; the head is crowned with an ushnisha like a tiered snail-shell; and the body is clothed only in a thin dhoti. The countenance is more ruddy and friendly than the stylized calm Gandhara face, and above all the Buddha is a strong and active hero – 'abounding with the energy of the "Awakened One" (Buddha), read to preach to a world in need of redemption'.[38] Here then is the core of genuinely Indian spirituality underlying the early Buddha image. Later Mathura sculptures gain in elegance and nobility, doubtless due to the influence of Gandhara. The standing Buddha, from fourth to fifth century, wears a long robe with symmetrical folds; but the Mathura style has transformed this into a thin, almost 'see-through' garment, the *sanghati* of the monk, with its rippling folds displaying the contours of the perfect body of the Lord Buddha like a 'second skin'.[39]

128. Seated Buddha, Mathura style.

In this period, the fourth to seventh centuries, the classic Gupta style combined these elements of the Indian tradition in images graced by aristocratic refinement and harmony. One of the most famous and influential of these was the seated Buddha from fifth-century Sarnath, at the 'Deer Park' where the Buddha had preached his first sermon. This theme is depicted iconographically in the hand-mudra; but interestingly the aniconic wheel of the Dharma is also shown (on the socle below the image, where men are worshipping the symbol). The Buddha is seated on a lotus-mat on his royal throne, with an ornate nimbus behind him and honoured by celestial beings above the flanking leogryphs. The yogic position gives a triangular form to the composition and the smooth slender figure conveys a typical inward spirituality:

The finest Buddha statues of the classical Gupta period, despite their delicate radiant beauty, soft lines and graceful majesty, seem to be withdrawn from the phenomenal world: they appear cool and inaccessible; the eyelids are half-closed, suggesting introspection; it is as though the Buddha is not looking at anything in the physical world but experiencing a vision by deep meditation.[40]

129. Mathura-style standing Buddha.

The later Gupta images display more of the Indian warmth and outgoing humanity, as in the cave temples of Ajanta and Ellura of western central India. The large seventh-century image in cave ten at Ellura depicts the Buddha seated in the 'European' fashion, suggesting action and mani-

festation rather than detached meditation. It was this grand but also warm Gupta style which Buddhism brought as it spread through southern Asia in these centuries, (whereas the Gandhara style influenced northern and east Asian Buddhism). The vitality of the classic styles was continued in new forms in these lands.

As in Hinduism, the medieval period brought close standardization of Buddhist images; the use of the 'pointing frame' ensured the exact proportions as enjoined in the text of instructions for image-makers. Thus the unit of measurement, the *thalam*, is the span of length of the face, five of these making the height of a seated figure and nine of one standing.[41] In Tibet this *navatala* of the ideal man was seen as the micro-cosm of the nine-fold division of the world.[42] Legends were also re-counted concerning the alleged origin of these images from the Buddha himself. Ordinary artists were said to have failed to capture his likeness, so the Buddha projected his own image for a picture or, again, had his shadow traced on the ground. One story about King Udayana of Kausambi told of the king's ardent desire for a picture after the Buddha's enlighten-ment, resulting in a sandalwood image, five feet high, which rose up to welcome the Buddha and was given the task of spreading his teachings.[43] Such legends gave legitimation to the portrayal of the Buddha by linking them to an 'authentic' archetype from the time of the historical Buddha with his express permission. At the same time they gave encouragement to popular belief in the miraculous power of such images and of true copies made of them.

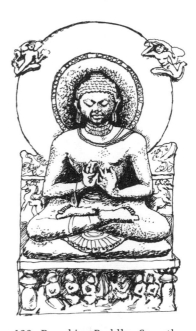

130. Preaching Buddha. Sarnath.

Theravada Buddhism and Southern Asia

It is customary to contrast the so-called superstitions and metaphysical elaborations of the Mahayana with the more sober simplicity of the Hinayana school (preferably called the 'Theravada' or teaching of the elders, as representing the older wisdom). 'In the art of the *Hinayana*, in Ceylon, Burma and Siam, there is nothing but an indefinite repetition of the image of the earthly Buddha. . . . Its repetitiveness seems to recall the serene and majestic monotony of the Sutras.'[44] There is some insight here, but the contrast is a gross over-simplification. The countries of south-east Asia which now solidly follow the way of Theravada Buddhism are actually the inheritors of a much more complex religious mixture. In earlier centuries Hinduism and Mahayana Buddhism prevailed for periods and contributed to the basic iconography of Buddhism accepted by all. Despite the differing emphases of the two major schools of Buddhism

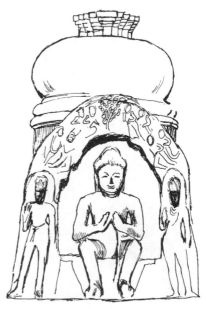

131. Seated Buddha from Ellura caves.

their common ground should not be forgotten. For instance, the ancient theme of the Buddha and Mucalinda (the serpent giving shelter) is featured in the Mahayanist phase of classic Khmer art in Cambodia, but it recurs in later Theravada Buddhist art also.

The case of Thailand shows the influence of Gupta art in the seventh to ninth centuries, including Mahayana Buddhist influences from Srivijaya to the south and later from Cambodia, followed by Theravada Buddhism in the northern kingdom of Sukhothai in the thirteenth to fourteenth centuries. In the latter period emerged the classic 'Siamese' type of Buddha renowned for its elegant suppleness, balance and simplicity. The oval face and austere meditation accord well with the Theravada emphasis. The *Bhumisparsha* mudra is the one most frequently shown in Thai images. The lotus-bud and flame from the *ushnisha* emphasize the supreme wisdom attained at the Buddha's earthly enlightenment.

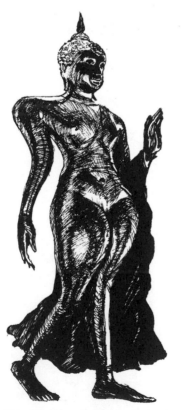

134. 'Walking Buddha'. Thailand.

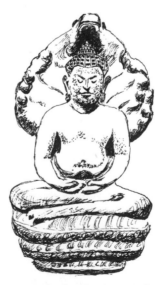

132. Mucalinda, Naga serpent-king sheltering Buddha. Cambodia.

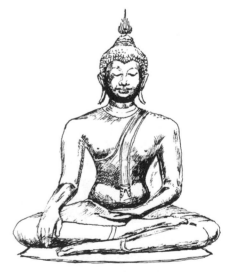

133. Buddha meditating at the Great Awakening. Thailand.

Yet this period saw other Thai images, some of them colossal, of the Buddha standing or reclining; such colossal images were a long-established Buddhist form, (for instance at Bamiyan in Afghanistan, fourth to fifth century) expressing the idea that in the golden age of the Buddha things were bigger and better. A unique development in Thai iconography was the beautiful 'Walking Buddha' of the fourteenth-century Sukthothai style. Here the Buddha is shown descending from heaven to perform his superhuman work as a missionary teacher of the Dharma, expressed by his mysterious gliding pace. The exaggerated proportions of the wide shoulder and long arm derive from the attempt to depict realistically such marks recorded in the texts as 'arms like the trunk of a young elephant'; these physical attributes may represent an attempt to relate man to the world of nature.[45]

In addition to cult images which portray some incident in the life and mission of the historical Buddha, there was much scope for narrative pictures in the Jataka stories, said to be told by the Buddha himself about his former lives. These may go back to pre-Buddhist Indian legends and are depicted in some of the earliest Buddhist reliefs where the Buddha is still in aniconic form. Out of the large collection of five hundred and forty-seven Jataka tales about the Buddha's succession of lives in animal, human and semi-divine forms, ten acquired a special place as illustrations of moral virtues in popular teaching; thus Sama the devoted son shows loving kindness, Mahosada the clever sage, wisdom and Prince Vessantara, charity. The ever-popular series has been the subject of much Buddhist art. An early nineteenth-century monastery, Wat Suwannaram, west of Bangkok features the ten stories as murals on the lower level of its interior, in addition to other large murals depicting the Buddha's enlightenment and the heavens and hells of Buddhist cosmology.[46]

Ceylon (Sri Lanka) came to be regarded as the fountainhead of Theravada Buddhism because of its early conversion to Buddhism (by Mahinda, son of King Ashoka, in the third century BC) and by its preservation of the Pali scriptures and Theravada teaching. Hence Thailand in the thirteenth to fifteenth centuries AD looked eagerly to Sinhalese Buddhism for the true canons of texts and images by which to renew and purify its own practice of Buddhism. Despite periodic conflict with Tamil Hinduism, Buddhism (chiefly of the Theravada school) was maintained over the centuries by an alliance of *sangha* and kingship in a Buddhist state.[47] Impressive monuments survive from the early centuries, such as the enormous stupas (called *dagobas* or relic-chambers) and Buddha images from the third century AD onwards. The Gupta style contributed monumentality and beauty without conventional or superficial prettiness, as

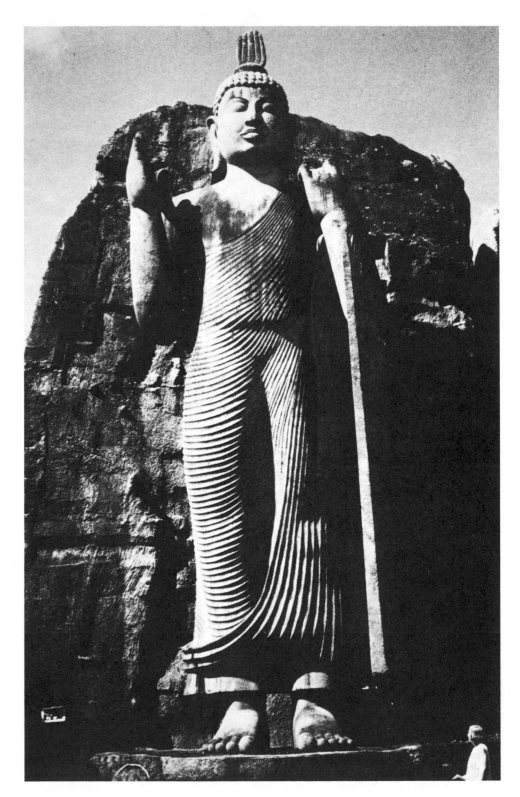

135. Colossal rock-hewn standing Buddha
from Aukana, Sri Lanka.

seen in the colossal forty-six-foot Aukana Buddha (*c.* eleventh century) in central Ceylon. This rock-hewn figure raises the right hand in majestic compassion and with the left clasps a thin robe of many graceful folds; the Buddha's small curls are surmounted by a five-pronged flame. A more refined and distinctly Sinhalese style is seen in the magnificent twelfth-century complex of Gal Vihara in the medieval capital at Polonnaruva. Three colossal statues depict the three main bodily postures of the Buddha – seated in meditation, standing and reclining at his parinirvana. Although now exposed to the elements these images are still in worship and their size in no way detracts from the refined simplicity of the Buddha in Theravada teaching.[48]

If, however, we turn to the popular practice of Sinhalese Buddhism, both traditional and modern, it is not confined to the adoration of the supreme Buddha figure. Even if he transcended the gods and cut across their authority to achieve salvation, the gods continued at other levels of religion. They were featured as guardians at the entrances to Buddhist stupas in antiquity and appear likewise in later ages; at an entrance to the round Buddhist relic-house (*Wat-a-dage*) at Polonnaruva stands a Naga-king in his splendour holding his offerings of rice and flowers with two fat gnomes at his feet. Modern studies of Buddhism in Ceylon, Burma and

137. Stone sculpture of Naga-king guardian, Sri Lanka.

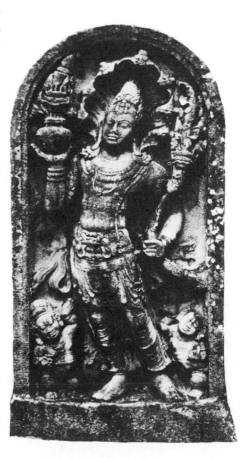

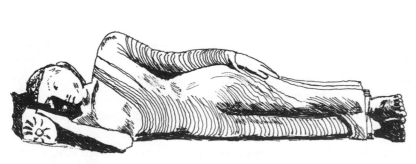

136. Rock-hewn reclining Buddha in his parinirvana, Sri Lanka.

Thailand have been seeking to analyse the complexities of this situation in terms of such categories as the 'Little Tradition' (local folk religion) with some illumination.[49] Yet the worshipper himself may not be aware of any incongruity and he may regard the various levels of worship as appropriate within the traditional Buddhist framework.

This is made possible by the established Buddhist cosmology with gods ruling the various heavens and a hierarchy modelled on the structure of authority in the feudal system and more modern administrative officers.[50] Thus in the Pali Canon the ruler of the second lowest heaven is Shakra (formerly the Vedic Indra) and he may appear along with Maha Brahma in representation of scenes from the life of the Buddha. The lowest heaven is ruled by the four great 'world guardians', usually depicted as young kings. These six gods are frequently portrayed together at the entrance to image-houses. Below them at the earthly level where human needs can be met are the four guardian deities, mostly of Hindu origin but now linked to Ceylon. Saman was originally Yama and after coming to Ceylon in antiquity became identified as the god of Adam's Peak, the site of the Buddha's footprint; consequently he may be accepted as next to the Buddha and depicted in local temples, as a white figure on a white elephant.[51] The great god Vishnu is accepted generally as a bodhisattva, a Buddha-to-be. The warlike Shaivite god Karttikeya was renamed Katagarama from his famous shrine in the south-east corner of Ceylon and is now the most important god of Ceylon whose festivals draw devotion from Buddhists as well as Tamil Hindus and others.[52] There are many other local gods, now largely subordinated to the authority of Katagarama. In popular religion there are presiding deities of planets and hosts of demons (*yakka*), both evil and benevolent, who are depicted in the imaginative and often awesome Sinhala masks for traditional rituals and folk plays.[53]

These gods are worshipped in their shrines (*devale*) and the ritual offered there (*deva pujava*) parallels the *Buddha pujava* in the temple.[54] However, it is much less public than the latter; typically the images of the gods are kept behind curtains like Hindu gods whereas the Buddha image in the temple is open for all to view. This coexistence of two religious systems, one based on canonical Buddhist concepts and monastic teachings, the other on Hindu and indigenous traditions, is found in the other Theravada Buddhist countries with parallels in other religions. In the personal practice of Buddhists the two belong together, as complementary and interwoven. In principle they can be separated along the lines stated by a perceptive English observer of seventeenth-century Ceylon: there are two sorts of festivals,

some belonging to their Gods that govern the Earth, and all things referring to this life; and some belonging to the Buddou, whose Province is to take care of the Soul and future well-being of Men.[55]

From the viewpoint of canonical Buddhism belief in the gods is irrelevant, for the gods are impermanent and inferior and praying to them for worldly concerns cannot help towards the true Buddhist goal of salvation which is liberation. Buddhism may be called in Western terms 'a transpolytheistic, non-theistic religion of contemplation'.[56] Accepting the ambiguity in practice which has evidently been a feature of Buddhism since earliest times, there is no question that the Buddha is ultimately acknowledged to be supreme.

This is shown by the dominant position given to the Buddha-image in the temple; it is elevated to a sacred place as the focus of attention. Although strictly speaking the Buddha is dead and the image can only be a reminder of his doctrine and goodness in affectionate memory, the act of consecration makes it an object of great respect. The climax of consecration is the *netra pinkama,* the 'eye ceremony' in which the craftsman paints in the eyes at an auspicious moment in the closed temple. He does this only after hours of ritual preparation lest he be involved in some evil due to the dangerous gaze:

Moreover, the craftsman does not dare to look the statue in the face, but keeps his back to it and paints sideways or over his shoulder while looking into a mirror, which catches the gaze of the image he is bringing to life.[57]

After this the image is treated as an object of devotion, like a king or an honoured monk, as in the traditional anointing or bathing of the Buddha-image which is still performed weekly at the Temple of the Tooth in Kandy. The worshipper at the temple makes offerings before the image. Many homes have Buddha-images and shrines as a source of blessing; increasingly the picture of the Buddha replaces the picture of his disciple Sivali as the one to whom one prays for blessings on the household.[58] All this suggests more than the memory of a great sage; worshippers behave as if he were numinously present, 'a powerful and omni-benevolent god, a supreme being who is still in some way present and aware. (Perhaps we might say that cognitively the Buddha is dead but effectively he is alive.)'[59]

In Sinhalese Buddhism as in Hinduism there are no doubt different levels of meaning given to the image, according to the attitude, interest and understanding of the worshipper. In any case the Buddha image has an assured place against any attempt to set it aside as absurd or un-necessary for developed intellects. In this context it is illuminating to

read a recent justification of the use of images by a monk who draws on modern psychological explanations.[60] Bhikku Punnaji opens his case by appealing to everyday practice, as in the acceptance of statues of heroes and the treasuring of a photo of a loved one. As applied to religion this means the veneration of symbols which express faith in spiritual values – hence the symbol is not to be confused with what it represents. The value of the Buddha-image lies in its making the abstract visually vivid and concrete, as in advertising. (Indeed, the Bhikku suggests that the more Buddha-images to be seen on the road-side, the better the answer to the multitude of symbols in public life which express material values so attractively.) This is all the more essential because behaviour is so largely determined by the unconscious and only a thorough 'reconditioning' can ensure a change for the good towards spiritual values. Hence the psychological importance, first, of repeating right thoughts and habitual actions. The physical act of raising the arm in salutation or of bowing in homage induces a right attitude to the Buddha's way; it is still better to offer flowers and chant hymns before his image because the principle of 'acting as if' creates a better mood. Secondly there is a need for the right integration of emotion and reason if mental ill-health is to be avoided. Image-worship has a rational foundation but this is part of the power of 'right imagination' to guide the strong forces of the emotions. The right emotion is faith (*Saddha*) which is the seed of spiritual growth:

We plant this seed properly in our minds when we see vividly in our imagination. the ideal; when we visualize it in concrete form. There is no better way to visualize it in concrete form than to look at the Buddha in person, or in his absence, to look upon the serene face of the Buddha image.[61]

Mahayana Buddhism

The Mahayana was responsible for developing not only the image of the Buddha as the focus of temple devotion but also a vastly expanded 'Buddhist pantheon'. This came to a spectacular flowering in the Buddhist iconography of China, Korea and Japan with further developments in Tibet and Nepal. Hence the term 'Northern Buddhism'[62] is sometimes used; but this is permissible only if we remember that the Mahayana originated in India, both northern and southern, from the first century BC and that it was also influential in south-east Asia, where some of its greatest monuments are found, as at Borodbudhur. It is important to maintain a synoptic view of the forms of Buddhism as an Indian and a pan-Asian phenomenon.[63]

The Mahayana developed and elaborated features common to all schools. Already in the ancient period there was a belief in a succession of Buddhas who had come to earth in distant ages. The stone roundel reliefs from Bharhut, second century BC, depict these previous Buddhas aniconically, each by means of his distinctive Bodhi tree which worshippers adore and deck with garlands – for instance Kashyapa by the Nyagrodha tree. The earlier number of six or seven such Buddhas grew later to some twenty-four, probably matching the similar succession of twenty-four Tirthankaras of the Jains, with overtones also of the Hindu Avatars.

More significant than these mythical past Buddhas, who are dead and gone, is the Future Buddha who is alive and waiting for the era when he is to preach the true Dharma on earth. In this sense Maitreya ('the friendly one') is called a *bodhisattva* because he has vowed to become a Buddha and is a Buddha-to-be, a figure of messianic hope. He will follow the pattern of his predecessor Shakyamuni who came in the earthly life a young prince before enlightenment and final Buddhahood. These two are recognized as bodhisattvas in Theravada countries. The Gandhara image of a bodhisattva, from the second century AD or later, could well be of Maitreya. In addition to the moustached version of an Apollo-type face and formal drapes, the figure wears heavy jewellery and a fancy hair-style; this represents the rich lay costume of the princely bodhisattva. It may also represent an actual royal personage or noble donor divinized like the later Khmer rulers in south-east Asia.[64] In any case this contrasts with the image of the Buddha who has cast away such worldly ornaments and has the distinguishing marks of the *urna* and *ushnisha*. The bodhisattvas were probably first depicted at Gandhara as attendants of the Buddha later becoming more individual figures with their own marks.

The crucial development came through the Mahayana doctrine of transcendent bodhisattvas as beings who not only strive for Buddhahood (as earthly disciples might do) but, having attained infinite wisdom in their perfected essence, remain available to help others. Their compassion, self-sacrifice and redeeming grace help struggling mankind towards salvation and ultimate Buddhahood. Here lies the basic difference between Theravada, which may be called 'the Buddhism of liberation through self-effort', merit being earned by monk and layman in their own strivings, and Mahayana with its liberation by 'Other-Power', merit being transferable by the bodhisattvas to others.[65] This opened up the possibility of a whole array of bodhisattvas as heavenly intermediaries

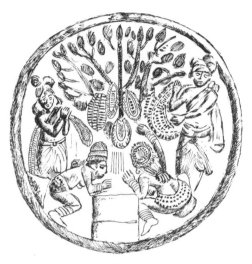

138. Previous Buddha, Kashyapa, venerated in aniconic form of the bodhi tree.

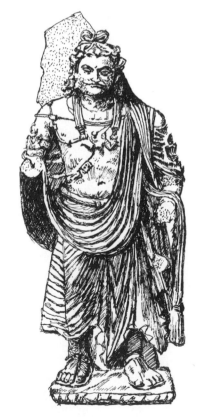

139. Standing bodhisattva (Maitreya?).

who, unlike Buddhas, are able to hear and answer prayers and work benevolently for the good of the world. Iconographically they may first have followed the triad-model where the Buddha instead of being flanked by Hindu deities such as Brahma and Indra, had now his chief attendants in Maitreya and Avalokiteshvara. Out of this developed a whole 'hierarchy of sacred figures' with different levels of spirituality, depicted in a corresponding 'hierarchy of styles'.[66]

These developments are all to be seen in the single figure of Avalokiteshvara whose very name is the epitome of the bodhisattva: the lord who looks down mercifully on the world's suffering (or alternatively, lord of resplendent brilliance). In the late Gupta art of the seventh century he appears in a grand wall painting in cave one at Ajanta. With princely head-dress, perfect ovoid face and supple animated body he gathers up many of the themes of the Hindu tradition – the poise of the dancer, the gestures of the hands, the elegant ideal beauty, the magnetic power of the cult-image.[67] But he also transcends the gods' world of splendour in his compassionate gaze. He holds a blue lotus, from which attribute comes his other name Padmapani, 'the one holding the lotus'. In the same period he is shown along with Maitreya as a majestic door-guardian for a colossal Buddha in the sanctuary of cave two at Ellura.

Meanwhile the princely aspects came to the fore in south-east Asia as Avalokiteshvara was brought on the wave of Hindu and Buddhist advance. The Gupta and Pala styles appear in the splendid, if damaged, image from eighth-century Thailand which received Mahayana Buddhism from the southern kingdom of Srivijaya. Most impressively he was

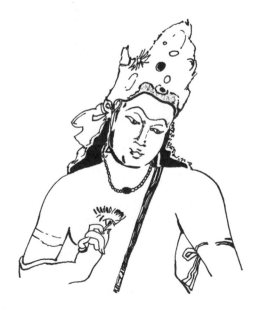

140. (*far left*) Avalokiteshvara-Padmapani from large cave wall painting at Ajanta.

141. (*left*) Avalokiteshvara from Thailand.

identified as Lokeshvara ('Lord of the World') with the later Khmer rulers who saw themselves as 'Buddharajas'. The climax of this was the Bayon at Angkor Thom where four colossal masks of Lokesvara gaze imperturbably over the four directions from each tower; the face is that of King Jayavarman VII of the early thirteenth century. Characteristic here is the smile which has often been a puzzle to Europeans. It probably originated in the Hindu tradition where the smile signified spiritual release, and the sense of inward ecstatic bliss here is conveyed in a mysteriously ineffable 'sublime smile'.[68] This is seen in the small sandstone head of Lokeshvara in the Bayon style. Also important here is the small meditating figure of Amitabha Buddha in front of the raised coiffure; this is usually a means of identifying Avalokiteshvara who as a bodhisattva manifests this particular Buddha on whom he attends. (As 'Buddha of Boundless Light' Amitabha is said to have fathered him spiritually when a white ray of light came from his right eye in a moment of earnest meditation.)

A wide range of activities and postures became associated with Avalokiteshvara as the worker of miracles who could take many forms for his merciful works. Chinese images drew on the Hindu tradition of gods with many arms and faces to express readiness of Kuan Yin to see all and show his compassion; the form with four faces and twelve pairs of arms became very popular. More complex still was the eleven-headed Kuan Yin as seen in the eighth-century T'ang image. The number of heads could be interpreted in China and Tibet as expressing different levels and aspects of the bodhisattva (who was said to have split up his

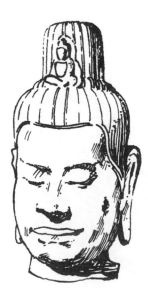

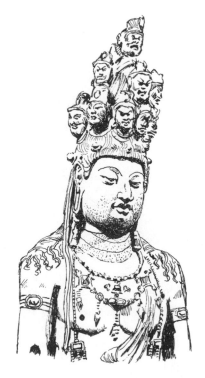

142. (*right*) Lokeshvara from Cambodia.

143. (*far right*) Kuan Yin with eleven heads. China.

from India

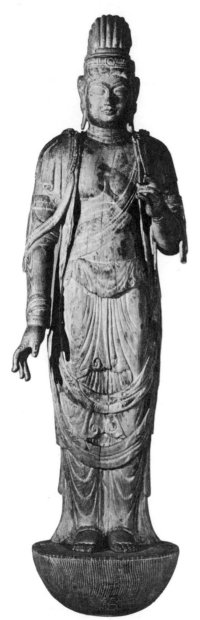

own head to multiply ways of salvation for man); but this probably originated as local or minor deities which were incorporated into the more powerful figure.[69] A further development of this was the 'thousand arms' by which he was able to save all mankind and a thousand worlds, and this is literally depicted in the central image of Kannon and the serried ranks of standing Kannons in the thirteenth-century Japanese temple of Sangyusangendo, Kyoto. In the Chinese bronze image made for Tibetans in the eighteenth century we see the thousand hands radiating with an eye in each palm, except for the original central pair of hands together in the *namaskara* mudra of worship. Nine heads have bodhisattva crowns, the tenth is crowned with skulls and Amitabha crowns the topmost (see Frontispiece). At the same time the majestic princely tradition went on, as in the strong serene standing figure of Kannon from ninth-century Japan, or the twelfth-century Kuan Yin from Sung China seated in the Indian posture of 'royal ease' and lavishly ornamented.

The compassionate nature of the bodhisattva led to certain feminine characteristics being emphasized in China, with the result that Kuan Yin has sometimes been labelled 'the Chinese goddess of mercy'; but this is erroneous for bodhisattvas transcend distinctions of sex. Avalokiteshvara could assume the form of a woman or a girl as a temporary expedient in his works of mercy; but even some of the 'feminine' pictures may show 'him' with a moustache.[70] Since he was capable of granting human wishes his help was sought by women seeking to bear children and this cult of the 'bringer of children' led later to a popular form of

146. (*above*) Life-size standing image of Kannon from Heian Japan.

144. (*right*) Kuan Yin in posture of 'royal ease'.

145. (*far right*) Kuan Yin as 'giver of children'.

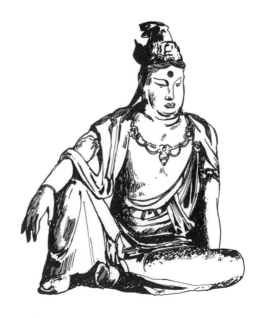

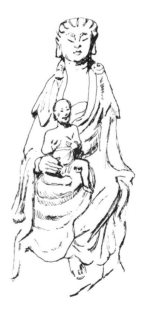

Chinese devotion on the periphery of Buddhism. The nineteenth-century white porcelain figure shows Kuan Yin as a woman clad in white (an early tradition associated with white light and perhaps also the White Tara who emerged as a tear from the eye of Kuan Yin to become his spiritual consort). This popular statuette is for homes, not temples of Kuan-yin; and the child which the woman carries in her arms is not her (his) own. Popular syncretism has here drawn on the great tradition of the bodhisattva.

However much Buddhist iconography may have owed in detail to such popular cults or even to the vision of artists, these were channelled by a primary source of inspiration – the Mahayana scriptures which were written from the first century BC onwards. The Sanskrit originals were eagerly translated into Chinese as Buddhism was brought into China via central Asia and their teachings continued to be illustrated in art through the following centuries in this area. For instance, in the rich provincial art of Tun-huang is a tenth-century painting of the miracles of Avalokiteshvara delivering his devotees in the nick of time from brigands, flames, serpents and other earthly dangers. This is based on the ever-popular twenty-fourth chapter of the *Lotus Sutra* (Saddharma Pundarika) which was written in Sanskrit, first to second century AD. The whole scripture presents Buddhism as a way of salvation open to all through the simpler yet higher way of Mahayana; it glorifies Shakyamuni as the supreme Buddha amid a galaxy of Buddhas, past and present, from all universes. The vivid parables and visions of the *Lotus Sutra* inspired Buddhist iconography in China and Japan.[71] For instance in chapter eleven a heavenly stupa descends containing a previous Buddha Prabhutaratna with whom Shakyamuni converses; this visionary scene was much depicted. Vivid popular material was also in the legendary account of the life of the Buddha in the Lalita-vistara and the colourful visions of paradises such as the Sukhavati, the 'Pure Land' of Amitabha. Even the more subtle dialogues of the Prajnaparamita literature (texts dealing with wisdom as the highest perfection of the bodhisattva) gave rise to illustrations and some images of the female figure of Prajnaparamita.[72] This attractive embodiment of supreme wisdom shares in some of the splendour and kindness of the bodhisattvas yet being female she can hardly be classified as such; she is called symbolically 'the Mother of all Buddhas' and seems to be rather the female counterpart of the supreme cosmic Buddha, embodying wisdom in the form of the traditional Indian Great Mother figure.[73] The beautiful Javanese image shows Prajnaparamita bejewelled but meditating and teaching on a lotus-throne, with an *urna* marking her forehead with highest wisdom. Special interest is

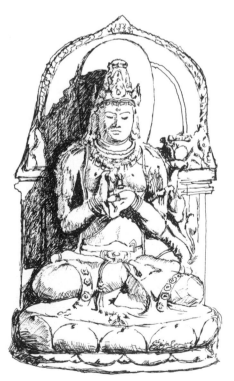

147. Prajnaparamita as Queen Dedes.

added by the fact that this is also a portrait of Queen Dedes in early thirteenth-century Java who is thus identified with the supreme Buddha – a parallel to the kings of Angkor but here in female form.

With the Mahayana sutras (literally 'guides') as the inspiration of much iconography there was the further need for a comprehensive doctrine to supply a cosmology and metaphysical framework for all these sacred beings. Were the Buddhas earthly or heavenly, human or super-human? Where should the bodhisattvas be placed? The answers were provided by the Mahayana doctrine of the 'three bodies' (*trikaya*) expounded by the fourth-century sage Asanga, if not earlier. According to this every Buddha has three bodies, the highest level being the absolute which unites and embraces all Buddhas. Even the myriads of Buddhas can thus be seen as manifestations of the one supreme Buddha; consequently the Mahayana Buddhology in its developed form is monistic.[74]

This may be more helpfully, if still inadequately, expressed in the schematic form of a diagram featuring selected examples. The *Dharma-kaya* is the Buddha-nature as the absolute body of truth, reality and 'natural law' conditioning all things; it is indescribable, being the absolute essence and impersonal. Yet it can be personalized, in a sense, in the universal or primordial (adi-) Buddha, venerated especially in the esoteric Buddhism of the Vajrayana as Vajrasattva ('diamond natured') or Vairocana (the 'sun-like' Buddha). Beneath this body is the *Sambhoga-kaya*, the 'body of bliss' or glorious superhuman body which can be perceived only by visionary powers, by the spiritual eye of the bodhi-sattva. Here are the transcendent Buddhas, lords of the paradises which many believers strive to attain; they teach their bodhisattvas and project the earthly Buddhas for mankind's deliverance. Over twenty transcendent Buddhas might be enumerated, but a conventional selection gives five so-called Dhyani (meditation) Buddhas orientated to the basic direc-tions. At the centre is Vairocana, represented by the colour white; Amoghasiddhi (green) is at the north; Akshobhya (blue) east; Ratna-sambhava (yellow) south; and Amitabha (red) west. The last is by far the most popular and venerated, but mudras, attributes, seasons and cosmic elements are linked to each.[75] The *Nirmana-kaya* is the 'body of mani-festation' where the Buddha-nature is transformed and revealed so as to be accessible at the earthly level. This is where the previous Buddhas, such as Dipankara in a remote era, came after preparing through many lives, and likewise the last Buddha, Shakyamuni in the earthly life of Siddhartha Gautama. Maitreya is still in the Tushita heaven waiting to come. Meanwhile the bodhisattvas such as Avalokiteshvara are available to bring their compassion and merit on earth. Although the earthly

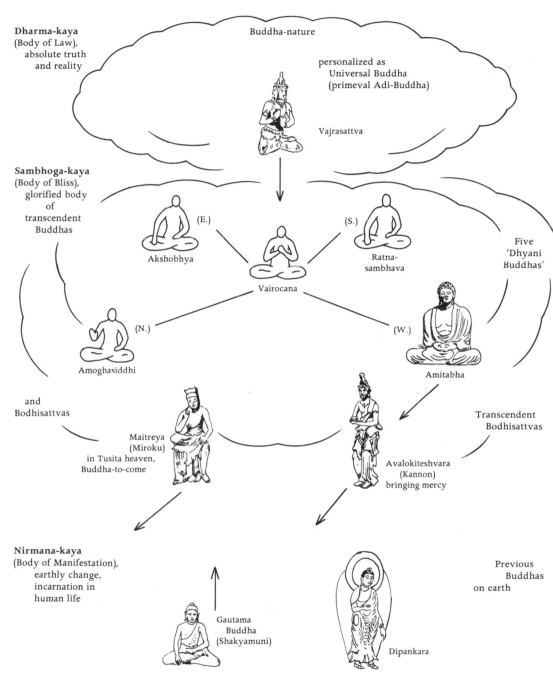

Dharma-kaya
(Body of Law),
absolute truth
and reality

Buddha-nature

personalized as
Universal Buddha
(primeval Adi-Buddha)

Vajrasattva

Sambhoga-kaya
(Body of Bliss),
glorified body
of
transcendent
Buddhas

(E.)

(S.)

Akshobhya

Ratna-
sambhava

Vairocana

Five
'Dhyani
Buddhas'

(N.)

(W.)

Amoghasiddhi

Amitabha

and
Bodhisattvas

Maitreya
(Miroku)
in Tusita heaven,
Buddha-to-come

Avalokiteshvara
(Kannon)
bringing mercy

Transcendent
Bodhisattvas

Nirmana-kaya
(Body of Manifestation),
earthly change,
incarnation in
human life

Previous
Buddhas
on earth

Gautama
Buddha
(Shakyamuni)

Dipankara

148. The Mahayana cosmos
according to the Trikaya doctrine (the 'three bodies' of Buddha)
pictured in selective and schematic form.

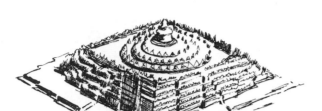

149. Borobudhur, monument in central
Java seen from the air.

Buddhas are mortal and are extinguished from this life after their work is
done, this is the realm where their teaching lives on, available to all men
in explicit words and deeds.

The importance of the *trikaya* doctrine is that it provides a compre-
hensive framework which relates man at the earthly level to the Buddhas
at the very highest level. The various intermediaries and sacred beings,
from the aloof to the active, are arranged in a meaningful hierarchy and
the proliferating iconography of the Mahayana is contained in an orderly
and inter-related system. This did not remain at the merely theoretical
stage but was embodied in one of the most stupendous monuments
of Buddhism at Borobudhur in central Java. Built under the Shailendra
dynasty, *c.* AD 800, it uses some basic symbolism of the religions of India –
a great Buddhist stupa for circumambulation, a microcosm of Mount
Meru, and the mandala pattern of the heavenly circle in the earthly
square. Thé four square terraces feature the four Dhyani Buddhas
regularly in niches on the sides appropriate to their directions, with the
central Vairocana on the surmounting terrace. Then the three circular
terraces at the top express the austere enlightenment of meditating
Buddhas enclosed in stone-latticed stupas, with a massive unadorned
stupa providing the final crown and central axis. All this marks an
ascending path from the world of appearances to the world of enlighten-
ment, from the world of earthly desires at the basement level to the final
release of nirvana. The Mahayana *trikaya* doctrine is followed in this
progression from the first gallery where the life of the Buddha is illustrated
by reliefs based on the Lalita-vistara, then to the pilgrimage of Sudhana
to encounter the bodhisattvas, depicted in the following galleries, leading
to the austere spirituality of the Absolute at the circular summit.

For this reason Borobudhur has rightly been called a psychophysical pilgrim's
path; the terraces lead the pilgrim through the different cosmic spheres, levels
of apprehension, and stages of redemption. It is an initiation course into the
Buddhist faith, executed in stone.[76]

The upward Buddhist path thus returns after the rich and varied iconography to contemplation of the bare aniconic symbol.

Summary

Both Jainism and Buddhism as heterodox movements originating in ancient India carried over the symbolism of the Hindu tradition including the gods who were given a subordinate position to Mahavira or Gautama. Devotion to the Buddha, the veneration of the stupa and the cult of relics led to the development of the Buddha-image in the Gandhara and Mathura styles. This Indian basis remained, but Buddhism became a pan-Asian religion open to diverse influences, especially through the Mahayana school as it developed an enlarged hierarchy of Buddhas and bodhisattvas. Nevertheless iconic and aniconic forms have continued side by side because ultimately the image is only a means to understanding and experience, a symbol pointing beyond itself:

But each Buddhist work is in one way or another symbolic. It has a meaning that transcends its appearance and immediate purpose. It stands for the Absolute, or the Nought (or Void) – that for which all images are only provisional signs.[77]

6 Religions of East Asia: China, Japan, Tibet

As a clue to the characteristic ways of thinking of the Eastern peoples, it will be important to study how they modified Buddhism.

Hajime Nakamura[1]

IT IS AN illusion to think of Asia as a cultural unity, as 'the Orient' or 'the mysterious East' to be contrasted with the ways of 'the West'. Against such clichés and monolithic concepts it is important to recognize the diversity of peoples, cultures and religions in Asia.[2] Such unity as these do possess is a result of their common humanity and their historical contacts. Buddhism brought about such contacts because it was a missionary religion arising out of the Hindu tradition and becoming pan-Asian in its influence. The point of Nakamura's suggestion is that Buddhism was received differently by the Asian peoples according to the differing character of the recipients. We can learn important things about them by taking Buddhism as a probe. Nakamura's illuminating investigation is concerned with 'ways of thinking'; but we may use the same approach to advantage to study the religious iconography of China, Japan and Tibet. The advent of Buddhism in each case brought a new awareness to the existing religious traditions of these lands and a new iconography; at the same time Buddhism and its iconography were altered. In this chapter we shall use this contact with Buddhism as a convenient focus for the iconographic riches of these east-Asian religious cultures.

China

The two great religions native to China, Taoism and Confucianism came to be conventionally grouped with Buddhism in 'the three doctrines'

after the entry and assimilation of Buddhism in the early centuries AD.
But these two derived from a much more ancient common Chinese
tradition of culture and folk-religion expressing man's relationship to
the cosmos; the sense of wholeness embracing man, society and nature
in the dynamic of a harmonious naturalistic universe has been called
'universism'.[3] This underlies the elusive term *tao* (the Way, the eternal
order) in the classical text of philosophical Taoism, the *Tao Te Ching*.
It underlies also the *I Ching*, an ancient treatise on divination from the
twelfth century BC which became the core of the Confucian Canon after
Confucius in the sixth century BC had written a commentary on it; as
the *Book of Changes* it sets out a system of signs for the changes in the
universe resulting from the interaction of the two basic forces, Yang and
Yin.[4] This tradition can be seen in some ancient symbols which are basic
to Chinese religions.

The complete cosmic circle comprises two complementary forces –
Yang representing the more male characteristics and Yin the female.
These correspond to polarities such as father-mother, sky-earth, dry-wet,
bright-dark which are involved in the constant creative interplay of
forces in the cosmos. The fact that the circle is divided not by a straight
but a wavy line points subtly to the interpenetration of these opposites
which share in each other's characteristics. This abstract symbol is
applicable to all phenomena constituting the wholeness of Tao. Hence
it came to be used by Taoists and Confucianists as the *T'ai Chi* symbol of
the 'supreme ultimate'. It could decorate everyday objects, gates, ritual
objects for exorcism, the robes of a Taoist priest and even a wrap for
babies in the belief that the design would be a protective charm against
demons.[5]

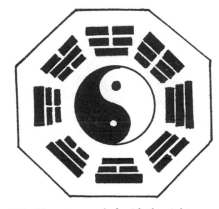

150. Yin-yang symbol with the eight
trigrams.

Around the circle are the eight trigrams (*pa-kua*) made up of variant
combinations of a single line, representing Yang, and a broken line for
Yin. These are orientated to the eight directions and also symbolize
basic elements of the cosmos – heaven and earth, wind and thunder, fire
and water, mountain and lake. As hexagrams these two lines give sixty-
four variants, used for consultation of oracles but also the subject of
philosophical interpretation for harmonious living.[6]

An ancient Chinese symbol of heaven is the circle, in contrast to the
square for earth. The circular jade *pi* is interpreted as a symbol for heaven,
the hole in the centre being the path of transcendence; if marked by
spirals and raised dots these would signify the stars. It was one of six jade
shapes used in the worship of heaven and was also placed on the corpse
in burials. However, in this period (late Chou and Han, from the fourth
century BC onwards) there were no images of gods. The highest deity

151. Pi, jade disc, originating probably in
the Shang period.

was Shang Ti, the Supreme Ruler in heaven, the source of the emperor's legitimation and of blessings and punishments; he was conceived of in anthropomorphic terms, perhaps as a royal ancestor, but not as a creator god or an absolute principle like Tao. Tablets from the Chou period with markings for the face have been interpreted as symbols of the earth god or of a sage; but otherwise in the first millennium BC the gods were not depicted anthropomorphically. Indeed there was little interest in depicting the human form. By contrast there was abundant interest in depicting animals – most probably through the concern of popular religion for fertility, but also for their powerful significance for astrology and magic, as in the 'Chinese zodiac' of twelve animals.

Foremost among the fabulous animals and monsters is the dragon, which is like the serpent in having an ambivalent and cosmic significance. (The Indian Naga Kings were transformed into Dragon Kings when they entered Chinese religion.) Dragons dwell in the air, in the waters and the earth's recesses; they are therefore able to link up the levels of the cosmos, from the highest to the lowest. The dragon brings rain and is thus a source of fertility; removal of misfortune is a further function of the great wood-and-paper dragons featured in Chinese traditional folk-religious processions at New Year; but the dragon is also a creature of speed and dangerous power. The bronze dragon, sixth to third centuries BC, is similar to a horse but is winged and shows a menacing watchfulness. The dragon normally had only four claws on each foot, but with five it became the exclusive emblem of imperial power.

These ancient symbols illustrate some of the themes basic to Chinese religion in both its popular and aristocratic forms. One other theme must be mentioned: the cult of ancestors. The family was of central importance in China and filial duties were taken seriously. Fear of the dead and the hope that they would become benevolent gods led to the deification of ancestors which has coloured Chinese religion.[7] Man is therefore surrounded by hosts of gods and demons, benevolent *shen* and harmful *kuei,* and he needs to deal with them by various appropriate means – from solemn rituals to the use of charms, spirit-mediums and exorcists. These are mainly ritual activities which do not imply or require the use of images to worship.

The advent of Buddhism in the first century AD brought religious features which were new to China and modified this scene. Coming from India with a message of individual salvation propagated by monastic orders and a growing treasury of scriptures and images of Buddhas and bodhisattvas, it made a great appeal to the strife-torn China of the early centuries. The example of its impressive images and of the devotion they

152. Bronze dragon resembling a winged horse.

inspired among Buddhists led to the development of images in a popular Chinese pantheon. It was at this same period that religious- or neo-Taoism was engaging on the quest for the magical elixir of life, for longevity and immortality; soon it acquired a whole cultic pattern, a canon of scriptures, temples, priests and monasteries modelled on Buddhist practices. The many deities[8] relating to the aspects of Chinese life and the cosmos were depicted in vivid images in temples and domestic worship from the second century AD onwards. Buddhism and Taoism flourished together in these centuries leading to a merging of deities in the popular Chinese folk religion. In the later folk pantheon the supreme deity was the Jade August One under whom were the Five Controllers of the Five Sacred Mountains of China; these were portrayed in imperial ceremonial costume, and the hierarchy was structured like the imperial court and the administration. Other popular figures such as the Eight Immortals were protectors of Taoism who while not worshipped in the full sense were attached to the pantheon and much featured in legend, art and drama.

The response of the Confucian tradition was very different. It shared of course in the common heritage of Chinese 'universism', and had been pressed into the service of the ancient state religion with its sacrificial rituals linking heaven, earth and man. But its more rationalistic temper and humanistic ethic were opposed to the ethos of Buddhism and Taoism with their temples devoted to Buddhas and gods. The Confucian temple was a civil temple of culture.

For Confucius was the patron of learning, of the high culture, and consequently of the scholar-bureaucrats who ruled the civil government of China. It is most interesting that these educated élite resisted all efforts to deify their Master and that in a land where it was common to turn men into gods, Confucius remained a human figure. Perhaps he could most aptly be called the spiritual ancestor of the literate.[9]

The Confucian temple was therefore a memorial hall containing the spirit tablets of Confucius and the great sages. In the form of temple officially established in AD 505 wooden images of Confucius and later of the sages, including wall-painting portraits, were introduced. These were replaced by clay images in 960, and finally removed altogether in 1530 by a return to the simple wooden tablet of the 'ancestral' tradition.[10] The tablet of Confucius himself, standing in the centre of the hall facing the entrance-way to the south was inscribed: 'Most Holy Former Master, The Philosopher K'ung'.

However, it should be pointed out that neither in the Confucian nor the Taoist traditions does the use of writing imply an absolute contrast to the visual image or symbol. Chinese has been called a 'picture language'

and the characters of its classical scripts arose out of ideograms. Chinese writing can be used as a form of visual symbolism and the art of calligraphy came to be much admired after the time of Confucius. There is a strong link between Chinese writing and painting, not least because they both apply brush to paper in rapid rhythmic strokes. Calligraphy and ink-painting were important artistic and spiritual media which Buddhism acquired in China and developed through Ch'an (Zen) Buddhism in Japan as well.

We turn now to ask what effect the religious culture of China had on Buddhism in return. Clearly it meant adapting to a very different culture from that of India. Just as Buddhist teaching and scriptures had to be translated from their Sanskrit originals into the thought-forms possible within the Chinese language, so the Buddha-image had to find indigenous styles which preserved the artistic power and iconographic features of the Indian originals from Gandhara. Buddhism won both popular support and imperial favour during its early centuries in China; but it still had to live with political uncertainty (culminating in the great persecution of AD 845), and it had to live with the other religions of China. Socially it had to come to terms with Chinese familism and ancestor-cults which were initially hostile to Buddhist monasticism and celibacy. The Chinese Buddhist monastery adjusted to this by becoming more sedentary and playing its part in the religious culture as a whole. This process of accommodation to Chinese culture has been suggested earlier by the example of the popular bodhisattva Kuan-yin. Another instructive example is that of Maitreya (Mi-lo) whose progress in China we shall now trace.

In both Theravada and Mahayana Buddhism Maitreya was accepted as the future Buddha to whom one could turn in hope. In the distant future – maybe in thousands of years – the world would be on an upward surge of its cycle and Maitreya would then come down from his waiting place in the Tushita heaven to become incarnate on earth for the last time. He would live out the same pattern of life as did Gautama, the last Buddha, and bring a time of joy and blessings – above all, the opportunity of hearing his three preachings and of thus being fired to attain nirvana. Hence the note of eschatological longing: 'Come, Maitreya, come!' Especially with the development of the Mahayana cult of great bodhisattvas, Maitreya became a messianic saviour, a god of light illuminating the minds of the Mahayana sages and a friendly consoler and guide to the pious follower who sought his paradise to wait for rebirth at his favoured time. He was the focus of much devotion in north-west India in the early centuries AD, as evidenced by art at Gandhara and in central Asia, by which route the

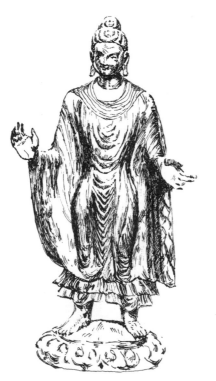

153. Standing Maitreya.

devotional cult came to China. One of the formative leaders in Chinese Buddhism was Tao-an (312–385) who as a monk assembled seven disciples before an image of Maitreya to vow collectively that they would be reborn in the Tushita heaven to obtain Maitreya's guidance; and they continued this cult with the repetition of Maitreya's name. Moreover this received support from the Emperor Fu Chien at Chang'an who donated Maitreya images, and these must have done much to popularize Buddhism among the unlettered masses (fig. 139, p. 161).[11]

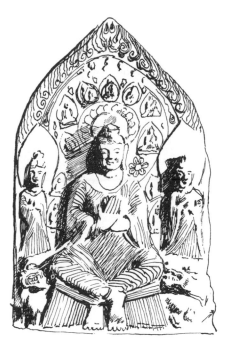

154. Seated Maitreya with halo, lions and attendants.

This fervour can be seen embodied in the many images of Maitreya (Mi-lo) made in China from the fifth to the seventh centuries. Out of this troubled period under the Northern Wei dynasty (AD 477) comes a majestic bronze conveying the splendour and spiritual command of the coming Buddha; one can well imagine the sense of vital hope and exaltation aroused in the worshippers. Stylistically this standing figure shows the cumulative heritage of the Buddha-images developed in the more Indian style of Mathura, the Hellenistic Gandhara style and that of central Asia,[12] but as a cult image it shows the Chinese tendency to portray Maitreya as already a Buddha and not simply as a waiting bodhisattva.[13] The details of the iconography can be traced from the numerous Maitreya images in their development during this period.[14] Several of these features are shown in the stone relief from the first half of the sixth century. The crossed ankles became a mark (for some, at least) of how Maitreya sat in heaven; he was shown enthroned with attendants at his sides and lions by his feet. Apart from the stylized folds of his garment, the most striking feature is the great nimbus decorated with flame and lotus patterns, the head of Maitreya is surrounded by miniature reliefs of the seven previous Buddhas, showing that he is their successor, and still living, a saviour waiting to come. The meditative aspect is beautifully expressed in the wooden image from Korea, early seventh century, to be further developed in the famous images of 'Miroku bosatsu' (the bodhisattva Maitreya) in Japan. There is an ambiguity about the pensive figure with flexed leg, for it could also represent the young Shakyamuni whose pattern he will follow.

Meanwhile in China the devotion of people and emperors issued in some colossal images among the cave sculptures of Yün-Kang and at Lung-men.[15] The cult of size derived not only from the desire for a permanent monument to Buddhism but also from the earlier belief that Maitreya was of tremendous size, linked to future well-being; and such colossi continued to be made down the succeeding centuries in China and Korea. In a less durable form the belief in Maitreya's coming inspired 'rebel ideologies' from time to time, from the early Maitreya societies

155. Meditating Maitreya (or Shakyamuni) from Korea.

whose leaders claimed to be incarnations of Maitreya to the later influential White Lotus Society (based on his traditional colour).[16] But as a devotional cult Maitreyanism declined in the seventh century. A count of images in such centres as Lung-men shows that by AD 650 the popularity of Maitreya had been replaced by that of Amitabha and Kuan-yin; these no doubt offered hope and blessings in a more appealing and immediate form, especially as preached subsequently by the 'Pure Land' school of Buddhism. After the greatness of the T'ang period Buddhism played a less creative role under the Sung dynasty (tenth to thirteenth centuries). At the same time it can be maintained that 'it is in the Sung dynasty that Buddhism began its most active period of involvement with the life of the Chinese people'.[17] In this period of popular religious sects there also emerged a form of devotion to Mi-lo. The older stately images of the future Buddha survived, but a completely different aspect is presented by Mi-lo Fo, the pot-bellied 'Laughing Buddha' of later popular Chinese religion depicted prominently in temples and domestic images.

The turning point of this metamorphosis was the story of a fat and jolly picaresque monk called Pu-tai who was a mendicant in the province of Chekiang and died in AD 916.[18] He carried around a hemp-cloth bag (Pu-tai, hence his name) and attracted children who clambered over him. When asked about the bag he would give mysterious non-answers in the style of his Ch'an Buddhist sect – 'How old is your bag?', 'As old as space'. He was a popular, if undignified figure, wandering with uncovered protruding belly and smiling face.[19] When he died it was rumoured in legend that he was still wandering and had the marks of a Buddha, or at least was an incarnation of Mi-lo. Wise sayings and Ch'an poems were attributed to him. The disreputable monk was really a saint, if a rather nonconformist one. This type of picaresque saint appears three centuries later in a traditional Chinese novel set in Chekiang about a drunken Ch'an monk Tao-chi.[20] It fits in with the tradition of spontaneity and unconventional answers and actions used as ways to enlightenment in early Ch'an (meditation) Buddhism.

These enlightened masters born Buddha-images and sutras, laugh in the face of inquirers or suddenly shout at them, and indulge in a thousand absurdities. Though they may behave like fools and possess nothing, yet they feel themselves to be true kings in their free mastery of enlightenment. They have no fear since they desire nothing and have nothing to lose.[21]

The nature of Zen iconoclasm will be further discussed in the following section on Japan. Meanwhile it should be noted that it took place within a framework of monastic discipline and belief in the Buddha-nature

156. Pu-tai, laughing pot-bellied monk.

pervading all things; this holds also for the Ch'an painters of the twelfth to fifteenth centuries such as Liang K'ai who could infuse this spirit into simple landscapes or shambling lumpish figures.[22] Freedom and traditional practice went together.

In the broader stream of Chinese culture and religion, however, the figure of Pu-tai took on other meanings. He was identified with the earthly incarnation of Mi-lo as a fat reclining figure, sometimes with children clambering over him; these jolly and folksy features are balanced by marks of Buddhist iconography such as the long ear-lobes, posture of royal ease and rosary in the hand. He could also be placed among the broad class of Lohan, the saintly Buddhists (Arahats) who could include incarnations of Bodhidharma the Ch'an master or of Mi-lo. The point is that he was now seen and acknowledged as an earthly figure; in terms of the Mahayana *trikaya* doctrine he was a manifestation of the Buddha-nature at the Nirmana-kaya level, the 'Body of Change' (Hua Shen in Chinese). The consequences of this for Chinese Buddhist temples were important in so far as the new form of Mi-lo was no longer suitable for the sacred rearmost hall which had been dedicated to Maitreya as the glorious Buddha-to-come. This earthly form had to be given a lesser and lower

157. Mi-lo, the 'laughing Buddha'.

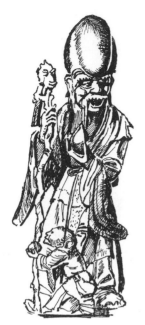

158. Shou-hsing, Chinese god of longevity.

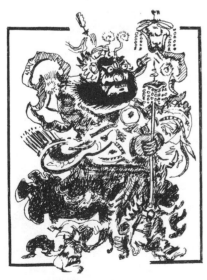

159. One of the door guardian gods (men-shen).

place – at the entrance to the temple building where a new front hall was developed. This naturally was more prominent from the worshipper's viewpoint; and thus the popular cult of Mi-lo Fo was enhanced and institutionalized.[23] Pu-tai was now so much identified with Mi-lo as the friendly figure of mercy and hope that the original Maitreya was forgotten. For instance at the Yung-ho-Kung ('Lama Temple') in Peking in the 1930s the colossal traditional image of Maitreya in the back hall was no longer recognized by the guide as Maitreya but designated as a more general 'manifested Buddha', Ju-lai.[24] In Japan the name of Pu-tai in Chinese characters was pronounced 'Hotei' and he became one of the Seven Gods of Good Luck, often represented in painting and carving.

The historian of religions might view this metamorphosis of Mi-lo as an example of a perennial tendency: the tendency of a spirituality, orientated towards the future and the world beyond, to become identified with material forms and worldly benefits. It is as if the colossal Maitreya had exchanged his height for an enormous stomach, with a bag denoting prosperity and material wealth, reclining in peace and contentment, happy with the children around him. But when we ask what these features meant for the average worshipper we can see that they are familiar 'Chinese life-ideals'.[25] The fat figure and his love of children and families come to the mind of a mother when she proudly calls her fat baby a 'porcelain doll'.

So another step towards the Sinification of Buddhism had been taken: the first god to greet the Chinese worshippers was bone of his bones and flesh of his flesh, and it was on him that the hope of Buddhism rested.[26]

Even monks could model themselves on Mi-lo Fo. In recent times they had their photographs taken in typical seated posture with protruding stomach, sagging breasts and a happy smile explicitly compared in the caption to that of the Laughing Buddha. The great Chinese Buddhist leader T'ai-hsü had an almost identical photograph taken in 1935.[27]

This extended example, by tracing the story of Maitreya through some 1600 years of Chinese Buddhism, has served to illustrate the process of 'assimilation' of a new religion to existing religious and cultural values.[28] Buddhism was accepted in China by taking its place alongside the existing religions and not by replacing them. Hence the early cult of Maitreya could not remain an independent Buddhist system but merged into other cultic practices and syncretistic sects. The Mahayana Buddhist pantheon was Sinicized and Mi-lo took his place in the popular Chinese pantheon. Thus a popular Shanghai lithograph of the 1920s–30s shows Mi-lo at the lowest level of four Buddhist tiers, guarded by the gods

Kuan-ti and Wei-t'o; and a devotional pantheon scroll places him, a distinctive bald-headed oddity, among eighteen so-called Buddhas.[29] The Mi-lo transformation also exemplifies one of the means of assimilation of the Buddhist pantheon – the category of the earthly Lohan applied to Pu-tai. Here is a process of 'euhemerization':

the tendency of a history-loving people to invest a god with the character and pedigree of a historical personality. . . . The Maitreyas, Amitabhas and other divinities had been transformed from symbols of religious ideas and aspirations into the pot-bellied patrons of one earthly concern or another, pawnbroker guilds, local industry, expectant motherhood.[30]

It will be appropriate to refer now, in conclusion, to some of these gods of Chinese folk-religion. They include a wide range of such deified men, nature divinities and gods governing the departments of man's life on earth.

Shou-hsing, the god of longevity, is not an object of temple worship but is much revered because of the Chinese regard for the blessing of old age, as at the birthday of an elderly person. He is shown as an old man with a white beard and an outsize forehead and bald head. He holds the peach of immortality in one hand and is often accompanied by a venerable turtle or stork; he may hold a dragon-headed staff with a gourd containing the elixir of life. He is believed to have decided the date of each person's death and written it on tablets.

Domestic protection is offered by the door-guardian gods (men-shen) just as the images of the celestial kings guard the vestibule of a Buddhist temple. These were also mythical beings originally but were replaced by deified generals. As two armed soldiers whose task is to keep away evil spirits, their pictures may be painted on doors or, for poorer homes, just stuck on in the form of cheap prints.

Kuan-ti is a clear example of an historical figure – the brave general Kuan Yu (d. AD 220) – who was renowned in stories and plays but not deified until the sixteenth century. He may be represented with his horse, in a green dress and with red face. His appeal was to both the group of scholars, officials and soldiers, as god of war to whom the official cult made spring and autumn sacrifices, and to the masses as a judge and protector to whom they could appeal. He is here a Taoist god and is also valued for predicting the future and as patron of literature and commerce.

Since the emphasis in the worship of these deities is on the practical benefits they will confer, it is not surprising that the god of wealth, Ts'ai-shen, is very popular not only with bankers and merchants but with any desiring financial prosperity. Taoism made him head of a ministry of wealth, following the idea of a heavenly hierarchy based on

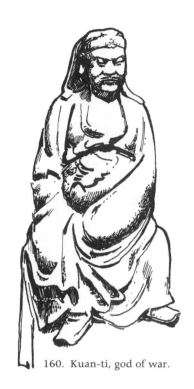

160. Kuan-ti, god of war.

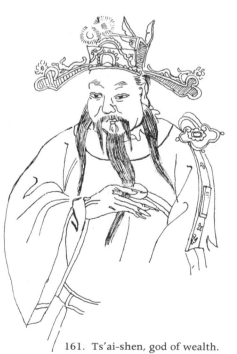

161. Ts'ai-shen, god of wealth.

earthly models. This idea applied also to the realms of hell in the Buddhist-Taoist system of hells presided over by the Yama kings (Yen-wang); these were related to ten law-courts which judged crimes and allotted the fearsome variety of tortures.[31]

Worship of the kitchen-god is of particular interest among the 'paper gods' of Chinese popular religion.[32] Although often crudely and gaudily depicted on the cheap prints, Tsao-wang and his wife are worshipped with circumspection for they witness all the words and deeds of the family and report accordingly to the Jade Emperor at the year's end to allot the next year's fortune. Before the annual report a sacrifice of sweets is offered to ensure sweet words from the god's mouth. During his few days' absence in heaven he does not see what goes on in the kitchen, which leaves room for freer behaviour. The old picture having been burned, a new one replaces it in the shrine over the hearth at the god's return at New Year, accompanied by fire-crackers and a sacrifice.

This indicates a very down-to-earth sense of the presence of the deity in the image, whether it be a paper god or the more usual clay image. Life is given to the image by placing small objects representing the internal organs into openings through the back, also by priestly ceremonies and the painting of the eyes. This recalls the use of images in India and a similar variety of images if found, including the worship of stones. The image is felt to guarantee the presence of the god, capturing this spirit and making it vivid and tangible to the worshipper. 'We make images of the gods so that we can see them and know what the gods are like.'[33] There are numerous temples which serve as palaces for the gods, ranging from tiny shrines to resplendent brightly-painted buildings housing the principal deity and an array of others of both Buddhist and Taoist origin.[34] Worshippers come to obtain the help of the gods by lighting incense, bringing sacrificial offerings and seeking their will by divination. Additional fervour and vividness are added by festivals such as that for the god's birthday and by theatricals – which are thought to entertain the gods as well as men.

Although certain deities such as Kuan-yin and Kuan-ti have led the field in popularity, it is clear that there is a tremendous variety of local and departmental gods according to place and time in China. Graham's survey in Szechwan over the period 1921–1948 indicates the changes that were happening before the advent of Communist rule.[35] The variety and the changes result from the Chinese functional view of their gods. Their cults wax and wane according to whether they work; if not, the gods can be neglected or dismissed. 'The gods are alive because they have manifested themselves through their works.'[36]

162. Tsao-wang, god of hearth and kitchen.

It is appropriate to lead on from China to Japan which derived so much of its culture from China. The advent of Buddhism in the sixth century AD gave Japan its script in the form of Chinese characters and a new art, architecture and iconography. Chinese influence on the arts and religions of Japan continued over the centuries with the result that some early Chinese forms have been better preserved in Japan than in China itself.

Nevertheless Japan had its own cultural roots which developed with the ingrafting of foreign elements. In the realm of art where it is sometimes hard to distinguish Japanese and Chinese works, the following general trends are contrasted by Paine and Soper: Japan gave more play to feeling and emotional longing in contrast to the ethical high-mindedness of Chinese arts influenced by Confucian standards; Japan favoured the concrete and the particular, the simple statement close to life itself, whereas China sought the universal, the symbolic and the intellectual representation; Japan long remained feudal with strict artistic traditions based on school lineage and master; Japan brought to a high pitch the art of decorative designing with a characteristic sensitivity, simplicity and charm.

To the Japanese the world was an object of beauty and pleasure. The satisfaction and the gaiety, which were basic, were sometimes tinged with Buddhist ideas of transitoriness or sometimes they reflected the ethical valuations of the Chinese, yet the pride of living in a country created physically by the gods, myths which in their day arose to explain the wonder the early inhabitants felt towards their bountiful land, derived from Shinto thought and gave to many forms of art an expression peculiarly Japanese.[37]

Likewise the various religious influences from China – not only Buddhism but Confucianism and religious Taoism – were interwoven with Japanese folk religion and become part of the heritage of Japanese life. 'The various traditions became so deeply rooted in Japanese life, that the ordinary villager considers every aspect of local religion as indigenous to his village.'[38] Local festivals and cults, the importance of clan, family and ancestors and a sense of national feeling all helped to relate these traditions to everyday life and reinforce a sense of cosmic harmony. As in China, and even more so, there is a basic sense of the closeness of man, gods and nature; man is related to the sacred powers whether they be Buddhas or Shinto 'gods' (*Kami*); all alike share in the beauty of nature.[39] Folk religion must be seen as a pervasive and continuing influence binding the plural traditions through such features as

seasonal festivals, domestic cults, mountain religion and the sacred powers of nature.[40] Bearing this in mind we shall now look at some of the distinctive Japanese developments in the Shinto and Buddhist traditions.

The indigenous religion of prehistoric Japan is obscure. Clay figurines from the Jomon period reaching back to the third millennium BC include quaint fish-eyed female images which may indicate a domestic cult of the Mother-goddess.[41] In the protohistoric period (second to sixth centuries AD) the Yamato people of central Honshu developed large tombs in which they placed terracotta figurines called *haniwa*; these served as tomb-guardians, perhaps substituting for people and possessions once buried with the deceased, and they represent soldiers, women, horses, monkeys and houses. The art of stylized representation was therefore not lacking, but the early religion of the clans out of which Shinto emerged made no use of images in worship. Cult-centres were extremely simple, without buildings and consisting of a sacred tree, stone or natural object marked off as a sacred space. This simplicity of the 'pure' element of nature is still a feature of Shinto, as is the use of ropes and the *Torii* arch as sacred markers. Sacred objects embody the divine powers which hallow all life and confer the blessings of harmony, rightness and co-operation on the varied enterprise of man. Shinto is not primarily a 'nature religion' but rather a community religion of family, clan and nation grounded in a sense of the harmony of the universe and of awe at the mystery of all life. It is an amorphous type of religion with no fixed theology and scripture. The multitudes of *Kami* are not so much gods as sacred powers embodied in cosmic forces, superior men, natural objects and even abstract principles. They take up their abode in objects which symbolize their presence, such as a special stone or mirror; these are regarded as the 'divine body' (*shintai*) which is housed in the innermost sanctuary of the shrine and constitutes it as a sacred place of worship.[42] Because of this direct presence of the *Kami* in sacred objects and symbols providing a bond between the human and sacred worlds there was no need for Shinto to develop images to represent the *Kami*. Shinto remains primarily aniconic, with the later addition of some images but not developing a distinctive Shinto iconography.

Although the *Kami* and their symbols are numerous and diverse, classic Shinto symbols are the mirror, the jewel and the sword. The mirror is a profound symbol of purity and clear light, and as the *shintai* of the Grand Shrine at Ise it is derived from the Sun-goddess Amaterasu whose spirit was caught by the mirror outside her cave. The *gohei* is a symbolic offering which can also be a symbol of the sacred presence. It is a wand with strips of paper folded in zigzag form hanging on each side and

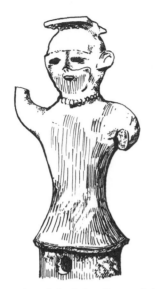

163. Haniwa, baked clay figure of the tomb guardian.

164. Gohei, Shinto symbolic offering.

stands in a central position before the inner doors of a shrine; in some shrines there may be more than one, representing several enshrined *Kami*. It is usually of white paper, but may also be coloured and of metal or cloth.[43] Miniatures of the Shinto symbols are found on the 'god-shelf' (*Kamidana*) of domestic worship. Here also may be found an *ofuda,* a sheet of paper folded over a supporting stick and imprinted with the name of the 'god' represented. When a person has made a pilgrimage to a Shinto shrine he can bring back this symbol of the *Kami* and place it either in his household shrine or over the entrance to the house to benefit from the continued protection of the family.

The more developed form of Shinto resulted from the example of Buddhism and the influence of Chinese culture. Thus the name Shinto is itself of Chinese origin (*shen-tao,* 'way of the gods') while referring to the distinctively Japanese *Kami* in contrast to the newly arrived 'way of the Buddha'. Chinese architectural forms were imposed on the simplicity of the earliest wooden shrine-buildings in the ancient traditions preserved at Ise and Izumo, leading to elaborate complexes of buildings and ornate curved roofs instead of thatch. As Buddhism became the dominant religion of the imperial court and state it supplied a more sophisticated pattern for Shinto, not only in its organization of temples and priests but also in its sacred hierarchy. In the eighth century period when Nara was the capital, the 'great Buddha' (*Daibutsu*) image was built there at the temple Todai-ji; and as Lochana and the so-called Sun Buddha, Vairocana, it was identified with the Shinto sun-goddess Amaterasu. This developed into a process of fusion whereby the Buddhas and bodhisattvas were regarded as counterparts of the Japanese *Kami*. In the following centuries of syncretistic *Ryobu* (two-way) Shinto the influence of Buddhist priests and practices was widespread. From this came the occasional use of images of Shinto gods and goddesses. The wooden image from the Kyoto area in the ninth century has its ultimate inspiration in Chinese Buddhism; but the face shows a mysterious puffiness characteristic of some Japanese images and the robe and headdress are not Buddhist.

The confluence of these traditions in religion and art is seen in the Toshogu shrine, a mausoleum to the great shogun Ieyasu (d. 1616). He was much influenced by Buddhism and his tomb is in the form of a bronze stupa, but he was regarded as a *Kami* at this Shinto shrine. The ornate polychrome carvings are not typical of the normal Shinto shrine, especially since the Shinto revival of the eighteenth to nineteenth centuries and the modern emphasis on ancient purity and simplicity of style. Shinto shrines do not usually feature paintings, but calligraphy may be used as an art-form along with the aniconic symbols. The popular shrine of the rice-

165. Ofuda, folded paper representing Shinto deity.

166. Shinto goddess from Kyoto region.

harvest god Inari at Kyoto (the Fushimi-Inari Taisha) occupies a whole hillside with its pathway, arched by many red-lacquered Torii, leading the pilgrim by sacred stones and the beauty of nature; the fox is here depicted frequently in images as the messenger of the *Kami* holding a jewel in its mouth. Shinto is a this-worldly 'way' of religion in which the *Kami* bless all aspects of man's life, but its distinctively Japanese tradition has incorporated many foreign elements in religion and art.[44]

167. Inari, Shinto god of the rice harvest with foxes as messengers.

Turning now to the Buddhist tradition we find explicit iconography as part of Buddhism from the outset of its establishment in Japan. When it was formally admitted in the mid-sixth century Buddhism came via Korea on the wave of Chinese culture with its script and scriptures, its impressive art and its promise of spiritual and material blessings. These were all new to Japan and proved very appealing to the ruling powers such as Prince Shotoku whose constitution of AD 604 made both Confucianism and Buddhism pillars of the state. The famous monastery of Horyuji which he founded in 607 near Nara not only became a centre of learning and community life but developed Buddhist art in the form of remarkable bronze images and wall-paintings based on the earlier Chinese style. These indicate that worship in early Japanese Buddhism was directed to a basic pantheon of four Buddhas: Shaka (Shakyamuni) the historic Buddha, Amida of the Western Paradise with his popular bodhisattva Kannon, Miroku the future Buddha and Yakushi the healing Buddha. The murals at Horyuji depict them receiving believers into their four Paradises. Bodhisattvas, saints, disciples and the four Guardian Kings fill out this familiar Mahayana Buddhist group which was to continue as the basis of Japanese developments in the following centuries.

168. Shaka-nyorai, infant Buddha.

Little more need be said about Kannon whose abundant compassion is expressed in many images (fig. 146, p. 164). The figure of Shaka is also central cultically. An interesting variant is the famous eighth-century bronze of the infant Shaka preserved at Todaiji, Nara. This is displayed at the festival of the Buddha's birthday on 8 April, for it depicts the scene of his 'seven steps' taken at his birth; here he points to the sky with his right hand and to the earth with his left claiming lordship over them. The Yakushi Buddha was lord of the Eastern Paradise but no rival to Amida; his renown was for healing, which is depicted by his attribute of a small medicine-jar, here held in his left hand but sometimes held in both hands of a seated Yakushi. It was primarily through the compassion of Kannon and the healing power of Yakushi that Buddhism made its appeal at the popular level. For the ruling class Buddhism offered protection for the state through its spiritual power, its teachings and its priests, as well as the prestige of high culture. Among the Buddhist rituals one which

affected all levels of Japanese society was the memorial service, as Shinto left the important area of funeral rites to Buddhism. This accords with the basic emphasis of Buddhist teaching on salvation beyond this world; but the history of Buddhism in Japan made it more world-affirming, more deeply involved in Japanese family life and culture and more diverse and expressive in iconography. This was the achievement of the emerging Japanese Buddhist sects.[45]

Shingon or esoteric Buddhism made an important contribution. As 'Chen-yen' (true word, mantra) Buddhism, it flourished for a short period in China, drawing on Tantric rituals and symbols as well as magical and cosmological aspects of Chinese Taoism. These were brought to Japan by the great religious thinker Kukai in the early ninth century who developed a system of 'Ten Stages of Religious Consciousness' leading to the supreme knowledge of Vairocana, the Cosmic Buddha. This made an intellectual appeal to some, while the Tantric emphasis on secret teachings to initiates had the added attraction of mystery. The Shingon readiness for syncretism of practices from India, China and Japan reflected the movement at this time for synthesizing Shinto and Buddhism. In addition to its appearance at the courtly level, Shingon could appeal to the masses with its magical practices, ritual formulae and richly expanded pantheon. Kukai's genius was able to harness these features to iconography; he himself excelled in the arts and appreciated them as a means of opening up profound truths to the understanding. The nature of the Buddha included the beautiful, and mastery of the 'three mysteries' – the actions, speech and thoughts of the Buddha – would enhance the ability of the artist.[46] This interrelation of nature, art and religion came to characterize not only Shingon Buddhism but the wider Japanese aesthetic attitude. Some examples will show the atmosphere of mystery and the specific iconographic contributions of esoteric Buddhism to Japanese art.[47]

The Great Sun Buddha Vairocana (Dainichi or Ichiji Kinrin in Japanese) is the primal source of all; his body is the universe which is understood in Shingon in the sense of pantheism or cosmotheism. Images such as the one from the late Heian period (*c.* 1100) express something of the awesome radiance of visions; he sits on a lotus with circles of light around his head and body, and the glittering crown on his head illumines the universe. He is also the source and revealer of truth – the higher esoteric truth of Shingon – and this is represented by the 'knowledge-fist', the Tantric *vajra-mudra* which is interpreted as the five elements of the world (the fist) clasping the sixth element, consciousness (the forefinger). The style of the earlier Shingon works is continued here, austerely spiritual and at the same time alluring 'with a kind of heavy Indian sensuousness, appeal-

169. Yakushi, healing Buddha with his medicine jar.

ing but still foreign';[48] this foreignness has now been absorbed into a Japanese style which is more lifelike and charming but suffused with a sense of mystery derived from the esoteric Tantric tradition.

An important innovation which Kukai brought back from China was the mandala, originating in India as the magic circle used for Tantric meditation. Since the world is based on dualities there are two complementary mandalas in Kukai's system of 'Ryokai' (both-circles) designed to frame the great pantheon of Shingon Buddhism. The 'Kongo-Kai' represents the Diamond or Vajra circle of the eternal 'indestructibles'; this refers to Vairocana who is shown as the Great Illumination in the centre of the upper row of nine squares, with the four hundred and thirty-seven Buddhas who are his emanations arranged in the squares and circles beside and below him.[49] The correlative 'Taizo-Kai' represents the womb circle of the changing world with its rows of deities who are partial manifestations; these came to include Shinto *Kami* under the

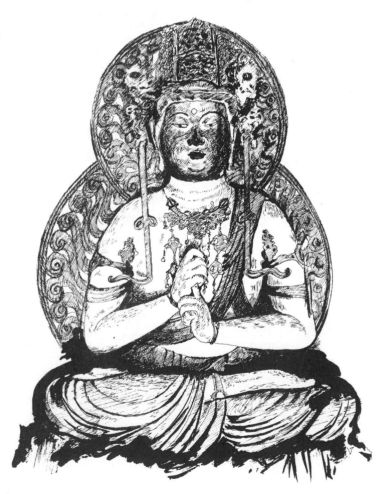

170. Ichiji Kinrin (Dainichi).

Buddhist theory of their being manifestations of the original substance ('Honji-suijaku').[50] The centre part shown in detail places Vairocana at the centre of an eight-petalled lotus for the four 'Dhyani' Buddhas and their bodhisattvas (Monju, Kannon, Miroku, Fugen). This pair of large mandalas is a feature of Shingon temple worship. It is intended as a cosmogram summing up the complementary eternal and dynamic categories of the Buddhas; absolute wisdom and redemption in the world. In meditation it is intended as a psychogram by which the viewer identifies his own innermost being with the cosmic essence, the microcosm with the macrocosm.[51] The mandala also serves as a model in some Shingon altar rituals, and it has wider applications in traditional architecture and town planning, but its primary religious purpose is to aid the worshipper to find his way to the Buddha-centre of the universe and thus be reintegrated.

This is brought out most clearly in the Shingon discipline (yoga) of ritual and meditation which Carmen Blacker aptly sums up as a method of 'symbolic imitation'.[52] The esoteric rituals, formerly secret to initiates, are an external performance of imitating the symbols and icons of the Buddha in order to release the Buddha-nature within and thus bring about a shift of consciousness. In Shingon the Three Mysteries provide the

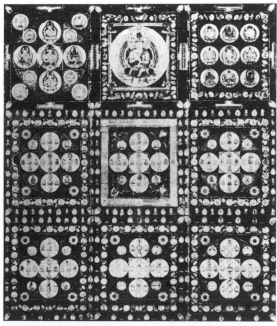

171. Kongo-kai (diamond-circle) Shingon mandala.

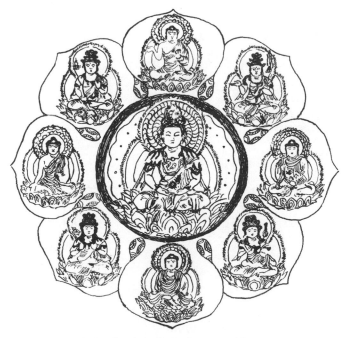

172. Taizo-kai (womb-circle) central lotus section.

basic framework of symbols – the bodily actions in the form of mudras with many forms and esoteric meanings, the Buddha's speech in the form of sound ('sonorous forms of the divinity') and the thoughts of the Buddha symbolized by visualized shapes and forms. When the disciple visualizes a lotus, just as when he utters a mantra, he is rousing up an image already latent within. In the intensive re-enactment of the ritual drama the disciple has to use these symbols. He has to visualize a mandala as a universal Mount Meru, a lotus, a palace and finally Vairocana; he then summons the Buddhas into his mandala until Vairocana is fused with the disciple, 'entering me and me entering'. The ritual drama thus symbolizes an inner awakening.

The repeated 'acting out' of this climactic union is believed to bring about its own reality, so that the disciple achieves his final end of *sokushin-jobutsu*, becoming a Buddha in this very body.[53]

One can recognize the Indian Tantric origin of this discipline. Likewise the much-expanded pantheon of Shingon shows the incorporation of Hindu deities with multiple arms and faces, such as Brahma (Bon-ten). Guardian Kings are depicted with fearsome visages and terrifying displays of power. An important figure of this type is one of the Wisdom-Kings, Fudo ('the Immovable') whose wooden image was said to have been brought by Kukai to Japan. The iconographic marks are a sword with a *vajra* symbol on its handle, a rope or lassoo to capture the evil demons and a glaring fearsome appearance. Later features shown here include a dragon on the sword and a nimbus of fierce flames to burn up illusion. All this is in the service of Vairocana whom he manifests in Japan; wrath against evil is for a benevolent purpose, that of bringing all beings to attain Buddhahood, in this respect using his power like the compassion of a bodhisattva. This tension contributes to the numinous power of Shingon images and one can sense the impact of such a flame-surrounded Fudo when shown amid the firelight and incense of a late night ceremony. Mystery of a quieter sort is felt in some other esoteric images where the half-opened eyes convey the sensuous enchantment of a day-dream. Of the six-armed Nyoirin-Kannon kept in a dark cupboard at Kanshin-ji, Osaka, Yashiro comments:

The limbs seem to move in mysterious rhythms, pulsating with warm blood beneath the white skin of the plump arms.[54]

In its art as well as in its ritual Shingon Buddhism exerted the appeal of its 'magic and mystery'. It gave its images special importance as embodying the Buddha-essence and the powers which the believer could appropriate in himself.

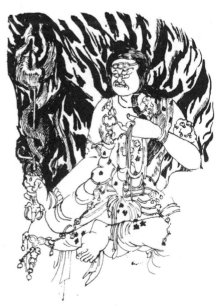

173. Fudo, Shingon 'King of Wisdom' (Myo-o).

Contemporary with Shingon in the Heian period and equally influential was the eclectic Buddhism of the Tendai sect, likewise derived from China in the early ninth century. Its great Japanese founder Saicho gave the *Lotus Sutra* a central place and also brought from China the way of faith in Amida and the practices of Ch'an Buddhism. These were all to prove important for the new medieval sects, even if Tendai iconography is less vividly impressive than that of Shingon. The interplay of the two major sects produced some inspiring images of Amida as the gracious Buddha of the Western Paradise whose name the faithful glorified by repeating the 'Nembutsu'. The gilded wooden image by the eleventh-century sculptor Jocho shows Amida meditating on a lotus but not in remoteness from man. His half-closed eyes seem to be fixed on the worshipper who is subtly related to him as the receiver of his promise

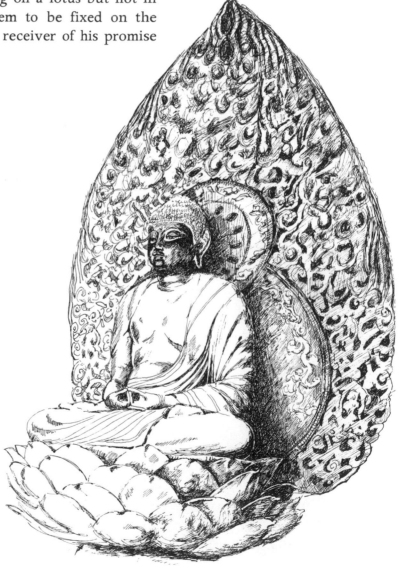

174. Amida Buddha in meditation on lotus with nimbus.

and gentle mercy. The glories of his paradise are symbolized by the ornate flame-like nimbus backing the image. More colourful and dramatic again are the paintings depicting the 'Raigo' (descent) of Amida who is not only approachable but in dynamic movement, rushing downwards to save men; he is accompanied by some twenty-five bodhisattvas whose plump and cheerful expressions as well as their joyful music welcome the faithful to paradise.[55] An interesting use of this theme is the 'Yamagoshi-Amida' who appears from behind the mountains resplendent with an enormous halo, as the Buddha of Infinite Light; in the foreground stand the smaller figures of the two accompanying bodhisattvas, Seishi praying and Kannon bringing a little lotus throne for the believer. This is a large scroll-picture from the thirteenth century when Amidism had gained a large popular following through the evangelists of 'Pure Land' Buddhism. One can imagine the intense devotion inspired by such a scroll at times of approaching death when strings could be drawn from the hands of Amida to the hands of the believer on his deathbed. Earth and its troubles are dwarfed by the huge Amida, of whom a text says: 'Sounds of celestial melody are heard far off, and from the regions of the setting sun Amida comes to save the world'.[56]

It is appropriate to mention some other figures popular in Japanese Buddhism. Among the bodhisattvas (*bosatsu*) the major ones were brought from China at an early date and it is possible to compare the iconographic forms with paintings from the seventh to tenth centuries preserved at Tun-huang on the crucial central Asian entrance to China where the Indian traditions of Buddhism mixed with others.[57] Avalokiteshvara proved to be no less beloved in Japan as Kannon. Samantabhadra (of 'omnipresent goodness') was associated with Shakyamuni in the Lotus sutra and as Fugen was emphasized in Japan by the Tendai sect as the protector of all devotees of this sutra. He could be taken as the representative of the Buddhist discipline of reason and concentration; but his wider popularity was associated with his power to save women and even to prolong life. Fugen is attractively shown seated on a lotus on his characteristic mount, a white elephant, which may have several heads each with six tusks. The bodhisattva Manjushri personifies supreme wisdom, said to be symbolized by the five knots of his hair for the collective teachings of the five Buddhas. He carries a sword (wisdom striking down the obstacles to enlightenment) and a sutra scroll. Seated on a lotus, his mount is a lion, here shown crossing the sea from India to China; his sacred mountain, Wu-t'ai in China, was a pilgrimage place. As Monju in Japan his greatest popularity came in the twelfth to thirteenth centuries as a guarantor of salvation through his wisdom.

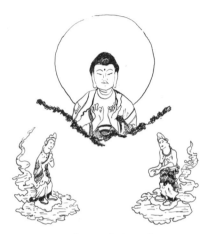

175. Yamagoshi-Amida (Amida appearing behind the mountains).

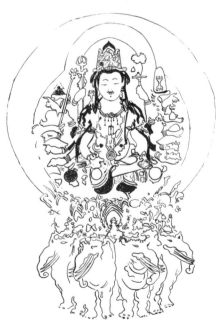

176. Fugen (bodhisattva Samantabhadra) on elephant mounts.

Most popular of all after Kannon, was Jizo. Of minor importance in India as Kshitigarbha (meaning 'earth-womb') his name connected him to the earth and lower world where he became counsel for the dead, consoling and alleviating their sufferings in hell and also helping bereft children there. This power to dispel darkness below led to his being a curer of darkness above as the healer of eye diseases and as guide of the dead he also became a guardian of travellers. Because he had been a woman in previous existences he was renowned as a helper of women and children, while some small images of him reflect a phallic cult. It is not hard to account for the continued popularity of Jizo since the eleventh century. He is depicted in kindly human form in a monk's robe with shaven head, a holy man who had vowed to devote himself to helping mankind until the coming of Miroku. His status as bodhisattva is indicated by his halo and lotus stand and even by an *urna* on his forehead. In one hand he holds a staff to open the doors of hell, surmounted by six tinkling rings to warn living creatures in his path, and in the other the inexhaustible jewel for granting human wishes.

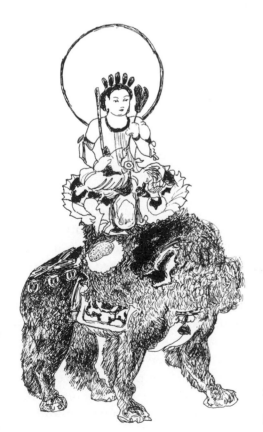

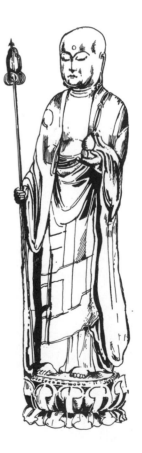

177. (*left*) Monju on lion mount (bodhisattva Manjushri).

178. (*right*) Jizo (bodhisattva Kshitigarbha) in monk's garb.

Complementary to Jizo but at a lower level is Emma-o, originally Yama, King of the dead and master of hell in the Hindu tradition continued by Buddhism. In China and Japan he is depicted as a Chinese judge meting out punishments, red-faced and angry though occasionally relaxing and granting an extension of life. Sitting at his judge's table with an official tablet he has secretaries in attendance to supply the records and subordinate kings of departments of hell. Emma-o is also aided by a mirror reflecting people's past deeds and a staff with accusing faces. He is just one of many figures from India, China and Japan which expanded the Buddhist pantheon by the addition of deities popularized in legend and folk-lore. In Japanese popular religion of later centuries there developed the group of 'Seven gods of Good Luck', mainly of Chinese origin and representing the desire for wealth, happiness and long life, such as Hotei and Daikoku.[58] Their pictures lend themselves to humour and caricature, and while they are not used as objects of worship they are often charms and omens of good luck and business prosperity.

Meanwhile the main stream of Japanese Buddhism was deeply affected by the emergence of the great popular Japanese sects in the twelfth to thirteenth centuries. Confronted by troubled times and a sense of crisis in what was believed to be the cataclysmic last age with the 'decline of the law', leaders trained in Tendai Buddhism developed new methods and teachings to meet the needs of farmers, fishermen and military men of Japan. They selected for emphasis certain teachings, scriptures and forms of discipline and devotion which gave their sects a more intense and exclusive tone. While this did not lead to any real iconoclasm it led to a selective use of images with new practices and interpretations. The popular 'Pure Land' evangelicalism of Honen and Shinran focused all on faith in Amida alone, with a corresponding simplification of worship. In the temples of the widely followed Jodo Shinshu sect there are no images of Buddhas apart from Amida and the bodhisattvas, enshrined in a side building; Shaka is neither represented nor worshipped, presumably being identified with Amida.[59] The main hall is dedicated to the founder Shinran whose image is enclosed behind the golden-decorated high altar.

Nichiren Buddhism takes an opposite line, opposing Amidism and proclaiming the *Lotus Sutra* as the exclusive scripture and hope for the nation, with the historic Shakyamuni as the Buddha. Nichiren temples therefore feature images of the seated Shaka and the former Buddha Prabhutaratna as recorded in the *Lotus Sutra*. But between the two is the distinctive mandala (*mandara*) of Nichiren which expresses in vertical writing the invocation of the title of the sutra which is the true object of worship: 'Hail to the wonderful Law of the Lotus!' The mandala includes

179. Emma-o (Yama-rama), King of the dead, judge and master of hell.

the names of the two Buddhas and the kings of the four directions, thus representing in Japanese characters the all-encompassing truth.[60] It is an inscription of the Buddha body in aniconic form. Nichiren himself, in taking his name meaning 'sun-lotus' was identified with this and saw himself as a bodhisattva in Japan's time of need; his image in a central cabinet in Nichiren temples is displayed briefly during rituals. It is even claimed that Nichiren wrote himself into the mandala, inscribing his life in ink, so that he is a true Buddha fulfilling the work of Shakyamuni. This is the view of the influential modern Soka Gakkai movement attached to the Nichiren Sho sect through its patriarch Nikko. Consequently the Soka Gakkai altar displays images of Nichiren and Nikko, both reading the *Lotus Sutra* whose glory is proclaimed in the central mandala. The supreme object of worship (Gohonzon) as the Buddha is thus represented visually in the mandala and repeated verbally in devotional recitation of the invocation (Daimoku); these are both sources of power to be received in the body of the worshipper.[61]

The third sectarian movement, Zen, has already been mentioned in its Chinese form of Ch'an (Dhyana or meditation) Buddhism. It set little store on traditional doctrines and sought the attainment of enlightenment by meditation and insight into everyday experience. This practical directness, itself a return to the original emphasis of the teaching of Gautama, appealed to ordinary folk, and the Rinzai Zen school's method of sudden enlightenment, through concentration on the stimulus of the master, appealed to the warriors of the Kamakura period. The Zen style influenced not only the martial arts but the whole culture of Japan through its simplicity, intuition and feel for nature, derived partly from Taoist influence in China.[62] The most characteristic Zen works represent nature and everyday objects, but also in depicting human figures Zen could draw on the grotesque and even the comic to express the immediacy of experience. We have already seen this in the figure of Pu-tai, and in a similar way Zen gave a novel twist to traditional Buddhist iconography.

These features are evident in the famous ink-painting of Bodhidharma, the founding patriarch of the Ch'an sect in China who had come from India in the sixth century AD. He is the archetypal meditator, resolutely sitting in the solitude of a cave for nine years. His eye has a fierce glare which expresses his spiritual concentration and his piercing challenge as a master to pupils.[63] His would-be-disciple Eka seeks to prove his earnestness by cutting off his own forearm. Legends recount how the tea-plant sprouted from the eyelids of Bodhidharma who had cut them off to keep himself awake, and how his legs withered away through years of disuse in meditation. This is the explanation behind the popular dolls of Daruma

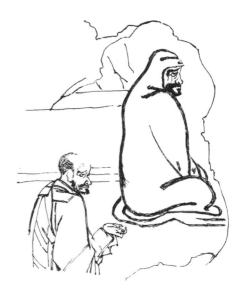

180. Bodhidharma meditating in a cave.

(his abbreviated Japanese name) which display his unmistakable glaring eyes. The stumpy legless doll is so weighted that when rocked it always rights itself like the imperturbable patriarch himself; an inscription reminds one of the saying: 'Seven falls and eight recoveries'. In this respect the doll is a bringer of good luck, and one custom is to paint in the eyes only after the good luck has eventuated. Daruma has here been absorbed into folk religious custom[64] which may well derive from ancient belief in the magical power of doll-like ancestral deities. Even as a charm and a children's toy the popular doll in its various forms pays silent witness to the Zen master and the power of disciplined meditation.

Another important emphasis in Zen art was the humanization of iconography. Traditionally Buddhas and bodhisattvas were portrayed with the idealized features of their 'glorified body' in the second realm of the three bodies (*trikaya*) of the Mahayana cosmos, but in Zen doctrine these distinctions did not hold. All beings belonged in all three bodies if they had an earthly body, were freed from attachment and were one with the absolute Buddha-nature; therefore the most ordinary people and things could be expressions of the supreme truth. The bodhisattvas did not need to be shown with the traditional marks of the world above, so the Ch'an painters broke through the conventions to depict them in unorthodox clothes and settings. Likewise the figure of Shakyamuni, traditionally idealized as the completely enlightened one reassuring the faithful with his power, was now shown as the earthly Buddha in his experiences of striving as an Indian monk in search of enlightenment. The picture of 'Shussan Shaka' became a typical theme of Ch'an painters in twelfth-to-thirteenth-century China such as Liang K'ai and in Japanese Zen painting also. This is the scene of Shakyamuni descending the mountain where he has been fruitlessly searching for enlightenment through ascetic austerities; he is emaciated by the fasting, roughly bearded and huddles in his windswept robe – a lonely and battered earthly figure who still presses on. This expresses the Zen interpretation of Shakyamuni as the historical founder of Buddhism to whom the Ch'an masters traced their succession through the twenty-seven patriarchs prior to Bodhidharma.

The Zen emphasis on transmitting teaching by personal contact between master and pupil produced many portraits of monks and patriarchs who represented the spirit of wisdom and enlightenment. Such portraits did not originate with Zen, as shown in the fine sculpture of the priest Ganjin in the Nara period[65] and paintings of great *lohan* and patriarchs in China and Japan,[66] but these were usually idealized in the service of Buddhist teaching and magical powers. With Zen the figure is portrayed

181. Red painted clay doll representing Daruma (Bodhidharma).

with simple realism on the one hand – a monk sitting in a tree meditating – but also suggesting that in his earthly body he is able to realize enlightenment as one already sharing the Buddha-nature. Since Zen avoided relying on the scriptures the subject-matter of its art was not the themes of the sutras but the tradition and teachings of the Ch'an masters, their contact with ordinary people and their everyday activities in the world of man and nature.[67] Here was a clear departure from traditional Buddhist iconography in the direction of the 'secular world'.

This leads to a consideration of the iconoclastic element in Zen. When the sixth patriarch Hui-neng tore up the scriptures (shown in Liang K'ai's famous ink-painting[68]) he was rejecting any written authority for Zen and relying solely on the Zen experience of intuitive insight for enlightenment as handed on in the monastic tradition from master to disciple. For anything else is liable to make one dependent and 'attached', to which the Zen answer is a relentless overturning of all idols. The rough-fisted Lin-chi, the Chinese founder of what became the Rinzai school of Zen in Japan, is reputed to have said:

> When you meet a Buddha, kill the Buddha;
> When you meet a Patriarch, kill the Patriarch.

As applied to idols in the tangible sense, iconoclasm is the theme of a classic anecdote of the Ch'an master Tan-hsia (738–824) who burned a Buddha-image to keep himself warm. When questioned he gave the tongue-in-cheek excuse that he was burning it to obtain its *sharira*, the indestructible 'relic' believed to reside in the ashes of holy men. This became a subject for Zen painters who brought out the comic implications – notably in the works of Fugai and Sengai (*c.* 1800) who depicted Tan-hsia bending over the flames warming his posterior.[69]

182. Shaka (historical Buddha) descending the mountain.

Humour is one of the characteristic means of Zen iconoclasm, using laughter to stand idols on their head and take away their absolute claims. An element of caricature appears in the fifteenth-century Josetsu's picture of 'The Three Teachers' as funny-looking old men; these are none other than Lao-tzu, Confucius and the Buddha, viewed in the Chinese syncretist tradition as manifesting one truth.[70] Laughing monks and cross-eyed patriarchs are depicted in the same spirit as the picaresque figure of Hotei, carefree and full of the peace of Zen.[71] Later paintings of Hotei continue this tradition in a somewhat more secularized form – Hotei on his enormous round bag (symbolizing perfection) pointing to the moon, kicking a football or playing cat's cradle. Thus playfulness is an integral part of the Zen tradition with its origins in China epitomized both in Bodhidharma, with his stern discipline of meditation, and in

Pu-tai with his pot-belly and carefree smile. Both belong in Zen experience and art, for the laughter is not opposed to seriousness but 'in tune with seriousness', 'a frivolity which emerges out of the harmony of spontaneity and discipline'.[72] This is the proper perspective in which to place Zen 'iconoclasm', for it is not customary in Zen to chop up the images for firewood. On the contrary, they are treasured and given due reverence, in accordance with Buddhist tradition and the monastic discipline. But the images are not worshipped with attachment; they are reminders of the Buddha's way to enlightenment which each person must follow for himself.

Thus in Zen the Buddhism of the Far East returns full-circle to the archetypal experience of the historical Buddha. Although it is only one of the influences in Japanese religion and iconography, as we have seen, its influence has been pervasive and it represents a recovery of some basic Buddhist teachings in a Japanese form. It even returns to the aniconic forms of early Buddhist art in its symbolism and calligraphy. In depicting simple things such as a fly-whisk, a tea-pot, a bird or a cloud, in a landscape, Zen art can suggest the oneness of all things in the great emptiness and thus transcend the tangible. Here lies the power of such a master of ink-painting as Sengai[73] (1750–1837). His three linked symbols may be read as a picture of the universe in its three basic forms – the square for man with his earthly house, the triangle for the fixed law of nature and the circle for the infinite, heavenly. There are other interpretations which see them as symbols of schools of Buddhist teaching (Zen being the circle). These forms are also basic to the traditional mandala, but in the spirit of Zen they express the unity of all realms in the one Buddha-nature. Again in the art of calligraphy[74] Zen drew on the ancient tradition of Chinese

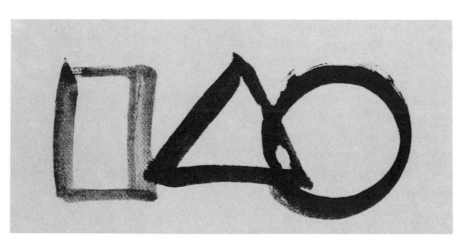

183. Square, triangle, circle – fundamental forms of universe.

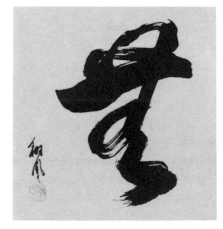

184. Zen Buddhist symbol 'Mu' (emptiness).

writing to express the Zen method; after meditation and concentration one draws the characters in rapid succession and in an apparently effortless flow as if guided by the 'Zen mind'. The characters thus drawn have a significance over and above any beautiful technique of writing. A character may even be given the highest place in iconography when it is set at the top of a scroll above other figures in the sacred hierarchy (in descending order from Buddhas and bodhisattvas to wisdom-kings and gods) ranged below. The simple character, like the form of the circle, becomes a non-representational symbol:

Both of these imply the highest positive form of true reality: something that can no longer be expressed in words, but may be experienced in every object encountered and at every moment of time.[75]

Tibet

One of the most elaborate systems of religious iconography was developed in the isolation of Tibet where its 'Lamaistic' form of Buddhism flourished for a thousand years until the theocracy ended in 1959. Prior to Buddhism the native Tibetan religion, Bon-po, centred round guardian spirits and demons, controlled by rituals and the ecstatic techniques of shamans. Among the monks who brought Buddhism to Tibet from the seventh century AD, the most famous was Padmasambhava (747) a Kashmiri trained in Bengal as a Tantric magician. He was reputed to bring the demons of Tibet under the spell of his mantras and magic thunderbolt and even to turn them into defenders of Tibet and Buddhism. This control of the demon world is characteristic of Tibetan Buddhism which features mystery plays and demon dances performed by monks in terrifying masks. The ancient religion is thereby incorporated in rituals for catharsis and entertainment, and still survives in the use of skulls, magical daggers and representations of violent demonic deities. At this point the influence of Indian Tantric practices and iconography is also involved. Tibet received the Mahayana Buddhist pantheon from India along with Hindu deities and their Shaktis and added further multiple manifestations of Buddhas and bodhisattvas to incorporate the Tibetan spirits and demons. Tibet thus preserved and elaborated the Tantric Buddhism of medieval Bengal, weaving in its native religion and further influences from Nepal, central Asia and China to create a uniquely Tibetan style of religion and art.

As in the case of Japan, it was Buddhism which brought writing to Tibet and fostered through its monasteries a rich development of the arts.

Tibetan art remained primarily art for ritual purposes, made by anonymous artists according to strict patterns. The resulting continuity makes works difficult to date; few can be dated earlier than the seventh century. The iconography is expressed in a rich variety of forms,[76] from paintings and banners to sculptures in metal, wood and butter, ritual objects, diagrams and calligraphy. Here we can do no more than discuss a few significant examples.

The Shri Yantra has already been described in connection with the goddess Kali and the union of Shiva and Shakti in the Hindu use of this diagram (see above ch. 4). Nine grades of revelation are symbolized by the five 'female' triangles pointing downward interlocking with the four upward 'male' triangles.[77] This union of the sexes in mystical marriage was adopted in Tibet to represent Buddha-figures in many manifestations, no longer alone but embracing their female partners (Shakti); as 'father-mother' in *yab-yum* embrace they symbolize complete union of wisdom and compassion in the fullness of being. The empty centre of this diagram represents the Absolute which cannot be visualized yet which is one with the heart of the person meditating on it. Tibetan iconography places at the centre the supreme Adi-Buddha. In the cloth-painting mandala it explicitly depicts Vajrasattva surrounded by the major transcendent Buddhas and bodhisattvas according to the teachings of Mahayana and

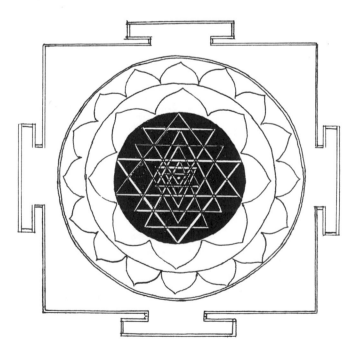

185. Shri Yantra, meditation diagram in Tantric Hindu tradition.

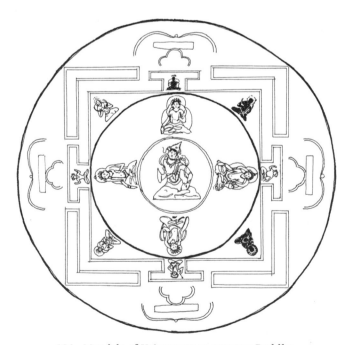

186. Mandala of Vajrasattva as supreme Buddha.

esoteric Buddhism; as also in the Shingon 'Taizo-kai' mandala. Used in meditation it represents the path to deliverance; outer circles stand for purification and initiation as preludes to spiritual rebirth; the gates of the inner square mandala admit the seeker to the ascending presence of the Buddhas culminating in the attainment of nirvana with the Absolute Buddha at the centre (fig. 172, p. 187).

The most common function of the mandala is to provide a ground-plan of the cosmos for invoking the 'deities' in ritual practice. A mandala of coloured sand on the ground represents the dwelling-place from which the sacred figure confers his powers on the officiating lama. The iconography is primarily related to liturgy and the temple where this occurs is itself modelled on the mandala, containing the major symbols of the Buddhas in the form of the three 'supports'. These are, first, the body supports in the visual form of images and paintings (which in the temple setting may be much larger than the examples usually seen in museums); speech supports are books derived from the words of the Buddha; mind supports are stupas (*chorten*) symbolizing his enlightened mind.[78] These are supports for meditation and rituals and serve not only the devotions of monks but also the popular Tibetan practice of religion which can be summed up in five universals: faith, 'speech work', offering, salutation by gestures and prostrations, and circumambulation.[79] The latter two categories represent 'body work' which is often focused on images. Of particular interest is the performance of circumambulation, an ancient Indian ritual (*pradakshina*) brought by Buddhism and developed into a pivotal rite of Tibetan society. It may be performed around the focus of images of all sizes, scriptures and persons of spiritual renown (who themselves are the object of much iconography); more frequently *chortens* and monasteries and trees or sacred places supply the focus. In his act of 'going' the Tibetan can bring his animals also, thus expressing the Buddhist attitude to the unity of living beings as he participates in the microcosmic ritual.[80]

Of the many symbols and ritual objects used in Tibet the most important is the *vajra* which gives the Sanskrit name to the major school of Tantric Buddhism.[81] Originating in India it meant the thunder-bolt or lightning sceptre of the god Indra. In Mahayana Buddhism it came to mean the indestructible supernatural substance, hard as a diamond. The idea of emptiness was developed by the Vajrayana school, applying to enlightenment and its goal of the Absolute Emptiness of the indestructible Buddha-nature. In the form of the ritual sceptre it thus is the possession of the Buddhas who wield it as the sign of supreme wisdom which overcomes all obstacles. Called *dorje* in Tibetan, the vajra is used ritually by monks. The

187. Vajra, thunderbolt symbol of the Absolute in Vajrayana Buddhism.

central part of the holder is interpreted as emptiness, while the four outer prongs and axis at each end symbolize the five Buddhas who join at the tip in a mandala pattern. The vajra is also used to surmount a priest's bell, in which case the sexual polarities are understood – the diamond world above and the female womb world of earthly phenomena below, fulfilled in unity.

When we turn to the distinctive sacred figures of Tibetan Buddhism the Taras occupy an important place. Again originating in India, probably as a Hindu goddess, Tara embodied the Shakti female principle as it was taken up into Tantric Buddhism. As the White Tara she became the Shakti of Avalokiteshvara who was believed to be more receptive to prayers when thus accompanied; then she became a bodhisattva in her own right and a much revered saviour-goddess and mother-goddess figure. (She is said to have originated from tears of compassion shed by Avalokiteshvara.) Just as Shiva and his consorts take terrible as well as benevolent forms, so the twenty-one Taras include the menacing (red, yellow, blue) and the gentle (white, green). The latter two are symbolized by the open lotus and the closed water-lily, signifying that by day or night one or the other soothes human suffering and guides people to wisdom and salvation. In this role the white and green Taras are popular in Tibet and the Himalayan area.[82]

On the other hand we confront a host of fierce and terrifying figures in Tibetan Buddhism, evidently derived from both the ancient heritage of demons and the angry forms of Indian deities. Instead of the calm medita-

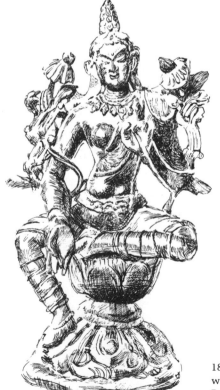

189. Green Tara, saviouress representing wisdom and compassion in Tibetan Buddhism.

188. Vajra bell, Tantric symbol of union of Diamond and Womb worlds.

tion of the Buddha these figures, even if regarded as benevolent, express sex and aggression in an ambivalent way.[83] Thus the fierce *dakinis* are female spirits who are said to give wisdom in initiation but they are also seductive and destructive denizens of the cemetery world over which the initiate must triumph by meditation. The many-armed Hevajra with his consort is a version of Shiva in Tantric Buddhism. The terrifying Heruka figures have four faces, six pairs of arms and a Shakti, thrusting out a leg in demoniac rage. These are frequently featured in Tibetan *tankas* (thangkas), large paintings on hanging scrolls of cotton which may have the central circles full of wrathful Herukas and hordes of demons.[84] The bronze of Yamantaka depicts a fearsome figure with sixteen legs, thirty-four arms and several skull-bedecked heads of which the front is the head of a raging bull. Yet his name means literally 'conqueror of death' and salvation comes through his union with his Shakti. He is therefore regarded as a *yi-dam*, a guardian spirit of the Tibetan church.

The cult of the macabre, the violent and the horrifying does not have the last word. That is reserved for the indestructible supreme Buddha who surveys all from above in the comprehensive iconography of some tankas. Nor is the earthly Buddha forgotten. Gautama is usually shown at his enlightenment, in the earth-touching mudra; and the centre of a large scroll full of figures and scenes from his own life shows him thus with this two leading disciples, Sariputra and Maudgalyayana. The serene calm of the Buddha does triumph after all, as in the history of Tibet it was able to pacify the wildness of the inhabitants.

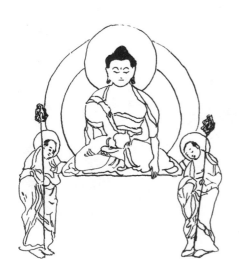

191. (*left*) Gautama Buddha with disciples.

190. (*right*) Yamantaka (conqueror of Yama, god of death) with bull's head.

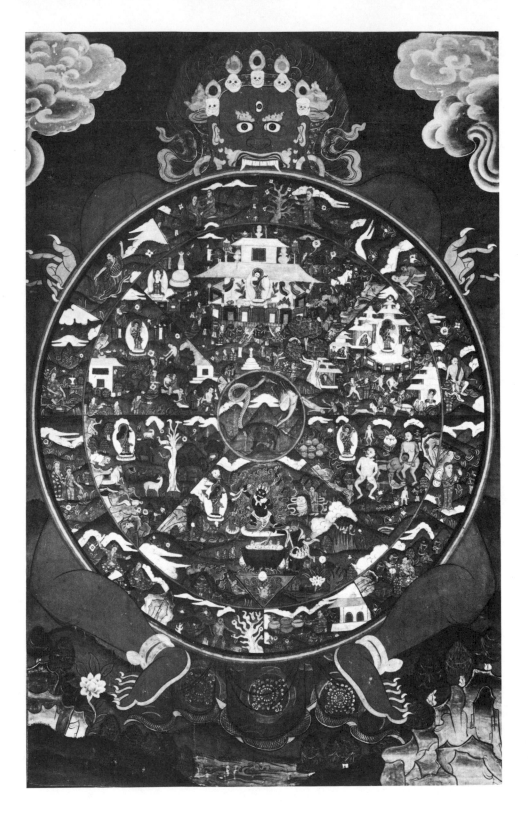

192. Wheel of life, cycle of becoming
(*samsara*) in the grip of the demon, Time.

A similar tension is felt in the 'Wheel of Life' painting which is usually displayed in the vestibule of Tibetan temples. It expresses visually the Buddhist conception of the cycle of transmigration (*bhava-chakra*) in which life inevitably leads to death and rebirth. The wheel is in the grip of a monster demon with fangs and long nails and a fearsome third eye; this is the demon of time (Kala), the impermanence which pervades all. In the hub of the wheel the cock, snake and pig symbolize the cardinal sins of greed, hatred and ignorance. The outer rim shows the twelve scenes from the chain of causation in one's life leading to continued rebirth, according to the doctrine of *karma*. The six interior segments show the six worlds where rebirth may occur – the superior worlds of gods, titans (*asuras*) and man, and the inferior regions of animals, hell and hungry ghosts. Each of these has its Buddha, indicating again that an answer is ultimately available in Buddhist teaching and wisdom leading to enlightenment and liberation. All this is standard Buddhist doctrine which, like the basic Buddhist iconography, reasserts itself in the midst of the strange and apparently alien forms.

Summary

In the religious traditions of China, Japan and Tibet the advent of Buddhist scriptures and art brought a rich iconography into being, but in each case the heritage of indigenous religion coloured the reception of Buddhism, giving a distinctive flavour to the Buddhist art of each civilization. The native traditions did not die in this process of syncretism and growth. The Buddha-image also retained its basic marks from its origins in India, notably its calm spirituality; and the expression of Buddhism in variant national and sectarian forms (as in Tibet and in Zen) could bring sharpened insights into the teachings and meanings found in Buddhist art and symbols.

7 Prophetic Iconoclasm: Judaism and Islam

India produces sages, Israel prophets.

R. C. Zaehner[1]

THE RELIGIOUS traditions which we characterize here under the heading 'Prophetic Iconoclasm' include much more than this. The ancient roots of Judaism and the vast extent of Islam have led to rich diversity in the religion, law and civilization of each. Nevertheless their core may justifiably be called prophetic in so far as their founding or archetypal figures – Abraham, Moses, the Hebrew prophets and Muhammad – bear a common stamp which is found throughout the subsequent religious history. The prophet is a man and not God; but he is an inspired man when God reveals to him a message, a 'word of God' which he has to hear and proclaim (forth-tell) publicly; despite his human inclinations he feels constrained to do this, as one speaking on behalf of God, because God has 'called' him.[2] The typical prophetic message concerns judgment, hope and man's obedience to a transcendent God.

Linked by their common basis in ancient Hebrew prophecy, the three great 'biblical' monotheistic religions – Judaism, Christianity and Islam – share certain of its distinctive emphases. First, the one God is supreme creator of all. Man is related to God by being his creation and not by sharing the same spiritual substance in an already existing cosmos. The prophetic religion of the Old Testament, and later again of Islam, stresses the distance between man and God. 'The central point in Old Testament anthropology is that man is dust and ashes before God and that he cannot stand before His holiness'.[3] At the same time man is given a special

relation to God as a creature destined to have dominion over the rest of creation: 'And God said, Let us make man in our image, after our likeness . . .' (Gen. 1.26ff.). The nature of the divine 'us' became a topic of debate in Rabbinic Judaism, and Christianity debated how far mankind had lost the divine image through the fall of Adam. But in all cases the divine likeness was viewed as a gift from the creator. Earthly man had no warrant to set himself up as equal with God or to elaborate on the appearance of God in words and pictures.

Other common emphases linked to this include belief in the 'will of God' as giving direction and purpose in the time process of earthly history where God has a plan and future for man. This involves a moral demand on man; the commands and laws of God are a means of fulfilling his promised destiny on earth and (in later Judaism) in the hereafter. Since God's command applies to all men alike, the prophetic faith cuts through traditional distinctions between castes and religious hierarchies to offer a more simple and direct access to God. Further, the teachings are freely available through scriptures which are read and interpreted in public worship; the predominance of the 'Word' leads to the high rate of literacy among Jews and the memorization and recital of the *Qur'an* among Muslims.

Religion of this type has little need of visual images, though it may be rich in verbal imagery and symbolism. We have seen the aniconic approach in other religions some of which accord the highest place to the teaching of a sage or the attainment of wisdom and supreme bliss in the experience of one-ness. Since that is within a basically monistic view of the world, sacred beings and men can there be related within a unified cosmos; a place for iconic representation can be found at various levels of spiritual experience, as in the case of Buddhist images. Where the gods hallow the many realms of nature and human experience, or where they are the parents and ancestors of mankind, there is every incentive to portray visually these powerful beings who share the world and life of man; this can be seen in ancient and primal religions. But where there is one supreme God who does not beget man but creates him and the universe, the problem of images is sharpened. God is beyond sexuality, bodily forms and the visible world; he is creator of all things and therefore not to be identified with any one of them. Therefore God (Yahweh, Allah) may not be represented in visual images. This is the basic principle of 'prophetic iconoclasm'. It remains to be seen how far it was fully practised in Judaism and Islam.

Hebrew monotheism is firmly based on the tradition of the exodus from Egypt and the revelation of the law to Moses (probably in the thirteenth century BC). The first commandment of the Decalogue states:

I am the Lord thy God, which have brought thee out of the land of Egypt, out of the house of bondage. Thou shalt have no other gods before me (Ex.20.2–3).

The second commandment implements this by prohibiting the making and worship of images:

Thou shalt not make unto thee any graven image, or any likeness of any thing that is in heaven above, or that is in the earth beneath, or that is in the water under the earth:
Thou shalt not bow down thyself to them, nor serve them (Ex. 20.4–5).

These commandments express the exclusiveness of the God of Israel and the corresponding sense of Israel as a special people devoted to God by the covenant at Mount Sinai. Hebrew religion had therefore to preserve its distinct loyalty to the one God, Yahweh, as against the many gods of Egypt in animal and anthropomorphic form. God could not be identified with any tangible and visible objects of his creation, whether representing so-called divine kings or features of nature as in sacred stones and the nature-deities of polytheism. Further, the reference to the realms above and below the earth shows a rejection of the ancient Babylonian cosmos graded into three levels with their ruling deities.

The prohibition against bowing down and serving such images shows that idolatry was the object of attack, but the prohibition against making graven images was amplified in the teaching of the book of Deuteronomy, a code of the seventh century BC presented as the words of Moses himself. There is a warning against the corruption of making images in the likeness of any figure, male or female, on the earth or in air and sea (Deut. 4.16–18). It is further found in a list of liturgical curses against law-breakers (Deut. 17.17):

Cursed be the man that maketh any graven or molten image, an abomination unto the Lord, the work of the hands of the craftsman, and putteth it in a secret place.

On the other hand the specifying of 'graven or molten' images could be held to apply only to three-dimensional sculptures, thus providing a loophole for later interpreters who wished to justify pictorial representations in the flat, especially if these were not intended for any idolatrous practice in terms of the original prohibition.

This is the basic tradition of the Mosaic law to which the Hebrew prophets recurrently appealed as kings and people lapsed into the idolatrous practices of the Canaanites and neighbouring peoples. In the northern kingdom of Israel in the ninth century BC the prophet Elijah opposed King Ahab for his support of the local cult of Baal and of foreign divinities from Egypt and Mesopotamia, images of which have been unearthed in the 'ivory house' which he built in Samaria (I Kings 16.31-3; 22.39). Also in the north King Jeroboam I had set up golden calves in temples at Beth-el and Dan (I Kings 12.28-33). The eighth-century prophet Hosea saw both king and idolatry as incompatible with the will of Yahweh (Hos. 8.4-6;10.1-5;13.2-4). In the southern kingdom of Judah Assyrian images were placed in the temple of Solomon at Jerusalem under the seventh-century king Manasseh. The prophets Isaiah and Micah uttered warnings of God's judgment on graven images and the groves and cities where they were worshipped (Micah 5.13-14). In the period leading up to the exile of 586 BC and the crucial decades following, the great prophets continued to denounce popular 'pagan' practices such as 'burning incense to the queen of heaven', and offering her cakes and drink (Jer. 44.15-19). Ezekiel prophesied doom on idols and their 'high places' (Ezek. 6.4-9), while offering almost anthropomorphic visions of the glory of God. Mocking descriptions are given of the elaborate manufacture of 'heathen' idols from the finest of materials which prove vain and impotent – in contrast to the true and living God they have no breath in them and no power to create and establish the universe (Jer. 10.3-15). The gods of Babylon are cunningly made to measure, imitating the beauty of the human figure; but Deutero-Isaiah contrasts this ineffective object of worship with the eternal God who 'sits upon the circle of the earth' (Isa. 40.18-23; 44.9-20). The two basic arguments which recur in the prophets are, first, that God alone is sovereign and may not be worshipped in any other way than according to his revealed will in his law, and secondly that idols are useless in a universe controlled by a single omnipotent god of all creation.

Yet the very persistence of such denunciations and appeals throughout the Hebrew Bible is evidence for the worship of idols in both domestic and public religion. The reason for this is doubtless to be found in the situation of the Hebrew people amid the great religious cultures of the ancient world. In contrast to these the twelve tribes of Israel formed a relatively small people with little power and cultural splendour, but united by a religious covenant as the people whose supreme god was Yahweh. This sense of distinctiveness was revived in periods of persecution and exile which featured strongly in Jewish history. On the other hand

they were exposed by their situation to the high culture and religious practices of their neighbours which could also prove very appealing. An archetypal instance of the recurring appeal of images is given in the story of the golden calf worshipped by the people during Moses' absence at Sinai (Ex. 32.1–8). In the northern kingdom, as we have noted, it was revived with royal support and widespread popularity. It probably expressed the belief, current in Egypt and the Ancient Near East, that a heavenly bull was the seat of certain gods and that an earthly replica could serve as a divine throne. For the Israelites it thus became a means of bringing God to be enthroned in their midst, ensuring his presence by possession of the image.[4] Even though intended as a pedestal of God it was linked with pagan practices and condemned accordingly by the prophets and biblical tradition.

Among the most frequently mentioned foreign gods seducing the Israelites were Baal (plural Baalim) and Ashtoreth, whose dismissal in favour of the Lord alone was sought by Samuel in the eleventh century (I Sam. 7.3–4). These were the most powerful of the Canaanite pantheon presided over by the high god El, and their connection with prosperity of the land and fertility made them popular with the Hebrew settlers in Canaan from the early period onwards (cf. Judg. 6.25–9). The ancient Canaanite goddess Asherah or Ashtoreth can be seen depicted in the bronze figurine of the naked goddess with a high horned headdress, also in many later clay figurines which must have been objects of continuing popular cults among the Hebrews. As a fertility goddess she was the consort of El and also the female counterpart of Baal ('lord'); she was associated with flocks and sacred trees and represented by a wooden pole near her altar. These and other 'strange gods' were opposed by the prophets not only as expressions of empty heathendom, 'false gods', but also as degrading and abominable with their fertility orgies, human sacrifices and practices of magic and divination. The many Hebrew words used in the Bible for images of such gods express contempt and loathing for both the idols and the heathen deities they represent. This attitude of prophetic rejection is carried over into the originally more neutral Greek term *eidolon* (picture or copy) which is used to translate many of these terms in the Septuagint (the Greek version of the Old Testament). Both images and gods are designated thus as 'copy' in contrast to reality:

The presence of images as the focus of worship is used to emphasize the unreality of heathen belief and the heathen gods. For the Jews idols and heathen deities are identical, and they prove that the heathen have images but no true God.[5]

193. Canaanite goddess Ashtoreth.

The dominant biblical tradition of the law and the prophets judged

the use of images as an act of disobedience. Yet it is also evident from the biblical record itself that within Israel certain ancient practices persisted as a sort of folk-religion alongside the aniconic worship of Yahweh. The household gods (*teraphim*) appear to be in this category of tacitly accepted images. They are referred to in the patriarchal period, when Jacob's wife Rachel steals the images of her father Laban (Gen. 31.19), and in the trad-itional period of the 'Judges' with the case of the man Micah who had a house of gods (Judg. 17.5). No doubt most of these family idols would have been ancestral figurines; some must have been life-size, for we read of Michal putting an image in David's bed to deceive King Saul (I Sam. 13). Another iconic practice which persisted until the seventh century BC was the magical use of a brazen serpent on a pole to cure snake bites (Num. 21.8–9). Even in the official temple worship there were representa-tions of *cherubim*, probably winged guardian figures like those of Egypt and Mesopotamia; these were featured as golden images facing one another on the 'mercy seat' above the sacred Ark of the Covenant and also on the tabernacle curtains and the veil of the temple (Ex. 25.18–22; 26.1,31). In the decoration of the Temple of Solomon in the tenth century BC probably carried out by foreign craftsmen, there is mention of figurines of cherubim, lions and a great bronze bowl supported by twelve oxen (I Kings 7.22–9). Visual imagery such as this must have contributed to the popular religious imagination and even to prophetic visions. When Isaiah received his call it was in a temple setting and the holiness of God was mediated to him by the six-winged *seraphim* (Isa. 6.1–8). Stranger visions of winged 'living creatures' and of the glory of God 'as the appearance of a man' occur in Ezekiel 1 and in the comparable apocalyptic visions of beasts and the white-haired 'Ancient of Days' in Daniel 7. These were to prove influential subsequently in Christian iconography, but for ancient Judaism these biblical examples are evidence for an iconic tendency, both in practice and in imagination, alongside the aniconic and iconoclastic tradition.

The two attitudes continued throughout the following centuries of Judaism. Times of stress led to a tightening of the prohibition on visual images in defence of the law constituting the central Jewish tradition. Out of the exile in the sixth century BC came the restoration of Jerusalem and a more definite adherence to the prescriptions of the law. When this weakened in face of Hellenism and paganism the Maccabean revolt rallied religious and national feeling against pagan desecration of the temple. Under Roman rule popular feeling was strong enough to prohibit the Romans from bringing the offensive Imperial images on their standards into Jewish territory. After the revolt of AD 66–70 culminating in the fall

of Jerusalem (and its complete destruction later in 135), Jewish orthodoxy hardened further to ban all representations, even of animals, in the flat. Before this there had been much greater diversity of parties within Judaism and a corresponding acceptance of various forms of art with the exception of sculptures of the human form and in due time, with a relaxation of persecution and tension there was a swing back to the more liberal position. This is indicated by the decorations in synagogues of the late Roman period and by the course of Jewish art in the following centuries.

The synagogue of Dura-Europos from AD 245 is a wonderful example of Jewish representational art influenced by Hellenism illustrating biblical themes. As a fortunate discovery of modern archaeology it is so far unique but it may well represent a cycle of biblical illustration used more widely in the decoration of synagogues and biblical manuscripts. Dura-Europos was a Roman fortress against the Parthians in north-east Syria. The walls of the synagogue depicted not only aniconic symbols but a whole series of human figures from the biblical history of salvation – Abraham, Moses and the exodus story, David and Saul and the prophets. The detail shown of Moses and the burning bush represents him in Hellenistic garments with his shoes removed from the holy ground. There is no hesitation in depicting the human face and figure in large and colourful frescoes.[6] Other pictures reflect eschatological hopes and Messianic expectations of Jews longing for spiritual and national renewal. The scene of Ezekiel's vision of the valley of dry bones is remarkable not only for the Parthian riding dress worn by the resurrected ones but also for the depiction of the hand of God (which became a convention of Christian art later). Biblical scenes were also depicted in mosaics; the sixth-century synagogue of Beth-Alpha had a floor mosaic including the sacrifice of Isaac, the four seasons and the twelve signs of the Zodiac round a central picture of the Greek sun-god Helios and his chariot.[7] This juxtaposition of biblical themes and Greco-Roman mythology is also found in some early Christian art. Here it suggests that Hellenistic Judaism was less orthodox than the classical biblical and rabbinic writings would allow, even to the extent of popular syncretism after the pattern of Hellenistic mystery-religions.[8] Since Judaism was a congregational religion without centralized authority there is no means of knowing how typical were such synagogues, but at least they prove that lavish use of representational art could develop at the focus of Jewish worship.

Since the fall of Jerusalem in AD 70 the loss of the temple had made Judaism a religion of the synagogue and of the rabbis. With only the memory of the temple, its ritual sacrifices and its visual splendour, symbols helped to perpetuate it. A convenient grouping of the major symbols

195. Moses and the burning bush, from a synagogue fresco, Dura Europos.

196. Ezekiel's vision of the dead being raised by the hand of God.

is seen in the 'gold-glass' dish from the Jewish catacombs in fourth-century Rome. At the top is the Torah shrine, the Ark containing the scrolls of the law, the focus of the traditional synagogue. Underneath is the seven-branched candelabrum, the *Menorah,* an important symbol since ancient times as the light in the temple; later it was interpreted as the tree of life and a symbol of planets and days with its seven branches. The amphora beside it contains oil for the lights. Also shown are (left and right) the vegetable species used in the Feast of Tabernacles service (Lev. 23.40) – the *ethrog* or citrus fruit and the *lulab* or palm-branch. The *Shofar* or ram's horn is blown to announce the New Year. Such symbols are evocative of the great Jewish tradition and of the rituals binding the people together. Other symbols such as the lions and birds may be classified rather among 'pagan' symbols adopted by Judaism.[9] Guardian lions in sculptured form were sometimes placed in synagogues representing the 'Lion of Judah'. The modern Jewish symbol of the so-called 'star of David' (*magen,* shield of David) may have originated as a magic hexagram and has no biblical or rabbinic warrant.

Symbolism, verbal or visual, was a richly established feature of Judaism and it came to provide the main part of Jewish religious art after the ancient period. The rise of Islam in the seventh century may have caused a swing to aniconism, and the Jews living under Muslim rule from the Near East to Spain produced mainly decorative art rather than representational. Those living under Christian rule may have reacted against the vigorous use of images developed by both Byzantine and Western Christianity, although later there was some positive influence. But in neither case was medieval Judaism in a situation which favoured the building of large decorated synagogues to rival the dominant churches and mosques. The synagogue building tended to be modest and functional, with care taken in the adding of ornament and inscriptions. Since the Talmud encouraged the use of fine arts to glorify God in the instruments of worship there were beautiful works of ritual art such as Torah scrolls and 'breastplates', lamps, plates and cups.[10]

The resulting impression made by Judaism in the centuries of its life under Christendom and Islam has been of aniconic worship in accordance with the biblical law and prophets. This attitude was inculcated by the teaching of the rabbis who developed the Pentateuchal prohibitions on idolatry in the tractate of the Mishnah and Talmud called 'Avodah Zarah'. The purpose here was to provide rulings on the proper Jewish attitude to idolatry and the avoidance of contact with heathen customs. The Talmudic commentary cites the opinions and actions of various rabbis of late antiquity, both iconoclastic and permissive – for instance Rabbi Johanan

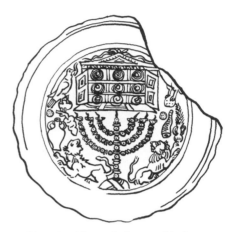

194. Jewish symbols on gold-glass.

of the early third century who did not object to frescoes and murals in synagogues.[11] A problem discussed by later Jewish scholars was how to classify other religions in the matter of idolatry. Islam was generally accepted as a pure monotheism but not Christianity with its images and its doctrines of Christ as the incarnation and of his real presence in the eucharist.

Nevertheless the example of Western representational art led to a modified form of Jewish iconography in the illuminated Hebrew manuscripts of the later medieval and Renaissance periods. It may be that this art tradition dates from late antiquity but no examples survive from before the tenth century. Following the main lines of Christian illustrations of the Bible, the Jewish art blossomed in Western and then central Europe from the thirteenth to the fifteenth centuries and, even after the invention of printing, continued to accompany calligraphy with decoration on biblical scrolls and marriage-contracts.[12] A popular subject for illumination was the Haggadah ('narration') dealing with the ritual in homes on the Passover eve and narrating the exodus story from biblical passages and midrashic elaborations. Illustrations were ideally suited to a book used with the whole family and not subject to the stricter standards of synagogue use. A whole series of pictures included the creation story in Genesis (though never depicting God himself) and stories of the exodus from Egypt, Moses receiving the law at Sinai, heroes of the Bible and the Passover meal. As with the cycle of frescoes at Dura-Europos a thousand years earlier, the hope in the world to come was strongly felt, both as a hope for individual salvation and as a Messianic expectation for a renewed world; hence the inclusion of such themes as the rebuilding of the temple and apocalyptic beasts. These book illustrations met spiritual and educational needs, although it cannot be said that the Jews with their high level of literacy required a visual 'Bible of the poor'. The art of making and decorating books became much more important for Jews than it did for Christians with their wider range of iconography:

For mediaeval Jews, however, the art of the book is the centre of all artistic activity. All talent is directed towards it. Here, the rich storehouse of Jewish thought and imagination, of Jewish solemnity and Jewish humour find pictorial expression. And here, finally, we have the clearest evidence of the fact that the Jews of the Middle Ages enjoyed form and colour.[13]

Mention should be made of one further influence in Jewish religion of this period; this is the mystical tradition known generally as the Kabbalah which sought to relate the material world to hidden divine mysteries by the symbolism of Hebrew letters and numbers and an esoteric teaching

of cosmology. The influential thirteenth-century Spanish work, the
Zohar, presents a 'commentary' on the Bible along these lines, showing
how the divine life relates to the earthly by means of emanations through a
series of ten spheres. This is the significance of the key cabbalistic diagram
of the 'Tree of Life'; the hidden *Ensoph* (Boundless) generates three triads
of spiritual spheres which include male and female polarities ending in the
tenth sphere, the 'Kingdom' or mystical Israel. Man participates in the
interaction of higher and lower spheres because he himself is a microcosm
who embodies these cosmic forces of body and spirit. The divine life is
manifested in the human body, symbolized by the figure of Adam
Kadmon – the 'primordial Man' before the Fall, representing the universe
made in God's likeness. In addition to ancient Gnostic conceptions,
there are interesting similarities between the microcosmic interpretations
of the diagram and Indian Tantric meditation on the mandala, allowing for
the very different presuppositions in religious iconography.[14]

Cabbalism was not confined to scholarly speculation and mysticism
but became a widespread influence in popular piety relating the actions
of men and women to cosmic significance. It could be used also as a system
of magic by the use of its secret symbols and for exorcizing evil spirits.
One example of the application of cabbalistic symbols in orthodox piety
is on the wall-plaque or *mizrach* ('east') which gives to Western Jews the
direction to turn towards the Jerusalem temple in prayer. Placed on the
east wall of traditional homes and synagogues these plaques follow no
strict pattern but may be adorned with biblical texts, symbols such as the
menorah, crown and hexagram, the names of God, the Decalogue, signs
of the Zodiac, pictures of holy places and cabbalistic inscriptions. This
mixture of words and symbols is a good reminder of the many influences
contributing to Judaism in the course of over 3000 years.

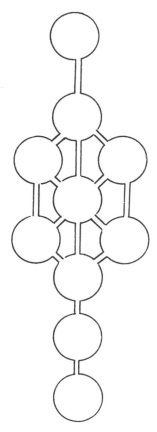

197. Cabbalistic diagram of the ten
spheres of *sephiroth*.

Islam

As one of the universal biblical religions Islam draws on the 'pure mono-
theism' of Abraham and the prophets of ancient Judaism. Intense in its
prophetic iconoclasm it nevertheless has developed an impressive and
distinctive culture. Whereas the history of Judaism has been one of
fighting to preserve its existence through foreign occupation, dispersion
and persecution, Islam has enjoyed a success story of expansion following
its spectacular rise in the 'Fertile Crescent' of the Near East in the seventh
century. It drew there on the art resources of older cultures – Byzantine,

Sassanian and Coptic – but wove the older traditions into a new synthesis of characteristically Islamic forms. These it stamped on the life and culture, the monuments, the cities, the very geography of the lands it conquered by a 'symbolic appropriation of the land'.[15] The classical art of Islam developed for a thousand years to reach its climax in the sixteenth- to seventeenth-century monuments of Ottoman Turkey, Safavid Persia and Mughal India.[16]

This art is predominantly associated with architecture and ornament, rejecting the use of images and most representational art which might serve as visual aids in worship or as means of propagating the faith, and even avoiding the use of special religious symbols. This does not mean that Islam has no religious art at all, for (as we shall observe) there are important exceptions to the iconoclasm and aniconism of Islam. Paintings of hunting and love scenes and illustrated books could be accepted in private homes, palaces and bathing-houses when they would be prohibited in a mosque, but in general there was less distinction between the secular and the sacred spheres, especially in the earlier period of Islam when mosques were unpretentious places for prayer. The same forms of decoration could be applied to both spheres; the same sort of vessels and furnishings were used in mosques and homes (e.g. rugs, vases, lamps); buildings were adaptable to varied purposes, so that even the magnificent façades of many later Muslim buildings 'almost never indicated whether the building was a mosque or a caravanserai'.[17] The religion of Islam is intended to govern all the affairs of man's life so that the 'secular' sphere is not sharply demarcated but rather covers the outer area of individual and social behaviour, less specifically religious and Islamic and perhaps expressing more ancient pre-Islamic customs and functions common to other cultures. Although court life, military and trading activities might all be classified as spheres of worldly wealth, prestige and power, it must be remembered that Islam developed in the midst of these from the beginning. The prophet Muhammed was a city-bred trader whose calling became that of God's *rasul,* the messenger and apostle for implementing the purified religion of Islam on earth. This he did in the Arabian cities of Medina and Mecca.[18] Islam is most characteristically a religion of the city (and not of the desert, as is often repeated); Muslim learning, mosques and art developed in the great city centres as Islam expanded within a few centuries from Spain to India.

We now turn more closely to examine the course of prophetic iconoclasm in Islamic art. It can be traced first of all to the protest of Muhammad against the idols of ancient Arabia. Spirits and demons filled the world of popular 'animistic' religion. Among the higher gods of Semitic polytheism

Allah was worshipped widely in Arabia and at Mecca was worshipped as the principal god of the city, probably represented by the traditionally sacred meteorite (the Black Stone) at the Ka'ba.[19] But at this shrine many images of other gods were worshipped, three being regarded as the daughters of Allah – Manat the goddess of fate, El-'Uzza of the planet Venus and Allat (El-Lat) the moon-goddess. The latter was probably a form of the ancient Semitic moon-deity of which a temple with crude images has been found at Hureidha, south Arabia, from the fifth to third centuries BC; at her sanctuary in Taif near Mecca she was represented by a rectangular block of stone. Against such pagan idolatry Muhammad was inspired to protest, perhaps being influenced also by monotheistic teaching from Jews and Christians trading and settling in north Arabia in the sixth century. His objection was directed against these three as blasphemous inventions of human imaginings without the authority of the one real God:

Have you considered El-Lat and El-'Uzza and Manat the third, the other?
What, have you males, and He females?
That were indeed an unjust division.
They are naught but names youselves have named, and your fathers.[20]

Allah is one, he is eternal, he is incomparable as the supreme creator and revealer. The prophet sees the folly of idolaters who would associate other beings alongside him as gods and daughter-goddesses:

Say: 'Have you considered your associates on whom you call, apart from God? Show me what they have created in the earth; or have they a partnership in the heavens?'[21]

The supreme error exposed here is that of 'associating' God with mere creatures and of thus bringing God down to a human level as in polytheism. In Islam this is defined as *shirk,* the idolatry of ascribing knowledge and power to beings other than God, of depending on them and offering worship to them as intercessors. This is 'a mighty sin' and unforgivable:

God forgives not that aught should be with Him associated.[22]

Muhammad met opposition from the unbelieving Meccans whom he sought to convert to the worship of Allah alone after his initial call as a prophet in AD 610. Only after his flight (*hijra*) to Medina in AD 622 (AH 1 in Muslim chronology) did he gain sufficient power to return later to Mecca and cleanse the Ka'ba of its idols which were said to number three hundred in all. Purified thus of its polytheism, Mecca became the focus of the true worship of Allah. The shrine of the Ka'ba and the Black Stone could be preserved along with the traditional pilgrimage because

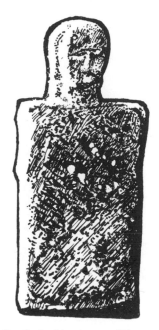

198. South-Arabian image of the moon-god, pre-Islamic.

they were now connected with the historical revelation of the eternal
God to his prophets from Abraham to Muhammad. What was in accord
with this could be accepted. It is even said that Muhammad left Byzantine
paintings of Abraham and of the infant Jesus with the Virgin Mary
untouched in the Ka'ba, Jesus also being accepted as a true prophet;
however, a fire in the Ka'ba in AD 683 destroyed any evidence of these.
The issue was simply one of idolatry and the one true God. At this stage
there was no concern for or against artistic representation as such.
Apparently Muhammad himself did not object to figures of animals or
men on woven materials in his house at Medina as long as they did not
prove a distraction from prayer and were kept in their proper place (on
cushions or carpets where people would sit or trample on them).[23] His
young wife A'ishah had dolls at the age of nine and this was permitted
as encouraging the maternal instinct, not idolatry.

Basic to the Islamic rejection of idols is the view of God and man
expressed through the revelations of the *Qur'an*. It is a theocentric view
in which God's total power and uniqueness defines his place at the centre
of the world of being. Nature and time are not independent processes
of natural law but dependent entirely on the divine fiat; time is a galaxy
of instants manifesting the will of the transcendent God. Man likewise is
utterly dependent on his creator to whom he should respond with thank-
fulness in prayer and obedience. In the dynamic tension between God
and man it is Allah who is the initiator and revealer and man (*insan*) the
one who responds, a servant who acknowledges the majesty of his lord.[24]
The *Qur'an* echoes the Hebrew Bible in stating that God breathed his
spirit into Adam but not that he created man in his own image (a statement
found in later tradition and the subject of differing interpretations).
Since God alone is creator he cannot share his 'image'. A typical Qur'anic
verse states:

> He is God,
> the Creator, the Maker, the Shaper.
> To Him belong the Names Most Beautiful.[25]

It is significant that the term 'shaper' or 'fashioner' is the term also used
for a painter. From this derives the moral force of later prohibitions on the
representation of living things; God alone is creator, he admits of no
competitors, no idols and hence no makers of idols in the sense of would-
be-creators.

This conclusion is drawn by later traditions (*hadith*) which purport
to recount the sayings and actions of the Prophet while in fact represent-
ing opinions of over a century later, probably of the eighth century.[26]
Here severe warnings are issued against painters who are numbered

among those to be most severely punished at judgment day. The angels will not enter a house containing images and pictures. But it is the painter himself who is really to blame because he usurps the function of the creator; consequently he will be exposed by being required at the judgment to breathe life into his works and finding himself unable to do so. The restrictive attitude was expressed as a ban on the copying of living beings with breath but permission for things like trees, plants and man-made articles. Further distinctions were made by scholars of religious law as to the admissability of representations in certain places such as hallways, floors and baths, or for certain purposes as in the case of dolls and puppet shows. The more tolerant voices argued for representations in the flat which did not cast a shadow. Others recommended that puppets be headless or perforated; the custom of defacing images is to be seen in lands conquered by Islam such as Afghanistan where the colossal rock-hewn Buddhas at Bamiyan have been defaced and used for target-practice by later generations. Clearly there were differing judgments as to what was permissible, resulting in varying degrees of representation in the arts of Islam in following centuries.

Simply on the basis of rejecting idolatry it was neither necessary nor inevitable that Islam should have taken this line. As we have seen, for Muhammad and the *Qur'an* the use of visual representation was still a matter of indifference. What then caused the transition to a general opposition to images of living things? It is not helpful to invoke some innate 'semitic' opposition to images or the influence of orthodox Judaism. It is most probably to be explained by the historical situation of Islam in the course of its rapid expansion and encounter with other religions and their art in the latter half of the seventh century. By this time Mediterranean Christianity had developed a rich tradition of churches and imagery, summed up in the brilliance of Hagia Sophia at Byzantium, but this was heavily involved in the doctrines and religio-political power of Christendom. If on the one hand Arabian Islam reacted at first with awe and admiration for the art of the conquered Christian lands it also felt ill-equipped to compete on their terms and ended with a reaction of jealousy and contempt:

. . . to a Muslim of the early eighth century images were one of the most characteristic and in part hateful aspects of Christianity.[27]

Rather than endanger its own intense moral vision by imitating the impressive religious symbolism of Christianity, Hellenism and Iran, Islam made its own selection of their elements and reinterpreted them in terms of its own vision based on the verbal revelation in the *Qur'an*. To define itself more clearly against the powerful rival traditions Islam withdrew

from the representation of living creatures. The eighth-century doctrines then sealed the reaction which had taken place by issuing formal prohibitions claiming the authority of Muhammad and tradition.

This attitude was further reinforced in following centuries by the situation within Islam itself. The Muslim world has always had cultural groups inclined to the use of visual images. At one extreme, that of folk culture from the pre-Islamic past, images retained a deep-rooted magical appeal. At the other extreme, that of aristocratic culture, the caliphs and high officials sponsored art as luxury, borrowing from ancient royal traditions elsewhere, but in between was the solid city-based Muslim moralism, the strict code of behaviour and understanding which held together the Muslim religious community (*the ummah*):

This Islamic middle rejected both extremes, the popular world as pagan and the aristocratic one as alien and hypocritical . . . it was this literate middle which provided us with most of the texts by which early Islamic culture is defined and which institutionalized into legal terms the moralistic attitude of the early ummah.[28]

While this provided the mainstay for norms of orthodoxy in Islamic art, it did not prevent variations and divergencies, especially at the 'extremes' of Muslim culture mentioned. Moreover the passage of time has rendered the strict prohibition on representations problematic, if not obsolete in many cases. Modern Islamic countries are accustomed to illustrated books, photographs and statues of public figures. The very success of Islam has meant that visual images no longer carry any danger of idolatry. (Even a modern secularist in the 'Western' world can say of the Commandments: 'At least I've never made a graven image'.) This raises the question whether the traditional veto in Islam reflects too limited a notion of idolatry. Religion can represent and also distort the nature of God through the media which it uses; and it may be that painting is no worse than writing and ritual activity in this respect. The question affects the wider discussion of the 'iconoclastic' position.[29]

Having examined the roots of prophetic iconoclasm in Islam we now turn to the more positive expressions of Islamic art. Even if these are not what we would designate as 'iconography' in the accepted sense they are instructive as evidence of the outlets which the genius of Islam found in alternative forms of religious iconography. Here Islam is considered primarily as a religion of the spoken and written word, of the mosque and its associated decoration, but also to be considered are book illustrations and syncretistic folk arts.

The heart and foundation of Islam is the *Qur'an*, the revelation of God given to Muhammad to recite and write in Arabic. The revelation

is eternal and universal, having been given to earlier prophets from Adam onwards; but the heavenly book is restored in its final and definitive earthly form in the *Qur'an*, the 'seal' of all earlier revelations. It is for Muslims more than a book; as the revealed Word of the eternal God it is more equivalent to what Jesus Christ means to Christians as the 'Word made flesh'. The *Qur'an* is the one central miracle of Islam, and this miracle of the Divine Word is actualized again and again, not in visual and material form but verbally in recitation.

This makes it possible to situate Islamic iconoclasm very precisely: the Divine Word must remain a verbal expression, and as such instantaneous and immaterial, in the likeness of the act of creation; thus alone will it keep its evocative power pure, without being subject to that attrition which the use of tangible materials instils, so to speak, into the very nature of the plastic arts. . . .[30]

From its early recital by Muhammad and the written text which provided the basis within a few years after his death, the *Qur'an* has continued to pervade the life of Islam. Its phrases are repeated in the cantillations at the mosque, in teaching and memorization at the mosque school and in the prayers of believers. The book provides the basis for the study of Muslim theology and law and even serves as the constitution of such a country as Saudi Arabia. At the popular level its texts may be regarded as talismans and protective charms and in the sphere of art it has conferred something of its religious power on the Muslim art of calligraphy.

The art of beautiful writing, above all writing of the *Qur'an*, became the most distinctive art and 'the most typical expression of the Islamic spirit'.[31] The *Qur'an* itself extols the importance of writing and its divine origin – God taught man with the pen (Sura 96) and the *Qur'an* is written on a heavenly tablet (85.21–22). In Islamic belief everyone's fate is thought to be 'written'. Poets have called God the 'Eternal Calligrapher'. As far as human practice is concerned, the development of appropriate scripts accompanied the spread of the *Qur'an* in the seventh century. Especially favoured was the Kufic script from the new Islamic city of Kufa near Babylon; this dominated the writing of the *Qur'an* for four centuries and its vertical massive and angular style continued to be used for many large public inscriptions. Meanwhile the more rounded and horizontal script, the *naskhi,* introduced a fluid and rhythmic style. Devotion to the art of writing the *Qur'an* as worthily as possible led calligraphers to exploit the possibilities of these styles to the full. The Arabic alphabet lent itself easily to the development of elegant and harmonious patterns. For instance the word 'Allah' includes three vertical stems which can be turned into intricate and inventive forms, especially in the central confession of Allah (the *shahada*) and the universally used

prefix from the Qur'anic suras, 'In the name of God . . .' (the *Bismillah*). The many varied and fantastic patterns woven out of the latter have been encouraged by the tradition which promises: 'He who writes beautifully the Bismillah obtains innumerable blessings'.[32]

Calligraphy most clearly merges into iconography in the ingenious use of writing to express pictorial shapes – flowers, ships, animals such as the lion, and the birds suggesting paradise, the stork and the parrot. Even faces of humans were patterned, in more adventurous circles such as the Turkish Bektashi order; but the traditional house 'portrait' of Muhammad was confined to a calligraphic description of the Prophet and his character. The influence of Sufism in the medieval period encouraged an interpretation of letters in terms of mystical symbolism. Calligraphy in all these ways was given an exalted position in the Muslim world and as art alone the single line written by an expert hand could be rewarded by a large sum of money as well as by praise. But the basis of this primacy lay in its connection with copying the *Qur'an*. Correspondingly the lack of this religious connection lowered the status of the painter in Muslim society.[33] Calligraphy was a sacred art; making the Word visible in writing (the language of God being sufficient without images). Its inscriptions became the most important means of decoration in religious architecture,

. . . playing in mosques, madrasahs and mausoleums approximately the same role as statues of Christ and the saints do in Christian architecture.[34]

Architecture is the other great art in which Islam excelled and again we perceive the distinctive imprint of the religion on the various forms borrowed from previous traditions. Essentially the mosque is not a sacred place in the sense of an ancient temple or a consecrated church (although over the centuries many mosques, mausolea and pilgrimage places have acquired a distinct sanctity in Islam). It is not the space which is important religiously here but the relation to the infinite God in the time of prayer. At its simplest the mosque is no more than a demarcated place of prayer, literally a 'place of prostration' (*masjid*) for the fulfilment of the basic obligation to perform prayers.[35] Originally Muhammad led his community outside the city for corporate prayer in an open space for prayer (*musalla*) without any buildings. At Medina his own house with its open courtyard was used for conversations with him and for public prayers; but it was a most unpretentious dwelling and the call to prayer was sounded from the flat roof-top, the mud walls and palm trees providing worshippers with shelter from the sun.[36] This set the basic pattern for the standard type of 'court mosque' which later architectural developments could ennoble and embellish but not fundamentally alter. In this

respect the early monuments of the Ka'ba at Mecca and the Dome of the
Rock at Jerusalem are not typical mosques but pilgrimage centres based
on pre-Islamic forms, the Meccan 'cube' and the domed octagon of the
classical-Byzantine tradition. The mosque properly has no centre of
worship in itself, no sacramental altar or liturgical sanctuary as a focal
point. Prayer is directed outward to God, facing towards Mecca (the Ka'ba
recalling the revelation to Abraham and Muhammad). The Ka'ba itself,
like the mosque, is empty of any sacramental support for worship:

. . . a Muslim's awareness of the Divine Presence is based on a feeling of limitlessness; he rejects all objectivation of the Divine, except that which presents itself to him in the form of limitless space.[37]

This Islamic sense of 'space transcended' was given grand architectural
form as Islam moved into contact with the Mediterranean and Meso-
potamian worlds with their forms of the arch, the vault and the dome.
The arched portal (*liwan*) and the domed mausoleum of medieval Iran
led on to the inspiring forms of the domed mosque created in the sixteenth-
to seventeenth-century flowering of Ottoman architecture (the mosques
of Sinan at Istanbul), Iran (the Isfahan of Shah Abbas) and Mughal India
(the justly famed Taj Mahal at Agra).[38] Islamic tradition's power to utilize
the modern international style of architecture is seen in the national mosque
of Malaysia, the Masjid Negara at Kuala Lumpur completed in 1965.

Yet such grandeur is not essential to the mosque. Certain of the early
additions to the simple house of prayer became established conventions
and definable marks of a mosque, such as the tall minaret for calling the
community to prayer or the pulpit-platform (*minbar*) inside. Some features
have acquired a deeply symbolical significance in addition to their func-
tion. The focal *mihrab* is the niche in the wall giving the direction (*qiblah*)
towards Mecca and its function is also acoustic, re-echoing the words
directed towards it in prayer; and by virtue of its reverberation of the
Divine Word it can symbolize the presence of God.[39] For this reason the
worshipper must never spit in the direction of the *mihrab*. Associated
with it in veneration is the sanctuary lamp (*misbah*) which is meant to
illuminate the niche; although only an accessory the lamp carries the
symbolic connotation of the divine light, recalling the mysterious words
of the *Qur'an* (in the Sura of Light, 4.35): 'Allah is the light of the heavens
and the earth. The similitude of His light is a niche wherein is a lamp.'
Symbolic meaning can also be associated with the fountain in the court-
yard or entrance for ritual ablutions; it is a reminder of the springs of
water flowing in paradise.

These themes can be found depicted on the prayer-rug which is, after
all, 'a sort of portable mosque'; when unrolled on the ground it provides

a place exclusively for prayer which isolates the worshipper from his surroundings while he prays.[40] In addition to the folk arts of rug-making and traditional geometric patterns the prayer-rug shows the pointed prayer-niche giving direction to the worshipper, whose head bows on this end; in the rare cases where Qur'anic inscriptions are woven in they must be at this head end and not where the feet would touch and profane them. Among the themes suggesting paradise are portals, gardens and birds; also the ancient symbol of the Tree of Life is in Islamic cosmology represented as a Tree of Bliss growing downwards to shelter all the mansions of heaven.[41] Although such symbolism is flexible and not essential to Islamic practice, these examples show a recognizable iconography at work.

Of great importance alongside calligraphy in the decoration of mosques as of books is the repetition of motifs in seemingly endless patterns. The motif may be figurative (such as a leaf or flower), or stylized into semi-abstraction (a vine tendril, a knot or a rosette) or completely abstract and geometric (a zig-zag or a star). But instead of being emphasized as an individual theme to be viewed within a framework like a picture, it is repeated, extended and interlaced until it fills an entire surface; as a result the motif loses its independence as a visual focus and is dissolved into the whole. This highly developed form of Islamic decoration has been called the 'infinite pattern' – the earthly, transient, material form being dissolved and covered by that which is eternal, represented by infinite repetition. According to another interpretation the infinitely growing arabesque (itself an adaptation of the vine tendril) expresses the arbitrary extension of the designer who thus avoids trying to rival God or to create something permanent. As the mystic al-Hallaj said, Satan weeps out of frustration because he wants to make the passing things of this world outlive destruction, but he realizes that only God remains. This abstract geometrically-based ornament seeks only to cover the object or wall with non-representational inventions – totally covering it as if from a *'horror vacui'*. The artist is thus free from the compulsion to imitate the physical world which is God's own miracle. Freedom from natural forms means greater freedom to recompose them artistically. The resulting ornament is arbitrary and impermanent, separating the surface from the monument like 'a skin that can be removed and changed as needs or tastes change'.[42]

An application of this principle can be seen in the covering of images with such patterns in order to circumvent the ban on representing living beings. A great bronze griffin, probably from a palace in eleventh-century Egypt, is covered with engraved patterns including a Kufic inscription; this decoration 'has nothing in common with the nature of the animal and

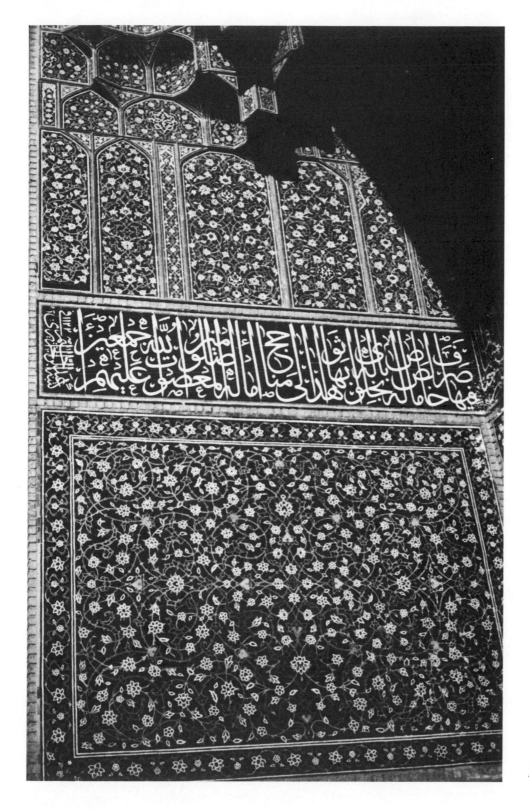

199. Islamic decoration: calligraphy and 'infinite pattern'.

serves rather to negate the form of the object'.[43] It should, however, be emphasized that such explanations must remain speculative in default of fuller knowledge of the intentions of Muslim decorators. Historically they may have owed much to the design traditions of Arab folk art and also to the concern with geometrical shapes shown also by Arab mathematicians. As Grabar notes acutely, there are paradoxes involved in this type of ornament which relates the visible to the invisible; the ornament is 'both the slave and master of the space on which it occurs'; it can also be both a practical exercise and an intellectual meditation, though the latter may be in the mind of the beholder.[44] No doubt the more subtle interpretations developed through the contributions of mystical thinkers on the pervading unity of God. It is right to point out that Islamic abstract patterns differ here from modern abstract art, in being more impersonal and directed towards the transcendent God who covers the multiplicity of creation with his unity.[45]

In contrast to the abundance of ornament, paintings are not featured at all in the mosque. There is nothing in Islam comparable to the Jewish synagogue frescoes at Dura-Europos or to the illustrated Bibles of Christendom, but the ban enforced by the religious authorities did not prevent the development of paintings for books used elsewhere for more secular learning or for entertainment (commissioned by the wealthy). The earliest surviving works are from the thirteenth century and Persia took the lead here, drawing on Arab and Chinese influences to produce a brilliant Persian style of miniature painting. In earlier centuries the Arabs may have drawn on the skills of Christian painters as they did on other craftsmen from the considerable Christian population which continued to live in lands dominated by Islam. The Christian monasteries of the Nestorian Church throughout the Near and Middle East were a source of Christian imagery which seems to have influenced Islamic illustrations of biblical themes. These include Adam and Eve and the Hebrew patriarchs and prophets as well as the figure of Jesus at his birth, baptism and last supper.[46] Comparable paintings of the life of Muhammad appear in illustrated copies of historical works made in early fourteenth-century Persia such as the Universal History of Rashid-al-Din. Here the Prophet is shown as an ordinary bearded man; but deference to religious scruples more frequently led painters to leave the face blank and dignify his figure with a halo. Such developments were more possible in Persia because of its powerful heritage from ancient Iran and the importance in its Islamic period, first of Sufi mysticism and later of the Shi'ite sect. While acknowledging the humanity of the prophet the Shi'a gives more scope to emotional devotion and to veneration of the Prophet as the perfection of

the human norm, the model for Muslim spiritual life and even as the Universal Man.[47] The mystical influence may account for the colourful paintings which blend man with nature in an almost pantheistic union, as well as those featuring love and wine which had mystical significance.

A brilliant example of this religious art is the sixteenth-century Persian manuscript painting of Muhammad's ascent to paradise. The theme derives from the brief Qur'anic accounts of the Prophet's 'Night Journey' under the guidance of the angel Gabriel from Mecca to Jerusalem and thence to heaven (Sura 17.62;53.1–18;81.19–25). A large Arabic and Persian literature arose subsequently to describe the Prophet's 'ascent' (*mi'raj*) through the seven heavens and his visits to the various realms of hell; these are depicted vividly in a fifteenth-century illustrated version of the Mi'raj Namah. The story itself resembles some Jewish accounts of the ascent of Moses and there are notable features reflecting the typical pattern of the shaman's initiation and ecstatic journeyings.[48] These may well have contributed to some visionary experience of Muhammad of the throne of Allah.

Our picture shows the Prophet mounted on Buraq, the mysterious celestial animal with a human head, who carries him through the heavens.[49] He is escorted by a number of winged angels (who are important in Islam as heavenly messengers, intercessors and singers of God's praise). Here Gabriel leads the way, with angels below him bearing a flaming censer and a dish of perfume. Behind the Prophet comes an angel carrying the *Qur'an* and those shown above swoop down with honorific gifts such as a crown, the famous green robe of the Prophet, dishes of fruit and cascades of pearls and rubies. Muhammad himself is reverently depicted with a wonderful flame-like halo, and the curious serpentine cloud combines with the colour and glitter to give an exciting visionary quality to the picture.

It is evident from such examples that official religious prohibition of images could, like the prohibition of wine, be circumvented. The decorated pleasure-houses of the early caliphs show this.

At all times, nevertheless, there was a great discrepancy between official dogma and private practice, especially since there were no religious or public bodies capable of enforcing the iconoclastic strictures in the inaccessible private rooms of palaces and houses.[50]

If this is true for the high culture of Islam it also can hold at the level of folk religion, custom and art in lands dominated by Islam.[51] In West Africa, for instance, Islam spread through various means – the influence of traders, scholars, artisans, men of influence and also through the mere fact of proximity of Muslims with non-Muslim people – resulting in a

flexible, pragmatic approach with many compromises between orthodoxy and the demands of culture contact.[52] The Muslim Mande of west central Ghana and in neighbouring areas continue to patronize the masked cults and shrines with the images of traditional African religions. These persist because they meet more immediate religious needs in an indigenous way; to some extent they can be subsumed under the angels and spirit-world of orthodox Islam, incorporating also the power of Qur'anic texts. Thus a shrine priest rubs Qur'anic amulets against two carved 'messengers of the spirit', a male and a female, 'so that they may transmit the messages more lucidly'.[53] The strength of the African masking traditions lies in their power to ward off witchcraft. Islam has accommodated itself to them, making the simple basic demands on Muslim followers and allowing a wide degree of latitude for the rest. Despite a few periods of fervour against idolatry the orthodox doctrines prohibiting images are little known or observed. The conclusion to be drawn from this is that one cannot assume the automatic hostility of Islam to 'pagan' practices and art traditions; on the contrary there is a high degree of tolerance and syncretism in West Africa:

This is true not only of the mass of believers but also of members of the religious elite, who realize that Islam can survive as a faith and continue to expand its influence only so long as it is willing to react flexibly to the non-Muslim world.[54]

The preceding case shows Islam at its most 'liberal' and tolerant position regarding images. But in Africa as elsewhere prophetic iconoclasm can still be revived with passion and even violence. Rioting in Srinagar, Kashmir, was sparked off in 1973 by the discovery of a picture of Muhammad in *The Children's Encyclopaedia* in a library.[55] Needless to say, such extremes are not typical of Islam as a universal religion.

Summary

Judaism and Islam are rooted in the prophetic witness to one God, the transcendent creator, who does not need to be pictured or worshipped in the form of visible icons like the heathen gods. Nevertheless from this basis both have developed certain art forms. Judaism has been limited historically in its art to manuscripts, biblical illustration and ritual art. Islam has had the opportunity to develop distinctively Islamic art forms in calligraphy based on the *Qur'an* and in mosque decoration expressing abstract infinite patterns. In both religions the primacy of the word has been periodically modified by man's need of the visual element. Throughout history ways have been found of circumventing the strict prohibitions against images.

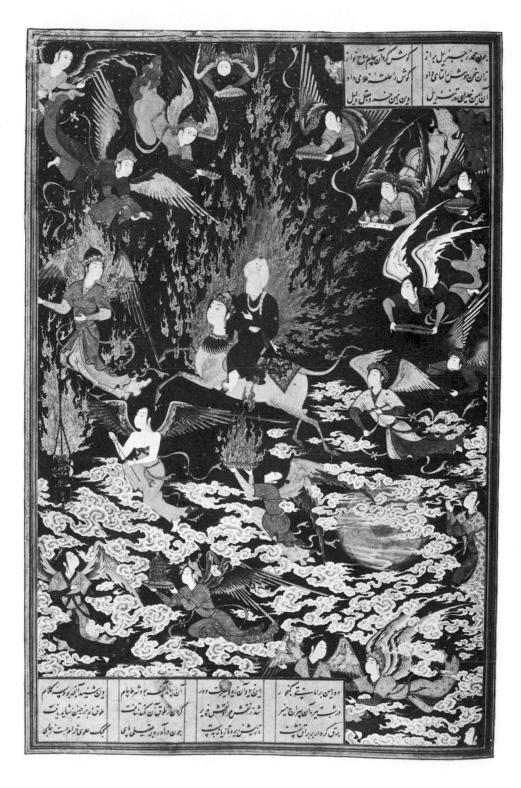

200. Muhammad's ascent to paradise.

 # Christianity

Although Christian art and culture introduced a new spirit, a new conception of the universe and a whole new set of values, their development was linked temporally and geographically with existing civilizations and existing cultural trends and characteristics.

<div align="right">H. P. Gerhard[1]</div>

The religious art of Egypt, of the Babylonians and the Greeks, however admirable, was of little use as a starting point for Christian artists and iconographers. . . . It was the task of the first Christian artists not merely to ignore but to destroy these potent images of power, efficiency and physical perfection, and to replace them by – what?

<div align="right">Eric Newton[2]</div>

A NEW SPIRIT in the midst of the religious and art traditions of the ancient Mediterranean world: this is the situation which gave birth to Christian iconography, supplying its tension and its potential. In Palestine, Jesus came preaching 'The Kingdom of God is at hand' (Mark 1.15) – an eschatological message of a new relation between God and man. For the early Christian church as it spread throughout the Roman Empire this message of salvation was grounded in the person of Jesus as the Christ, crucified and risen as Lord and Saviour, the Servant and Son of God. The message took written form in the New Testament as the Christian complement to the Jewish Bible; and it shaped the life and ministry of the church with its teaching and sacraments.[3] But it did not at first stimulate the visual arts, and during the first three centuries Christians had neither the opportunity nor the need for much more than aniconic symbols. When the church ceased to be a suspect minority and received imperial

support there developed new and impressive church buildings, accompanied by decorations, images and ultimately a proliferation of Christian art throughout Europe.

This development immediately suggests a parallel with the emergence of the Buddha-image after several centuries of aniconic representation. Buddhism of course flourished for a long time in the country of its origin before finding its destiny as a pan-Asian religion, whereas Christianity developed in the wider Mediterranean world almost from the start and it is necessary to keep in mind the distinctive principles underlying the iconographies of Buddhism and Christianity. While both are universal religions of salvation with historical founders and emphasis on teaching and ethics, they differ in their axioms about God and the historical destiny of man.

From its Jewish heritage Christianity continued to hold to monotheism in the sense of a transcendent creator God, with a will and purpose at least personal, who reveals his will to men through the prophets. For Christianity this divine word reaches a climax and fulfilment in the advent of Jesus, embodied in a human life in history. 'And the Word was made flesh and dwelt among us . . . full of grace and truth' (John 1.14). In the title 'Christ' Jesus is acknowledged by Christians as mediator of God's salvation, of the grace bringing forgiveness of sins and of the hope conquering even death. These features of the work of Jesus Christ continue through history, proclaimed and enacted in the witness of the church as the continuing 'people of God' (I Peter 2.10). Christians in each place are 'called to be saints' (I Cor. 1.2) in that they share in the salvation of Christ and also in the fellowship (*koinonia*) of a community based on an ethic of love. The realities of the all-too-human historical church are honestly faced in Paul's first letter to the church at Corinth; yet just here the apostle pays supreme tribute to the primacy of love (I Cor. 13). Again, this love of one another is a human expression of the divine self-giving love (*agape*). The Johannine literature of the New Testament stresses this:

No man has seen God at any time. If we love one another, God dwells in us and his love is perfected in us (I John 4.12).

These words illustrate the religious quality which we have seen in other religions discussed – a core of spirituality that is concerned with the transcendent and unseen, a concern for a relationship with God or sacred powers and a way of life based on the religious values. Christianity is about these primarily, rather than about visible expressions in iconography, but at the same time the distinctive features of Christianity open up the possibility of an explicit iconography. God is transcendent, yet

as the creator and loving Father he is related positively to his creation and to the experience of men. Especially the incarnation of God in the human life of Jesus Christ implies that the divine image is somehow available for men to 'see'. His life and ministry, his death on the cross and re-surrection as recounted in the gospels provide a story which can be told in pictures as well as in words. Further, this story is linked to a whole series of events in former times as recounted in the Old Testament – the creation, the patriarchs and the prophets of ancient Israel. Correspondingly it is continued into the life of the church up to the present and even into the future with the expectation and visions of 'a new heaven and a new earth' (Rev. 21.1). The whole panorama of history is the scene of God's activity; the Spirit of God is believed to be working in various ways through the church and the lives of teachers, saints and martyrs. The Christian shares in the heritage and communion of the saints. All these provide material for iconography.

It may have been noticed that these features of Christianity correspond to the three aspects of God described in Christian doctrine as the 'three Persons of the Trinity'. This need not be due to forcing a faith and its history into the mould of dogma, for although the doctrine of the Trinity was the subject of prolonged theological debate and of decisions by ecumenical councils in the fourth to fifth centuries, the religious experi-ences out of which they arose can be seen in the first generation of Christianity. They are reflected in the phrases of Paul and summed up in the concluding formula which has become familiar to Christians as a benediction:

The grace of the Lord Jesus Christ, the love of God and the fellowship of the Holy Spirit be with you all (II Cor. 13.14).

The one God is known in these three ways – through the central figure of Christ as the person who reveals God's grace and mediates his salvation to men; through the heavenly Father experienced in creation, as the source of all being, law and love; and through the work of the Holy Spirit experienced in the church and human lives as God at work in the world. The interrelation of the 'three Persons' meant that Christians could con-ceive of the mystery of God's nature both in a monotheistic transcendent sense and in a more concrete personalized sense. This complexity made the Trinity a problem not only for intellectual definition in the credal formulas but also for depictions in 'sacred art', as we shall see. Neverthe-less it may be claimed that the distinctive Christian understanding of God in the Trinity provides, for better or worse, the matrix of subsequent Christian iconography.

Out of this has emerged, over the centuries of Christianity in its diverse forms, a tremendous variety of visual images used in the liturgy of the churches, in the decoration of churches (both inside and outside), in the illustration of religious books and in domestic devotion. How should iconographers classify this great wealth of material? One way is according to the derivation of the themes – the Bible (Old and New Testaments) and the saints of the church.[4] The plan of a large five-volume work on the iconography of Christian art in process of publication is instructive in its grouping of the major themes:

Christ's incarnation, childhood, baptism, temptation, transfiguration, work and miracles.
Christ's passion.
The resurrection and glorification of Christ, and the images of the *Majestas Domini* and the Trinity.
The church (*Ecclesia*); Mary.
The Last Judgment and the Old Testament.[5]

Our discussion in this chapter does not attempt a systematic summary of these themes when they are readily accessible in a number of excellent reference works.[6] Our concern is rather to show the types of Christian iconography in the major Christian churches,[7] using some of these themes (especially the Christ-figure) to illustrate developments from the earliest period to the present.[8] We may thereby see what the use of images has meant to Christians in their different situations.

Ancient Christianity

Despite the continuity which Christians experience with the faith of the earliest church and its literature in the New Testament, that church was part of the ancient world, even in its protest against it:

The Christian Church arose in a world given to idolatry, but arose out of the Jewish community which maintained, in the midst of that world, its intransigent protest against image-worship.[9]

The church of the first five centuries is to be understood in its ancient setting, related both to its Jewish heritage and to the pagan Hellenistic-Roman world. History and archaeology again illuminate the origins of Christianity and its iconography.[10] They help to explain both why Christian art was slow to emerge and why, when it did, it used certain forms. This is not to minimize the problems of knowing precisely what these early images meant to Christians – how far the memory of pre-Christian meanings survived and what changes were wrought by succes-

sive Christian interpretations. There is uncertainty about the dating and significance of a number of the early Christian monuments.[11]

These issues are exemplified in the interpretation of early aniconic forms such as the famous fish-symbol, which has often been romanticized as a secret sign of Christ among the early Christians. This derives from an acrostic which was circulating in the late second century – perhaps originating in Gnostic circles which were fond of alphabet mysticism and magic formulas.[12] The Greek word for fish, *IXΘΥΣ* (Ichthus), can be formed from the initial letters of the Greek words for Jesus Christ, God's Son, Saviour. But it is not easy to determine whether this was the cause or effect of the fish being equated with Christ as a visual symbol in the same early period. The fish was already a religious symbol in Judaism and cults of the ancient world. In Christianity it became associated with the sacraments of baptism and communion. A Christian epitaph, *c.* AD 200, depicts two fishes and an anchor with the words 'Fish of the living'; the fish suggest the presence of living water, the life-giving source in the New Jerusalem of which baptism is a foretaste in the new life of Christians. Tertullian, an early third-century Latin theologian, wrote:

But we small fishes, thus named after our great Ichthus, Jesus Christ, are born in water and only by remaining in water can we live.[13]

201. Loaves and fishes from a fresco in the catacomb of Callistus, Rome.

The fish is also depicted from the third century in banquet scenes and groupings of Jesus and the twelve disciples at the Last Supper. The reference is clearly to the Christian eucharist; the story of the loaves and fishes in Jesus' feeding of the five thousand is understood as a eucharistic looking forward to the coming kingdom of God. All this is summed up in the wall-painting from the catacomb of St Callistus in Rome which shows a small basket of loaves standing on a fish; the symbolism speaks immediately of the communion. Here we come close to the faith and worship of the early Christians. These elemental symbols were thus used in a specifically Christian sense, and for several centuries mosaics and manuscript paintings depicted the Last Supper in similar forms.

Another symbol for Christ is seen in the sacred monogram, the Greek letters *XP* (Chi-Rho) which begin the name 'Christos'. This influential symbol became associated with victory and it is appropriately shown in the form of a trophy on a fourth-century sarcophagus. Here it is encircled by a triumphal wreath hanging from the beak of an eagle. Below it the stem turns into a cross with soldiers sleeping at the foot like defeated barbarians on imperial trophies; this refers to the soldiers guarding the tomb at Christ's resurrection. The whole 'trophy of the cross' thus symbolizes the resurrection victory over death. Besides this central motif

202. Sacred monogram and 'Trophy of the Cross'.

the sarcophagus also depicts scenes from the passion of Christ such as his encounter with Pilate, and Simon of Cyrene; but the crucifixion itself is not shown. This is all the more surprising since the cross and resurrection formed the core of Christian teaching from New Testament times, as attested by Paul (I Cor. 15.1ff.). The cross was to become after the sixth century a dominant Christian symbol, taking a variety of forms and linked with cosmic symbols such as the tree of life,[14] but for the early Christians crucifixion was a sign of shame and offence, a form of death for the worst criminals which Jesus shared. The earliest crucifixion picture seems to be a pagan caricature crudely scrawled on a Roman wall; it shows a young man adoring a man's body with an ass's head on a cross, with the inscription 'Alexamenos worships his god' – a crude piece of derision.[15] This of course would not have prevented Christians from using the symbol among themselves. The reason why they did not represent it directly was most probably that their focus of interest was not on the cross in itself but on the resurrection sequel where 'death is swallowed up in victory', in salvation and eternal life.

In the same spirit but with a different set of symbols, the monogram appears as the cross with peacocks, vines and a chalice in the sixth-century chancel slab relief from Ravenna. Here the associations are eucharistic; the Christogram rises from the chalice along the vines and grapes, recalling Christ as the vine to which Christians are joined (John 15) and the eternal life in which they share. The peacock is a beautiful symbol with rich associations in the cultures and religions of Asia. In Christian iconography it signifies immortality and is linked with the sacrament of communion, as in this example and many others from ancient and medieval Christianity, in churches and sarcophagus decorations.

The lamb is another symbol from the natural world given a specifically Christian meaning. Against the background of the ancient Jewish

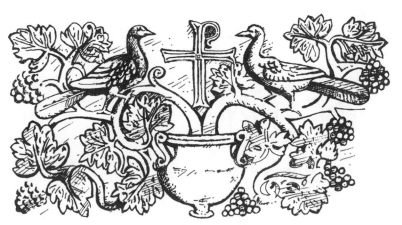

203. 'Source of Life'; sixth-century relief from chancel slab, Ravenna.

sacrificial lamb, Christ himself is referred to in the New Testament as the 'Lamb of God who takes away the sins of the world' (John 1.29–36). This appears early in Christian iconography in the catacombs.[16] The lamb can also be a follower of Christ who is the shepherd; and this meaning is developed in the apse of St Apollinare in Classe, Ravenna, where the twelve lambs represent the apostles, but the dominant meaning is of Christ as the paschal lamb 'slain from the foundation of the world', as in the apocalyptic vision (Rev. 5.6). That this was no sentimentalized little woolly lamb is indicated by the representation on a marble sarcophagus from fifth-century Ravenna. He stands with the cross, noble and elevated on the hill, a messianic redeemer. The same impression is conveyed by a fine ivory diptych from fifth-century Milan in which a magnificent haloed lamb stands at the centre of a wreath of the fruits of the seasons and a further frame of scenes from the biblical story of salvation; the numinous lamb of the Easter sacrifice and victory stands at the centre of the church year and of God's plan.[17]

The examples described above illustrate the predominantly aniconic form of Christian art in the earliest period. Some of the symbols continued to influence Christian iconography – such as the Chi-Rho monogram and the Greek letters Alpha and Omega signifying Christ as the beginning and the end. Others, such as the fish symbol, declined in significance. The lamb (*agnus dei*) continued to flourish in the Western church; in the East the lamb figure is imprinted on the sacramental bread, but Eastern iconography discontinued its use when a council of 692 decreed that Christ was to be pictured as a man instead of a lamb. How this transition was made possible may be gathered from a brief survey of the factors, both negative and positive, involved in the development of early Christian art.

Much is obscure about the attitudes of Christians in the first three centuries, and there is insufficient evidence on which to base generalizations. The New Testament gives no description of the appearance of Jesus and we may gather from this that the church was not particularly interested in such details. In a world that was passing away what really mattered was the story of salvation, the narration of what Christ had done and what he meant spiritually to his followers as Lord and bringer of hope in eternal life. With this as their prime concern, visual images were not necessary. Christian worship took place in family homes and church gatherings had no permanent cultic centre like temples focused on images and altars.

Negatively there was also a strong opposition to images because of the surrounding pagan world. The whole art and culture of the Roman empire

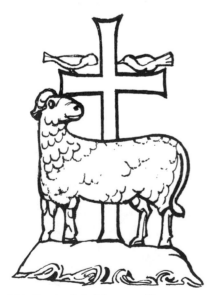

204. Lamb of God from marble sarcophagus, Ravenna.

was connected with ancient myth and ritual and it was no matter of easy tolerance or indifference when Christians came into conflict with the culture; some were martyred rather than sacrifice before images which they saw as idolatrous abominations.[18] Here Christianity inherited the Jewish prohibition of images in the Decalogue. Although the early church fathers do not appear to prohibit the making of images but only their worship, they went further than Jewish critiques in regarding the pagan idols as indeed animated by spirits – evil spirits or devils.[19] This is why it was a problem for first-generation Christians living in a pagan society whether they should eat meat that had been sacrificed to idols; St Paul deals with this (I Cor. 10.19–20).

In order to hold fast to their faith and witness to its unique claims Christians had to stand out against the pagan symbols, not only of the official temple cults but also of the many foreign cults and 'mystery-religions' current in the Roman world. For instance Mithraism was probably the greatest rival of early Christianity, being a male cult especially popular among Roman soldiers. It was centred on Mithras, derived from the ancient Indo-Iranian deity of light and contracts. His most famous exploit is the slaying of the bull whose life-giving blood is poured out for man's benefit; this is represented in the typical cave-like sanctuary, the *mithraeum*.[20] Mithras is also shown ascending to the realm of light. There is some similarity to Christian and biblical themes, but Christianity did not compete with Mithraism in exploiting the powerful natural symbols of blood, bull, sun and planets which featured in the vivid Mithraic images and rituals; only later did Christian iconography incorporate them as subsidiary visual symbols.

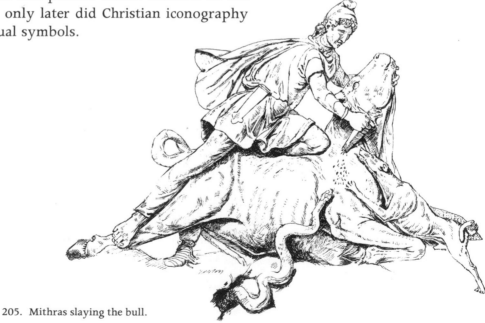

205. Mithras slaying the bull.

Early Christian writers of the second to third centuries such as Irenaeus, Origen and Clement of Alexandria were hostile to pagan images in the spirit of prophetic iconoclasm. Origen proclaimed against the pagan Celsus that Christians and Jews detested temples, altars and images and were ready to die, if necessary, rather than unlawfully debase their idea of the almighty God. There was a further suspicion of art as something vain, worldly and unspiritual; Christians were to renounce passing luxuries as non-essentials, especially when art could become a temptation to evil living as well as to idolatry. This seems to underlie the polemic of Clement of Alexandria against the material and sensual basis of art; further, images were a form of stealing from God, the primal source of all spiritual beauty, (an argument similar to later Muslim teaching). Eusebius of Caesarea, the bishop and historian, continued this stand in the fourth century, arguing that the pure divine essence could not be reproduced in dead and lifeless colours in images of Christ and the saints. However, by this time the Christian churches were attracting masses of people for whom visual images filled a need in devotion and instruction, while the long-established forms of Christian funerary art required some official concessions. The rigorist position had to be modified. The fourth-century eastern fathers, Gregory of Nyssa and Basil the Great gave increasing justification to images of the saints while still careful to avoid any suggestion of idolatry; thus narrative paintings of the saints and martyrs served as edifying illustrations in the churches dedicated to them.

We have already mentioned the latent tendency to iconography in the Christian doctrines of the incarnation and Trinity. The positive factors which led to its open expression in the Christian churches of the fourth to fifth centuries may be enumerated as follows.

First, the heritage of Judaism in the Old Testament scriptures provided a rich store of symbols and incidents waiting to be depicted. Despite the prohibition of images, Jewish liturgy became linked with symbolism and visual images were produced at certain periods, as at Dura-Europos in the third century. This may have stimulated Christian developments more widely, for the small Christian house-church at Dura had a baptistery with wall-paintings of Adam and Eve, David and Goliath and scenes of the ministry of Jesus. But apart from this the subject-matter of the Bible readily evoked pictures in the mind – the grandeur of nature as God's creation, the dramatic events of creation, the fall of man, the flood, the patriarchs and the exodus from Egypt. The story of salvation included great personalities such as Moses, King David, the prophets and heroes of Israel in their historic actions and their individual relation to God. Now the early Christians eagerly used these stories to symbolize their own faith,

finding in them pointers or 'types' from the past prefiguring what had now come to pass through Jesus Christ.[21] This 'typological' interpretation of the Old Testament which is evident already in the New Testament writings was used not only in preaching and theology but also in the earliest visual Christian art of the catacombs.

Among the themes depicted are Noah's ark, Moses at the Red Sea, David the young warrior, Daniel in the den of lions, the three Hebrews in the fiery furnace, Jonah emerging from the whale, the suffering of Job.[22] Just as God saved these people in the past, he continues to offer salvation and hope through Christ. This is the pervading emphasis which led on to the depiction of explicitly Christian themes from the New Testament. A further example of typology is seen in the appeal, in both teaching and iconography, to the incident in Gen. 18 where three heavenly visitors appear to Abraham by the tree at Mamre; this was interpreted to mean the revelation of God in three persons, and as a type of the Trinity it was used in ancient church painting and continued in the Byzantine and Orthodox tradition.

Secondly it is significant that most of the earliest evidence is in the realm of funerary art – art connected with tombs and decorated caskets or sarcophagi. While Christianity remained a minority religion within the Roman Empire subject to periodic persecution at times of crisis, it was not likely to build large and ostentatious churches; the simple unadorned house-church sufficed for worship. Art work was mainly sponsored by Christian individuals or families sufficiently wealthy to commemorate their dead with sculptures or paintings. A good example is the sarcophagus, finely carved with a whole series of incidents from the Old and New Testaments, of the Roman Junius Bassus, a professing but unbaptized Christian who died in AD 359.[23] Less artistic skill is shown in paintings, sometimes crude and sketchy, found in the 'catacombs'. This is the modern name for the underground cemeteries ('sleeping-places') where Jews and Christians were permitted to bury their dead, in contrast to the surrounding Roman practice of cremation; in Rome the vast networks of subterranean passages total over 500 miles in length. Christians did not worship there as a church but on occasion they would assemble to honour the dead. Some of the more spacious tombs had chapels or could be decorated with wall-paintings. In the gloom such paintings scarcely needed to be elaborate works of art; a simple bold symbolism was sufficient to express the theme. And the dominant theme in such a setting was that of hope for life beyond death, a hope based on the resurrection victory of Christ. Most of the paintings of Old Testament scenes can be interpreted typologically in this sense. The heavenly city of

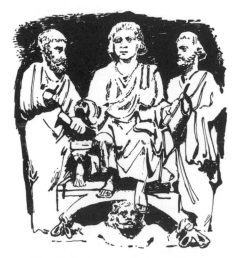

207. Christ between Peter and Paul.

Jerusalem likewise expresses this hope, along with explicitly Christian themes from the New Testament such as Christ, the Good Shepherd, carrying the individual lamb of his heavenly flock.

Other scenes were taken from the gospel accounts of the ministry of Jesus – his calling of the disciples, his miracles, his giving of the law to Peter, his own baptism. We have already seen that the passion and resurrection were not portrayed, except aniconically. Nor was the childhood of Jesus shown. However, the Virgin Mary, the apostles and martyrs began to appear in catacomb art, also the Last Supper and communion as a table gathering. A distinctively Christian figure is of the *orans*, the person praying in the early Christian manner, with the hands raised to heaven (fig. 213, p. 243).[24] Expressing the pious believer's relation to God, it was also used for pre-Christian figures such as Noah, depicted in his box-like ark in the gesture of piety. Increasingly refined painting led to realistic portraits of deceased persons; subsequently the orant symbol became reserved for saints and martyrs. The evidence of the catacombs shows that already in the third century biblical subject-matter was providing the elements of a Christian iconography, though not following any uniform programme.

But biblical themes and funerary settings were not the only factors. A third factor is the positive influence of Hellenistic and Roman art, for while the early Christians were so strongly opposed to pagan religious culture, such rejection could never be absolute. As Christians began to express their faith through the visual arts they turned naturally to the style and forms familiar in the contemporary painting and sculpture. For instance in presenting the figure of Christ they drew on the costume, gestures and posture of familiar Roman figures.

Christianity, at its birth, borrowed, and kept, the Greco-Latin iconographic language as commonly practised at the beginning of our era everywhere around the Mediterranean.[25]

The pagan mythology and its religious content could be rejected, but the artistic style could be accepted. The influence of this style was already at work in the Gandhara style of Buddhist art; much more can be said of the first Christian art which belonged in the family of Greco-Roman art of late antiquity. Not only the style of art but the themes of classic mythology were exploited and woven into a Christian pattern in the decoration of tombs. Stories of Cupid and Psyche, Orpheus, the heroes Ulysses and Hercules and the winged figure of Victory were used in this way.

Finally, the effect of the 'triumph of the church' must be noted. With the conversion of Constantine and his imperial rule in the early fourth century the Christian church could look forward to peace and the freedom

to build churches in increasingly impressive form with openly Christian symbols and images. Further, the support of imperial power brought a shift of emphasis in the symbols used, especially when Christianity was established as the state religion by the imperial edict of Theodosius in AD 380. This was the period when the triumphal art of Roman emperors was reaching its peak; the grandeur and majesty of the monarch was celebrated in colossal statues, sacred palaces and large gold medallions (showing, for instance, Constantine being crowned by the hand of God). Although this art was pagan in spirit its triumphalism helped to express certain Christian themes in a new way – the majesty of the omnipotent redeemer; Christ the king giving mandates to his disciples; the victory of Christ and the saints. Ceremonies of coronation and investiture were also popular in the art of tombs and church mosaics. In explaining this selection one may conclude with Grabar:

Christian art took over the formulas used to extol the glory of the monarch and adapted them to Christian uses.[26]

The foregoing factors are evident in the early representations of Christ to which we now turn. There is no question of there being any historical 'portrait' of Jesus, for as we have seen the early Christians were not interested in this question. Only in later legends was it claimed that the image of the face of Christ was impressed on the cloth or 'veil' of a woman who in the thirteenth century was identified as Veronica on the road to Calvary; her name (meaning 'true image') is clearly an invention. Interesting questions of authenticity are raised by a relic appearing in the fourteenth century, the 'Holy Shroud of Turin', which bears the impression of massive features claimed to be those of Christ.[27] Meanwhile it is evident that the early images of Christ were not intended as likenesses at all but as forms symbolizing the meaning of Christ's work of salvation. For centuries quite different types of images of Christ co-existed in Christian art. While some catacomb paintings represent him with a beard and long hair, many other images follow a youthful type with short hair and no beard. A current Greco-Roman model is used in the fine early third-century marble statue of the Good Shepherd, the curly-headed young man in a short tunic bearing a lamb on his shoulders. Although the Christian context makes it refer to Christ as the trustworthy shepherd and deliverer, the question of the Christian flock in the light of biblical references from St John's gospel and the Old Testament shepherd image, it could also be a pagan image. Pastoral imagery was popular in Roman

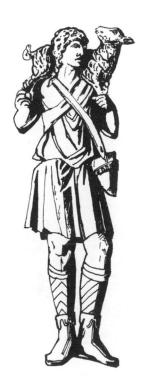

206. Christ the Good Shepherd with lamb.

painting and pagan sepulchral art could use the same shepherd motif to evoke the ideal sojourn in the after-life.[28] It could also symbolize philanthropy and *humanitas*. Hence pagan and Christian figurations are intertwined, making them sometimes hard to distinguish. Associated with the shepherd is the figure of Orpheus with his lyre who becomes a deliverer of souls from death. Christian art in the catacombs and in later church painting combined the ideas of David, the Old Testament shepherd-king, and Christ the Good Shepherd with the Orpheus figure charming a flock of animals with his music.

The youthful Christ appears in the classic Greco-Roman tradition in the round-cheeked figure on the Junius Bassus sarcophagus. Serene and symmetrical like Apollo, he sits in authority commissioning the apostles Peter and Paul who themselves are depicted in the style of philosopher-orators. A further classical motif is the lower figure of Caelus the sky-god holding an arched piece of drapery, or canopy, on which rest the feet of Christ ascended in heaven above. As Jane Dillenberger points out, the use of classical gods and allegorical figures is not uncommon in early Christian art:

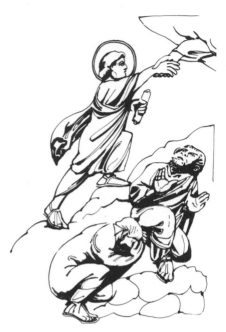

208. Christ ascending: detail of a Roman Christian ivory.

It is part of the artistic vocabulary of the time, and no more remarkable perhaps than the English Anglican bishop who, when nettled, exclaims, 'By Jove!' and sees no contradiction between his Christian faith and his oath naming the father of the classical gods.[29]

The youthful vigorous figure of Christ mounts heavenward in the resurrection pictures depicted on the ivory diptych from north Italy *c.* 400. Not shown here are the scenes of the empty tomb with the soldiers sleeping and an angel addressing the three women on Easter morning. In the detail shown Christ is ascending, with two disciples at his feet. Of particular interest is the hand of God reaching through a heavenly cloud to grasp the outstretched hand of Christ. The image of the hand or arm of God is frequently used in the Old Testament to express the creative and redeeming power of God, as in the Jewish synagogue paintings of Dura-Europos (fig. 196, p. 210). This accords with the probable Syrian origin of its use in Christian iconography. Since God could not be shown directly this device became a convention in Byzantine paintings which showed the hand of God thrusting down from a blue segment of heaven. The hand of God also had a religio-political significance in coronation themes from late Roman to Carolingian times.[30]

With the triumph of Christianity and the building of churches with suitable wall space colourful frescoes and mosaics began to illustrate the Christian story. The sixth-century churches of Ravenna in north Italy are famous for their mosaics which link the Eastern (Byzantine) style

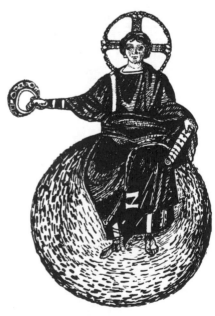

209. Christ enthroned over the cosmos.

with the Latin West. From the church of San Vitale we have another figure of the youthful Christ, now as triumphant ruler of the cosmos:

Bright in the glittering livery of youth and preceded by winged figures proudly brandishing the monogram of the triumphant Redeemer, Christ sits in glory on the sphere of the cosmos, welcoming into his celestial garden the saints and the donor of the Church of San Vitale.[31]

Also in Ravenna from this period, in the church of St Apollinare Nuovo, is a whole series of mosaics of scenes showing the youthful Christ in his gospel ministry, miracles and passion. This type continued in the West, as in the Carolingian book-covers of the eighth to ninth centuries showing Christ enthroned. The 'youthful Christ' has reappeared in various periods of Christian art; (but moves in this direction in modern European art received a set-back in the late 1960s with the vogue for beards and long hair).

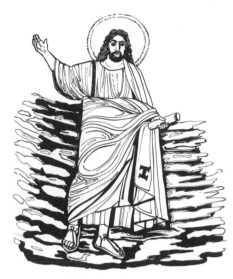

210. Christ in glory.

All these examples represent Christ as a vigorous and handsome young man in the Hellenistic tradition. They accord with the opinion of fourth-century church fathers such as Jerome who cited Psalm 45.3 as a reference to Christ: 'Thou art fairer than the children of men'. Earlier Christian writers such as Justin Martyr and Tertullian had cited Isaiah 53.2 ('he has no form nor comeliness . . .') to show that Christ was a suffering figure without physical beauty.[32] The latter opinion did not prevail in Christian art. The alternative to the youthful Hellenistic ideal was the long-haired bearded type, probably of Syrian origin. Because it appears in some early catacomb paintings and has been subsequently hallowed by centuries of tradition, this type is sometimes referred to as 'historical', but we have seen that this term is inapplicable. It too seeks to present an ideal Christ – the mature and powerful Lord, majestic like an oriental monarch. This is evident in the impressive mosaic in the apse of the early sixth-century Roman church of St Cosmas and St Damian. The whole scene shows the hand of God above, the apostles as twelve lambs below with Peter and Paul included in the saints at the sides. Christ himself is here descending on red clouds at his second coming (*parousia*); his appearance is majestic and his gesture imperious conveying a sense of numinous awe.

A more serene and kindly bearded Christ appears more than a century earlier in another Roman apse mosaic, at Santa Pudenzia, AD 401–17. The centre detail shows Christ splendidly enthroned as he teaches the twelve apostles with a commanding and perhaps judging gesture. Based on a classical semi-circular arrangement of teacher and disciples, the whole scene is set in heaven, a counterpart to the earthly scene of the bishop and presbyters who would be seated in the church below. It is the heavenly Jerusalem, with a large triumphal cross and the four apocalyptic

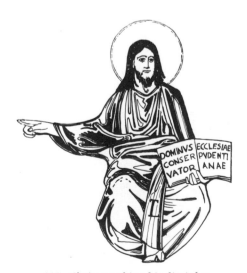

211. Christ teaching his disciples.

beasts featured above the Christ-figure, foreshadowing their later importance in iconography. With this splendid scene in an early Roman mosaic 'truly Christian work on a grand scale appears for the first time'.[33]

A leap of seven centuries shows the full flowering of the Byzantine tradition of this majestic bearded Christ. In the cathedral of Cefalu, near Palermo in Sicily, a Greek artist with craftsmen executed a mosaic to fill the upper part of the apse with the huge figure of Christ as 'Pantocrator', ruler of all the universe.[34] This is the eternal Christ present in creation and judgment and radiating the divine energy; the Byzantine flavour is expressed in the brilliant golden mosaic background representing the splendour of heaven, also in the detail of the double forelock of hair. Otherwise this is Christ the Lord of the early Christian tradition. As the true 'image of God' he looks out on the congregation with a serene and penetrating gaze. As the redeemer he gives the blessing with his right hand and holds in the other St John's gospel opened to read (in both Greek and Latin): 'I am the light of the world. He who follows me shall not walk in darkness'.

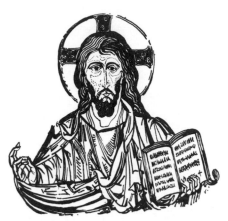

212. Christ as Pantocrator.

Icons and Eastern Christendom

There are good reasons for spending time on the study of Eastern Christendom and its iconography which have received little attention or sympathy in the West until recent decades. First, in its own right the Byzantine tradition is an impressive one. For eleven centuries it flourished at Constantinople (Byzantium), especially at the time of the so-called 'Dark Ages', of Western Europe.[35] Constantine intended his city to be a new Rome; but as well as this ancient imperial heritage it came under the sign of the cross – it was to be the new Jerusalem, as a Christian state witnessing to the kingdom not of this world.[36] The great church of Hagia Sophia built in Justinian in the sixth century was renowned throughout Christendom and Byzantine art reflected the faith in rich and diverse forms.[37] Culturally Byzantium was related to the worlds of Sassanian Iran, Islam, Armenia and the Slavs and peoples of Eastern Europe to whom it mediated Christianity. Even when it succumbed politically to the Ottoman empire its religious influence persisted in the Eastern Orthodox Church.

Secondly, the art of Western Europe owes much to the East, as evidenced in the art of sixth-century Ravenna and works throughout the following centuries leading to the Romanesque style. In a wider sense it can be argued that Byzantium continued the art of ancient Greece and handed

on to medieval Europe a sense of harmony and colour and a spiritual humanism.[38] In the more specific sense of religious iconography some of its themes and conventions can be seen in Western paintings.

Thirdly Byzantine art produced the icon, a distinctive form of sacred art which we shall now examine. The term 'icon' was originally used in its wider sense of 'image', referring to any depiction of Christ, the Virgin, the saints and biblical figures, including frescoes and monuments. But in Eastern Orthodoxy it has come to be restricted to movable pictures (apart from paintings in illuminated manuscripts) which are not three-dimensional.

Thus the Byzantine icon may be defined as a representation of a sacred subject on a portable plaque of wood, stone or metal, no matter what the technique employed – painting on wood surfaced with plaster, enamel-work or mosaic.[39]

The importance of this form lies first in its close association with the life and worship of the church.[40] The liturgy of the church does not depend on visual icons or on the typically central plan of Orthodox Church architecture but these are vital expressions of it, and icons have an important place also in domestic devotion. Further, the icons are linked with the Bible and the church's teaching. The didactic value of images was recognized also in the Western church, especially in the classic statement of Pope Gregory I (*c.* 600) who rebuked a too-ardent bishop's over-reaction in breaking up pictures which had been ignorantly worshipped. Certainly images were not to be adored by acts of homage, but they had a valid function:

For that which a written document is to those who can read, that a picture is to the unlettered who look at it. Even the unlearned see in that what course they ought to follow; even those who do not know the alphabet can read there.[41]

The Eastern church, however, went further than this by developing a sacramental view of images as mirrors of the sacred; its doctrine of sacred art was hammered out through the iconoclastic controversy of the eighth to ninth centuries. This will become clearer as we trace the historical emergence of icons in the East.

As we have observed, the earliest Christian images in catacombs and churches were not icons in the specific sense. Only a few examples of portable paintings survive from sixth- to seventh-century Rome and Egypt. These show the saints and the Virgin Mary in stiff frontal poses with a penetrating gaze which seems fixed on the viewer. This characteristic of figures in Byzantine art and icons may well have originated in Egypt with funerary portraits of earlier centuries.[42] It appears in the sixth-century, Coptic (Egyptian Christian) monastery fresco from Bawit. Here

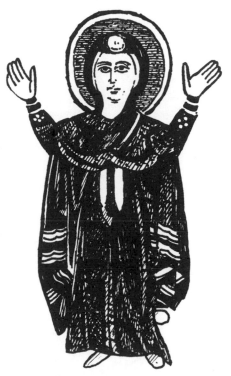

213. Coptic fresco of 'Mother of God' at prayer (orans).

the Virgin Mary as 'Mother of God' stands with her hands raised in prayer, following the ancient Christian *orans* position as seen in catacomb paintings. The frontal steadfast gaze is seen also in a Coptic icon preserved at St Catherine's monastery of Mount Sinai from the sixth century; there the Mother of God is enthroned holding the infant Christ, flanked by standing saints and angels. These types were subsequently combined in the main icon of Orthodoxy depicting the incarnation – the 'Virgin of the Sign'[43] who with hands raised outward stands in a large halo with Emmanuel, the infant Christ in a medallion (*clipea*) on her breast. This signifies the inseparability of Mother and Son of God in the Orthodox view; he shares in her humanity and she in his divine glory.

The Virgin and Child enthroned are also shown in the mosaic of the vestibule in Hagia Sophia, Constantinople. Although it is probably of tenth-century origin, its themes are relevant and instructive concerning the earlier period, for in an anachronistic or perhaps 'timeless' way it depicts the Byzantine emperors making their offerings to the Virgin. Constantine at the right presents the city of Byzantium which he founded (AD 330) and Justinian at the left presents Hagia Sophia (AD 537). In return she is the protectress of Constantinople; regally enthroned in her blue garment against the heavenly gold background, she holds Christ whose right hand is raised in blessing. This exemplifies the interrelation of church and emperor in the sacred city – the religious, political and social context of the early Byzantine iconography.[44] The dominant figure is

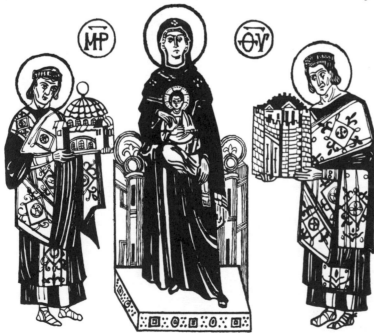

214. 'Mother of God' enthroned, with Byzantine emperors.

clearly that of the Virgin Mary, as indicated by her title written in the Greek capital letters in the roundels by her head: MP ΘY, the first and last letters of the words *Meter Theou*, 'Mother of God'. As in the case of the signets for Jesus Christ, these are not abbreviations to save space; they are due to awe at the powerful and holy name, lest it be profaned by careless voices.

That people regarded icons as powerful sources of divine protection is seen from the use made in Constantinople of a great icon of the Virgin Protectress on the city walls to ward off the Persians and Slavs in 625. Also in the early seventh century the Emperor Heraclius carried an icon of Christ into battle against the Persians and was victorious. This post-Justinian period saw a great increase in the devotional use of icons, both inside and outside the church, as receptacles of wonder-working power. In the case of some famous icons this was attributed to their miraculous origin as 'not made by human hands' (*acheiropoietos*). Here we have a belief similar to the ancient Greek legends of images which had dropped from heaven, but the Christian legends looked to historical beginnings, as in the Mandilion of Christ. This was believed to have been imprinted by Christ when he dried his face on a piece of fabric and gave it to the messengers of King Abgar of Edessa who had asked for a portrait. This became the prototype of the much-copied 'Holy Face' icon in the Orthodox tradition. The bearded, long-haired face is given an almost abstract form based on concentric circles and a square cross in the halo in which may be found Greek letters for 'He who is'.[45] The elemental harmony and simplicity of this icon puts the worshipper in touch with Christ as the ever-present eternal source of grace and true being. Neo-platonic philosophy gave intellectual support to belief that behind the material image lay sacred reality, just as Christ was the image of the invisible God (Col. 1.15).

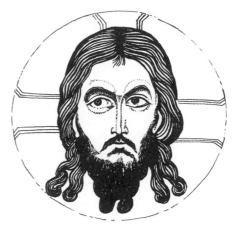

215. 'Mandilion', image of Christ 'not made by human hands'.

In popular practice the miraculous powers of icons were the object of growing veneration in the sixth to seventh centuries. This was no doubt a legacy of the great influx of former pagans into the church from the fourth century onwards; there was a continuing desire for images as visible mediators of the divine and of protective power. Their desire was not largely by the growing cult of saints and martyrs whose images were believed to bring blessings, miraculous cures and protection from harm; they were even taken as baptismal sponsors and treated as spiritual agents in themselves to be addressed in prayer. An element of commercialization entered through the independence of powerful monasteries, able to cater for this demand by the manufacture and sale of icons.

The protest against such developments and abuses, regarded as forms of idolatry and superstition, took political shape in the Eastern empire

in the iconoclastic controversy which lasted officially from 726 to 843. In this struggle various social, political and cultural forces can be seen ranged against one another, with the religious issues often used as banners or labels. The Byzantine emperors were interested in enlarging their power, wealth and 'imperial image' by removing rival images; the church and monasteries sought largely to defend their power and the use of images. Nevertheless this should be seen as a religious question which deeply divided the East over a period of two centuries. The spectacular rise of Islam in the seventh century appeared to many in the Eastern empire as a judgment from God and a warning against apostasy, leading to decay and destruction. The prophetic iconoclasm of Islam was a reminder that Christian monotheism had its basis in the Old Testament commandments. In such a mood it was possible to revive the early Christian puritan suspicion of art and images as pagan and to agree with the fourth-century theologian Eusebius that the Lord's Word was the best painter. The outcome was a systematic removal and destruction of religious images (not of art in general) and a ban on the manufacture of icons. Churches, palaces and public buildings were stripped of images and Christ could be symbolized only by the cross with 'Alpha and Omega' letters; thus in the church of St Eirene in Constantinople only the bare symbol of the cross remained in the apse. A ninth-century psalter illumination depicts an iconoclast whitewashing over a wall bearing an image of Christ; to the supporters of icons such an act was deplored as sacrilege, like recrucifying Christ himself. Deep feelings were aroused on both sides; but we can best look at the main arguments to which they appealed.

The iconoclasts drew support largely from the court, the army and many bishops. Their theological case might be summed up in the biblical teaching that no man has seen God. The arguments, in brief, claimed first that images were a reversion to pagan idolatry, forbidden in the Bible and the fathers. Secondly, it was impossible to represent the Godhead in images without falling into heresy concerning the two natures of Christ; one would either circumscribe the uncircumscribable Godhead or divide the human from the divine (the christological dilemma of Constantine V). Thirdly, the eucharist was the only true image of Christ. Fourthly, the only admissible images of saints were the virtues lived out by Christians who copied them.[46]

The iconodules, those who supported the use and veneration of images, drew their support from the general populace and the monasteries. It is significant that their most decisive arguments were thought out by a monk, John of Damascus, who lived under Muslim rule in mid-eighth-century Syria. His teaching was influential at the second council of

216. Byzantine iconoclast whitewashing an image of Christ.

Nicaea (in 787), regarded as the seventh ecumenical council; eventually it won the day for the iconodule position in the East. The council justified the use of images as mediators and reminders of the divine activity, so that to honour (but not to worship) the images would arouse the beholders to recollect the original: 'For the honour paid to the image passes to the original, and he that adores an image adores in it the person depicted thereby.' Among the various arguments put forward by the Damascene[47] and developed at the council and in later more mystical Neo-Platonist terms in the ninth century, the most important point was the doctrine of the incarnation. If God really became man in Jesus Christ, he provided an earthly visible image of himself, the Son being a perfect image of God the Father. Matter was thereby sanctified by spirit and the foundation laid for a doctrine of images which answered the needs of man, himself a creature of body and spirit. On this theological basis the iconodules could challenge the iconoclasts with rejecting the incarnation and orthodox christology.

In the developed doctrine of Eastern Orthodoxy icons are seen as sacred manifestations pointing beyond themselves to the eternal archetype who is unseen in heaven. The icon should not therefore be realistic; anything in the nature of statues or three-dimensional images is prohibited, with tests and limits specified on reliefs to ensure their flatness; likewise natural light and shadow are omitted from paintings. The icon is regarded instead as a window or mirror reflecting supernatural light and enabling the viewer to experience the power of the Holy from beyond. At the same time the fixed gaze of Christ and the saints draws the viewer into their mystical presence. On this basis also the icon is credited with miraculous power to protect, to heal and to mediate divine grace in the various concerns of life. Popular practice is thus justified on the principle that matter can carry grace; but doctrine sets a limit on superstitious abuses by affirming that the icon does not possess such divine grace and power in itself – these are reflected from the heavenly source and work through the prayers of the worshipper.

With the victory of this position icons became more firmly established than ever in the Eastern church. Continuing the former traditions, icons were made on a growing variety of themes and used in the churches, in processions and in domestic devotion. The council of 787 declared icons to be on the same level as the Bible; both were means of God's revelation to men (the one visual, the other verbal). Therefore Byzantine churches in the following centuries developed an elaborate programme of church decoration which featured on the church walls the whole divine plan of salvation from the Bible. Instructions for these depictions, relating to the

techniques and the iconography, are to be found in the *Byzantine Guide to Painting*, a manual from the sixteenth century preserved by the monks at Mount Athos and doubtless derived from earlier works of lesser scope.[48] The following headings will serve to show the grand sweep of the pictorial cycle from part II:

The Wonders of the Ancient Law (Old Testament).

The Wonders of the Gospel (Life of Christ).

How to represent the Parables.

How to represent the Apocalypse.

The Feasts of the Divine Mother.

The Twenty-four Stations of the Divine Mother.

The Seven Holy Synods.

The Miracles of the Principal Saints.

How to represent the Martyrs of the Year.

Allegories and Moralities.

218. Byzantine miniatures representing the twelve feasts of the church:

Christ's incarnation and earthly ministry.

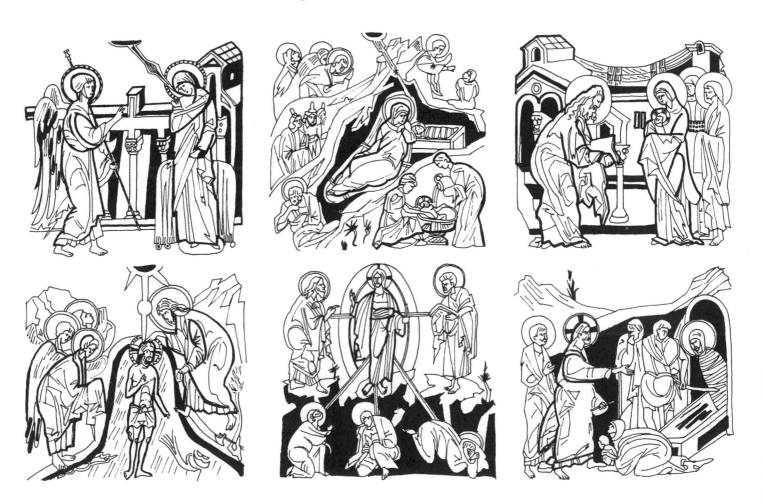

Part III instructs the painter in the distribution of subjects in a church, beginning at the top with Christ as Pantocrator at the centre. Finally, before the details of appropriate inscriptions, the painter of holy images is reminded of the Orthodox veneration of icons and of the great tradition in which he stands:

We have learned not only from the holy fathers, but even from the apostles, and, I might venture to say, from Christ himself . . . how holy images should be represented.[49]

The painter works not as an individual but as a participant in the unchanging tradition of the church which is based on the divinely-wrought originals.

A good example of a miniature cycle of themes from the Bible and church tradition is the 'Twelve Feasts of the Church', a popular series from the eleventh century onwards (earlier series featured fewer feasts, as in the fifth-century series of seven suggested by the days of creation).[50]

Passion, resurrection and the continuing presence of the risen Christ.

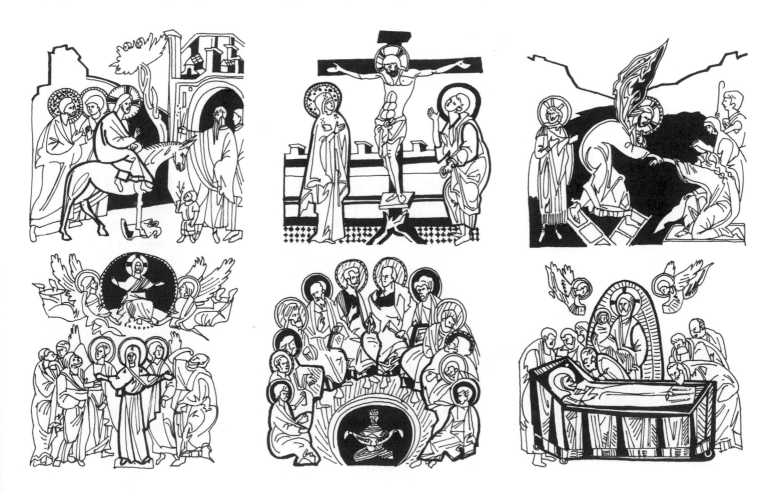

A double-leaved icon from fourteenth-century Byzantium depicts the twelve scenes in miniature mosaics to make a portable altar diptych; but in whatever forms, the iconography remains faithful to the traditional lines laid down. These twelve feasts referred to basic themes from the gospels and the traditions concerning Christ and Mary, some interpreted in distinctively Byzantine ways. They can be conveniently arranged in four groups of three.

The first line deals with Christ's incarnation – the annunciation to Mary by an angel; then the nativity scene which includes other incidents besides the birth in the manger;[51] then the presentation of the infant Jesus by Mary and Joseph at the temple in Jerusalem, with the aged Simeon.

The second line deals with the earthly ministry of Jesus, showing his divine calling as revealer and redeemer. The beginning is marked by the baptism in the river Jordan where the traditionally naked Christ descends as the divine word and the Spirit come down on him from heaven. John the Baptist (the 'Harbinger') is an important figure in Eastern iconography and devotion; he is also represented in the prominent 'Deesis' (prayer) icons and mosaics showing Christ in the centre with John the Baptist and the Virgin Mary interceding at his sides. The next scene shows Christ at the Transfiguration on Mount Tabor bathed in divine light (which is also represented as a six-pointed star); the disciples below are dazzled and terrified; Elijah and Moses bend reverently towards Jesus, confirming this revelation of him as the eternal Christ. Christ's power as redeemer is depicted in the next scene where he uses an unearthly gesture of the arm to command the dead Lazarus to come forth from his grave-clothes. This incident from the gospel of John is most important for Eastern Christendom with its stress on eternal life and the restoration of immortality through Christ; in liberating Lazarus from bondage Christ shows himself as Lord of life and death for all mankind.

This is ultimately the purpose of the passion and resurrection of Christ, depicted in the third line. Jesus rides into Jerusalem as palms are strewn in the way. There follows the crucifixion scene with Mary and the apostle John sorrowing beside the cross. Then comes the distinctive Byzantine depiction of the resurrection (*anastasis*) in the form of Christ's triumphant 'descent into hell' to break the gates and locks of hell and to rescue the imprisoned souls from past ages. Here he vigorously wrenches Adam and Eve from limbo, again expressing the redeeming and liberating power of the risen Lord. The strong eschatological emphasis in Eastern Christendom is also seen in cycles depicting the last judgment. The west (entrance) wall of the church was the place to show the figure of Christ

enthroned as judge, with angels announcing the Last Day on their trumpets and people being sifted out into the elect or saved in heaven and the damned suffering torments in hell.

The fourth line shows the continuing presence of the risen Christ. The 'two-tier' representation of the ascension goes back to Coptic frescoes of the sixth century symbolizing the church; Mary and the apostles stand on earth below. In the heavenly aureole above, the ascended Christ is enthroned, flanked by angels. The following picture shows the beginning of the church at Pentecost when the Holy Spirit was given to the twelve apostles, here gathered in a circular group. A distinctive Byzantine addition here is the figure of a little man in a circular vault in the foreground; he personifies the world into which the apostles are to be sent with the gospels written in twelve languages. Finally the Byzantine scene of the 'Dormition' of the Virgin Mary shows her death-bed at Jerusalem whither the apostles were brought by angels according to legend. The subject is to be distinguished from the Assumption of the Virgin in which she ascends heavenward from the empty tomb or coffin and astonished apostles. In the Dormition she lies with her arms crossed in death while the risen Christ standing by the bed receives in his arms the little person representing her soul. This scene is a counterpart or reversal of the 'Virgin of the Sign' icon in which she stands as the Mother of God holding and containing the incarnate Son.

This selection shows how icons are related to the Bible on the one hand and the ongoing life of the church on the other, as in the cycle of festivals of the church year. Their place in the church's liturgy is built into the structure and decoration of the church interior by means of the *iconostasis* (icon-stand). This developed from early forms of chancel barrier into the high screen, the classic sixteenth-century form of iconostasis dividing the sanctuary from the nave of the typical Orthodox church with its dome and central plan.[52] Its function is to screen but also to reveal, in the sense that it displays the whole history and life of the church through the icons; in the unity of this fellowship of believers the people are united also in the liturgy with the holy mysteries celebrated in the sanctuary through the three doors of the iconostasis. The classical arrangement of the icons is in five tiers each culminating in a central image.[53] At the top is the row of Old Testament patriarchs with the central representation of the Trinity; then the row of Old Testament prophets with the incarnation shown centrally by the 'Virgin of the Sign'; then the icons of liturgical feasts of Mary and Christ; then angels and saints standing towards Christ enthroned in glory, shown in the central 'Deesis' group of intercession (the central icon of the iconostasis). The lowest tier

features icons of 'local' significance as well as icons on the three holy doors showing the Annunciation, the four evangelists, church fathers, saints and archangels; above the central 'royal door' is shown the communion of the apostles.

These icons mirror the heavenly saints, fellow-worshippers with the earthly church joining in one cosmic liturgy; the church itself is a microcosm. Through them and with them the worshipper utters his prayers. He will kiss the icons in reverence and light candles before them. But above all the icons stand for communion with the saints and the kingdom of heaven.

The transcendental solemnity of the holy faces, the solemn ritual gesture of the hands when administering the blessing and the poise of the movements, all silently proclaim the gospel and the joyous message. . . .[54]

From the wealth of iconography that emerges in this setting, we select two or three icons for further mention. The famous 'Holy Virgin of Vladimir' is by an unknown twelfth-century artist in Constantinople and was brought to the Russian cathedral town of Vladimir in 1164. It was believed to derive from an original type painted by St Luke himself and because of its miracle-working properties was framed in precious stones – as were many treasured icons in Russia. The iconography is significant in combining two basic types of Eastern representation of the Virgin and Child. One is more austere; the mother looks at the viewer and points with her hand to the Christ child as the way of salvation; she is the *Hodegetria* (pointer of the way). The other type is the *Elousa* (Virgin of tenderness) in which the child's face is pressed affectionately on the mother's. Both types were popular and this icon successfully united something of each.

The iconography of the saints[55] in Christianity both Eastern and Western covers a great range of figures beginning with the apostles and early martyrs to include also the gospel writers, doctors and fathers of the church, monks and Christians of acknowledged piety and sanctity, patron saints and heroes of the faith. In the latter category comes St George who is shown typically in the act of overcoming the dragon. This theme probably derives from pre-Christian legends of the hero destroying a monster; and in Russia the shield of St George sometimes showed the face of the sun, linking him with pagan sun worship which his cult replaced. But the Christian icons depict him as a saint receiving victory and blessing from an angel or from God's hand in the clouds. Other icons depict his martyrdom at the hands of various torturers, in popular biographical miniatures framing a central picture.[56]

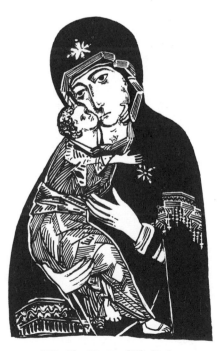

217. The Virgin of Vladimir.

The cults of the saints in Russia (and elsewhere) in some cases, at least, drew on ancient popular religion. This is evident from accounts of the conversion of Russia to Christianity. The grand duke Vladimir of Kiev in the tenth century was at first a worshipper of Perun, the thunder-god who headed the pantheon of the eastern Slavs; in 978 he had a richly ornamented wooden image made of Perun, honoured in the Kiev sanctuary with a sacrificial fire. Ten years later marriage to a Byzantine princess led him to become a Christian, whereupon he decreed the destruction of all idols and the mass baptism of the people in the river Dnieper led by Greek priests. The image of Perun was dramatically discarded by being

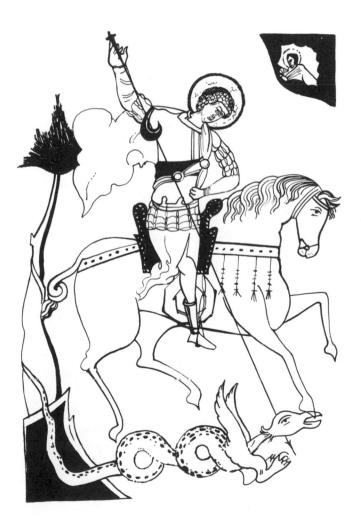

219. St George slaying the dragon.

tied by the tail, beaten with clubs and thrown in the river:

The astonished people did not dare defend their idols, but they shed tears for Perun, whom they regarded as the last prop of their superstition.[57]

The former sanctuary of Perun now became the church of St Basil. Devotion to Perun in his chariot was replaced by invoking the prophet Elijah as a thunder-spirit in his fiery chariot. This is a pattern familiar in the history of religions and it has left its mark on Christianity at the popular level especially through the mediating figures of saints.

The use of images had deep roots in popular religion, as we can understand from the various miracle-working icons which became so widely venerated in the Eastern church. They are part of a tradition which relates to various levels of spirituality and religious practice, from the profoundly mystical to the matter-of-fact and the ignorant and credulous. In long-established churches, in Eastern Christendom as elsewhere, the religious life is too complex to be confined to one of these types. It would be wrong to think of Orthodox worshippers as all deeply appreciative of the art of icons or well versed in their theological significance. Icons are not primarily fashioned as works of art but as means of devotion in the setting of the church community and its liturgy. The monks and artists who paint them prepare themselves spiritually for the task and the finished icon is consecrated in a service.

If any one doctrine can supply the theological undergirding for icons in their varied uses, it is the doctrine of incarnation, signifying the union of spirit and matter. Jesus Christ is the first and the perfect icon, the image of God himself. As the Word made flesh he has deified flesh. (As the early church father Irenaeus said, God became man that men could become like God.) Man is an icon – a tarnished icon carrying the image of God in himself, restored to his true destiny by Christ. The Christian saints are likewise icons, the living images of Christ who is their archetype; therefore the veneration that is offered to the saints returns to Christ, the original source. The church is an icon, reflecting on earth the unity-in-diversity which is the nature of God the Trinity. The earthly city or kingdom (as in the case of Byzantium) is an icon of the heavenly kingdom of God. The Bible is a verbal icon of Christ, as the word is the image of thought. In the practice of Eastern Orthodoxy veneration is given equally to the gospels and to holy icons which are kissed and honoured at the altar and in processions. The doctrine of icons thus applies to all of man's life and leads to the vision of a transfigured cosmos based on the incarnation and glorification of Christ.

The roots of the doctrine of the Trinity in early Christian thought and experience have already been mentioned. The concern of the classic doctrinal definitions of the fourth to fifth centuries was to safeguard the distinctiveness of the work of the three 'persons' of the Trinity while maintaining their oneness within the divine being. If verbal statements were difficult, how much more so were representations in visual form. The danger lay in depicting the three natures or 'masks' of God in the anthropomorphic form of three visible persons; this would confirm the worst fears and allegations of Jews and Muslims that the Trinity was a form of tritheism or polytheism. This would be a heretical misinterpretation from the Christian viewpoint also; but if aniconic monotheism were the only solution what could remain of the vivid personal event of the incarnation? The solution lay in using a combination of symbols with the figure of Christ, or sometimes aniconic forms such as three interlaced circles or a triangle to suggest the three-in-one nature of God. Of prime importance to the iconography here was the appeal to biblical texts understood as referring to the Trinity. For instance, at the baptism of Christ the Holy Spirit descended 'as a dove' (Matt. 3.16–17 parallels) and this was linked with Old Testament references to the dove of Noah and the spirit of God over the waters at the creation. The baptismal scene thus provided a 'vertical' image of the Trinity – God the Father (represented by his hand and the heavens opening), the Holy Spirit as a dove and the earthly Christ below.

For the Eastern church the most important icon of the Trinity was derived from the Old Testament text (Gen. 18) describing Abraham's welcome to the three heavenly visitors. This incident, interpreted as a type of the Trinity in the early church, is expressed vividly in mosaic in a lunette of the sixth-century church of San Vitale, Ravenna.[58] Here the three visitors sit at a table, similar in their appearance, garb and haloes, but with differing gestures. The form became established in the Greek church in the following centuries, as shown in medieval frescoes and icons at Mistra and Athens.[59] It reached its climactic expression in the work of the early fifteenth-century Russian icon-painter Andrei Rublev whose icon of the Trinity (*Troika*) was declared to be a definitive model for future representations at a Moscow church council in 1425. The beautifully harmonious painting groups the three angelic figures around a miniature table with a chalice; the inner life of the Trinity is shown as communion, a silent discourse. Although the three figures are similar in type their relationship is not static; the forms and faces are so placed

as to suggest a movement in an anti-clockwise direction. It may be that the central figure is intended to represent the person of Christ, but in any case there is a dynamic interplay between the three, suggesting the life of God. While there is some use of traditional symbolism in the details and colours, this does not obtrude. An interesting Byzantine convention is the use of 'reversed perspective' in the table, thrones and footstools, presenting a foreshortened view which comes from the other world in the picture, not from the spectator's human standpoint:

To explain it we must put ourselves behind the Christ in the glory, and look as it were through the openings of the eyes in his face.[60]

The composition of the icon is of interest from both an artistic and a doctrinal point of view, for it can be analysed as an inverted triangle (the three heads being along the top) enclosed in a circle.[61] This is an ancient sign of the Trinity which recurs in Christian art – for example the later German engraving of the eternal God holding a triangle in a circle.[62]

 Another Trinitarian icon from Russia, the 'Paternity' is based on the vertical model. A high-backed throne provides a unifying background for the three persons. God the Father, shown with the traditional bearded face of the mature Christ, is seated with a scroll in his hand, clad in white. On his lap sits the infant-sized Son, clad in red. The Son in turn holds on his knees a disc of blue-shaped circles out of which flies the white dove of the Holy Spirit.[63]

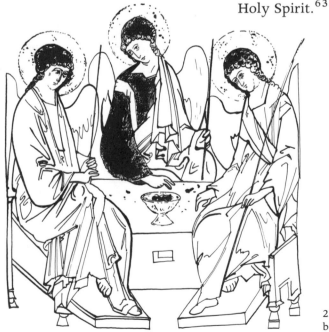

220. Painted icon of the Trinity by Andrei Rublev.

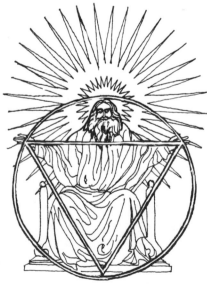

221. Aeternitas: Greuter's engraving of the Trinity as a triangle and circle held by God.

Western Christendom saw a much greater variety of attempts to represent the Trinity, some of them eccentric such as pagan-inspired versions of the three-headed or three-faced god.[64] The more horizontal type of representation shows the three persons as equals – for instance, in an Austrian altar of 1515, with three similar figures reigning, each with a bearded Christ-like face; the Father is distinguished by a tiara instead of a crown, the Son by a bared side and spear-wound.[65] The vertical type appears in the West increasingly as the 'Throne of Grace', characterized by the Western concern for grace and atonement through the cross; in the twelfth-century French example the dove of the spirit descends from the Father to the crucified Christ. The expanded version of the Intercession from Florence in 1402 is clearly much more anthropomorphic in representing the Trinity than an Eastern 'Deesis' or 'Paternity'. Here God the Father appears from the clouds and starry heavens sending the Spirit to the Son, who along with the Virgin Mary is interceding for two human souls. But it accords with the East in showing God the Father not as an old man with white hair and beard but in the likeness of Christ, based on the gospel words: 'He who has seen me has seen the Father' (John 14.9).

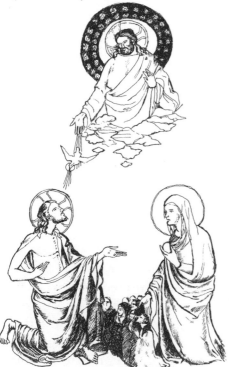

224. The intercession of Christ and the Virgin.

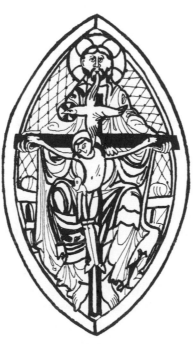

223. The Throne of Grace: detail from a twelfth-century French missal.

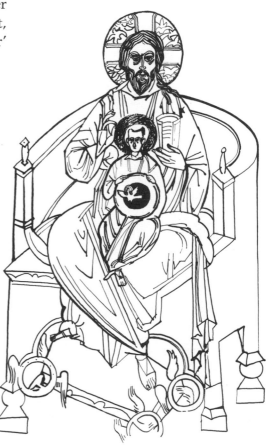

222. The Paternity: Russian icon.

The art of Western Christendom was at first overshadowed by the splendour of Byzantine art which exerted a strong influence throughout Europe. The legacy of Christian themes and the hieratic forms to represent them were continued in the sacred art of the early Middle Ages.[66] Although the West did not develop icons in the specific sense of the Eastern church it shared the same basic intentions in its sacred art:

Icons were made, not to reveal this or that natural beauty, but to recall theological truths and to be the vehicles of a spiritual presence.[67]

For instance the majestic Mother and Child of the frontal Byzantine icons and mosaics is clearly seen in the French Romanesque images of the 'Throne of Wisdom'; here the enthroned Virgin provides in her own lap a throne for the Christ child, showing the humanity and divinity of his incarnation. But these were free-standing wooden statues (never permitted in the Eastern church), probably originating in the cult of relics; they were light enough to be carried round in processions which further enhanced the range of their powers. As icons in '3-D' they were for the faithful not only representations but representatives of Mary and Christ, serving as aids for communion with them.

Inspiring the devotion of worshippers they were and often still are, true cult statues. With an air of monumental calm they receive the petitions of the faithful; they are credited with countless miracles; they are subjected to cult practices such as the offering of lighted tapers, votive plaques and other gifts, or are adorned with flowers, jewelry and rich costumes. Some are still carried round in annual processions, attract throngs of pilgrims and have been honoured in solemn coronation ceremonies.[68]

But the common ground diminished as the centuries advanced; Western Europe was consolidated as the East steadily crumbled in face of the advance of Islam. Long-standing theological and ecclesiastical differences were sealed by the official schism in 1054 between the Eastern and Western churches. The Latin-speaking West had the heritage of Rome, its approach to law and organization seen both in the more practical orientation of monasteries and the hierarchical structure of the church headed by the Pope. The ethos of the churches differed also in their theology and liturgy. We have noted the Eastern emphasis on Christ's incarnation and resurrection as the way of mystical glorification; this contrasts with the growing Western emphasis on the sufferings and sacrifice of Christ on the cross as the means of atonement. The Pauline doctrine of grace for the forgiveness of sins was developed intellectually in the tradition of Western thinkers such as Augustine and Aquinas,

and in the liturgy of the mass. Without making these generalizations into rigid contrasts one can see the differing emphases of the West.

Medieval Catholicism had no major iconoclastic controversy such as that which rent the East; consequently it was not challenged to produce an orthodox theology of images nor to restrict artists so specifically in their choice of themes and media. In the West there was no ban on three-dimensional images. The later Middle Ages brought a growing naturalism, humanism and individual artistry into religious art – features which came to be more fully developed in the Renaissance and modern Europe. It would be a gross exaggeration to say that the East had none of this, for changes can be seen over the centuries of Byzantine and Orthodox art despite the 'splendid changelessness' of that church's tradition. But the Western church experienced changes which led to much more diversified responses, as at the Reformation and the exploration of the New World. Prior to this, it had produced in medieval Europe two notable styles of religious art.

Romanesque art of the eleventh to twelfth centuries brought the vitality of northern barbarian art into the Mediterranean tradition.[69] Associated with monasteries and fortress-like churches, its painting and sculpture depict stern scenes of the last judgment and mystical visionary themes expressed with dynamism and distortion. The Gothic style of the following centuries was focused on the cathedral and the city where it flowered into a profusion of forms and themes. A cathedral such as Chartres expresses the basically sacred and anonymous art of the Gothic style, but in cycles of sculptures and stained glass windows which relate the realms of nature and grace.[70] Depictions of scenes from the Bible, church tradition and everyday life made the walls and windows truly a '*Biblia Pauperum*' (Bible of the poor), full of story and symbolism,[71] and relating the church's teaching to all areas of man's life – his work, his morality, his culture and learning, history and the order of nature. In depicting these the Gothic church craftsman was guided by handbooks such as the *Biblia Pauperum* and the *Speculum humanae Salvationis* (Mirror of human Salvation) and the 'Bibles moralisées' which used typology to link the events of the Old and New Testaments and allegory to read from the past the eternal truths of morality and natural theology. With this setting in mind we now examine some examples of religious iconography.

Although Western church interiors have no iconostasis, the portal with its tympanum over the doorway can be seen as fulfilling this function.[72] Above the royal portal at Chartres Cathedral (at the centre of the west front) is depicted a scene from the vision of John the seer in the Apocalypse (Rev. 4.2–8). God, in the form of Christ, sits enthroned while

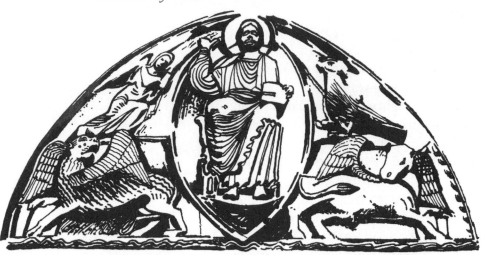

225. God as Christ enthroned, from the west portal of Chartres Cathedral.

twenty-four elders worship him; (the latter are sculptured in the archway above the relief shown). Around him are the 'four living creatures' which derive from the Old Testament vision of the prophet Ezekiel by the river Chebar (Ezek. 1.4–12) and reappear in the New Testament Apocalypse although not in the same order. In the early church they were explained to baptismal candidates as referring to the four evangelists:

Matthew: the man (or angel)
Mark: the lion
Luke: the ox, bull
John: the eagle.

This symbolism of the four beasts or 'Tetramorph' has continued in the Christian church. It was frequent in Romanesque and early Gothic art, and medieval commentaries added further interpretations relating to the work of Christ (the ox and lion for sacrifice and resurrection) and virtues towards salvation (the soaring eagle, courageous lion, reasonable man).

The theme of judgment, prominent in Romanesque doorways and also in Byzantine frescoes and mosaics, is given both delicate and fearsome expression in the relief from Bourges Cathedral. Here a kindly angel is weighing the good and evil of a waiting soul while a disappointed devil stands at the right. Further scenes show the joy of the blessed with angels in heaven and the torments of the damned in the stewing-pots of hell. The weighing of the soul is not a biblical theme but a tradition derived ultimately from ancient Egypt.[73] Death and eschatology were vivid realities, to be depicted as the essential backdrop for the drama of salvation.[74]

226. Angel weighing a soul: detail from The Last Judgment, Bourges Cathedral.

The crucifix became in this period the dominant symbol of Christ's work as redeemer, after emerging late in Christian art. The twelfth-century wooden crucifix at Lucca, Italy, was renowned as a prototype of supernatural origin which led it to be much copied throughout Europe. Syrian or Eastern in style, it was said to have been brought to Lucca in the eighth century but made by Nicodemus after the ascension of Christ. The legend told of his falling asleep while trying to carve the crucifix; when he awoke the head of Christ was miraculously completed. Hence the crucifix was called 'Volto Santo' (the Holy Face) and richly ornamented with crown, robe and shoes by later devotees.

The later Middle Ages paid attention to the 'instruments of the passion' and showing the sufferings of Christ in extreme forms to arouse pity in the viewers. The fourteenth-century German bough-crucifix shows him as 'a flayed corpse',[75] reduced to such an abased level that the resurrection of Easter seems inconceivable. On the other hand the tree-cross suggests the 'Tree of Life', the central source of regeneration and immortality. In a similar vein is the grouping in which the Virgin Mary sits with the dead Christ on her knees. Because of the compassion shown in her extremes of sorrow she is called a Pity (*Pietà*). The sufferings are shown in heightened form by the blood and wounds and the arched back of the dead Christ; this dramatic posture and the emotion shown by Mary combined to make this a popular theme in the West from the Gothic period onwards. (The medieval mystery plays were probably a stimulus to such dramatic and emotional effects.) The theme of suffering is extended into the saintly life in the case of St Francis of Assisi who was so aware of the divine sufferings that in his last year he was said to have received

227. 'Volto Santo', the holy face.

230. Late Gothic 'Pietà'.

228. Bough crucifix with emaciated Christ.

the *stigmata* on his own hands and feet, similar to those made by the nails on the body of Christ on the cross. The fourteenth-century Italian painting attributed to Giotto shows the stigmata coming in rays from the hands, feet and side of the heavenly Christ who is enveloped in the Byzantine-type angelic wings, six in number. The psycho-physical connection between the two figures is reminiscent of Tantric meditation relating the human body to the divine image.

The foregoing examples illustrate the continuity with the past – the ancient church, Byzantine and early medieval traditions – but also the newer developments in the West by the thirteenth to fourteenth centuries. To the established symbols and iconography based on these traditions and the Bible, artists in the West added manuscripts which they illuminated and drew on for further illumination; a famous early example is the Irish (Celtic) *Book of Kells* of the eleventh century; an equally famous fifteenth-century French illuminated work is the *Rohan Book of Hours*.[76] Further, ancient works on more secular subjects of knowledge such as the arts and sciences, animal lore and the battle of virtues and vices ('Psychomachia') were used, along with religious themes, for the decoration of books and churches. Christian history down the ages supplied abundant material from the lives of saints and martyrs, not only those of the early church but the saints and founders of new monastic orders in the West such as St Francis and St Dominic.[77]

The sources of iconography lay not only in books but in the whole life and liturgy of the church. Invocation of the saints as intercessors was an intense feature of medieval piety, linked with the veneration of patron saints, the cult of relics, pilgrimages, processions and a variety of traditional and local feast days. All of these provided the living context of church art; this was meaningful not only to clergy and those alert to theological teaching and symbolism, but also to the ordinary man who saw therein a reflection of his everyday life.[78]

Devotion to the Virgin Mary, the 'Madonna and Child' and the Holy Family took on new forms; the great French Gothic cathedrals were now mostly dedicated to 'Notre Dame' (Our Lady). The later Gothic paintings and sculptures depicted her with an increasing humanism and tenderness.[79] Narrative cycles of paintings of the life of the Virgin also were elaborated, along the lines of cycles for Christ and the saints, using many post-biblical stories concerning the infancy and girlhood of the Virgin, her death, glorification and subsequent miracles and apparitions.[80] The coronation of the Virgin became a favoured theme in showing her heavenly glory as 'Queen of Heaven'; her majesty and dignity balance the warmth and sweet playfulness of the later maternal images.

The churches provided the physical and liturgical setting for most of this iconography at many levels. It is estimated that by the year 1500 the three million people of Catholic England were served by 19 cathedrals and 9000 parish churches, plus 650 abbeys and priories and 200 mendicant establishments.[81] These had a profusion of crosses, images, shrines and relics, the last judgment and narrative wall-paintings. The dominant image was the crucifix mounted on the rood-screen or over the high altar flanked by life-size figures of Mary and the apostle John. (Compare the central icon of the Deesis in the Eastern church, with Mary and John the Baptist.) This expressed the theme of the central sacrament of the Eucharist or Holy Communion. The medieval church was above all a church of sacraments, visible means of divine grace, supported by a whole range of media in words and images to heighten the human response.

Every Sunday and on the thirty-five or forty important feast days of the Church year, Christians witnessed Mass, the holy drama recreating the bloody sacrifice on Calvary. A dramatic ceremonial, it was enriched through the graphic embroidering of ornament, symbolic movement and the repetition of details which eventually led to the consecration itself. The Mass, like images, sought to enrich the wealth and depth of man's existence by appealing to a wide range of human experience.[82]

Images in the West were therefore justified by their practical acceptance in this context of the church and its sacraments. In so far as theological defences were offered in the West they could look back to the early centuries, to Pope Gregory's emphasis on the didactic value of images and to the formulations of the 787 council affirming that true worship belonged only to God but that images could be effective means of leading men from material to spiritual things. This was the basis on which the great scholastic theologian of the thirteenth century, St Thomas Aquinas, built his defence. He carefully distinguished idolatry from iconolatry and, further, the kinds of devotion appropriate in the latter. The term *latria* is reserved for worship: *latria absoluta* for the adoration due to God alone, *latria relativa* for that offered to his image in Christ because he is the Word of God incarnate. The council's principle is affirmed, that honour paid to an image is referred to the thing represented. But since saints are in a different category, their images refer to a different sort of archetype and deserve only the reverence called *dulia*: the adoration of saints that reflect the perfection of the gift of grace.[83]

Aquinas was a Dominican, and this order vigorously favoured the use of images in devotion; it is of interest that the famous fifteenth-century Italian artist Fra Angelico was a Dominican. Likewise the Franciscan order combined iconism with its mysticism (as exemplified in the *stigmata*); a

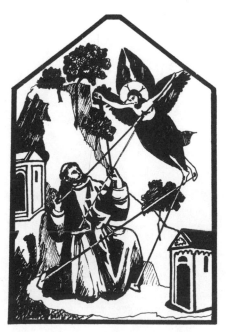

229. St Francis receiving the stigmata from Christ.

Franciscan theory of meditation on Christ postulated five stages beginning with the imagining of Christ as written and leading up to the individuated Christ painted and modelled.[84] But the Cistercian order in the twelfth century had been given an orientation against images by St Bernard of Clairvaux with his inward mysticism of love. Although he allowed that images could educate the illiterate, the simple and 'carnal folk' by appealing to the senses, he thought that monks should be above such allurements.

Not the painted face soon to decay, nor precious garments destined to age, nor the glitter of gold and the splendour of jewels, nor any other such, for all these things are subject to corruption.[85]

In accordance with monastic vows of poverty the Cistercians were recalled to the simplicity of their Rule and cleansed their churches of the paintings and images, mosaics and stained glass of the current Romanesque church art. However, these luxuries began to return a century later and Cistercian mystical imagery of love actually influenced iconography towards more benign representations of Christ and Mary.

Despite the dominance of iconism the medieval West did see occasional aniconic outbursts against abuses recurring in connection with images – luxury, superstition, the pull of the senses and of idolatry. Reformers preached and wrote against these. The fifteenth-century Dominican friar Savonarola denounced the worldliness of the church and the current art of the Renaissance. In fourteenth-century England the Lollards had already rejected images, relics and saints as excessive and some English humanists of the fifteenth to sixteenth centuries had ridiculed them as unnecessary; these views helped to prepare the ground for more explicit iconoclasm at the Reformation.[86]

Renaissance, Reformation and After

In the realm of Christian iconography the Renaissance stands for a renewal of forms, themes and styles from the ancient Greco-Roman world. We have already seen their presence in early Christian art and the classical heritage continued in varying degrees through the medieval period. With the burst of artistic creativity beginning with fifteenth-century Italy, the religious humanism of the Gothic led on to a further search for realism, naturalism and individualism in art. For this reason the Renaissance creativity is seen by some as the antithesis of sacred art, representing autonomous man and natural beauty instead of the spiritual goals of a sacred tradition.[87] The Renaissance masterpieces may have Christian

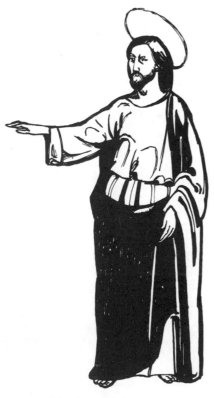

231. Earthly Christ by Masaccio: detail from 'The Tribute Money', Florence.

themes but they are individual works of art for patrons and specialists in art, not inherently religious works for the worship and edification of people in the church. We are not concerned here to argue this issue but simply to note the effects of the Renaissance in Christian iconography where biblical and classical subjects rub shoulders. Renaissance artists felt free to oscillate between Christian and pagan references.[88] But there was no lack of Christian and biblical subject matter.[89] We shall turn to some examples of the Christ figure.

The short career of Masaccio pioneered some of the key points of Italian Renaissance art – a sense of space and perspective with man placed solidly at the centre, the measure of all things. In the Brancacci chapel at Florence *c.* 1425 his narrative painting of the gospel incident of the 'tribute money' places Christ in a harmonious arrangement of his disciples. There is a human earthly feel about these figures, quite different from traditional sacred art and Eastern icons; their impressiveness comes from a rounded sculptural quality (which greatly influenced the modern sculptor Henry Moore in his younger days).

Almost a century later in the High Renaissance Michelangelo was propounding his thesis that no beauty exists outside the human form. The influence of classical antiquity (among other influences such as neo-Platonism) is behind the Sistine Chapel ceiling paintings of 1512 depicting biblical themes.[90] In the famous scene of the creation of man the outstretched finger of God awakens Adam to life as by an electric charge; both figures express a common humanity – the image of God transmitted to man – and God is a heavenly sculptor. Michelangelo's much later painting of the Last Judgment, a huge fresco on the altar wall, 1536–41, is a sombre work but interprets the central figure of Christ in a humanistic way. His hand raised in unassailable judgment, Christ is pictured as a powerful Renaissance prince issuing the decrees of his own will, with the gentler figure of Mary in a secondary role at his side. Further, Christ is shown almost nude, after the pattern of the classical hero (a 'Christus Heroicus'). This is in contrast with previous Christian art. The ancient church depicted only three biblical figures naked – Adam and Eve, Jonah and Daniel – and Byzantine art depicted an unclad Jesus in the water at his baptism. Late medieval and Renaissance thought distinguished four types of *nuditas*: The natural nudity of innocence, the temporal due to poverty, the virtuous as a symbol of purity, and the vicious or criminal nudity symbolizing lust and vanity. It was legitimate to depict nude figures on Gothic cathedrals in scenes of the dead rising at the last judgment and of hell with its tormented bodies and grotesque devils, but the Renaissance by-passed such conventions in representing the human

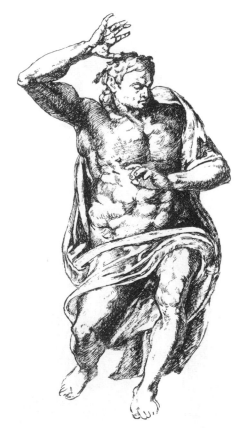

232. Heroic Christ: detail from Michelangelo's 'Last Judgment', Sistine Chapel, Rome.

body as an object of natural beauty, idealized after the classical tradition.[91] For Michelangelo the male nude was virtually an icon which reflected God in visible form.

A reaction against this portrayal of Christ as a glorious heroic figure is seen in the work of Rembrandt in mid-seventeenth-century Holland. His etching of Christ preaching to the poor shows an ordinary human engaging the attention of his hearers by what he says. Perhaps his raised hands suggest the ancient *orans* position, but it is not this nor the faint halo and light overhead that convey the sense of the divine. He is the Word in personal relation with his hearers; the divine is manifested in his simplicity and humility. While Rembrandt could scarcely be called an orthodox Protestant in his time he was expressing here a 'theology of the cross' rather than a 'theology of glory'.[92] Thus his 1648 painting of the risen Christ at the Emmaus supper shows no triumphant figure but a rather pale and weary little man whose radiance lies in his suffering.[93] Rembrandt is the painter of the 'moment of truth' as evidenced in his many convincing paintings and etchings of biblical incidents and parables. His 1654–5 etching of David and Nathan[94] shows the obscure prophet admonishing the king not in any melodramatic way but with the quietly penetrating words: 'Thou art the man' (II Sam. 12.7–14).

An example of how Catholic painting of the same century depicted the suffering Christ is the head of 'Christ crowned with thorns' by Guido Reni. Here are drama, emotion and pathos as the eyes of Christ search agonizingly upward; it is a more psychological version of the Gothic portrayals of Christ's sufferings.[95] While this form of religious art became melodramatic and sentimental as it was diffused in popular holy pictures, it was part of the impressive Baroque movement which dominated European culture for two centuries after the Renaissance.[96] The genius of this complex and dazzling style lay in its combination of tensions – the spirituality of Gothic along with the worldly classic humanism of the Renaissance; realism in capturing emotion and movement, but also fantasy and distortion, fervent passion along with order and restraint. These might be seen as polarities contained within an oval (which was, in fact, a shape favoured in Baroque design). It was a 'total style' in the sense of uniting the arts in a total 'happening', using a wealth of symbolism, illusion and dramatic effect as in the theatre.

That this theatrical style was enlisted in the service of the church may be attributed to the efforts of the Jesuit order. In the mid-sixteenth century the response of Roman Catholicism to Protestant iconoclasm was to reaffirm the traditional positions along with an effort to suppress abuses; images of Christ, the Virgin and saints were to be preserved and given due

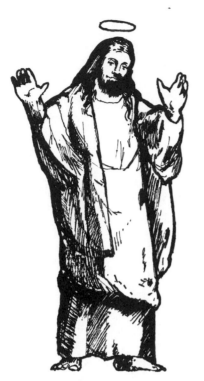

234. Rembrandt: 'Christ Preaching'.

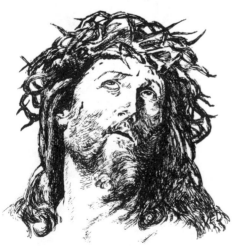

233. Christ crowned with thorns, by Guido Reni.

honour according to the Council of Trent. The tone was austere and severe. But the Society of Jesus was concerned to make more positive use of the forms of education and culture to win back lost ground for Catholicism and progressively develop new forms of church drama, art and architecture (as in the influential church building of Il Gesu, Rome 1575). It is interesting here that the founder of the Jesuits, St Ignatius Loyola, stressed the element of visualization in his 'Spiritual Exercises'. Scenes from the life of Christ, especially the passion and resurrection, had to be imagined in the mind, applying all the five senses. The result was an openness to the use of sensory media which eventually led to the union of sacred and profane elements in the Baroque church style; heaven and earth were distinct realms, but the uplifting atmosphere of the church liturgy and the heavenly scene painted on the ceiling could transport one from the finite to the infinite.

Bernini is the exemplar of this style at its peak in seventeenth-century Italy. As an all-round Baroque artist he worked for secular commissions but also gave his talents to expressing the power and glory of the church in St Peter's, Rome. The majestic figure of one of the 'doctors of the church' is one detail of the dazzling *cattedra,* the throne of Peter which symbolizes the triumph of the church.[97] Another famous sculpture by Bernini is the 'Transverberation of St Teresa' in the Cornaro Chapel in Rome. This is of interest for its theatrical setting, with a sculptured audience in side boxes to view the scene; the Baroque devices of illusion, lighting and 'the heavens opening', are all used to marvellous effect. More important for iconography is the subject matter, the ecstasy of a saint which is vividly recreated from literary accounts of the saint's mystical experience.[98] Baroque church art sought to portray realistically the experiences of saints in their state of ecstatic vision as well as their sufferings. A pioneer of this approach was El Greco with his many portrayals of the saints each with his own individual vision and vocation; his varied paintings of St Francis in ecstasy reflect fervour through dynamic distortion, showing a progressive concern with mystical relation rather than with the externals of the stigmata. Later Baroque artists, however, tended towards ever more lurid and emotional scenes of ecstasy and martyrdom.

Associated with the Catholic Reformation was the exaltation of the Virgin by the immaculate conception. This achieved an almost definitive iconographic form in the famous painting by Murillo at Seville. Here she appears as a young girl, radiant in her purity, the *Immaculata* and *Purissima* who is innocent of all original sin:

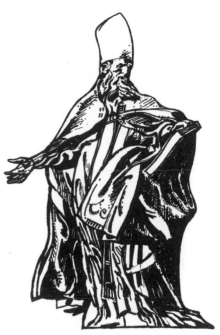

235. Doctor of the church: Baroque sculpture by Bernini.

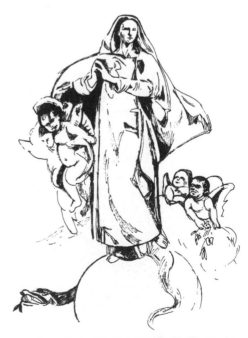

236. Immaculate Conception.

Suspended in space above the earth, the Virgin meditates upon a mystery, hands clasped in prayer, with downcast eyes. The wind of the infinite blows out her hair and raises her cloak.[99]

To the conventional cherubs and clouds, sometimes a crescent moon is added. Another popular theme was Mary Magdalen because she exemplified the sacrament of penance. Along with the older traditions new forms of devotion such as those to St Joseph and the guardian angel were depicted. A further rich source of iconographic themes came through the liking for allegory which personified virtues, vices and abstractions such as truth, peace, Europe. An influential book of allegories accompanied by engravings was Cesare Ripa's *Iconologia* 1593 which was translated from Italian into French, German and English and continued to be reprinted in the eighteenth century.[100] This provided ideas that were used in church art, by Bernini, for instance. A similar form popular in England during the Elizabethan and Jacobean periods was the 'emblem book', a collection of moral symbols with pictures and interpretative poems and explanations.[101] This derived from the medieval readiness to see the world as full of symbolism and allegorical meanings; and a Protestant parallel in the seventeenth century was Bunyan's *Pilgrim's Progress*.

The climax of the Baroque in religious art and architecture may be seen in Central Europe in eighteenth-century Austria, Bohemia and southern Germany with their sometimes palatial monasteries and fantastically ornamented pilgrimage churches. To Baroque was added the refinement of the Rococo style which exploited the elegance of the curl, the shell, foam and plant forms. Church decoration combined this with traditional iconography and sometimes local devotional cults and legends to create dazzling hierarchies of images and symbols; the often plain exterior of the church could conceal an interior vision of heaven on earth.[102]

Meanwhile the New World conquered by Spain and Portugal had been marked by Catholicism in 'Latin America'. Ornate southern Baroque flowered in churches there, modified in some cases by local Indian artists.[103] The stone image of Christ merged into the form of a tree-cross is a vivid example of such cross-fertilization of iconography in seventeenth-century Mexico. Despite the centuries of official Catholicism, many old pre-Christian Indian beliefs and customs persist, as shown in a study of an Aztec village.[104]

An instance of popular devotion developing a new symbol in this period is the Sacred Heart of Jesus which provided a simple, if often sentimental, approach to the grace and love of Jesus. While it can be found in medieval piety it gained official recognition after revelations were

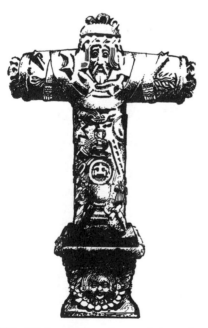

237. Mexican Indian stone sculpture of the crucified Christ.

received by a French nun in the seventeenth century; it became the subject of a feast of the church in 1765 and spread all over the Catholic world (and even among non-Christians in India where it is featured among the bright popular religious prints). The usual iconography shows Jesus with a wounded heart painted on his bared chest or gown; the heart is encircled by a crown of thorns and surmounted by a small cross; light radiates from it. An unusual form of this is the late eighteenth-century painting of Jesus holding his heart. The focus of devotion is thus different from traditional cults of the infant Jesus or the crucified Christ; it expresses the redemptive love of the adult personal Jesus.[105] Another prominent form of Catholic devotion has been penitential prayer and meditation on the fourteen 'stations of the cross' depicting the sufferings of Christ from the condemnation to death, through the way to Calvary, to the entombment. The full form in which these arc now seen around the interior of churches was not finalized until the eighteenth to nineteenth centuries; but it derives from much earlier pilgrimages to Jerusalem, following the traditional route to Calvary which pilgrims sought to reproduce devotionally on their return home.

It is appropriate to ask how such devotions and the attendant images work out in the everyday practice of Roman Catholics. It is not possible to generalize for the world-wide church with its many levels and regional differences, but it is worthwhile citing some of the observations made in a recent study of a rural Catholic community in northern Spain.[106] There are many images found in village parish churches, in wayside chapel-shrines and in homes with their religious pictures and calendars and little plastic statues. The shrines represent an 'exchange' relationship with the saints as sources of divine power and probably go back to ancient forms of religion; this instrumental side of religion is still emphasized by the male population. The parish church represents the redemptive and purifying work of Christ and Mary, based on the family analogy and appealing more to the women.[107] One can discern here the links of religion with family relationship and also the age-old tension between folk religion and the church with its priesthood and teaching of salvation.

What is of special interest is the process of change: Thus the devotions of the villagers, concretized in the images and pictures of the parish church, are like a series of geological strata, some dating back for centuries.[108]

In the churches and chapels of the mountain district of the study, the most common images are the Sacred Heart of Jesus, the Immaculate Conception, St Joseph and St Anthony of Padua, followed by others such as Our Lady of Fatima. In actual devotional practice the Sacred Heart

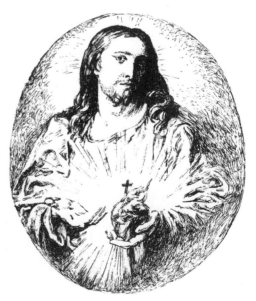

238. Batoni: 'Sacred Heart of Jesus'.

and St Anthony are the most popular, the latter being a miraculous protector of infants who appears holding the baby Jesus. The Sacred Heart has had political overtones in Spain standing for the church's struggle against twentieth-century unbelief (as in the anticlericalism and iconoclasm of the 1930s). For a variety of reasons, saints and devotions go in and out of fashion. Churches tend to accumulate images but they are also removed or replaced from time to time. In the past religious orders and priests have propagated new devotions in order to revitalize popular piety; but in the last hundred years there has been a falling away from the saints as priests encourage veneration of Mary and Christ – 'the main doors, not the side doors'.[109] This is in accord with wider Catholic trends, over and above regional cults and variations. Younger priests with modern theological training discourage the use of images of the saints as divine intermediaries.

As a result of the Liturgical Movement in the twentieth century and the second Vatican Council of the early '60s an impetus has been given to the reformist approach to images. Instead of having churches cluttered with statues the concern is now to reduce their number by removing them to side-chapels or turning to reliefs and murals so that the imagery does not distract worshippers from the central liturgy. On such a reformist view images of the saints still may have a subordinate place, expressing the saints' presence in worship with the congregation on earth. But the centre of attention should be the image of Christ as the living leader and head of the church, perhaps hovering over the celebration of the liturgy – 'a large figure looking or reaching out to encompass the whole congregation together with the images of the saints'.[110]

The use of images is a vivid example of the Western (Roman) Catholic Church consciously seeking to combine tradition and change in modern times.[111] It has been challenged not only by the aniconic position of the Reformation Protestant churches but also by the secular aniconism of the Enlightenment and French Revolution of the eighteenth century. Withstanding these, the church has been faced in the twentieth century by the challenge of secular ideologies and the confusion of the modern scene in both art and religion. The official response (especially since the papal pronouncements of 1952) has been to encourage the use of modern art and architecture resulting in many striking experiments in Europe, America and Japan.[112]

In turning now to look at the churches of the Reformation we cannot expect to find a 'Protestant art' and distinctive iconography in the sense of Catholic or Orthodox sacred art. This is not because religious art did not exist. The instances of Protestant iconoclasm should not be taken as a

norm or stereotype; and some great artists may be named as in the Protestant tradition – Dürer, Rembrandt and William Blake. But there was no agreed theology of images among the sixteenth-century reformers who were primarily concerned not with art but with the restoration of Christian truth centred on the Bible and the preaching of the word based on Christ. Instead of the icon or sacred art, Protestant worship found its typical expression in the word, prayer, music and hymns and the fellowship of the congregation:

> We have come to hear Thy word. . . .
> Ear and heart await Thy leading.
> In our study, prayer and praising,
> May our souls find their upraising.[111]

Luther attacked the use of images for spiritual merit but he regarded images in themselves as *adiaphora* (neither good nor bad). Where they assisted faith for the individual they could be good, as Luther himself affirmed from his experience; his piety was strengthened by the sight of a crucifix, the sound of anthems and partaking of the body of Christ on the altar. Luther stood between the Middle Ages and Modernity and in the German Reformation which he led Catholic churches were taken over with their images and paintings, along with changes in the liturgy and the removal of side-altars and pictures of saints. Hence many Lutheran churches feature a large medieval crucifix flanked by Mary and John; both music and the visual arts have been valued, though without creating a 'sacred art'.[114]

Luther's acceptance of the arts is in accord with his insistence on the unity of spirit and flesh in the incarnation. His sacramental position was opposed to those who devalued the physical. Hence he rejected the extreme 'spiritualizing' position of his former colleague Carlstadt, as well as that of the Swiss reformer Zwingli, both of whom sought to cast out the sensory aids of music and visual arts from the church. Zwingli saw the sacrament of communion as purely a commemorative Lord's Supper; the Catholic spectacle of the mass was to him a form of idolatrous worship of God reduced to visible and sensuous forms. Hence all such forms had to be eliminated.[115] Zwingli's thoroughgoing position was based on the Bible in so far as he rejected whatever the Bible did not enjoin; Luther's accommodating position, by contrast, permitted whatever the Bible did not explicitly prohibit.

A mediating position in the issues of the sacraments and the arts was taken by Calvin. Thus he permitted the symbol of the cross but not the Catholic and Lutheran crucifix; in church one could sing psalms but not have other music. Calvin's theology of the arts and on the question of im-

ages is made explicit in his *Institutes* (Book I, ch. xi) where he expounded the principle:

It is unlawful to attribute a visible form to God, and generally whoever sets up idols revolts against the true God.[116]

Basing his argument on the scriptural rejection of images and agreeing with early fathers of the church such as Augustine he demolishes the traditional defences of images. Are they the Bible of the uneducated? – but if the church had done its duty there would be no 'uneducated'. Did the early church need images? – not when it was pure and strong in the early centuries. Is there a valid distinction between *latria* and *dulia*? – this is only a foolish evasion of the fact that images pander to man's desire for a tangible God, leading to idolatry, ignorance and indecency. Yet Calvin hastens to add that he is not opposed to art: 'But because sculpture and painting are gifts of God, I seek a pure and legitimate use of each'.[117] This does not include images in church for they debase the sovereign majesty of God by bringing him down to physical perception, in images motivated by pleasure and thoughtless craving. The visual arts are legitimate when they portray what can actually be seen, i.e. a truthful vision of visible realities past and present.

This sober view of the arts and religion was clearly influential in Holland (where it produced both the biblical illustrations of Rembrandt and the tradition of faithfully realistic painting of scenes from landscape

239. The Scottish reformer Wishart preaching against Mariolatry.

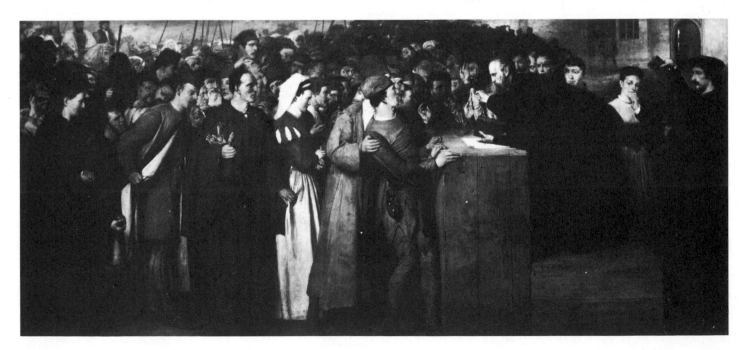

and life) and in other lands following the Calvinist reform. But first the zeal for reform required the destruction of images. In the painting of the Scottish reformer Wishart preaching against Mariolatry the people clutch their images as he persuades them (with John Knox behind him) to abandon their old errors. With the sweeping away of the cults of the saints and the replacement of the traditional seven sacraments and rituals of Catholicism by simpler forms of worship in the vernacular, the effect was an austere concentration on the written and spoken word, with little room for visual imagery. This is typified by the scene of a nineteenth-century kirk in Scotland where the minister and elders are reverently gathered. It could be paralleled in many Protestant churches to this day.

240. Lorimer: 'Ordination of the Elders in a Scottish Kirk'.

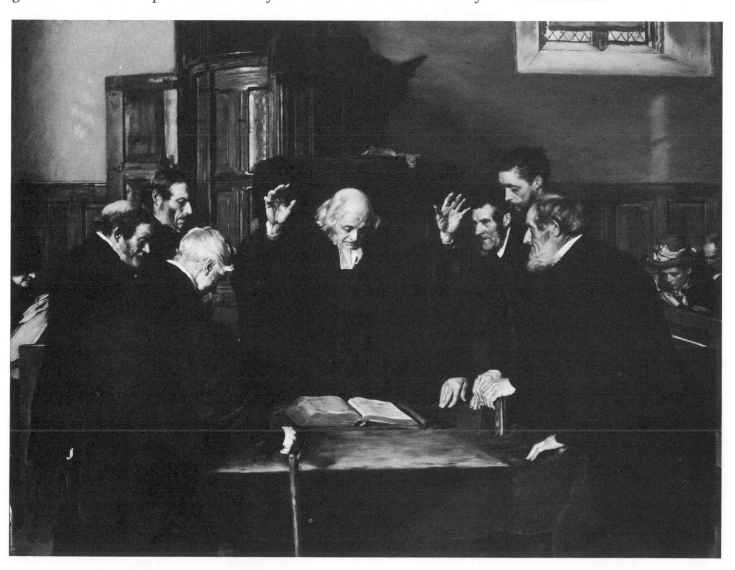

The Reformation in England was influenced by sixteenth-century Calvinism among various forces, including political factors. Images were swept from the churches and the visual arts became secularized as means of beautifying life rather than serving the sacred. The iconoclasm involved more than religious debates about the use of images; it should be seen in the larger context of transition from one type of church-state relationship to another – 'the replacement of devotion to king and church with loyalty to God and the nation'.[118] But Puritan thought did not finally dominate England and the Anglican church developed its characteristic breadth and continuity with much of the medieval Catholic heritage.[119] The nineteenth century saw both evangelical and high church movements and in the arts a revival of Gothic architecture and liturgical arts.[120] The mid-twentieth century has brought renewed concern to relate the liturgy to life and modern art and architecture.[121] This can be said also of the Church of Scotland and the major Protestant churches in Europe and America. Protestantism in general has developed a richer appreciation of the arts both from within its own resources and from the more 'Catholic' traditions.[122] This is evident in ecumenical discussions of art and archi-

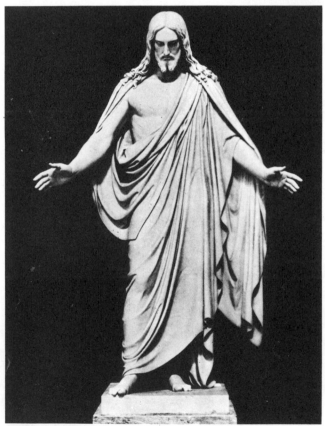

241. Neo-classical Christ. Early nineteenth century.

tecture since the 1950s. Issues of art and imagery which formerly ranged Catholic versus Protestant are now left behind in a concern for the modern problems involved in religion and the arts.[123] Instead of separating, the arts now provide occasions of meeting and gaining mutual understanding.

This does not imply that differences between Catholic and Protestant are no longer relevant. Traditional practices and theological viewpoints continue from the past. For instance within Protestant theology of the 1950s, Paul Tillich was appreciative of art which expressed man's existential plight (e.g. Picasso's 'Guernica') and symbolized the 'New Being'.[124] Karl Barth, on the other hand, saw no value in pictorial art for church worship and instruction. For Barth, the humanity of God in Christ is an event and happening which requires movement and dialogue. If the would-be biographer of Christ has a difficult task, it is quite intractable for the would-be portrayer in art:

The picture of Christ is far too static as a supposed portrayal of the corporeality of Jesus Christ in a given moment.[125]

These divergent approaches may represent the legacy of Lutheran-Calvinist differences worked out in new and differing situations of modern American and European life, but the point is that differences are now spread 'right across the board'. Not only Protestants but some modern Catholics come near to a new aniconism in their preference for simplicity and the use of abstract art in the church. The resulting situation is a very confusing one, full of cross-currents of tradition and experiment out of which no new definitive Christian art seems to have yet emerged in place of the decline in traditional representational art. To resolve this requires that Christianity find 'a meaningful artistic expression that can absorb and transform the contemporary artistic vision'.[126]

More has to be said about the future in the final chapter, but to conclude our discussion of Christian art and iconography at this point might imply that the problems and destiny of Christianity lie with the theologians and artists of European Christendom. This may not be so. Christianity may uncover new and unexpected things in the churches of its universal spread in Africa, Asia, the Pacific, the Americas. Some of the churches outside Europe are only beginning to express their Christianity in the arts. Others already have a considerable tradition to be uncovered and reappropriated. This is the case with the United States which has a rich variety of religious art ranging from formal painting to popular biblical illustrations and also the Spanish south-west.[127] There is Christian art in many countries and cultures and this includes folk art as well as the works of professional artists following the set iconographies.[128]

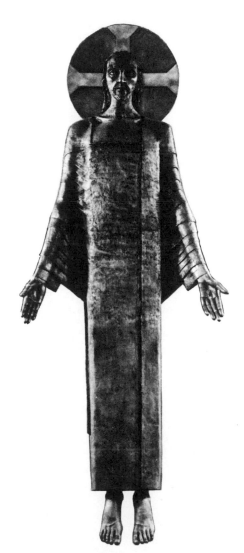

242. Jacob Epstein: 'Risen Christ'. Mid-twentieth century.

Until recently the art of the 'younger churches' was often called 'missionary art'.[129] Although this need not imply an attitude of cultural superiority it has been taken to do so. European Christian art has not been accustomed to depict Christ as a Jew but rather as a 'white man' with European features, and this image has been accepted in the 'foreign missions'. For instance in India the most popular pictures of Jesus are, among Catholic Christians, the Mediterranean-type 'Sacred Heart of Jesus', and among Protestants the American-type heroic Jesus by Sallman. But in recent years the churches of the West have been made aware, sometimes painfully, of the cultural bias of the West which is itself increasingly in a 'missionary' situation. Instead of transplanting Western Baroque and Victorian art there has been encouragement to 'adapt' to the indigenous art of the younger churches.[130] Some of the art has been available to Western readers through publications.[131]

Taking India for examples of such indigenous Christian art, one may see in Frank Wesley's painting of the Prodigal Son's return a striking arrangement of undoubtedly Indian figures after the manner of Rembrandt. The paintings of Alfred Thomas present Christ as an Indian holy man, sitting in the lotus posture and with the familiar *mudras,* holding a lotus blossom in his ascended bliss, or transfigured in Krishna-blue light.[132] Such work has aroused controversy, both on artistic grounds and on the religious issue of syncretism in identifying so far with Hinduism. A Goanese Catholic, A. de Fonseca, has painted the three persons of the Trinity, Indian in features, surmounting the inverted cosmic tree familiar from the *Bhagavadgita* (ch. 15).[133] Other painters, however, are more radically 'modern', such as M. Reddeppa Naidu of Madras, and Jamini Roy who can paint both Hindu and Christian themes in a manner combining modern Western art with the bold Kalighat style from Bengal.[134] This is sufficient to indicate the range and sophistication of Indian painting of Christian themes.[135] At the same time it is apparent that mere adaptation to 'indigenous' art is not enough when that art is itself changing through the impact of modern trends, not only from the West. One may also question the iconographic significance of such paintings when for most Indian Christians they are unfamiliar and not accessible. The effective iconography remains that of the popular bazaar prints and Western-style inspirational pictures of Jesus; Christmas and Easter greeting cards are also a means by which Christian themes are disseminated widely. This is a reminder that both folk art and popular forms in the mass media (print and film) are important in shaping iconography in the present age.

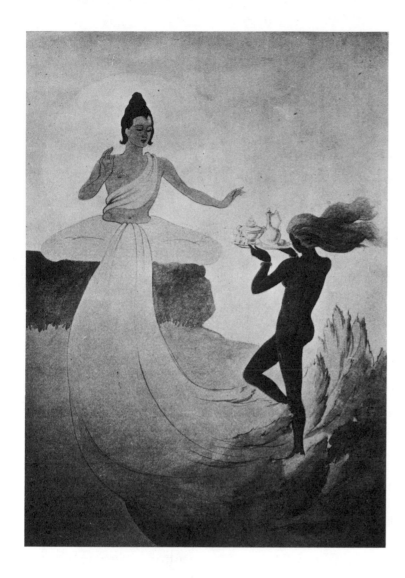

243. A. D. Thomas: Christ's temptation in the wilderness.

Summary

Despite the prophetic heritage and phases of aniconism and iconoclasm, Christianity developed images after three centuries of limited symbolic forms. The doctrines of the incarnation and Trinity made this possible without, however, determining the specific forms. The Eastern church made of icons a sacred art with a distinctive theory of images. Western Catholicism permitted a wider range of visual images and experienced many changes including the Protestant aniconic emphasis. The twentieth century brings a general crisis for sacred art but also a diversity of new forms in the West and in the wider non-European scene.

Conclusion:
The End of Iconography?

It's God
– I'd know him from Blake's picture anywhere.

Robert Frost[1]

WILLIAM BLAKE is a paradoxical figure who typifies the problematic situation of religious art and iconography over the last two centuries. On the one hand he was a religious artist and poet who expressed his visions and imagination with the help of traditional art – Renaissance, Gothic and neo-classical.[2] He illustrated themes from the Bible and Dante. His God is recognizable. But on the other hand it is *Blake's* God and not the God of orthodoxy. Blake was a rebel against dogma and conventional morality; and the mythology which he expounded in his poems and illustrated with engravings and paintings is his own creation resulting from his own intensely personal vision. The result is an iconography of one man's imagination, powerful but so individual as to become eccentric, by traditional standards. Blake's life (1757–1827) was lived in the period of change from the traditions of the established order in eighteenth-century Europe to the new world opened up by the French Revolution.[3] His individualism typifies the situation of the modern artist isolated from social tradition and his interest in many aspects of world culture, including exotic religions, anticipates the eclecticism and individual inventiveness of the modern age.

Glancing over the classical iconographies of the religions surveyed in preceding chapters we can see that generally they have depended on certain features in the society and religion which they served. There was first a sense of cosmic symbolism relating the life of man in this world

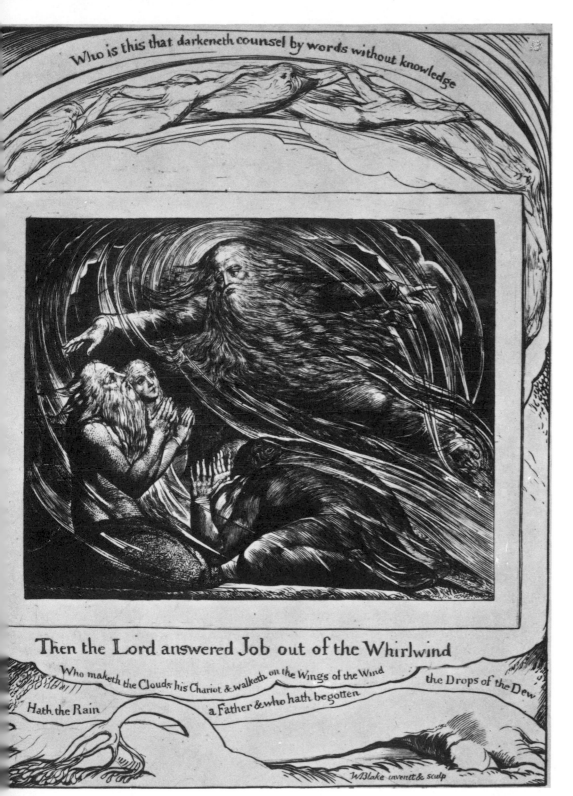

244. William Blake:
'The Lord Speaking
to Job out of the
Whirlwind'.

to the unseen cosmic mysteries. This was rooted in an acceptance of a given order, authority and hierarchy in both this world and the beyond, man expressed his relation to the cosmos also in terms of the ideas of microcosm and macrocosm. In religion there was a strong basis in public life for religious belief and also fervour in certain places and times; the existence of rival religions and sects (as in India) or of different monastic orders and pilgrimage-centres (as in Catholic Europe) gave stimulus to the development of new buildings and images. Patronage from kings and powerful religious organizations made it possible to embark on great building projects (such as Hagia Sophia in Justinian's Byzantium) with the necessary command of funds and manpower. The iconography of a Gothic cathedral expresses the presuppositions of medieval religion and life: the authority of the church and divine revelation; the hierarchy of heaven and earth in which God and the saints, the king and his subjects all had their place; a cosmology with heaven and hell waiting for man beyond this life; the story of salvation in the Bible and miraculous stories of the saints. Images and decorations, in the form of murals, reliefs and windows were executed in a variety of styles but were always able to communicate and appeal to a wide section of the public. Vivid symbolism, the realistic illustration of narratives and sometimes a certain flamboyant theatricality (as in Baroque art) were all effective answers in this situation.

When we look at the modern Western world, however, these factors are not dominant. It is not that religious activities and movements are lacking; it is rather that these are not harnessed to a commonly accepted cosmic symbolism nor to political and economic power. In the realm of the visual arts representational art is not commonly favoured and traditional iconography is now obscure and archaic in the view of the majority; on the other hand modern art presents such a wide spectrum of styles that no one style is able to satisfy. The situation is confused and chaotic, providing little basis for a meaningful religious iconography. For this reason 'modern art' has been strongly criticized for its individualism, decadence and loss of a vital spiritual centre; some would seek a renewal of the great tradition of 'sacred art' of the Middle Ages by recovering its spiritual roots.[4]

What has caused the break-up of the old order and its iconography in the West? The acceptance of a symbolic interpretation of the universe which made possible the sixteenth- to seventeenth-century fashions in allegory and emblem-books was based on a two-level view of the universe in which symbols could serve as a bridge between the seen and unseen worlds, between man and things divine. But the rise of science was already beginning to undermine this world-view and the belief in symbolic

relations; increasingly scientific causation was looked to as the realistic answer to the mystery of how the universe is connected. Then the thinkers of the European Enlightenment such as Voltaire and Diderot questioned the traditional authorities in a frontal attack on orthodox religious dogmas and institutions. Politically this was given practical form in the French Revolution. Culturally it meant a rejecting of authority based on appeals to the sacred past; for the Enlightenment the only valid authority was the light of reason and human demonstration. This was hostile to the hierarchical organization of the church and traditional society as well as to its symbol system. In the world of art there was a breach in tradition with the radically individual work of Goya and Blake who took their own way with freedom to reinterpret the familiar images of the past. Henceforth there were no uniformly accepted standards or style, so that artists could explore reality according to their individual vision (or according to the dictates of rapidly changing art fashions).[5] In protest against representational realism the twentieth century has produced successive waves of experimental art and anti-art with some novel and on occasions astonishing exhibits, but the result of this may be that, to quote an astute art critic, 'the Angry Young Man has become a bore'.[6] It is hard to envisage any sort of iconography, religious or humanist, emerging from the ceaseless quest for novelty. This tension may explain why, where efforts have been made to establish collections of religious art in the modern idiom the results in the Christian West have been unimpressive:

With the exception of the gloomy Georges Rouault, not one significant modern artist has built his imagery around doctrinal religion and its themes. . . . Nearly all the major sculpture of our age has been secular in content; its spirituality, though abundant, cannot be explained either in terms of Christian dogma or traditional religious iconography.[7]

On the other hand artists such as Cézanne and the sculptor Henry Moore who were once regarded as radical destroyers of tradition are now seen to be links in a continuous chain of art developments. It is not possible to predict where modern art will link up with traditional religious iconography and lead to cross-fertilization. Even the ingenious devices of kinetic art (which seem utterly removed from the vision of either God or man) may prove to have something substantial for the electronic and 'space age'.[8] The issue turns on whether art forms inspired by modern technology are still able to relate to human emotion and memory or whether they dissolve art into science and technology without remainder. If the latter is the case the art works are seen as mere optical phenomena and open to the following critique:

Tek art turns the artist into a technician who, for the sake of experimenting with new tools, sacrifices iconic associations evoked by memory. Expression is existentialist. Tek art is instrumentalist.[9]

Allied to this loss of social authority and the dissolution of traditional art are the effects of the modern mass media. Technology affects not only the artists (as in the case of photography taking over the function of realistic representation and driving the artist to abstraction); it affects the attitudes and expectations of the potential audience. Whereas people once had to go to a church or palace or gallery to experience the impact of a religious painting, modern means of printing have made excellent colour reproductions available in books and magazines. John Berger points up the contrast:

The visual arts have always existed within a certain preserve; originally this preserve was magical or sacred. But it was also phusical: it was the place, the cave, the building, in which, or for which, the work was made. The experience of art, which at first was the experience of ritual, was set apart from the rest of life – precisely in order to be able to exercise power over it.[12]

Despite the 'bogus religiosity' which still surrounds original works of art in museums, they no longer have the authority of holy relics with authorized admission and interpretation; they are removed from their preserve and made freely available, like language itself, by the abundant means of modern printing.

The art of the past no longer exists as it once did. Its authority is lost. In its place there is a language of images. What matters now is who uses that language for what purposes.[11]

The mass media based on printing, photography and film have combined with modern travel to extend the field of man's visual experience to global dimensions. For instance the brilliant light effects of Gothic stained glass have a modern parallel in the illuminated pictures made possible by 'colour slides'; but whereas medieval man was limited to his cathedral where he could view some of the series of Christian themes, modern 'slides' are portable and multipliable, enabling the viewer to range over the art, religious and secular, of many civilizations and many different peoples. This has immense educational possibilities; one is able to appreciate distant worlds and empathize with their art and religion. Some of the effects of this on Western art are evident in the twentieth-century 'discovery' of so-called 'primitive art' and in the longer period of interaction with 'the East'[12] which has become much more significant in recent decades. But along with this widening of horizons goes a weakening of conviction that one's own traditional way of life and religion can

be accepted with absolute seriousness for a lifetime. In contrast to the secure 'home-world' of traditional society, modern man faces a plurality of life-worlds and a consequent relativism which undermines his consciousness of the givenness of society and religion.[13] Religion becomes increasingly a private matter for individuals or enclaves, and in the social vacuum of belief there is little place for traditional iconography.

A further important effect of the mass media on modern life and attitudes lies in their drive towards continuous change. People are flooded with a great variety of images – from news of the world to fiction and advertising. When life is filled with changing images there is little room for the 'eternal icon'. The individual is invited to put himself into the shoes of many different types of people so he too tends to 'psychic mobility', expecting his life to be changing rather than fixed in traditional roles inspired by the archetypal images of the past.[14] His model is rather that of 'Protean Man' who is constantly adopting a new form.[15] Socially this tends to a diversification and fragmentation of community life and an increasing movement towards pluralism where the many images and life-styles are accepted as they jostle in the market-place and on the mass media. In this situation religious iconography becomes little more than another set of images which the individual is free to draw on if he wishes to do so. But a pluralist society has no set of images and symbols which are commonly accepted and valued.

Criticism of the tradition may take a more directly ideological form. The claim is made that our life is being progressively desymbolized and that this is a necessary escape from prehistoric and pre-scientific modes of thinking. This is the position taken by Peter Fingesten, an art historian who otherwise is interested in the religious symbols of mankind.[16] He concludes that symbolism must give way before the experimental method, on the one hand, whereby science has detached fact from symbol, and the development of non-objective art on the other which breaks through all traditional symbols in order to gain direct experience of reality (as in Zen mysticism). His verdict would be echoed by many.

Symbols are antiques. Their only reality is as part of the history of religion and art.[17]

But the reader can hardly find the argument satisfactory when it cites such pioneers of modern abstract art as Kandinsky who followed theosophy. This suggests that it is not symbolism as such which is at fault but rather certain symbols or groups of symbols which need refurbishing or replacing to meet human needs. In the history of religions some symbols die but others are reborn. A further criticism must be made of the notion that any way of life offers 'a direct experience of reality'.

Man does not have such 'direct' experience for his life is constantly being interpreted and mediated through language and symbol. Under these circumstances one can hardly claim for science and mysticism a special access to reality while denying it to more explicit symbolic systems. Symbolism need not be viewed as leading away from scientific reality; on the contrary it may encourage that imaginative stimulus which is often the vital spark in scientific hypotheses. It is not surprising then that symbolism has not been entirely 'eclipsed' in this century but has been the subject of renewed interest. In the realm of the arts one of the formative

247. Symbolic egg, suggesting fertility and cosmic creation.

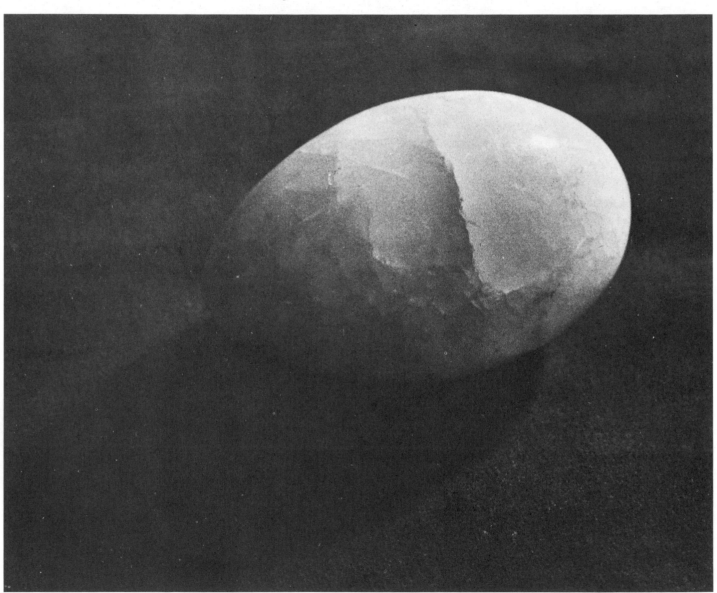

figures of modern sculpture, Constantin Brancusi, was deeply influenced by the cosmic symbolism of his Romanian peasant background; using such themes as the tree or pillar of the world, the mythological bird and the cosmic egg.[18] It is unlikely that this deep appeal of symbols will disappear from modern man's experience.[19] The persistence of symbolism provides the ground for the persistence of iconography.

After having considered the formidable battery of forces making for 'the end of iconography' it is appropriate to consider some of the more favourable factors. Allied to the symbol with its rich mental associations is the individual's world of imagination which, like a moving film made up of still pictures, dramatizes the images stored up from experience. Psychological studies reveal the prevalence of imagery; and as the raw material of man's capacity to image and symbolize it underlies both his creation of art and his ability to span time and create order out of everyday experience:

Every man walks around in the world enveloped in a carapace of his own images. Their presence enables him to structure and to organize the multiplicity of the objects and the stimuli which throng upon him. . . .[20]

While this image-world is inalienably private to the individual it also draws on public experience for its content and is the means by which the visual imagery of religious iconography can be absorbed by the individual. It need not serve an individualistic way of thinking and acting. The religious imagination, as evidenced in visions, draws on visual imagery from the tradition with which the person is most familiar (Buddhist, Christian, Hindu . . .) as well as from contemporary images. Moreover, the fragmented nature of modern pluralistic society is not to be regarded as a permanent achievement of 'modernity'. The emphasis of the 'Counter-culture' among Western youth indicates a reaching-out for the world of imaginative experience in a more communal context. The process of 'modernization', including such familiar features as technology, bureaucracy, education and the mass media is not an irreversible journey towards 'progress'; it takes a variety of forms and combinations and is subject to modification by counter and de-modernizing movements.[21] One critic of Western culture suggests that the Renaissance type of individual man will give way to a new communal type of man and that art will return to a medieval pattern.[22] This is not to endorse such a prophecy, nor to view it as 'salvation' but simply to leave the possibilities open for fresh combinations of tradition and modernity.

It would be hazardous to describe what forms religious iconography might take in the future. The varied experiments of modern art may become resources for renewal of traditional themes. For instance, the

modern German sculptor Ernst Barlach portrays the fixed gaze of the risen Christ in a modern expressionist form.[23] The clinging figure of Thomas suggests the longing of the devotee to grasp the visible icon; yet even in this act he is reminded by his Lord:

Have you believed because you have seen me? Blessed are those who have not seen and yet believe (John 20.29).

Again, word and image may be fused in works featuring religious texts; these reveal the influence of the modern poster and collage as well as of William Blake, biblical illuminations and traditional calligraphy. Understanding and sharing between different cultural and religious traditions may also enrich the forms as well as the content of art. Already explorations of these serve as pointers to new possibilities. For instance, the interest of a number of Westerners in 'Eastern meditation' and mysticism may be directed towards the use of religious art for meditation directed towards concentration, peace, healing and renewal in the person.[24]

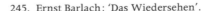

245. Ernst Barlach: 'Das Wiedersehen'.

Modern interest in the symbolism of the body is relevant here, both in the academic field of studies in anthropology and psychology and in the more practical forms of bodily-spiritual discipline such as yoga. It may well be that the simplicity and abstraction of much modern art proves helpful here because it involves the viewer in filling in the details and thus helps him to identify with and to participate in the subject depicted – as with the media labelled by McLuhan as 'cool'.[25]

Complementary to the meditation picture is the image used in the festival and in the playful and ebullient expression of the body in dance and drama. These are perennial features of many religions such as Hinduism with room for both solemn ritual processions and for spontaneity. The same may become increasingly true of the West with a recovery of the element of the 'happening'.[26] In this context the traditional icon with its aura of solemnity and eternal power may not exert much appeal; for it seems too remote. The opportunities for iconography here may lie rather

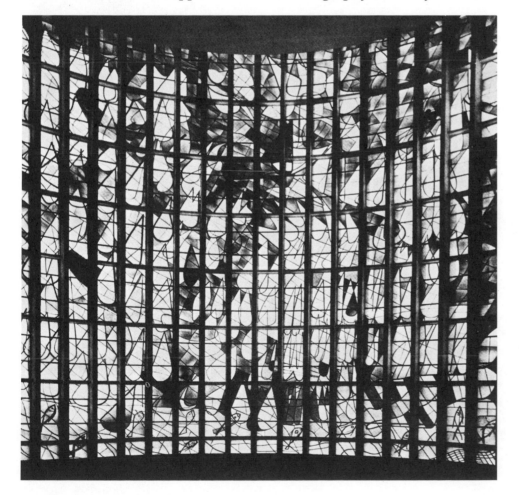

246. Meistermann: 'Outpouring of the Holy Spirit', church of St Kilian, Schweinfurth.

in forms associated with movement and participation – for instance, in semi-permanent 'optional art' which offers the spectator invitations to 'walk in' and handle the object.[27] The attraction of this lies in its combining the traditional movement and ritual with which icons are surrounded and the new sense of freedom in play involving an awareness of active belonging. What may be more superficially taken as 'fun' and spontaneity is rooted in the deeper sense of joy and celebration involved in much traditional religious ritual and iconography. The artist takes delight in depicting the sacred powers in all their awesome beauty; the viewer can still experience delight and enjoyment in this fusion of

248. Henry Moore: 'Crowd Looking at a Tied-up Object'.

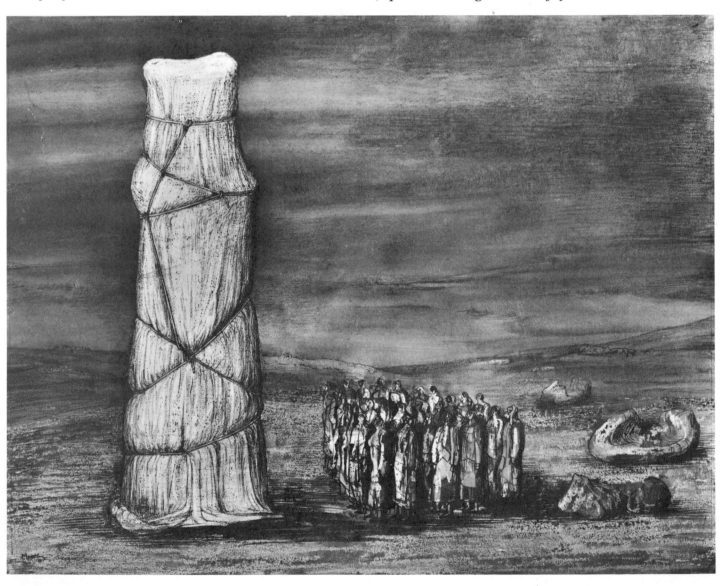

art and religion. These examples suggest that, after all, iconography can find new forms relevant to people's needs today, and that these show some surprising affinities with the past.

The modern reaction to iconography is ambivalent. It is easy to dismiss icons from the religious cultures of the past as archaic and outmoded; yet we also feel moved to awe and sometimes love for the art of classical Greece, India and China and the great ages of Byzantine, Gothic and Baroque art. What makes this reaction possible? Is it due to some continuity in man's religious awareness? Or is it just a matter of historical empathy through art, human but not specially religious? Here the question of iconography raises the question of religion itself – what is its reality and what will become of it? In puzzling over this basic question we are rather like the crowd in Henry Moore's surrealist drawing of 1942,[28] gazing at a great 'tied-up object'. The shape may suggest various things to different viewers. But will the strange object ever be unwrapped?

The various reactions to iconography can be arranged in a spectrum of modern options. At one extreme is the view of icons as nothing but museum-pieces to human ignorance and folly, imprisoning the icons in boxes for detached viewing. A second view would be more appreciative at the human level, opening up the glass frames so that the viewer feels some common ground with the human strivings of men of past ages. A third view would draw on these opened icons for spiritual lessons, perhaps the lessons of mysticism seen as the common ground of the religions. A fourth view would respect the differences between the icons and seek to understand the individual contribution of each in a relationship more of dialogue than of identity. A further option would be that of defensive traditionalism. In this instance there is a return to the shut case for the icon; but this time the viewer is also shut inside the case with his icon.

Man's use of religious images reflects his wider religious outlook – hence the deep feelings that have been aroused in controversies concerning images. Religion is a complex of happenings in people's lives – of rituals, prayers, meetings and experiences of longing and fulfilment. Within this context visual images play a significant and mediating role. It is when they are taken out of this context and viewed in isolation that images seem remote objects, fixed, frozen and irrelevant. Certainly there are varied 'ways of being religious'[29] and some ways have led men to do without images – apparently, at least, for certain periods and in certain circumstances. But does man ever transcend the use of all visual images? We have noted earlier how icons in religion derive from the basic fact that man has a body while seeking to transcend the body. Even when he transcends the image he still needs the image.

Notes

Preface and Acknowledgments

1. Th. P. van Baaren (ed.), *Iconography of Religions*, E. J. Brill, Leiden 1970ff. The many sections of this work, being published over a number of years, are based on the archive of photographs at the Institute of Religious Iconography at the State University of Groningen (Netherlands).

2. For instance, the *Oxford Companion to Art* (ed., H. Osborne, 1970), a most clear and helpful general source of information on many iconographical matters. Readers seeking more exact transliteration of words from Asian languages may refer to C. H. Philips (ed.), *Handbook of Oriental History*, Offices of Royal Historical Society, London 1951, 1967.

3. Albert C. Moore, 'Religion and the Arts in the work of Mircea Eliade', in *Miorita: A Journal of Romanian Studies*, Hamilton, New Zealand 1974, vol. i, pp. 71–8.

Chapter 1 Introduction

1. E. H. Gombrich, in *New York Review of Books*, xviii, 8, 4 May 1972, p. 38.

2. Ruth Mellinkoff, *The Horned Moses In Medieval Art and Thought*, University of California Press, Berkeley 1970, p. 139.

3. William Willetts, *Chinese Art*, Penguin Books 1958, p. 348.

4. Ibid., p. 350.

5. M. D. Anderson, *History and Imagery in British Churches*, John Murray 1971, p. 3.

6. S. G. F. Brandon 'The Holy Book, the Holy Tradition and the Holy Ikon: a phenomenological survey', *Holy Book and Holy Tradition*, ed., F. F. Bruce and E. G. Rupp, Manchester University Press 1968, pp. 1–19.

7. Nancy D. Munn, in A. Forge (ed.), *Primitive Art and Society*, Oxford University Press 1973, p. 193.

8. J. Bialostocki, 'Iconography and Iconology', *EWA*, vii, 769–785.

9. Rosemary Gordon, 'A Very Private World', *The Function and Nature of Imagery*, ed., Peter W. Sheehan, Academic Press 1972, pp. 63–80.

10. T. P. H. McKellar, in Sheehan (ed.), op. cit., pp. 36ff.; also *Imagination and Thinking: a psychological analysis*, Cohen & West 1957.

11. Herbert Read, *The Art of Sculpture*, Faber 1956, ch. 2, 'The Image of Man', p. 29.

12. John Berger, *Ways of Seeing*, BBC and Penguin Books 1972, p. 9.

13. Peter Fingesten, *The Eclipse of Symbolism*, University of South Carolina Press 1970, pp. 37ff. on 'The Eye of God'.

14. R. L. Gregory and E. H. Gombrich (eds), *Illusion in Nature and Art*, Duckworth 1973, pp. 204–5.

15. J. N. Banerjea, *The Development of Hindu Iconography*, University of Calcutta 1941, 1956.

16. R. van Marle, *Iconographie de l'Art Profane au Moyen Age et à la Renaissance, 1931*, Hacker, New York, reprinted 1971, 2 vols.

17. O. Grabar, *The Formation of Islamic Art*, Yale University Press 1973, p. 139.

18. Frederick Ferré, 'The Definition of Religion', *JAAR*, 1970, xxxviii, pp. 3–16; also *Basic Modern Philosophy of Religion*, Scribner, New York 1967, ch. 2.

19. Winston L. King, *Introduction to Religion: a phenomenological approach*, Harper & Row 1968, ch. 1.

20. Ninian Smart, *The Religious Experience of Mankind*, Scribner, New York 1969, p. 16, ch. 1.

21. F. Sierksma, *The Gods as we Shape Them*, Routledge & Kegan Paul 1960, pp. 183–4 for a discussion of Picasso's 'Guernica', plate 91.

22. See the discussion on Tillich and Picasso in F. David Martin, *Art and the Religious Experience: The 'Language' of the Sacred*, Bucknell University Press, Lewisburg 1972, pp. 160–64. On the religious importance of beauty and artistic creativity as expressing the religious dimension, see the succinct outline by F. J. Streng, *Understanding Religious Man*, Dickenson, Belmont, California 1969, ch. 9. Iconography is usually here associated with the specific traditions of liturgical art ('visual theology'). But other, less explicitly religious, forms and styles may also express spiritual reality. This difference is sometimes polarized as a distinction between formal 'religious art' and personal 'spiritual concern'; see E. B. Feldman, *Art as Image and Idea*, Prentice-Hall, Englewood Cliffs, New Jersey 1967, pp. 24–30.

23. Clear and scholarly outlines of the discipline, and its history are given by J. H. A. Engelbregt, 'Iconology and Iconography', *NCE*, vii, pp. 329–33, and by Bialostocki, op. cit., *EWA*, vii, 769–85.

24. For interesting examples of these changes, see Fritz Saxl, 'Continuity and Variation in the Meaning of Images', *A Heritage of Images*, Penguin Books 1970, pp. 13–27.

25. Engelbregt, op. cit., pp. 332–33, provides a useful summary and chart based on E. Panofsky, *Studies in Iconology*, 1939, Harper & Row, New York 1962. See also E. Panofsky, *Meaning in the Visual Arts*, Doubleday, Garden City 1955, ch. 1.

26. Bialostocki, op. cit., pp. 780–81.

27. Ernst Cassirer, *Essay on Man*, Yale University Press 1944, p. 25.

28. Clifford Geertz, 'Religion as a Cultural System', *Anthropological Approaches to the Study of Religion*, ed., M. Banton, Tavistock Publications 1965, pp. 3–8ff.

29. Winston L. King, 'Sunyata as a "Master-Symbol"', *Numen*, xvii, 1970, pp. 95–104.

30. Mircea Eliade, *Patterns in Comparative Religion*, Sheed & Ward 1958; J. E. Cirlot, *A Dictionary of Symbols*, Routledge & Kegan Paul 1962.

31. Thomas Fawcett, *The Symbolic Language of Religion*, SCM Press 1970; Edwyn Bevan, *Symbolism and Belief*, 1938, Fontana 1962; Gilbert Cope, *Symbolism in Bible and Church*, SCM Press 1959; see also articles 'Symbol', 'Symbolism', in *NCE*, xiii, and 'Symbolism and Allegory', in *EWA*, xiii.

32. Amy Goldin, 'Words in Pictures', *Narrative Art*, ed., T. B. Hess and J. Ashberry, Macmillan 1970.

33. Herbert Read, *Icon and Idea,* Faber 1955, p. 5.

34. The association of word and image is brought closer in the art of calligraphy as in the art of Islam and East Asia. In the European tradition William Blake often made the written poem or text an integral part of his pictures, and some modern artists have combined words and pictures.

35. John Philips, *The Reformation of Images,* University of California Press, Berkeley 1973, p. 201.

36. M. J. Herskovits, *The New World Negro,* Indiana University Press 1966, p. 166, and plates following p. 162 in 'Bush-Negro Art', pp. 157–67 (reprinted from 1930). See also Philip J. C. Dark, *Bush Negro Art: An African art in the Americas,* Academy editions 1973, pp. 14–21.

37. P. and C. Cannon-Brookes, *Baroque Churches,* Hamlyn 1969, pp. 183–6. See further references below in ch. 8, notes 101–3.

38. For many other illustrations of prehistoric figures and images from ancient religions, see Erich Neumann, *The Great Mother: an analysis of the archetype*, Routledge & Kegan Paul 1963, 1970.

39. Edwyn Bevan, *Holy Images,* Allen & Unwin 1940, p. 157, citing this as popular practice deviating from church authority.

40. H. W. Janson, 'The Image of Man in Renaissance Art', in B. Kelly (ed.), *The Renaissance Image of Man and the World,* Ohio State University Press 1966, pp. 81–82.

41 E. H. Gombrich, 'The Use of Art for the Study of Symbols', *Psychology and the Visual Arts,* ed., J. Hogg, Penguin Books 1969, p. 157.

42. See the beautifully illustrated series *Art and Society,* ed., Peter Ucko, Duckworth 1971-2, 4 vols; A. Forge (ed.), *Primitive Art and Society*, Oxford University Press 1973, including stimulating essays by Edmund Leach and Nancy Munn; Charlotte M. Otten, *Anthropology and Art: Readings in Cross-Cultural Aesthetics,* Natural History Press, Garden City 1971.

43. R. Beals and H. Hoijer, *An Introduction to Anthropology,* Macmillan 1971, ch. 16 on the Arts, especially p. 515.

44. Richard Brilliant, *Roman Art from the Republic to Constantine,* Phaidon 1974, p. 8.

45. Arnold Hauser, *The Social History of Art,* Routledge & Kegan Paul 1951; vol. i covers from prehistory to the baroque era, vol. ii continuing to the 'film age'.

46. P. W. Sheehan (ed.), *The Function and Nature of Imagery*, Academic Press 1972.

47. Rudolf Otto, *The Idea of the Holy,* Oxford University Press 1923, reprinted 1972.

48. W. Brede Kristensen, *The Meaning of Religion,* M. Nijhoff, the Hague 1960.

49. G. van der Leeuw, *Sacred and Profane Beauty: The Holy in Art,* Weidenfeld & Nicolson 1963, pp. 155ff.

50. R. H. Robinson, *The Buddhist Religion*, Dickenson, Belmont, California 1970, p. 81.

51. Mircea Eliade, *The Sacred and the Profane,* Harper & Row 1958; *Cosmos and History,* Harper & Row 1960.

52. See further: Fritz Saxl, 'Macrocosm and Microcosm in Medieval Pictures', in *Lectures*, 2 vols, Warburg Institute 1957, vol. I, pp. 58–72; vol. II, plates 34–42. See also M.-D. Chenu, *Nature, Man and Society in the Twelfth Century,* University of Chicago Press 1968, pp. 24–37 on 'Man as Microcosm'. On the wider implications of this theme, see G. P. Conger, *Theories of Macrocosms and Microcosms in the History of Philosophy,* Columbia University Press 1922, reprinted 1967; and A. C. Moore, 'The Human Body

as Microcosm in Religious Images', in *The Religious Dimension*, ed., J. Hinchcliff, University of Auckland, New Zealand 1976.

53. Titus Burckhardt, *Sacred Art in East and West,* Perennial Books 1967, p. 131.

Chapter 2 Primal Religions

1. Stuart Piggott (ed.), *The Dawn of Civilization*, Thames & Hudson 1961, p. 15.

2. S. Giedion, *The Eternal Present (I): The Beginnings of Art*, Oxford University Press 1962.

3. 'It is not the anatomical "sexual" organ that is being symbolized, but the stories, characters and processes with which the symbol had become associated', notes Alexander Marshack, *The Roots of Civilization: the cognitive beginnings of man's first art symbol and notation,* Weidenfeld & Nicolson 1972, (illustrated), p. 297.

4. S. Giedion, op. cit., p. 273.

5. Ibid., pp. 435; 6.

6. S. G. F. Brandon, *Religion in Ancient History,* Allen & Unwin 1973, pp. 13–17.

7. Germain Bazin, *A Concise History of Art*, Thames & Hudson 1962, pp. 11–12.

8. Mircea Eliade, *Shamanism: Archaic Techniques of Ecstasy,* Routledge & Kegan Paul 1964.

9. Weston La Barre, *The Ghost Dance: The Origins of Religion*, Doubleday 1970, ch. 5 'The First Gods' and ch. 13 'The Dancing Sorcerer'. For criticism see the full review by M. L. Ricketts, *HR,* xi, 1971, pp. 147–56.

10. Peter J. Ucko and Andrée Rosenfeld, *Palaeolithic Cave Art,* Weidenfeld & Nicolson 1967, pp. 204–206.

11. Ibid., pp. 238–39. See also Peter J. Ucko, *Anthropomorphic Figurines,* Szmidla 1968, part 5: 'Interpretations'.

12. Andreas Lommel, *Prehistoric and Primitive Man,* Hamlyn 1966, p. 8.

13. Ibid., pp. 8–16. For another attempt to recover the origins of religion see H. R. Hays, *In the Beginnings: Early Man and his Gods*, G. P. Putnam's Sons 1963.

14. Ucko and Rosenfeld, op. cit., p. 152. The whole discussion on pp. 151–58 is useful.

15. Harold W. Turner, *Living Tribal Religions,* Ward Lock Educational 1971, 1973, p. 7. Also John V. Taylor, *The Primal Vision: Christian Presence amid African Religion*, SCM Press 1963, third impression 1972, p. 18. For criticism of 'primitive' and other 'errors of terminology', see E. Bojali Idowu, *African Traditional Religion: A Definition,* SCM Press 1973, ch. 4, 'It is the outsider, the observer, the investigator, the curious, the detractor or the busybody, who first supplied labels' (p. 136).

16. Useful introductory studies are: W. Howells, *The Heathens: Primitive Man and his Religions,* Doubleday 1948, 1962; W. A. Lessa and E. Z. Vogt (eds), *Reader in Comparative Religion,* Harper & Row 1958, 1965, 1972.

17. For a modern Western sculptor's appreciation of 'Primitive Art', see the essay by Henry Moore, pp. 155–63, in P. James (ed.), *Henry Moore on Sculpture,* Macdonald 1966. He reluctantly uses the term 'primitive' in describing the intense vitality of this art, its primary concern with the elemental, its direct and strong feeling. 'All art has its roots in the "primitive", or else it becomes decadent . . .' (p. 155).
Two useful books of readings are: Charlotte M. Otten (ed.), *Anthropology and Art,* Natural History Press, New York 1971; Carol F. Jopling (ed.), *Art and Aesthetics in Primitive Societies,* E. P. Dutton, New York 1971.

18. W. B. Spencer and F. J. Gillen, *The Native Tribes of Central Australia,* Macmillan 1899, 1927; this is one of the pioneering studies. For a recent introductory survey, see T. G. H. Strehlow, 'Religions of Illiterate People: Australia', *Historia Religionum*, ed., C. J. Bleeker and G. Windengren, vol. 2, Brill 1971, pp. 609–628.

19. W. E. H. Stanner, 'The Dreaming', in Lessa and Vogt, op. cit., 1965, pp. 158–167.

20. W. E. H. Stanner, 'Religion, Totemism and Symbolism', *Aboriginal Man in Australia*, ed., R. M. and C. H. Berndt, Angus & Robertson 1965, p. 227.

21. A. P. Elkin, *The Australian Aborigines: How to Understand Them,* Angus & Robertson 1938; 1958, p. 238; ch. 9, 'Art and Ritual'. A good popular introduction is the pictorial by D. Baglin and R. Robinson, *The Australian Aboriginal in colour,* Reed, Sydney 1968.

22. R. M. Berndt (ed.), *Australian Aboriginal Art,* Macmillan, New York 1964, pp. 75, 15; plate 44. See also R. M. Berndt, *Australian Aboriginal Religion,* Brill 1973, in *Iconography of Religions,* section 5 (4 fasc.).

23. Karel Kupka, *Dawn of Art: Painting and Sculpture of Australian Aborigines,* Angus & Robertson, 1965, p. 76. See also Ian M. Crawford, *The Art of the Wandjina,* Oxford University Press 1968.

24. Charles P. Mountford, *The Tiwi: their Art, Myth and Ceremony,* Phoenix House, 1958. For Central Australia compare: C. P. Mountford, *Ayers Rock,* Angus & Robertson 1965, chs 8–10.

25. Anne E. Wells, *This is their Dreaming,* University of Queensland Press 1971.

26. C. H. and R. M. Berndt, *The Barbarians, an anthropological view,* Watts 1971, note to plate 10(a).

27. R. M. Berndt (ed.), *Australian Aboriginal Art,* pp. 81–82, 23–24, and plate 25.

28. Kupka, op. cit., p. 109.

29. Nancy D. Munn, *Walbiri Iconography,* Cornell University Press 1973.

30. Nancy D. Munn, 'The Spatial Presentation of Cosmic Order in Walbiri Iconography', *Primitive Art and Society*, ed., A. Forge, Oxford University Press 1973, pp. 193–220.

31. See further: A. H. Chisholm (ed.), *The Australian Encyclopaedia,* Angus & Robertson 1958, vol. I, for authoritative short articles on Aboriginal life and culture – on dance (pp. 62–64 by Berndt) and sign-language (pp. 28–29 by F. D. McCarthy). For a comprehensive introduction to the aboriginal arts, see R. M. Berndt and E. S. Phillips (eds), *The Australian Aboriginal Heritage: An Introduction through the Arts,* Australian Society for Education through the Arts, Ure Smith, Sydney 1973. This is splendidly illustrated and the text covers not only rock art, sculpture and bark painting but oral literature, music and dance and a discussion of the future of these arts, with good bibliographies.

32. Munn, in A. Forge (ed.), op. cit., pp. 215–16.

33. J. van Baal, *Dema,* Nijhoff, the Hague 1966, pp. 177–187; also: J. van Baal, *Symbols for Communication,* Van Gorcum, Assen 1971, ch. 11.

34. Peter Lawrence and M. J. Meggitt (eds), *Gods, Ghosts and Men in Melanesia,* Oxford University Press 1965, introduction.

35. R. H. Codrington, *The Melanesians,* Oxford University Press, 1891.

36. Jean Guiart, *The Arts of the South Pacific,* Thames & Hudson 1963, is richly illustrated on Melanesia. See also articles by H. Tischner in *EWA*, ix, pp. 691–727.

37. Anthony Forge, in P. Hastings (ed.), *Papua/New Guinea, Prospero's Other Island,* Angus & Robertson 1971, p. 72.

38. C. A. Valentine, *Masks and Men in a Melanesian Society,* University Kansas Press 1961.

39. F. E. Williams, *Drama of Orokolo,* Clarendon Press, Oxford 1940, 1969.

40. A. M. Kiki, *Kiki, Ten Thousand Years in a Lifetime: A New Guinea Autobiography,* F. W. Cheshire, Melbourne 1968.

41. Kiki, op. cit., p. 47.

42. Anthony Forge, 'Style and Meaning in Sepik Art', *Primitive Art and Society,* ed., A. Forge, Oxford University Press 1973, p. 190.

43. Olive Riley, *Masks and Magic,* Thames & Hudson 1955, plate 40.

44. Guiart, op. cit., plate 28.

45. Douglas Fraser, *Primitive Art,* Thames & Hudson 1962, plate 138, from a photograph taken in 1912.

46. Roy Sieber, 'Masks as Agents of Social Control', *The Many Faces of Primitive Art,* ed., D. Fraser, Prentice-Hall 1966, pp. 257–63.

47. Alfred Bühler, *et al., Oceania and Australia*, Methuen 1962, p. 130.

48. Philip J. C. Dark, 'Kilenge Big Man Art', in A. Forge (ed.), op. cit., pp. 49–69.

49. Well-illustrated introductions to the art of Africa, including masks, are: Elsy Leuzinger, *Africa: the Art of the Negro Peoples,* Methuen 1960; Frank Willett, *African Art, an Introduction,* Thames & Hudson 1970; Paul S. Wingert, 'African Masks: structure, expression, style', in *African Arts,* Winter 1973, University California, vol. 6, pp. 56–64. See also: Daniel F. McCall and Edna Bay (eds), *African Images: Essays in African Iconology,* Africana Publishing Company, New York 1975.

50. W. L. d'Azevedo, 'Mask Makers and Myth in Western Liberia', in A. Forge (ed.), op. cit., p. 148.

51. Forge, in A. Forge (ed.), op. cit., p. 174.

52. Carl A. Schmitz, *Wantoat,* Mouton 1963, pp. 87–88 and plate 13.

53. Paul S. Wingert, 'Primitive Masks', *EWA,* ix, p. 547.

54. Mircea Eliade, *et al.,* 'Masks', *EWA,* ix, pp. 520ff. 'Transformation' can include a whole range of arts of dress and adornment, including masks, and may be 'man-regarding' or 'spirit-regarding'; for an illuminating illustrated survey from an exhibition along these lines, see Herbert M. Cole, *African Arts of Transformation,* University of California, Santa Barbara 1970.

55. Poster used for festival 'Wellington '73', 23 March 1973, Wellington, New Zealand.

56. Fraser, *Primitive Art,* pp. 280–312.

57. Deborah Waite, 'Kwakiutl Transformation Masks', *The Many Faces of Primitive Art*, ed., D. Fraser, Prentice-Hall 1966, pp. 264–300. Also: F. Sierksma, *The Gods as We Shape Them,* Routledge & Kegan Paul 1960, p. 167, plates 47–48.

58. Robert Brain and Adam Pollock, *Bangwa Funerary Sculpture,* Duckworth 1971, pp. 132–133.

59. Andreas Lommel, *Masks, their meaning and function,* Elek 1972; Walter Sorell, *The Other Face: The Mask in the Arts,* Thames & Hudson 1973.

60. A. and M. Strathern, *Self-Decoration in Mount Hagen,* Duckworth 1971, pp. 1–3, 54–59, 171–77.

61. Forge, in P. Hastings (ed.), op. cit., p. 70.

62. James C. Faris, *Nuba Personal Art,* Duckworth 1972.

63. Denise Paulme, 'Adornment and Nudity in Tropical Africa', in A. Forge (ed.), op. cit., pp. 11ff.

64. Robert C. Suggs, *The Island Civilizations of Polynesia,* Mentor Books, New American Library 1960; William Howells, *The Pacific Islanders,* Weidenfeld & Nicolson 1973, ch. 8.

65. Gilbert Archey, 'Polynesia', 'Polynesian Cultures', in *EWA,* x, pp. 438–462. Other

useful introductions are: Paul S. Wingert, *Primitive Art*, Oxford University Press 1962, pp. 269–329. Roslyn Poignant, *Oceanic Mythology*, Hamlyn 1967, pp. 12–69; Terry Barrow, *Art and Life in Polynesia*, A. H. & A. W. Reed, Tuttle 1972.

66. E. S. C. Handy, *Polynesian Religion*, Bulletin no. 34 of Bernice P. Bishop Museum, Honolulu 1927, pp. 87–120. R. W. Williamson, *Religion and Social Organization of Polynesia*, Cambridge University Press 1937.

67. Poignant, op. cit., pp. 37–47.

68. Raymond Firth, 'Tikopia Art and Society', in A. Forge (ed.), op. cit., 1973, pp. 26ff.

69. Edmund Leach, in A. Forge (ed.), op. cit., 1973, pp. 230–234.

70. Antony Alpers, *Legends of the South Sea*, John Murray 1970, pp. 47–80.

71. Te Rangi Hiroa (Sir Peter Buck), *The Coming of the Maori*, Whitcombe & Tombs, Wellington 1949, part 4. Also D. R. Simmons, *The New Zealand Myth*, unpublished dissertation, University of Auckland 1963.

72. Sir George Grey, *Polynesian Mythology*, John Murray 1855.

73. T. Barrow, *Maori Wood Sculpture of New Zealand*, A. H. & A. W. Reed, 1968, pp. 33, 104–107.

74. Pieter H. de Bres, 'Maori Migration and Maori Identity', ANZAAS conference, Brisbane 1971, mimeo., p. 8.

75. Peter H. Buck (Te Rangi Hiroa), *Arts and Crafts of Hawaii*, xi, 'Religion', Bishop Museum, Honolulu, 1957.

76. R. C. and Kaye Green, 'Religious Structures (Marae) of the Society Islands', in *New Zealand Journal of History*, vol. 2, April 1968, pp. 66–89, illustrated.

77. Eric Schwimmer, *The World of the Maori*, A. H. & A. W. Reed, Wellington 1966, chs 7 and 13. (This work is an excellent short survey of Maori life and culture, including religion and art.)

78. Barrow, *Maori Wood Sculpture*, pp. 76–94; Alan and W. A. Taylor, *The Maori Builds*, Whitcombe & Tombs, Wellington 1966; Michael Jackson, 'Aspects of Symbolism and Composition in Maori Art', *Bijdragen tot de Taal-, Land-en Volkenkunde*, 1972, vol. 128 (1), pp. 33–80, especially pp. 37–40, 60–64 on the house.

79. Barrow, *Maori Wood Sculpture*, pp. 13–23.

80. Ibid., pp. 19, 56.

81. Schwimmer, op. cit., p. 94.

82. Barrow, *Maori Wood Sculpture*, pp. 34ff. Also the classic study by General H. G. Robley, *Moko or Maori Tattooing*, Chapman & Hall 1896, and the exhibition catalogue *Face Value: A Study in Maori Portraiture*, Dunedin Public Art Gallery, Dunedin, New Zealand 1975.

83. Margaret Orbell, 'The Maori Art of Moko', *Te Ao Hou, the Maori Magazine*, Wellington, June 1962, no. 43, pp. 30–34.

84. Schwimmer, op. cit., p. 93; see also Jackson, op. cit., pp. 69–72.

Chapter 3 Polytheism in Ancient Religions

1. E. H. Gombrich, *The Story of Art*, Phaidon 1950, twelfth edition 1972, ch. 2.

2. John Manchip White, *Everyday Life in Ancient Egypt*, Batsford 1963, p. 114.

3. Henri Frankfort, *Ancient Egyptian Religion: An Interpretation*, Harper 1961, p. 4. See also Henri Frankfort *et al.*, *Before Philosophy*, Penguin Books 1949.

4. R. T. Rundle Clark, *Myth and Symbol in Ancient Egypt*, Thames & Hudson 1959,

p. 29. This book has useful summaries of the gods and the mythological scheme (pp. 18–21) and of 50 major religious symbols (pp. 257–59).

5. Frankfort, *Ancient Egyptian Religion,* pp. 6–7.

6. W. B. Emery, *Archaic Egypt,* Penguin Books 1961, pp. 76, 123.

7. Rundle Clark, op. cit., pp. 235–38.

8. Ibid., pp. 218–230.

9. Siegfried Giedion, *The Eternal Present (II): The Beginnings of Architecture,* Oxford University Press 1964, pp. 70–73.

10. G. W. F. Hegel, cited by H.-J. Schoeps, *The Religions of Mankind,* Doubleday, Anchor 1968, p. 68.

11. Flinders Petrie, 'Egyptian Religion', *ERE,* v, p. 244 (following Maspero).

12. Giedion, op. cit., p. 30, citing Kurt Sethe's dictum. For a wider examination of the significance of the animal in prehistory, in several ancient civilizations and 'barbaric' styles, see: Francis Klingender, *Animals in Art and Thought, to the End of the Middle Ages,* Routledge & Kegan Paul 1971, part I.

13. W. Brede Kristensen, *The Meaning of Religion,* Nijhoff 1960, p. 156.

14. Ibid., p. 159.

15. Giedion, op. cit., pp. 4–6, comparing lion sculptures from Egypt and Mesopotamia.

16. Frankfort, *Ancient Egyptian Religion,* p. 14.

17. Rundle Clark, op. cit., chs 3, 4, 5. See also: E. A. Wallis Budge, *Osiris and the Egyptian Resurrection,* 2 vols, Warner 1911; this includes many illustrations of the variety of representations of Osiris.

18. Eberhard Otto, *Egyptian Art and the Cults of Osiris and Amon,* Thames & Hudson 1968, pp. 121–25.

19. Siegfried Morenz, *Egyptian Religion,* Methuen 1973, p. 106.

20. S. G. F. Brandon, *Religion in Ancient History,* Allen & Unwin 1973, ch. 9; Cyril Aldred, *Akhenaten: Pharaoh of Egypt,* Thames & Hudson 1968.

21. Covering the whole Egyptian art tradition are two richly illustrated volumes: K. Lange and M. Hirmer, *Egypt – Architecture, Sculpture, Painting in three thousand years,* Phaidon 1956, fourth edition (enlarged) 1968; K. Michalowski, *The Art of Ancient Egypt,* Thames & Hudson 1969.

22. Emery, op. cit., p. 128. See also: E. O. James, *From Cave to Cathedral,* Thames & Hudson 1965, ch. 3, pp. 99–130.

23. Morenz, op. cit., p. 88. See also: Mircea Eliade, *The Sacred and the Profane,* Harper 1961, pp. 58ff.

24. Cited by James Baikie, 'Images and Idols (Egyptian)', *ERE,* vii, p. 132. A New Kingdom papyrus contains the book of temple rites and pictures of the temple.

25. Morenz, op. cit., p. 88.

26. Ibid., pp. 94, 100.

27. Ibid., pp. 150–156.

28. Ibid., pp. 155–56.

29. White, op. cit., pp. 153–54, in a useful chapter describing artists, priests and other professions in Egyptian society.

30. Ibid., pp. 160–61.

31. G. Garbini, 'Divinities', Mesopotamia, in *EWA,* iv. See further such works as: Leonard Woolley, *Mesopotamia and the Middle East,* Methuen 1961; Anton Moortgat, *The Art of Ancient Mesopotamia,* Phaidon 1969; André Parrot, *Sumer,* Thames & Hudson 1960.

32. Geo Widengren, 'Divinities, Iran', *EWA*, iv, pp. 390–19. See further the two volumes in the 'Archaeologia Mundi' series: J.-L. Huot, *Persia, I,* and V. Lukonin, *Persia, II,* Nagel 1967. Also Roman Ghirshman, *Iran, from the Earliest Times to the Islamic Conquest,* Penguin Books 1954; J. Hinnells, *Persian Mythology,* Hamlyn 1973.

33. Wordsworth, 'The World is too much with us', in William Wordsworth, *Selected Poems,* Oxford University Press 1932, p. 247.

34. W. B. Kristensen, *The Meaning of Religion,* Nijhoff 1960, p. 21.

35. Jean Seznec, *The Survival of the Pagan Gods,* Harper Torchbooks 1961.

36. Marija Gimbutas, *The Gods and Goddesses of Old Europe 7000–3500 BC: Myths, Legends and Cult Images,* Thames & Hudson 1974.

37. Ekrem Akurgal, *The Birth of Greek Art: The Mediterranean and The Near East,* Methuen 1968.

38. Pierre Grimal, 'Divinities: Greco-Roman', *EWA*, iv, p. 395.

39. L. R. Farnell, *Outline History of Greek Religion,* Duckworth 1920, ch. I.

40. C. Kerenyi, *The Religion of the Greeks and Romans,* Thames & Hudson 1962, ch. 2: 'The Feast'.

41. Farnell, op. cit., pp. 31–34.

42. E. O. James, *From Cave to Cathedral,* Thames & Hudson 1965, ch. 7: 'Greek Temples'.

43. S. Ferri, 'Images and Iconoclasm Antiquity', in *EWA*, vii, p. 806.

44. L. R. Farnell, *Cults of the Greek States,* vol. I, Oxford University Press 1896, p. 13.

45. *Pausanias: Description of Greece,* Loeb Classical Library, Heinemann 1933, viii, 17, 1; xi, 11, 40; xi, 14, 4.

46. Karl Schefold, *Myth and Legend in Early Greek Art,* Thames & Hudson 1964, p. 52 and plate 39.

47. P. Gardner, 'Images and Idols: Greek', *ERE*, vii, pp. 134–35.

48. Martin P. Nilsson, *The Minoan-Mycenean Religion and its survival in Greek Religion,* second edition, C. W. K. Gleerup, Lund 1950, chs 9-12. See also: Jacquetta Hawkes, *Dawn of the Gods,* Chatto & Windus 1968, illustrated.

49. C. M. Bowra, *The Greek Experience,* Mentor Books 1959, p. 57.

50. Charles Seltman, *The Twelve Olympians,* Pan Books 1952, p. 42.

51. E. N. Gardiner, *Athletics of the Ancient World,* Oxford University Press 1930, pp. 57–58.

52. Kenneth Clark, *The Nude: A Study of Ideal Art,* John Murray 1956, pp. 29–30.

53. Charles Seltman, op. cit., p. 43.

54. Max Wegner, 'Greek Art', *EWA*, vii, pp. 25–26.

55. Bowra, op. cit., p. 171.

56. Farnell, *Outline-History,* pp. 99ff.

57. Fine illustrations are accessible in such books as: John Boardman, *et al., The Art and Architecture of Ancient Greece,* Thames & Hudson 1967; Gisela M. A. Richter, *A Handbook of Greek Art,* Phaidon 1959; William H. Hale (ed.), *The Horizon Book of Ancient Greece,* American Heritage Publishing Co. 1965; *Larousse Encyclopaedia of Mythology,* Hamlyn 1959, pp. 87–133; Michael Grant (ed.), *The Birth of Western Civilization: Greece and Rome,* Thames & Hudson 1964, illustrated, especially chs 3, 4.

58. W. K. C. Guthrie, *The Greeks and their Gods,* Methuen 1950, pp. 34–41.

59. A. B. Cook, *Zeus,* 3 vols, Cambridge University Press 1914–1940.

60. Farnell, *Cults,* vol. i, pp. 102–3. See chs 4-6.

61. Ibid., pp. 128ff.

62. C. Seltman, op. cit., pp. 45–46.

63. Karl Schefold, *Classical Greece,* Methuen 1966, p. 131.

64. Walter F. Otto, *The Homeric Gods,* Thames & Hudson 1954, pp. 59–60.

65. Guthrie, op. cit., pp. 106–108.

66. Cook, *Zeus,* vol. iii, 1940, pp. 776–836 on Athena and owl.

67. Seltman, op. cit., pp. 59–60.

68. Schefold, *Classical Greece,* pp. 121–124.

69. Boardman, op. cit., p. 37, line-drawings. An impressive imaginative reconstruction in colour is given in C. M. Bowra, *Classical Greece,* Time-Life International 1966, p. 115. See also: R. J. Hopper, *The Acropolis,* Weidenfeld & Nicolson 1971, illustrated.

70. Farnell, *Cults,* vol. i, p. 376. See chs 10–12.

71. Guthrie, op. cit., pp. 73ff. on Apollo.

72. Otto, op. cit., p. 79; pp. 61–80 on Apollo.

73. Bowra, *Classical Greece,* p. 19.

74. Seltman, op. cit., pp. 127–28.

75. K. Clark, op. cit., p. 45, in ch. 2, 'Apollo'.

76. Gombrich, op. cit., pp. 67–69.

77. Grimal, op. cit., p. 396.

78. Gardner, op. cit., pp. 137–38.

79. Seltman, op. cit., p. 43; cf. p. 186.

80. Farnell, *Cults,* vol. I, pp. 20–21.

81. H. J. Rose, *Ancient Greek Religion,* Hutchinson 1946, p. 98 in ch. 5: 'The Gods on Trial'.

82. Heraclitus, *On Nature,* fragment, cited by H.-J. Schoeps, op. cit., p. 139.

83. Kristensen, op. cit., p. 246.

84. Kristensen, op. cit., p. 248.

85. Kristensen, op. cit., pp. 254, 396–97.

86. G. Parrinder, *Dictionary of Non-Christian Religions,* Hulton Educational Publications 1971, pp. 65–66 (illustrated).

87. Schoeps, op. cit., pp. 150–153. See also: John Ferguson, *Religions of the Roman Empire,* Thames & Hudson 1970.

88. Anne Ross, *Pagan Celtic Britain: Studies in Iconography and Tradition,* Routledge & Kegan Paul 1967; J. M. C. Toynbee, *Art of Roman Britain,* Phaidon 1962; Joan Liversidge, *Britain in the Roman Empire,* Routledge & Kegan Paul 1968, chs 15, 16.

Chapter 4 The Hindu Tradition

1. Lubor Hajek, in W. and B. Forman, *Art of Far Lands,* Spring Books, no date, p. 109.

2. Alain Daniélou, *Hindu Polytheism,* Routledge & Kegan Paul 1964, p. 353.

3. Thomas J. Hopkins, *The Hindu Religious Tradition,* Dickenson, California 1971, pp. 5–10.

4. J. R. Hinnells and E. J. Sharpe (eds), *Hinduism,* Oriel Press 1972, p. 9. Cf. also A. L. Basham, *The Wonder that was India,* Sidgwick & Jackson 1954, 1967, ch. 2.

5. Benjamin Rowland, *The Art and Architecture of India,* Penguin Books 1967, third edition, p. 18.

6. Sherman Lee, *A History of Far Eastern Art,* Prentice-Hall 1964, pp. 79–80. On the

importance of the ancient cult of yakshas for the development of Hindu and Buddhist iconography, see A. K. Coomaraswamy, *Yaksas,* 1928–31, reprinted by M. Manoharlal, New Delhi 1971.

7. J. M. Rosenfield, *The Dynastic Arts of the Kushans,* University of California Press 1967, pp. 245–46.

8. Veronica Ions, *Indian Mythology,* Hamlyn 1967, pp. 111–117, also Daniélou, op. cit., ch. 10.

9. J. P. Vogel, *Indian Serpent-lore, or the Nagas in Hindu Legend and Art,* Probsthain, London 1926.

10. Stella Kramrisch, *Indian Sculpture in the Philadelphia Museum of Art,* University of Pennsylvania Press 1960, p. 19.

11. Kramrisch, op. cit., pp. 14–18.

12. Rowland, op. cit., pp. 41–43.

13. John Irwin, '"Asokan" Pillars: a reassessment of the evidence', *The Burlington Magazine,* CXV, 1973, pp. 706–20.

14. Tyra de Kleen, *Mudras, the Ritual Hand-poses of the Buddha Priests and the Shiva Priest of Bali,* Kegan Paul 1924.

15. J. N. Banerjea, *The Development of Hindu Iconography,* second edition, University of Calcutta 1956, pp. 247–48.

16. Banerjea, op. cit., pp. 264–67.

17. Useful inventories, classified and partly illustrated, are given in R. S. Gupte, *Iconography of the Hindus, Buddhists and Jains,* Taraporevala, Bombay 1972. See further the standard work by T. A. Gopinath Rao, *Elements of Hindu Iconography,* 4 vols, The Law Printing House, Madras 1914–16, reprinted 1968.

18. Banerjea, op. cit., pp. 32–33.

19. Heinrich Zimmer, *The Art of Indian Asia: its mythology and transformations,* Bollingen Foundation and Princeton University Press 1955, 1968, vol. i, p. 3. Zimmer's work, edited after his death in 1943 with a second volume of black-and-white plates, accords with the approach of A. K. Coomaraswamy and Stella Kramrisch.

20. Titus Burckhardt, *Sacred Art in East and West,* Perennial Books 1967, pp. 20–25, in a chapter on the Hindu Temple (following Stella Kramrisch). The Golden Embryo is also identified with Brahma, the creator god, in the Puranas.

21. Hopkins, op. cit., p. 60; also chs 1 and 2.

22. Hopkins, op. cit., p. 62.

23. Sukumari Bhattacharji, *The Indian Theogony,* Cambridge University Press 1970.

24. Hopkins, op. cit., pp. 108–109.

25. Rowland, op. cit., ch. 15.

26. H. Goetz, *India: 5000 Years of Indian Art,* Methuen 1959, pp. 131–33.

27. Louis Frédéric, *Indian Temples and Sculpture,* Thames & Hudson 1959, p. 29.

28. Hopkins, op. cit., pp. 110–111.

29. S. Bhattacharyya, in K. W. Morgan (ed.), *The Religion of the Hindus,* Ronald Press, New York 1953.

30. Philip Rawson, *The Art of Tantra,* Thames & Hudson 1973, p. 9.

31. Hopkins, op. cit., pp. 114–15. On Tantric initiations and worship see Bhattacharyya, in op. cit., pp. 193–98.

32. Rawson, op. cit., chs 9–10, including Tantric pictures of cosmograms and the 'subtle body'.

33. Daniélou, op. cit., p. 350ff. on Yantras and their symbolism.

34. A. Avalon (J. Woodroffe), *Principles of Tantra,* 1916, Ganesh & Co., Madras 1970, part ii, p. 273, from the *Tantratattva,* a nineteenth-century Bengali treatise.

35. Hopkins, op. cit., p. 113.

36. Banerjea, op. cit., pp. 240–41.

37. W. G. Archer, *Kalighat Paintings,* Victoria and Albert Museum, HMSO 1971.

38. See the works of Banerjea, Gopinath Rao and Gupte, mentioned in notes 15 and 17 above, also Daniélou in note 2.

39. Daniélou, op. cit., p. 154, chs 11–14 on Vishnu.

40. Hopkins, op. cit., p. 114.

41. D. D. Kosambi, *The Culture and Civilization of Ancient India,* Pantheon Books 1965, p. 205.

42. K. S. Desai, *Iconography of Visnu,* Abhinav, New Delhi 1973. Ions, op. cit., pp. 46–72 gives a useful summary of the myths and on p. 49 a colourful eighteenth-century painting of Vishnu and the series of avatars.

43. W. G. Archer, *The Loves of Krishna,* Allen & Unwin 1957.

44. R. C. Zaehner, *Hinduism,* Oxford University Press 1966, p. 86.

45. Daniélou, op. cit., p. 214.

46. In the Nepalese cult of Bhairava one ritual involved devotees in taking liquid through a hole in the mouth of an image of Bhairava to which was attached a pipe for pouring the liquid from behind (J. Lowry, *Tibetan Art,* HMSO 1973, p. 39).

47. G. van der Leeuw, *Sacred and Profane Beauty: The Holy in Art,* Weidenfeld & Nicolson 1963, part I, 'Beautiful Motion'.

48. Burckhardt, op. cit., p. 38. On Indian dance-forms see Rina Singha and Reginald Massey, *Indian Dances, their history and growth,* Faber 1967.

49. Hajek, in Forman, op. cit., p. 109.

50. Heinrich Zimmer, *Myths and Symbols in Indian Art and Civilization,* Harper Torchbooks 1962, pp. 151–57 in ch. 4 on Shiva. See also the title essay in A. K. Coomaraswamy, *The Dance of Shiva,* Noonday Press, New York 1957.

51. Zimmer, *Myths,* p. 155.

52. Kramrisch, op. cit., p. 105 citing the Kurma Purana.

53. Ions, op. cit., p. 31.

54. Daniélou, op. cit., pp. 291–97 on Ganesha.

55. Nancy W. Ross, *Hinduism, Buddhism, Zen,* Faber 1973.

56. J. N. Banerjea, 'The Hindu Concept of God', in K. W. Morgan (ed.), op. cit., pp. 66–71 on Shakti.

57. Rawson, op. cit., p. 183.

58. Zimmer, *Myths,* p. 215. This conjunction of maternal life and the destructive hag in Kali finds a parallel in the Greek Athena with her tranquil domestic aspect and her warlike stance – both aspects are equally ancient. Cf. Robert Luyster, 'Symbolic Elements in the Cult of Athena', in *HR,* v, 1965, pp. 133–163.

59. Zimmer, *Myths,* pp. 140–48; Rawson, op. cit., ch. 5.

60. Wendy Doniger O'Flaherty, 'Asceticism and Sexuality in the Mythology of Siva', part II, *HR,* ix, 1969, p. 35.

61. O'Flaherty, op. cit., p. 40.

62. A. L. Basham, op. cit., pp. 346–47, criticizing Coomaraswamy.

63. Rowland, op. cit., pp. 173–74.

64. Kramrisch, op. cit., p. 26.

65. Kramrisch, op. cit., p. 28; pp. 24ff.

66. Kramrisch, op. cit., p. 33; pp. 34–37.

67. Daniélou, op. cit., pp. 4 and 36.

68. Daniélou, op. cit., p. 332.

69. Kramrisch, op. cit., p. 38.

70. Kramrisch, op. cit., p. 40.

71. A. Beteille, 'Social Organization of Temples in a Tanjore Village', *HR*, v, 1965, pp. 74–92.

72. James L. Martin, 'Hindu Orthodoxy in a South Indian Village', in *JAAR* 1967, xxxv, pp. 362–71.

73. Ursula M. Sharma, 'The Image and its Meaning in Popular Hindu Ritual', *Studies in Comparative Religion,* London 1967, i (4), pp. 150–163.

74. Sharma, op. cit., p. 157.

75. K. W. Morgan (ed.), op. cit., pp. 60, 161.

76. Sharma, op. cit., p. 156.

77. Sharma, op. cit., p. 163.

78. Cited by L. S. S. O'Malley, *Popular Hinduism: The Religion of the Masses,* Cambridge University Press 1935, p. 24.

79. Abbé J. A. Dubois, *Hindu Manners, Customs and Ceremonies,* Clarendon Press, Oxford, third edition 1906, 1968, part III.

80. A. Avalon, op. cit., pp. 341–42. The widespread use of the term 'idol' is still evidenced by a recent newspaper report of a Los Angeles court case with intriguing implications. The 'Sivapuram Nataraja Idol' has been demanding its return to the temple in India whence it was allegedly stolen in 1954. The claim of the Government of India against the American collector-owner of the idol is for the sum of $4.18 million as compensation for its worshippers being 'deprived of their right to freedom of religion'. India states that under its laws the idol 'is a juristic person and a legal entity, entitled to own property and to sue and be sued to vindicate its rights' (*Otago Daily Times,* Dunedin, 13 January 1975).

81. Cited in K. W. Morgan (ed.), op. cit., p. 79.

82. Cited by A. Daniélou, op. cit., p. 372.

83. W. H. McLeod, 'The Influence of Islam upon the Thought of Guru Nanak', *HR,* viii, 1968, pp. 302–316.

84. W. G. Archer's illustrated survey, *Paintings of the Sikhs*, Victoria and Albert Museum, HMSO 1966, pp. 18–19, dates the commencement from 'the second quarter of the nineteenth century'. But painted Sikh illustrations are already found in a Sikh manuscript dated AD 1733, held in the India Office Library, London; see W. H. McLeod, *The B40 Janam-sakhi,* Guru Nanak University Press, Amritsar (forthcoming).

85. W. T. de Bary (ed.), *Sources of Indian Tradition,* vol. II, Columbia University Press 1963, pp. 19–28.

86. Cited by Benjamin Walker, *Hindu World,* Allen & Unwin 1968, Vol. I, p. 471, article 'Idolatry'.

87. Cited by de Bary (ed.), op. cit., p. 78.

88. De Bary, op. cit., pp. 85–94, O'Malley, op. cit., p. 25.

89. De Bary, op. cit., pp. 95–97.

90. A. Avalon, op. cit., pp. 288–89.

91. Daniélou, op. cit., p. 364.

92. John G. Arapura, 'Rediscovering the meaning of the Symbol', *Indian Voices in Today's Theological Debate*, ed., H. Burkle and C. Roth, Thames & Hudson 1972, pp. 110–111.

93. Louis Frédéric, *The Temples and Sculpture of Southeast Asia,* Thames & Hudson 1965; Bernard Groslier, *Angkor, Art and Civilization,* 1966.

94. A. Bernet Kempers, *Ancient Indonesian Art,* Harvard University Press 1959; Philip Rawson, *The Art of Southeast Asia,* Thames & Hudson 1967.

95. K. P. Landon, *Southeast Asia: Crossroad of Religions,* University of Chicago Press 1949, 1969, ch. 3; M. Bussagli, 'India, Farther', *EWA,* vii, pp. 193–30.

96. Frits A. Wagner, *Indonesia, the Art of an Island Group,* Methuen 1959; M. Hallade and R. Heine-Geldern, 'Indonesia', 'Indonesian Cultures', *EWA,* viii, pp. 31–90.

97. C. Hookyaas, *Religion in Bali,* Brill 1973, (in *Iconography of Religions,* Section 13, 10).

98. Claire Holt, *Art in Indonesia: Continuities and change,* Cornell University Press 1967, ch. 7 on Bali, p. 171.

99. Beryl de Zoete and Walter Spies, *Dance and Drama in Bali,* Faber 1938; Jane Belo, *Rangda and Barong,* J. J. Augustin, New York 1949.

100. Hookyaas, op. cit., pp. 8–10, plates e1–j8.

Chapter 5 Sages and Saints from India

1. Rudyard Kipling, 'Mandalay', in *Barrack-Room Ballads and Other Verses,* Methuen 1892, p. 50.

2. Dietrich Seckel, *The Art of Buddhism,* Methuen 1963, p. 22.

3. Edward Conze, *Thirty Years of Buddhist Studies,* Bruno Cassirer 1967, p. 53.

4. Seckel, op. cit., pp. 17ff.

5. Hendrik Kraemer, *World Cultures and World Religions,* Lutterworth 1960, p. 159.

6. H. Goetz, 'Jainism', *EWA,* viii, p. 786.

7. J. Finegan, *The Archaeology of World Religions,* Princeton University Press 1952, pp. 190ff.

8. U. P. Shah, *Studies in Jaina Art,* Jaina Cultural Research Society, Banaras 1955, p. 40.

9. U. P. Shah, op. cit., pp. 81–82.

10. Heinrich Zimmer, *Philosophies of India,* Meridian Books 1956, pp. 182–204 on Parshva.

11. These are listed by H. Goetz, *EWA,* viii, pp. 795–96, and more fully by R. S. Gupte, *Iconography of the Hindus, Buddhists and Jains,* D. B. Taraporevala, Bombay 1972.

12. A. L. Basham, *The Wonder that was India,* Sidgwick & Jackson 1967, p. 295.

13. Finegan, op. cit., pp. 231–33 and figs 82–87.

14. U. P. Shah, op. cit., pp. 94, 123–30 and fig. 76.

15. Finegan, op. cit., pp. 226–28.

16. Zimmer, *Philosophies,* pp. 208–12.

17. See W. T. de Bary (ed.), *Sources of Indian Tradition,* Columbia University Press 1958, 1966, vol. I, chs 4–5.

18. Benjamin Rowland, 'Buddhist Primitive Schools', *EWA,* ii, pp. 703–22.

19. Seckel, op. cit., p. 152.

20. Ananda K. Coomaraswamy, *Elements of Buddhist Iconography,* second edition, Munshiram Manoharlal, New Delhi 1972, p. 63, cf. pp. 3–7.

21. Coomaraswamy, op. cit., p. 69.

22. Coomaraswamy, op. cit., pp. 18–22, 59, 77. On the symbolism of the lotus throughout Asia see Heinrich Zimmer, *The Art of Indian Asia,* Princeton University Press 1955, 1968, vol. i, pp. 158–230.

23. F. D. K. Bosch, *The Golden Germ: an introduction to Indian Symbolism,* Mouton 1960, pp. 186–228.

24. Coomaraswamy, op. cit., plate I, fig. 1.

25. Seckel, op. cit., pp. 152–54, plate 10.

26. Seckel, op. cit., traces the developments across Asia in an excellent chapter, 'From the Stupa to the Pagoda', pp. 103–32.

27. Benjamin Rowland, *The Art and Architecture of India,* Penguin Books 1953, pp. 51–54.

28. Titus Burckhardt, *Sacred Art in East and West,* Perennial Books 1967, p. 130, ch. 5.

29. Seckel, op. cit., pp. 133–51, 'Monasteries and Temples'; also Percy Brown, *Indian Architecture (Buddhist and Hindu Periods),* Taraporevala, Bombay 1956, chs 2–9.

30. Seckel, op. cit., p. 30.

31. R. H. Thouless, *Conventionalization and Assimilation in Religious Movements as problems in Social Psychology,* Oxford University Press 1940, ch. 2.

32. Edward Conze, *Buddhism: its Essence and Development,* Bruno Cassirer 1951, Harper 1959, pp. 114–117.

33. Seckel, op. cit., pp. 32ff.

34. Rowland, *Art,* chs 9–10.

35. William Willetts, *Chinese Art,* Penguin Books 1958, vol. i, pp. 327–30.

36. E. Dale Saunders, *Mudra: A Study of the Symbolic Gestures in Japanese Buddhist Sculpture,* Routledge & Kegan Paul 1960, pp. 111–120.

37. Seckel, op. cit., pp. 30–40. Cf. Madeleine Hallade, *The Gandhara Style and the Evolution of Buddhist Art,* Thames & Hudson 1968.

38. Seckel, op. cit., pp. 159–60; Rowland, *Art,* pp. 195–96.

39. Willetts, op. cit., pp. 300ff.

40. Seckel, op. cit., p. 172.

41. Rowland, *Art,* 1953, pp. 214–15 and fig. 34 (Ceylonese).

42. P. H. Pott, in A. Griswold *et al., Burma, Korea, Tibet,* Methuen 1964, pp. 192–93, and fig. 4; also Burckhardt, op. cit., pp. 128–29.

43. Seckel, op. cit., pp. 156–57 and fig. 54d.

44. Burckhardt, op. cit., p. 125.

45. Nancy Wilson Ross, *Hinduism, Buddhism, Zen,* Faber 1973, p. 105.

46. Elizabeth Wray, *et al., Ten Lives of the Buddha,* Weatherhill, New York 1972, illustrated. See also Rudolf Hampe (illustrator) *The Life of the Buddha in Thai Temple Paintings,* United States Information Service, Bangkok 1957; Reginald le May, *Concise History of Buddhist Art in Siam,* Cambridge University Press 1938; Louis Frédéric, *Temples and Sculptures of Southeast Asia,* Thames & Hudson 1965, ch. 7 on Thailand.

47. Trevor Ling, *The Buddha: Buddhist civilization in India and Ceylon,* Temple Smith 1973, chs 10, 12.

48. On Sinhalese Buddhist art, see Rowland, *Art,* ch. 20; Roloff Beny and John L. Opie, *Island Ceylon,* Thames & Hudson 1970, illustrated; S. Paranivatana, 'Ceylonese Art', *EWA,* iii, pp. 330–39.

49. Manning Nash, *et al., Anthropological Studies in Theravada Buddhism,* Yale University Press 1966.

50. Richard F. Gombrich, *Precept and Practice: Traditional Buddhism in the Rural Highlands of Ceylon,* Clarendon Press, Oxford 1971, pp. 168–181.

51. S. Paranivatana, *The God of Adam's Peak,* Artibus Asiae, Ascona 1958, 1970, illustrated.

52. Gombrich, op. cit., pp. 172–76.

53. E. D. W. Jayewardene, *Sinhala Masks,* Godamunne, Kandy 1970, illustrated. See also Paul Wirz, *Exorcism and the Art of Healing in Ceylon,* Brill 1954.

54. Hans-Dieter Evers, *Monks, Priests and Peasants: a study of Buddhism and Social Structure in Central Ceylon,* Brill 1972, ch. 4.

55. Robert Knox, *An Historical Relation of Ceylon,* (AD 1681), MacLehose 1911, p. 125.

56. Ninian Smart, 'Problems of the application of Western terminology to Theravada Buddhism', *Religion,* ii, 1972, p. 41.

57. Richard Gombrich, 'The Consecration of a Buddhist Image', *The Journal of Asian Studies,* xxvi, 1966–67, pp. 24–25.

58. L. A. de Silva, 'Worship of the Buddha Image', *Dialogue,* Colombo 1972, 25, pp. 3–6. See also L. A. de Silva's useful survey of Theravada Buddhism in Ceylon: *Buddhism: Belief and Practices in Sri Lanka,* L. A. de Silva 1974, 211 pp. (c/o Study Centre, 490/5 Havelock Road, Colombo 6).

59. Gombrich, 'Consecration', p. 23; see also the same author's *Precept and Practice,* pp. 4–9, 141–43, on the paradox of the Buddha's absence and presence, and pp. 91–140 on Buddha-images in rural Ceylon.

60. Bhikku Punnaji, 'The Significance of Image Worship', *Dialogue,* Colombo 1972, 25, pp. 6–9.

61. Punnaji, op. cit., p. 8.

62. Alice Getty, *The Gods of Northern Buddhism,* Clarendon Press, Oxford 1914, Tuttle reprint 1962.

63. A synoptic view of Buddhism is presented in Dietrich Seckel's admirable *Art of Buddhism,* Methuen 1964. Useful accounts of Buddhism, past and present, include: K. W. Morgan (ed.), *The Path of the Buddha: Buddhism Interpreted by Buddhists,* Ronald Press 1956; Rene Grousset, *In the Footsteps of the Buddha,* Routledge & Kegan Paul 1932, 1961. A wealth of pictorial material for the iconography is given in *The Way of the Buddha,* Publications Division, Government of India 1956.

On the other hand Benoytosh Bhattacharyya, *The Indian Buddhist Iconography,* Oxford University Press, Calcutta 1924, is based mainly on the eleventh-century Sadhanamala and cognate Tantric texts on rituals and images; its emphasis on the Vajrayana school is followed in R. S. Gupte's *Iconography of the Hindus, Buddhists and Jains,* Taraporevala, Bombay 1972, pp. 108–163.

64. Rowland, *Art,* p. 80.

65. H. W. Schumann, *Buddhism: An outline of its teachings and schools,* Rider 1973, chs 2 and 3.

66. Seckel, op. cit., ch. 4 and pp. 258–60.

67. Benjamin Rowland, *The Ajanta Caves,* Mentor Books 1963, pp. 10–16, plate 1.

68. Peter Fingesten, 'The Smile of the Buddha', *The Eclipse of Symbolism,* University of South Carolina Press 1970, pp. 54–66.

69. P. H. Pott, in Griswold, op. cit., pp. 194–200.

70. See the discussion in F. Sierksma, *The Gods as we shape them,* Routledge & Kegan Paul 1960, pp. 34–39, 154–59 and plates 27–31; also Sheila Riddell, 'The Kuan-yin image in post-T'ang China', *Mahayanist Art after A.D. 900,* ed., W. Watson, Percival David Foundation of Chinese Art, University of London 1971, pp. 17–24, plates 6–8.

71. J. Leroy Davidson, *The Lotus Sutra in Chinese Art,* Yale University Press 1954.

72. Edward Conze, 'The Iconography of the Prajnaparamita', *Thirty Years of Buddhist Studies,* Cassirer 1967, pp. 243–68. Conze also describes the frontispiece illustration to the

Diamond Sutra in the world's oldest extant printed book (from Tun-huang, AD 868) in his *Buddhist Wisdom Books,* Allen & Unwin 1958, pp. 72–74.

73. D. Seckel, op. cit., pp. 32–37; H. Zimmer, *Art,* ii, pp. 135–42.

74. H. W. Schumann, op. cit., pp. 98–109.

75. R. S. Gupte, op. cit., pp. 108–109.

76. Seckel, op. cit., p. 132. The Vajrayana themes are well brought out by Philip Rawson in his illustrated *Art of Southeast Asia,* Thames & Hudson 1967, pp. 216–39. See also Rowland, *Art,* pp. 260–268. A splendid pictorial *Borobudhur* is published by Heibonsha, Tokyo, 1971.

77. Seckel, op. cit., p. 288.

Chapter 6 Religions of East Asia

1. Hajime Nakamura, *Ways of Thinking of Eastern Peoples: India – China – Tibet – Japan,* East-West Center Press, Honolulu 1964, p. 11.

2. John M. Steadman, *The Myth of Asia,* Macmillan 1970.

3. J. W. Kitagawa, *Religions of the East,* Westminster Press, Philadelphia 1960, pp. 48ff. citing de Groot's phrase.

4. James Legge (trans.), *The Yi King,* Clarendon Press, Oxford 1899, plates I–III on the Hexagrams. A useful reference work here is C. A. S. Williams, *Encyclopaedia of Chinese Symbolism and Art Motives,* 1932; Julian Press, New York 1960.

5. David C. Graham, *Folk Religion in Southwest China,* Smithsonian Press, Washington D.C. 1961, plate 22.

6. Frederic Spiegelberg, *Living Religions of the World,* Thames & Hudson 1957, ch. 9, for a vivid introduction to the *I Ching.*

7. Laurence G. Thompson, *Chinese Religion: An Introduction,* Dickenson, Belmont, California 1969, chs 1–3. See also B. Laufer, 'The Development of Ancestral Images in China' (1913), reprinted in W. A. Lessa and E. Z. Vogt, *Reader in Comparative Religion,* Row, Peterson 1958, pp. 404–9, Harper & Row 1972.

8. Holmes Welch, *The Parting of the Way: Lao Tzu and the Taoist Movement,* Methuen 1957, part 3, pp. 135–41.

9. Thompson, op. cit., p. 72.

10. H. A. Giles, *Confucianism and its Rivals,* Williams & Norgate 1915, pp. 181–83.

11. J. H. Kamstra, *Encounter or Syncretism,* Brill 1956, ch. 3, pp. 172–73; see also: E. Zürcher, *The Buddhist Conquest of China,* Brill 1959, 1972, chs 3–4.

12. William Willetts, *Chinese Art,* Penguin Books 1958, pp. 337–38.

13. Willetts, op. cit., p. 360 and pp. 358–63.

14. The iconographic similarities and changes are described and tabulated in the thorough study by Max Wegner, 'Ikonographie des chinesischen Maitreya', in *Ostasiatische Zeitschrift* 1929, N.F. Bd. 5, Ss. 157–178, 216–229, 252–270.

15. Illustrated works on Chinese Buddhist sculpture include: L. Sickman and A. Soper, *The Art and Architecture of China,* Penguin Books 1956, 1971, chs 8–14; Alan Priest, *Chinese Sculpture in the Metropolitan Museum of Art,* New York 1944; T. Akiyama and S. Matsubara, *Arts of China,* vol. 2, *Buddhist Cave Temples, New Researches,* Kodansha International, Tokyo 1969.

16. K. K. S. Ch'en, *Buddhism in China, a historical survey,* Princeton University Press 1964, pp. 425–34, 451–52; C. K. Yang, *Religion in Chinese Society,* University of California Press, Berkeley 1961, pp. 214–15, 229–33.

17. D. L. Overmyer, 'Folk Buddhist Religion: Creation and Eschatology in Medieval

China', *HR,* xii, 1972, p. 43.

18. Helen B. Chapin, 'The Ch'an Master Pu'tai', *Journal of American Oriental Society,* 1933, vol. 53, pp. 47–52.

19. Ch'en, op. cit., pp. 405–8.

20. Translated by Ian Fairweather as *The Drunken Buddha,* University of Queensland, Brisbane 1965.

21. Heinrich Dumoulin, *A History of Zen Buddhism,* McGraw-Hill, New York 1965, chs 5–7, p. 104.

22. Liang K'ai, 'An Immortal', painting in splashed ink style in National Palace Museum, Taichung, Taiwan. Compare his 'A drunken man', in D. T. Suzuki, *Zen and Japanese Culture,* Routledge & Kegan Paul 1959, 1973, plate 16.

23. J. Prip-Møller, *Chinese Buddhist Monasteries,* 1937, Hong Kong University Press 1967, pp. 24–30, plates 29, 30. This is an excellent source, especially on southern China.

24. Chapin, op. cit., p. 47.

25. Ch'en, op. cit., p. 407.

26. Ferdinand D. Lessing, *Yung-ho-kung, an iconography of the Lamaist Cathedral in Peking,* Sino-Swedish expedition, publication 18, Stockholm 1942, p. 20. A useful discussion of Pu-tai is given on pp. 16–37, 166–67.

27. Holmes Welch, *The Practice of Chinese Buddhism, 1900–1950,* Harvard University Press, Cambridge, Massachusetts 1967, pp. 343–44.

28. R. H. Thouless, *Conventionalization and Assimilation in Religious Movements as problems in Social Psychology,* Oxford University Press 1940.

29. Clarence B. Day, *Chinese Peasant Cults, Being a Study of Chinese Paper Gods,* Kelly & Walsh, Shanghai 1940, (reprint, Taipei 1969), pp. 156–59, plates opposite pp. 144, 176.

30. A. F. Wright, *Buddhism in Chinese History,* 1959. Atheneum, New York 1965, p. 99.

31. Henri Maspero, 'The Mythology of Modern China', in J. Hackin *et al., Asiatic Mythology,* Crowell, New York 1932, 1969, for useful descriptions of the gods and hells, illustrated.

32. On the paper gods, see C. B. Day, op. cit., illustrated.

33. David C. Graham, *Folk Religion in Southwest China,* Smithsonian Press, Washington, D.C. 1961, 1967, pp. 172–88.

34. Thompson, op. cit., ch. 4, 'The Community: Gods and Temples'. This succinct survey includes a sampler of the gods most popular in the folk-religion of Taiwan in 1960. For a comparison with Szechwan in south-west China in 1940 see Graham, op. cit., pp. 200–203.

35. Graham, op. cit., pp. 189–216.

36. Thompson, op. cit., p. 55.

37. R. T. Paine and A. Soper, *The Art and Architecture of Japan,* Penguin Books 1955, ch. I, p. 2. Among the many fine illustrated works on Japanese art, a good introduction is Hugo Munsterberg, *The Arts of Japan,* Thames & Hudson 1957. See also: Sherman Lee, *A History of Far Eastern Art,* Thames & Hudson 1964; Yukio Yashiro (ed.), *Art Treasures of Japan,* 2 vols, Kokusai Bunka Shinkokai, Tokyo 1960; Shin'ichi Tani, 'Japanese Art', *EWA,* viii, pp. 845–97, plates 259–330. The whole field is covered in some thirty beautifully illustrated volumes of the *Heibonsha Survey of Japanese Art,* Heibonsha, Tokyo and Weatherhill, New York 1971–75.

38. H. Byron Earhart, *Japanese Religion: Unity and Diversity,* Dickenson, Belmont, California 1969, p. 1. This book is a good introduction to the 'wholeness' of Japanese religion in the historical relationship of its various elements. See also J. M. Kitagawa,

39. Earhart, op. cit., p. 5.

40. Ichiro Hori, *Folk Religion in Japan. Continuity and Change,* University of Chicago Press 1968. For an example of the iconography of folk religious themes, see the account of mid-nineteenth-century 'cat-fish' pictures related to numinous crisis-event of the 1855 Tokyo earthquake: C. Ouwenhand, *Namazu-e and their themes,* E. J. Brill, Leiden 1964.

41. Johannes Maringer, 'Clay Figurines of the Jomon Period: a contribution to the history of the ancient religion of Japan', in *HR,* xiv, 1974, pp. 128–139.

42. Sokyo Ono, *Shinto: The Kami Way,* C. E. Tuttle, Tokyo 1962, chs 1, 2.

43. Ono, op. cit., p. 24.

44. Haruki Kageyama, *The Arts of Shinto,* Phaidon 1973.

45. Charles Eliot, *Japanese Buddhism,* 1935, Routledge & Kegan Paul 1959; E. Dale Saunders, *Buddhism in Japan,* University of Pennsylvania Press, Philadelphia 1964.

46. R. Tsunoda *et al., Sources of Japanese Tradition,* Columbia University Press, New York 1958, p. 142.

47. Takaaki Sawa, *Art in Esoteric Buddhism,* Weatherhill, New York 1971.

48. Paine and Soper, op. cit., p. 36.

49. Minoru Kiyota, 'Shingon Mikkyo Mandala', *HR,* viii, 1968, pp. 31–59, for a detailed explanation with analytical diagrams and photographs.

50. Alicia Matsunaga, *The Buddhist Philosophy of Assimilation,* Sophia University Press, Tokyo 1969.

51. Giuseppe Tucci, *The Theory and Practice of the Mandala,* Rider 1961. This expounds the Indian basis of Tibetan mandalas. Interpretation in terms of analytical psychology, with many illustrations, is given by C. G. Jung, *Collected Works,* vol. 12, *Psychology and Alchemy,* Routledge & Kegan Paul 1953, pp. 91–213. Visionary implications and Asian and modern applications are featured in Jose and Miriam Arguelles, *Mandala,* Shambala, Berkeley and London 1972; extensive bibliography on pp. 130–34.

52. Carmen Blacker, 'Methods of Yoga in Japanese Buddhism', *Comparative Religion,* ed., John Bowman, E. J. Brill, Leiden 1972, pp. 82–98.

53. Blacker, op. cit., p. 88 and pp. 88–93.

54. Y. Yashiro and P. C. Swann, *2000 years of Japanese Art,* Thames & Hudson 1958, p. 80. See also D. Seckel, *The Art of Buddhism,* Methuen 1964, plate 40, p. 233.

55. Paine and Soper, op. cit., plate 38, showing the great painting of the Descent of Amida, Mount Koya.

56. Paine and Soper, op. cit., p. 60.

57. Basil Gray and J. B. Vincent, *Buddhist Cave Paintings at Tun Huang,* Faber 1959.

58. A useful outline of the mythology and iconography of Japanese Buddhist deities is given by E. D. Saunders and B. Frank in P. Grimal (ed.), *Larousse World Mythology,* Hamlyn 1965, pp. 312–333. Excellent photos, drawings, notes and appendices on Japanese images are included in the large catalogue of the Museum für Ostasiatische Kunst der Stadt Köln: G. Gabbert, *Buddhistische Plastik aus Japan und China,* Franz Steiner, Wiesbaden 1972.

59. Eliot, op. cit., pp. 379–80.

60. The mandala is illustrated in G. Renondeau, *La Doctrine de Nichiren,* Presses Universitaires de France, Paris 1953, p. 180.

61. Nichiren Shoshu, *Soka Gakkai,* Seikyo Press, Tokyo 1966.

62. On Zen Buddhism and the arts see: D. T. Susuki, *Zen and Japanese Culture,* Routledge

& Kegan Paul 1959; Nancy W. Ross (ed.), *The World of Zen*, Random House, New York 1960; Eugen Herrigel, *Zen in the Art of Archery*, Routledge & Kegan Paul 1953; H. Munsterberg, *Zen and Oriental Art*, Tuttle, Tokyo 1965.

63. Nancy W. Ross, *Hinduism, Buddhism, Zen,* Faber 1973, plate 91, p. 160.

64. Hugo Munsterberg, *The Folk Arts of Japan,* Tuttle, Tokyo 1958, plate 66; Kiyoshi Sonobe, *Japanese Toys, playing with history,* Tuttle, Tokyo 1965, plates 161, 287.

65. Paine and Soper, op. cit., p. 28, plate 19. Portraits of monks, along with guardians and lower ranks in the hierarchy of sacred figures, were much more subject than Buddha-images to the depiction of individuality and emotion, indicating movement from the universal to the particular and the representational. See Shuichi Kato, 'Style in Buddhist Sculpture', in *Form, Style, Tradition*, University of California Press 1971, pp. 59–126.

66. Seckel, op. cit., pp. 248–54, plates 48–50.

67. Helmut Brinker, 'Some secular aspects of Ch'an Buddhist painting during the Sung and Yuan dynasties', *Mahayanist Art after A.D. 1900*, ed., W. Watson, Percival David Foundation of Chinese Art, London 1971, pp. 86–95.

68. Ross, *Hinduism, Buddhism, Zen,* plate 118, p. 173.

69. M. Conrad Hyers, *Zen and the Comic Spirit,* Rider 1974, pp. 104–5; plate 8.

70. Paine and Soper, op. cit., p. 81, plate 76B.

71. 'Hotei' by Mokuan, fourteenth century, in Paine and Soper, op. cit., plate 72.

72. Hyers, op. cit., p. 47, in ch. 2: 'Zen Masters and Clown Figures'; also ch. 1: 'The Smile of Truth'.

73. Daisetz T. Suzuki, *Sengai, the Zen Master,* New York Graphic Society 1971.

74. Yajiro Nakata, *The Art of Japanese Calligraphy,* Weatherhill, Tokyo 1973.

75. Seckel, op. cit., p. 258.

76. Antoinette K. Gordon, *Iconography of Tibetan Lamaism,* 1939, and *Tibetan Religious Art,* 1952; both from Columbia University Press, New York. Recent authoritative surveys are by G. Tucci, 'Tibetan Art', *EWA*, xiv, pp. 67–81, plates 35–54; P. H. Pott, 'Tibet', in A. Griswold, *et al., Burma, Korea, Tibet,* Methuen 1964; Blanche C. Olschak and G. T. Wangyul, *Mystic Art of Ancient Tibet,* Allen & Unwin 1973; John Lowry, *Tibetan Art,* Victoria and Albert Museum, HMSO 1973.

77. A further interpretation of the yantra, complex and abstruse, is cited by Tucci, *Mandala,* pp. 137–41.

78. Philip Denwood, 'The Tibetan Temple', in Watson (ed.), op. cit., pp. 47–55; also David L. Snellgrove, 'Indo-Tibetan Liturgy and its relationship to Iconography', pp. 36–46 of the same work.

79. Robert K. Ekvall, *Religious Observances in Tibet: Patterns and Functions,* University of Chicago Press 1964, chs 4–8.

80. Ekvall, op. cit., ch. 8, pp. 236–37.

81. For the four schools or methods for salvation in the Tantrayama, see H. W. Schumann, *Buddhism,* Rider 1973, ch. 5.

82. Mandanjeet Singh, *Himalayan Art,* New York Graphic Society, 1968, Macmillan 1971; E. and R. L. Waldschmidt, *Nepal, Art Treasures from the Himalayas,* Elek 1969; B. C. Olschak and U. Gansser, *Bhutan, Land of Hidden Treasures,* Allen & Unwin 1971; Stephan Beyer, *The Cult of Tara,* University of California Press 1973.

83. F. Sierksma, *Tibet's Terrifying Deities,* Mouton, the Hague 1966.

84. For instance, the comprehensive *tanka* shown in H. Osborne (ed.), *Oxford Companion to Art,* Clarendon Press, Oxford 1970, fig. 373 and diagram p. 1137; also in colour in Philip Rawson, *The Art of Tantra,* Thames & Hudson 1973.

Chapter 7 Prophetic Iconoclasm

1. R. C. Zaehner, *The Comparison of Religions*, Beacon Press, Boston 1962, p. 25. (British title: *At Sundry Times*, Faber 1958.)

2. J. Lindblom, *Prophecy in Ancient Israel*, Blackwell 1962, ch. 1, pp. 1–6.

3. G. von Rad, in G. Kittel (ed.), *Theological Dictionary of the New Testament*, Eerdmans, Grand Rapids 1964, Vol. II, p. 390 (in article on *eikon*, image). On the biblical veto on images, see also G. von Rad, *Old Testament Theology*, vol. 1, SCM Press (1962) 1975, pp. 212–19.

4. José Faur, 'Idolatry', *Encyclopaedia Judaica,* viii, Keter Publishing House, Jerusalem 1971, col. 1229.

5. F. Büchsel, in Kittel (ed.), op. cit., vol. II, p. 377 (in article on *eidolon*).

6. Further illustrations in Cecil Roth (ed.), *Jewish Art: an illustrated history*, W. H. Allen 1961, New York Graphic Society 1971, pp. 194–207.

7. Roth, op. cit., pp. 208–13, illustrated.

8. For this thesis and a wealth of illustrated material, see Erwin R. Goodenough, *Jewish Symbols in the Greco-Roman period,* Pantheon Books 1953–65, 13 vols. Reviews of the first 8 vols are reprinted in A. D. Nock, *Essays on Religion and the Ancient World,* Clarendon Press, Oxford 1972, ii, pp. 877–918.

9. Goodenough, op. cit., vols 7, 8.

10. Roth, op. cit., pp. 254–375, on medieval synagogue and ritual art. See also N. Peter Levinson, *Die Kultsymbolik im Alten Testament and im Nachbiblischen, Judentum,* Tafelband, Anton Hiersemann, Stuttgart 1972. See also: R. D. Barnett (ed.), *Catalogue of the . . . Jewish Museum London,* Harvey Miller 1974. Two volumes of scholarly essays have been edited by Joseph Gutmann – *No Graven Images: Studies in Art and the Hebrew Bible,* Ktav, New York 1971; and *Beauty in Holiness: Studies in Jewish Customs and Ceremonial Art,* Ktav, New York 1970.

11. Cited by Roth, op. cit., pp. 20–21.

12. Roth, op. cit., pp. 377–492. See also the articles by C. Roth, 'Illuminated Manuscripts, Hebrew', and by J. Gutmann, 'Iconography', *Encyclopaedia Judaica,* viii, 1257–88 and 1216–22, illustrated. Many illustrations appear in the large work by Mendel Metzger, *La Haggada Enluminée,* I, *Etude iconographique et stylistique . . . xiiie au xvie siècle,* E. J. Brill, Leiden 1973. A new translation of the Haggadah, beautifully illustrated, is by Chaim Raphael, *A Feast of History: Passover through the Ages as a Key to Jewish Experience,* Simon & Schuster, New York 1972.

13. F. Landsberger in Roth, op. cit., p. 422.

14. For a contemporary Kabbalist's attempt to apply the principles to human life in modern terms, in order to awaken the soul to spiritual progress, see Z'ev ben Shimon Halevi, *Adam and the Kabbalistic Tree,* Rider 1974, including several diagrams on pp. 20–31.

15. Oleg Grabar, *The Formation of Islamic Art,* Yale University Press 1973, ch. 3. On the characteristic 'Muslim landscape' see Xavier de Planhol, *The World of Islam,* Cornell University Press, Ithaca 1957.

16. A finely illustrated general survey is by Ernst Grube, *The World of Islam,* Hamlyn 1966; see also D. Talbot Rice, *Islamic Art,* Thames & Hudson 1965, and F. R. J. Verhoeven, *Islam, its origin and spread, in words, maps, pictures,* Routledge & Kegan Paul 1962.

17. Grabar, op. cit., p. 209, also ch. 6. 'Islamic Secular Art: Palace and City'.

18. Emel Esin, *Mecca the blessed, Madinah the radiant,* Elek Books 1963, illustrated.

19. Jack Finegan, *The Archaeology of World Religions,* Princeton University Press 1952, pp. 461–85 on the pre-Islamic background of Arabia.

20. *Qur'an,* sura 53. 20–23, in translation by A. J. Arberry, *The Koran Interpreted,* Allen & Unwin 1955, Oxford University Press 1964, p. 550. Descriptions of practices in pagan Mecca were given by the eighth- to ninth-century Muslim writer Hisham ibn al-Kalbi in *The Book of Idols,* Princeton University Press 1952.

21. *Qur'an,* sura 35. 38, Arberry, op. cit., p. 448.

22. *Qur'an,* sura 4. 51, Arberry, op. cit., p. 80.

23. T. W. Arnold, *Painting in Islam,* 1928, Dover Publications, New York 1965, p. 7.

24. T. Izutsu, *God and Man in the Koran,* Keio University Press, Tokyo 1964, ch. 3.

25. *Qur'an,* sura 59. 24, Arberry, op. cit., p. 576.

26. Grabar, op. cit., p. 86.

27. Grabar, op. cit., p. 89; for the explanation outlined here, see pp. 90–103.

28. Grabar, op. cit., p. 102.

29. Kenneth Cragg, *The Dome and the Rock,* SPCK 1964, pp. 125–136 on an 'Islamic dilemma'.

30. Titus Burckhardt, *Sacred Art in East and West,* Perennial Books 1967, pp. 117–18, ch. iv. However, the insights of this chapter are confused by questionable appeals to the 'nomadic mentality' in Islam. (cf. also pp. 104–5). On the *Qur'an* as itself the normative work of art which emphasizes not human nature but divine nature and transcendence, see Isma'il al-Faruqi, 'Islam and Art', in *Studia Islamica,* 1973, xxxvii, pp. 81–109.

31. Annemarie Schimmel, *Islamic Calligraphy,* (Iconography of Religions, xxii, 1), E. J. Brill, Leiden 1970, p. 1. Fine illustrations are also in Naji Zain-al-Din, *The Beauties of Arabic Calligraphy,* through Luzac 1972.

32. Schimmel, op. cit., pp. 3ff.

33. Arnold, op. cit., pp. 1–4.

34. Schimmel, op. cit., p. 4. See also Erica C. Dodd, 'The Image of the Word: Notes on the Religious Iconography of Islam', in *Berytus,* Beirut 1969, xviii, pp. 35–79, illustrated. With the aid of the ancient Logos concept Islam substituted for the human image of the divine a non-realistic symbolic image of God in the form of writing: 'God did not send down his Image in the form of a Man, but rather in the form of a Book' (p. 47).

35. Johannes Pedersen, article 'Masdjid', 1930, reprinted in H. A. R. Gibb and J. H. Kramers (eds), *Shorter Encyclopaedia of Islam,* Luzac 1961, pp. 330–52; also O. Grabar, op. cit., ch. 5 on the mosque; Werner Speiser, *Oriental Architecture in colour,* Thames & Hudson 1965, pp. 10–174.

36. Finegan, op. cit., pp. 497–99.

37. Burckhardt, op. cit., p. 106. On the Divine Unity, infinity and otherness as expressed spatially, see S. H. Nasr, 'The Significance of the Void in the art and architecture of Islam', in *The Islamic Quarterly,* 1972, xvi, pp. 115–120. This approach, linked to mystical and esoteric doctrines in Shi'ite Islam in Persia, underlies the impressively produced volume by N. Ardalan and L. Bakhtiar, *The Sense of Unity: The Sufi Tradition in Persian Architecture,* University of Chicago Press 1973, illustrated.

38. In addition to illustrated surveys of Islamic Art, see Arthur U. Pope and P. Ackerman (eds), *Survey of Persian Art,* vol. 5, Oxford University Press 1938; Godfrey Goodwin, *History of Ottoman Architecture,* Thames & Hudson 1971; Percy Brown, *Indian Architecture,* vol. 2, *Islamic Period,* Taraporevala, Bombay 1942.

39. Burckhardt, op. cit., p. 117.

40. James Dickie, 'The Iconography of the Prayer Rug', *Oriental Art,* 1972, xviii, pp. 2–11.

41. Dickie, op. cit., pp. 5–8.

42. Grabar, op. cit., pp. 200–201, ch. 7 on early Islamic decoration and the arabesque.

43. Finegan, op. cit., p. 525, fig. 239.

44. Grabar, op. cit., p. 202.

45. Burckhardt, op. cit., pp. 102–3.

46. T. W. Arnold, *The Old and New Testaments in Muslim Religious Art,* British Academy, Oxford University Press 1932, illustrated.

47. S. H. Nasr, *Ideals and Realities of Islam,* Allen & Unwin 1966, chs 1, 2.

48. J. R. Porter, 'Muhammad's Journey to Heaven', *Numen,* xxi, 1974, pp. 64–80; also the article 'Miradj' in *Shorter Encyclopaedia of Islam,* pp. 381–84.

49. Arnold, *Painting,* pp. 117–122 on Buraq.

50. Richard Ettinghausen, 'Images and Iconoclasm: Islam', *EWA,* vii, p. 817.

51. An interesting recent work is by Marian Wenzel, *House Decoration in Nubia,* Duckworth 1972. On the interplay of Islam with traditional religions and folk beliefs see, for instance, Clifford Geertz, *The Religion of Java,* University of Chicago Press 1960, and E. Westermarck, *Ritual and Belief in Morocco,* 2 vols, Macmillan 1926.

52. René A. Bravmann, *Islam and Tribal Art in West Africa,* Cambridge University Press 1974, chs 1–3.

53. Bravmann, op. cit., p. 97.

54. Bravmann, op. cit., p. 174.

55. *Overseas Hindustan Times,* Thursday 31 May 1973.

Chapter 8 Christianity

1. H. P. Gerhard, *The World of Icons,* John Murray 1971, p. 9.

2. Eric Newton, in E. Newton and W. Neil, *The Christian Faith in Art,* Hodder & Stoughton 1966, pp. 16–17.

3. J. G. Davies, *The Early Christian Church,* Weidenfeld & Nicolson 1965. For a survey of the variety of Christian churches down the ages, see Einar Molland, *Christendom,* Mowbrays 1959.

4. Louis Réau, *Iconographie de l'art chrétien,* Presses Universitaires de France 1955–59; parts I, II, III, in 6 vols.

5. Gertrud Schiller, *Iconography of Christian Art,* Lund Humphries 1971, vol. i, p. 3.

6. Good short articles on the major Christian themes are included in H. Osborne (ed.), *The Oxford Companion to Art,* Clarendon Press 1970. Fuller, well-illustrated articles on the iconography of the persons of the Trinity, Mary and the saints, angels etc., are in the 15 vols of *The New Catholic Encyclopaedia,* McGraw-Hill, New York 1967. Compressed scholarly reference and useful clear illustrations mark the recent *Lexikon der christlichen Ikonographie:* E. Kirschbaum (ed.), *Allgemeine Ikonographie,* 4 vols, Verlag Herder, Freiburg 1968–72; W. Braunfels (ed.), *Ikonographie der Heiligen,* 4 vols, Herder, Freiburg 1973 ff.

7. The liturgical symbolism and iconography of the major divisions of Christendom are included in the German series edited by F. Herrmann, *Symbolik der Religionen,* Anton Hiersemann, Stuttgart 1960ff. Catholicism, Protestantism, Eastern Orthodoxy and smaller Western churches are described respectively in vols 6, 7, 10, 11 with the accompanying annotated illustrations in vols 13, 15, 16 (16 goes with 10 and 11).

8. The successive periods of Christian art in Europe are helpfully outlined in art histories such as E. G. Gombrich, *The Story of Art,* Phaidon 1950, twelfth edition, 1972. A stimulating illustrated survey, relating sacred art to modern developments, is edited by Gilbert Cope, *Christianity and the Visual Arts,* Faith Press 1964. Jane Dillenberger's *Style and Content in Christian Art,* Abingdon Press, Nashville 1965, effectively concentrates on selected works of art from the main periods. Well illustrated popular introductions include Newton and Neil, op. cit., and the lavishly illustrated American Heritage edition of Roland H. Bainton's *The History of Christianity,* Nelson 1964.

9. Edwyn Bevan, *Holy Images,* Allen & Unwin 1940, p. 84. This stimulating book outlines the Jewish and pagan attitudes to images and discusses the pros and cons of images in ancient Christianity with reference also to later debates.

10. From the immense literature on Christian origins the following may be recommended for vivid illustrations and expert introductions to the history and archaeology of religion in the Mediterranean area before and after the appearance of Jesus and the church: Arnold Toynbee, (ed.), *The Crucible of Christianity,* Thames & Hudson 1969; F. van der Meer and C. Mohrmann, *Atlas of the Early Christian World,* Nelson 1958, 1966.

11. These problems in iconography are discussed by André Grabar, *Christian Iconography: a study of origins,* Routledge & Kegan Paul 1969, introduction, pp. xli–l. This book is a scholarly analysis of material set out in his more descriptive work: A. Grabar, *The Beginnings of Christian Art, AD 200–395,* Thames & Hudson 1967, illustrated. See also W. F. Volbach and Max Hirmer, *Early Christian Art,* Thames & Hudson 1962. Two very useful illustrated paperbacks are by Walter Lowrie, *Art in the Early Church,* 1947, Harper Torchbooks 1965; and Pierre du Bourguet, *Early Christian Painting,* Weidenfeld & Nicolson 1965.

12. J. Quasten, 'Fish, symbolism of', *NCE,* pp. 943–46, illustrated. A large German treatise on the subject is by F. J. Dölger, *ΙΧΘΥΣ,* 5 vols, 1910 . . . 1943.

13. Tertullian, *On Baptism,* I, 3, cited in Newton and Neil, op. cit., p. 31.

14. C. E. Pocknee, *Cross and Crucifix, in Christian Worship and Devotion,* Mowbrays 1962; Van der Meer, op. cit., plates 468–78; Gertrud Schiller, op. cit., vol. ii, *The Passion,* 1972; Heather Child and Dorothy Colles, *Christian Symbols Ancient and Modern,* Bell 1971, pp. 10–42 on the cross, with many diagrams.

15. J. Finegan, *Light from the Ancient Past,* Princeton University Press 1946, p. 292, plate 124.

16. V. M. Oberhauser, in article 'Lamb of God', *NCE,* viii, pp. 338–42.

17. Van der Meer, op. cit., plates 202–3.

18. H. von Campenhausen, *Tradition and life in the Church,* Collins 1968, ch. 8: 'The Theological Problem of Images in the Early Church' (1960), pp. 171–201.

19. Bevan, op. cit., pp. 85–95.

20. M. J. Vermaseren, *Mithras, the Secret God,* Chatto & Windus 1963; L. A. Campbell, *Mithraic Iconography and Ideology,* E. J. Brill, Leiden 1968; J. Hinnells (ed.), *Mithraic Studies,* 2 vols, Manchester University Press 1975.

21. G. Cope, *Symbolism in the Bible and the Church,* SCM Press 1959.

22. Grabar, *Beginnings,* plates 101, 147–48, 239; John Beckwith, *Early Christian and Byzantine Art,* Penguin Books 1970, plates 7–10.

23. For a full description see Dillenberger, op. cit., pp. 40–45.

24. Grabar, *Beginnings,* pp. 116–19, plates 115, 118.

25. Grabar, *Christian Iconography,* p. xlv.

26. Grabar, *Beginnings,* pp. 33–34, 193.

27. A. J. Otterbein, 'Shroud, Holy', *NCE,* xiii, pp. 187–89.

28. Grabar, *Christian Iconography,* p. 36.

29. Dillenberger, op. cit., pp. 43–44.

30. On the hand of God, see F. de'Maffei, *EWA,* iv, pp. 408–10.

31. A. Grabar, *Byzantine Painting,* Skira 1953, p. 65.

32. Opinions of the church fathers cited in J. Jobé, *Ecce Homo: The Christ of all the World,* Macmillan 1962, p. 14.

33. D. Talbot Rice, *The Beginnings of Christian Art,* Hodder & Stoughton 1965, pp. 64–65.

34. For a complete photograph showing the other decorations, on the apse and ceiling at Cefalu, see Newton and Neil, op. cit., p. 81.

35. D. Talbot Rice (ed.), *The Dark Ages – the making of European Civilization 300–1100 AD,* Thames & Hudson 1965; this beautifully illustrated volume contains excellent chapters relating Byzantine to other areas.

36. P. Sherrard, *Constantinople, Iconography of a Sacred City,* Oxford University Press 1965, pp. 36–39, 111–18.

37. Large illustrated works are: O. M. Dalton, *East Christian Art*, Clarendon Press, Oxford 1925; D. Talbot Rice and Max Hirmer, *The Art of Byzantium,* Thames & Hudson 1959; André Grabar, *Byzantium from the death of Theodosius to the rise of Islam,* Thames & Hudson 1966; W. F. Volbach and J. L. Lafontaine-Dosogne, *Byzanz und der Christliche Osten,* Propyläen Verlag, Berlin 1968. Recommended for student use are: D. Talbot Rice, *Byzantine Art,* Penguin Books 1968, and P. Sherrard, *Byzantium,* Time-Life, New York 1967; both full of illustrations.

38. Otto Demus, *Byzantine Art and the West,* Weidenfeld & Nicolson 1970.

39. Grabar, *Byzantine Painting,* p. 187.

40. On worship and art see Nicholas Zernov, *Eastern Christendon,* Weidenfeld & Nicolson 1961, chs 9, 11; also Timothy Ware, *The Orthodox Church,* Penguin Books 1963. Icons provide an illuminating starting point in Ernst Benz, *The Eastern Orthodox Church, its thought and life,* Doubleday, Garden City, 1968.

41. Cited by Bevan, op. cit., p. 126.

42. H. P. Gerhard, *The World of Icons,* John Murray 1971, p. 47 and plates 1–2. A useful wide-ranging survey of icons.

43. Titus Burckhardt, *Sacred Art in East and West,* Perennial Books 1967, pp. 66, 77, plate v.

44. An interesting explanation of connections between political hierarchy and early Byzantine doctrine and iconography is by Edmund Leach, 'Melchisedech and the Emperor: Icons of Subversion and Orthodoxy', in *Proceedings of the Royal Anthropological Institute of Great Britain & Ireland for 1972,* pp. 5–14.

45. Konrad Onasch, *Icons,* Faber 1963, p. 32.

46. John Kremitske, 'Images and Iconoclasm', *EWA,* vii, pp. 811–16.

47. Bevan, op. cit., pp. 128–146, discusses critically the arguments of John of Damascus.

48. The *Byzantine Guide to Painting* was translated into French by the renowned Byzantinist, Napoleon Didron, in 1843. The English translation of part II on the iconography is given as appendix II of A. N. Didron, *Christian Iconography,* Bell 1886, vol. ii, pp. 263–399, also pp. 188–95. (The two volumes of Didron's work are interesting and impressive in coverage.)

49. Didron, op. cit., p. 394.

50. See article 'Festbildzyklus', in Kirschbaum, *Lexicon,* ii, pp. 26–31.

51. Philipp Schweinfurth, *Russian Icons,* Batsford 1953, p. 50, gives useful information on details of his typical scene, passim on other biblical scenes.

52. Richard Krautheimer, *Early Christian and Byzantine Architecture,* Penguin Books 1965, chs 9, 13, 17 on the central plan and cross-domed church. See also Cecil Stewart, *Byzantine Legacy,* Allen & Unwin 1947.

53. A useful diagram of the iconostasis and outline are given by L. Ouspensky, article 'Icon', *NCE,* vii, pp. 324–26. See also Gerhard, op. cit., pp. 205–8.

54. Heinz Skrobucha, *Icons,* Oliver & Boyd 1963, p. v. This short book includes clear explanatory notes on the forty-seven Greek and Russian icons reproduced in colour from later centuries. Earlier icons from Sinai, Greece, Bulgaria, and Yugoslavia are illustrated in colour in Kurt Weitzmann, *et al., Icons from South-eastern Europe and Sinai,* Thames & Hudson 1968. See also D. and T. Talbot Rice, *Icons and their Dating,* Thames & Hudson 1974, illustrated.

55. F. de'Maffei, 'Saints, Iconography of', *EWA,* xii, pp. 641–69; this is an excellent survey article with many illustrations and a selected inventory of saints. Short articles on the saints in relation to devotion, intercession, legend and iconography are in *NCE,* xii, pp. 962–75. A short book on the early period is Edith Simon, *The Saints,* Penguin Books 1968. A definitive reference work in process is W. Braunfels (ed.), *Ikonographic der Heiligen,* 4 vols, Herder, Freiburg 1973ff.

56. Tamara Talbot Rice, *Russian Icons,* Hamlyn 1963, plates 15, 22.

57. Cited from the eleventh to twelfth-century 'Chronicle of Nestor', *ERE,* vii, p. 158.

58. Grabar, *Byzantium,* plate 169, p. 157.

59. Grabar, *Byzantine Painting,* p. 192.

60. Onasch, op. cit., p. 28.

61. Zernov, op. cit., pp. 281, giving a full analysis of the meaning and symbolism of this icon.

62. The inverted triangle in the circle can also be discerned in the composition of the Shiva Nataraja image (ch. 4 above).

63. Onasch, op. cit., pp. 355–56, notes on plate 24.

64. A wealth of material is found in Didron, op. cit., vol. ii, pp. 1–82 on the Trinity; vol. i, part 2 on the 'history of God', the persons of the Trinity.

65. *EWA,* iv, plate 231, lower right; text pp. 413–17.

66. Peter Lasko, *Ars Sacra: 800–1200,* Penguin Books 1972; C. R. Dodwell, *Painting in Europe, 800 to 1200,* Penguin Books 1971.

67. Burckhardt, op. cit., p. 145.

68. Ilene H. Forsyth, *The Throne of Wisdom: Wood Sculptures of the Madonna in Romanesque France,* Princeton University Press 1972, pp. 2–3.

69. George Zarnecki, *Romanesque Art,* Weidenfeld & Nicolson 1971, is a short introduction, copiously illustrated.

70. Dillenberger, op. cit., ch. 4. George Henderson, *Gothic,* Penguin Books 1967, is a fine introduction. Wim Swaan, *The Gothic Cathedral,* Elek 1969, and Georges Duby, *Europe of Cathedrals,* Skira 1965, are richly illustrated. Charles R. Morey, *Mediaeval Art,* W. W. Norton, New York 1942, is a useful comprehensive work covering earlier Christian art also. The iconography is helpfully outlined in relation to the medieval view of the world and history in Gilbert Cope, *Symbolism in the Bible and the Church,* SCM Press 1959, ch. 2: 'Medieval Imagery'. The art of the stained-glass window reached its fulfilment in this period (see books by Swaan and Duby), becoming for Gothic what the mosaic was for Byzantine art, but now transmitting light instead of reflecting it.

The underlying symbolism is of God as Light. A detailed coverage of medieval stained glass is given in the many volumes of the international series, *Corpus Vitrearum Medii Aevi.*

71. On the didactic symbolism and iconography of thirteenth-century French cathedrals a now classic work is Émile Mâle, *The Gothic Image,* 1910, Harper Torchbooks 1961. A short selection in translation from his four French volumes is: Émile Mâle, *Religious Art, from the twelfth to the eighteenth century,* Routledge & Kegan Paul 1949.

72. Burckhardt, op. cit., p. 88, in ch. 3 on the iconography of the Romanesque church portal.

73. S. G. F. Brandon, *The Judgment of the Dead,* Scribner, New York 1969. Useful chapters on the soul, judgment, devil and angels with iconographic illustrations and bibliography, are in S. G. F. Brandon, *Religion in Ancient History,* Allen & Unwin 1973.

74. T. S. R. Boase, 'King Death: Mortality, Judgment and Remembrance', *The Flowering of the Middle Ages,* ed., Joan Evans, Thames & Hudson 1966, pp. 203–44, illustrated.

75. Henderson, op. cit., p. 164.

76. M. Meiss (ed.), *The Rohan Book of Hours,* Thames & Hudson 1974; and the facsimile reproductions of *The Book of Kells,* Thames & Hudson 1974.

77. Mrs Jameson, *Legends of the Monastic Orders,* Longmans 1890. Useful material is found also in the other works of this assiduous nineteenth-century researcher; on the earlier saints see her *Sacred and Legendary Art,* 2 vols, and *Legends of the Madonna,* all reprinted by Longmans 1890.

78. M. D. Anderson, *History and Imagery in British Churches,* John Murray 1971; much interesting detail on medieval imagery is given in part II, 'The Picture Book of the Churches'.

79. Vincent Cronin, *Mary Portrayed,* Darton, Longman & Todd 1968, chs 4–6; this is a good and most attractive selection of over eighty diverse portrayals of Mary down the ages. See also Henri Ghéon (introduction), *Mary Mother of God,* Éditions Pierre Tisné, Paris 1956.

80. J. Lafontaine-Dosogne, 'Mary, Blessed Virgin, Iconography of', *NCE,* ix, pp. 369–84. See also Réau, op. cit., iii, pp. 1–200, 'Vierge'; Kirschbaum, *Lexicon,* iii, pp. 154–233, 'Maria, Marienbild', 'Marienleben', (illustrated).

81. John Philips, *The Reformation of Images,* University of California Press 1973, ch. 1: 'Medieval Fabric'.

82. Philips, op. cit., p. 22.

83. Aquinas, *Summa Theologica,* III, 25, 3; and other references cited by Philips, op. cit., pp. 15–16.

84. R. Assunto, in *EWA,* vii, p. 819.

85. Bernard of Clairvaux, *Sermons on the Song of Songs,* XXV, iv, 6; cited in *EWA,* vii, p. 818.

86. Philips, op. cit., p. 6.

87. Burckhardt, op. cit., pp. 143ff.

88. Edgar Wind, *Pagan Mysteries of the Renaissance,* Faber 1958, 1968; Jean Seznec, *The Survival of the Pagan Gods,* Harper Torchbooks 1961.

89. See H. Wölfflin, *Classic Art,* second edition, Phaidon 1953; André Chastel, *The Myth of the Renaissance 1420–1520,* and *The Crisis of the Renaissance 1520–1600,* Skira, Geneva 1968–69; Otto Benesch, *The Art of the Renaissance, in Northern Europe,* Phaidon 1945, 1965. Renaissance art predominates in such pictorial anthologies as M. Brion, *The Bible in Art,* Phaidon 1956, and in the reference-work by G. W. Ferguson, *Signs and Symbols in Christian Art,* 1954. Oxford University Press 1966.

90. Charles Seymour, Jr, *Michelangelo, The Sistine Chapel Ceiling,* Thames & Hudson 1972. See also L. Goldscheider (ed.), *The Paintings of Michelangelo,* and *The Sculptures of Michelangelo,* Phaidon, Allen & Unwin 1939–40.

91. Kenneth Clark, *The Nude: A Study of Ideal Art,* John Murray 1956.

92. W. A. Visser't Hooft, *Rembrandt and the Gospel,* SCM Press 1957. On the other hand Rembrandt was a man of his time who learned from the work of Catholic artists of the Renaissance and Baroque; see Kenneth Clark, *Rembrandt and the Italian Renaissance,* John Murray 1966.

93. Horst Gerson, *Rembrandt: Paintings,* Weidenfeld & Nicolson 1968, plate p. 87.

94. Otto Benesch, *The Drawings of Rembrandt,* Phaidon Press 1957, vol. v, plate 1159, cat. 948.

95. For a sequence of varied art portrayals of the face of Christ down the ages, see *NCE,* vii, pp. 964–67.

96. Michael Kitson, *The Age of Baroque,* Hamlyn 1966, is an excellent introduction to the art. Larger works of scholarship include Germain Bazin, *The Baroque,* Thames & Hudson 1968, and the three relevant volumes in the Pelican History of Art covering Italy, Spain and Portugal and Central Europe.

97. Howard Hibbard, *Bernini,* Penguin Books 1965, ch. 4; also James Lees-Milne, *Saint Peter's,* Hamish Hamilton 1967.

98. Robert T. Petersson, *The Art of Ecstasy,* Routledge & Kegan Paul 1970. This illuminates both the Bernini sculpture and the poem by Crashaw, 'The Flaming Heart', on St Teresa.

99. Mâle, *Religious Art,* p. 170. The full exposition of the religious iconography is in Émile Mâle, *L'Art religieux après le Concile de Trente,* Librairie Armand Colin, Paris 1932, 1972. An impressive study in detail is John B. Knipping, *Iconography of the Counter Reformation in the Netherlands: Heaven on Earth,* 2 vols, B. de Graf, Nieuwkoop 1974.

100. Again reprinted as Cesare Ripa, *Baroque and Rococo Pictorial Imagery,* Dover Publications, New York 1971; this is an English version of the German 'Hertel' edition of 1758–60, with 200 illustrations. See also the large classified guide to sixteenth- to seventeenth-century symbolism: A. Henkel and A. Schöne, *Emblemata,* J. B. Mertzlersche Verlagsbuchhandlung, Stuttgart 1967.

101. Rosemary Freeman, *English Emblem Books,* Chatto & Windus 1948.

102. John Bourke, *Baroque Churches of Central Europe,* Faber 1958; pp. 280–87 on attributes, symbols and terms; Nicholas Powell, *From Baroque to Rococo,* Faber 1959, pp. 174–77 listing iconography. These are helpful introductions. A larger illustrated study is H. R. Hitchcock, *Rococo Architecture in Southern Germany,* Phaidon 1968.

103. Sacheverell Sitwell, *Southern Baroque revisited,* Weidenfeld & Nicolson 1967; also *NCE,* viii, pp. 418–40 on art and architecture in Latin America, illustrated.

104. William Madsen, *The Virgin's Children,* University of Texas Press, Austin 1960.

105. The symbolism of the Sacred Heart is discussed in a wider context by the anthropologist Raymond Firth, *Symbols, Public and Private,* Allen & Unwin 1973, pp. 230–37.

106. William A. Christian, Jr, *Person and God in a Spanish Valley,* Seminar Press 1972.

107. Christian, op. cit., pp. 167ff.

108. Ibid., p. 82.

109. Ibid., p. 90; also pp. 180–87.

110. Fr Colum Kenny, 'Images in Church', *African Ecclesiastical Review,* 1966, viii, pp. 40–44.

111. For the wider life of the church see: Sebastian Bullough, *Roman Catholicism,*

Penguin Books 1963; John L. McKenzie, *The Roman Catholic Church*, Weidenfeld & Nicolson 1969.

319 *Notes*

112. A modern statement of the principles and potential of Catholic Church art is by Fr P.-R. Régamey, *Religious Art in the Twentieth Century*, Herder & Herder, New York 1963 (French edition 1952). Some very good illustrated articles in *NCE* deal with 'Abstract Art and the Church', i, pp. 44–54; 'Church Architecture', iii, pp. 814–44; and 'Liturgical Art', viii, pp. 857–89.

113. From the seventeenth-century Lutheran hymn 'Liebster Jesu, wir sind hier', translated in English as 'Look upon us blessed Lord', in *The Church Hymnary*, Oxford University Press, revised edition 1927, Hymn no. 203, 3rd edition 1973, Hymn no. 129.

114. Kurt Goldammer, *Kultsymbolik des Protestantismus*, Tafelband, Anton Hiersemann, Stuttgart 1967; this provides good illustrations of Lutheran and Reformed worship and the arts, from the sixteenth century to today.

115. Charles Garside, Jr, *Zwingli and the Arts*, Yale University Press 1966.

116. *Calvin: Institutes of the Christian Religion,* (Library of Christian Classics, vol. xx), SCM Press 1960, pp. 99ff.

117. Ibid., p. 112.

118. Philips, op. cit., p. 205.

119. See J. W. C. Wand, *Anglicanism in History and Today*, Weidenfeld & Nicolson 1961.

120. Victoria and Albert Museum, *Victorian Church Art,* HMSO 1971.

121. Peter Hammond, *Liturgy and Architecture*, Barrie & Rockcliff 1960. G. Cope (ed.), *Christianity and the Visual Arts,* Faith Press 1964, includes a critical discussion of Coventry Cathedral.

122. Martin E. Marty, *Protestantism*, Weidenfeld & Nicolson 1972, pp. 234–37 on the visual arts, pp. 350–54 bibliography.

123. Frank and Dorothy Getlein, *Christianity in Modern Art*, Bruce Publishing Company, Milwaukee 1961; G. E. Kidder Smith, *The New Churches of Europe,* The Architectural Press 1964. Both books include Protestant along with Catholic works.

124. Paul Tillich, *Theology of Culture*, Oxford University Press 1959.

125. Karl Barth, *Church Dogmatics*, T. & T. Clark 1958, iv (2), pp. 102–3.

126. R. J. Verostko, 'Abstract Art and the Church', *NCE,* i, p. 54.

127. Jane Dillenberger and Joshua C. Taylor, *The Hand and the Spirit: Religious Art in America 1700–1900*, University Art Museum, Berkeley, California 1972.

128. Joseph Jobé, *Ecce Homo: The Christ of all the World,* Macmillan 1962.

129. 'Missionary Art', *NCE,* ix, pp. 9-7-19.

130. These and several other factors encouraging an adaptation of Christianity to indigenous art-forms are well discussed by John F. Butler, 'The New Factors in Christian Art outside the West: Developments since 1950', *Journal of Ecumenical Studies*, x, 1973, pp. 94–120, 229–31. See also Cope (ed.), op. cit., ch. 9.

131. Arno F. Lehmann, *Christian Art in Africa and Asia*, Concordia Publishing Company 1969. This is a sequel to his earlier work, *Die Kunst der jungen Kirchen,* 1955.

132. Alfred Thomas, *The Life of Christ, by an Indian artist*, Society for the Propagation of the Gospel 1948.

133. Jobé, op. cit., p. 182. Compare the illustration of the 'cosmic asvattha tree' (*Gita*, 15:1–5) in P. S. Mehra, *Shrimad Bhagavadgita in Pictures*, Motilal Banarsidass, Bombay 1954, 1964.

134. W. G. Archer, *India and Modern Art*, Allen & Unwin 1959.

135. Richard W. Taylor, 'Some Interpretations of Jesus in Indian painting', in *Religion and Society*, 1970, Bangalore, S. India, xvii, pp. 78–106; and *Jesus in Indian Paintings*, Christian Literature Society, Madras 1975. I am also indebted to the comments of Mr Josef James of Madras Christian College.

Chapter 9 Conclusion: The End of Iconography?

1. Robert Frost, cited by Kathleen Raine, *William Blake*, Thames & Hudson 1970, p. 185.

2. George W. Digby, *Symbol and Image in William Blake*, Clarendon Press, Oxford 1957, pp. 111–27; Anthony Blunt, *The Art of William Blake*, Oxford University Press 1959.

3. The significance of the Romantic movement in this period lies in its rejecting the authority of established tradition and seeking instead the experience of inwardness, emotion, feeling for nature and the sublime. The Romantic may identify imaginatively with some past era of religion, art and culture (as in neo-classicism) but he does this now on a 'romantic' basis, eclectically, by his own free insight and 'elective affinity'. See H. W. Janson, *A History of Art*, Thames & Hudson 1962, pp. 453–54, on 'Neoclassicism and Romanticism'. Compare Kenneth Clark, *The Romantic Rebellion: Romantic versus Classic Art*, John Murray 1973, which includes Goya, Blake, Fuseli, J.-L. David, and others through to Rodin.

4. For instance: Titus Burckhardt, *Sacred Art in East and West*, Perennial Books 1967, ch. vii; Hans Sedlmayr, *Art in Crisis: The Lost Centre*, Hollis & Carter 1957. A stimulating polemic by a Dutch Protestant is: H. R. Rookmaaker, *Modern Art and the Death of a Culture*, Inter-Varsity Press 1970.

5. For a clear and illuminating analysis of the factors changing the position of art and artists in the twentieth century, see E. H. Gombrich, *The Story of Art*, Phaidon 1966, ch. 27 on 'Experimental Art' and 'Postscript 1965'.

6. Peter Spence, 'Artful Dodgers', *New Humanist*, 90, May 1974, pp. 22–23.

7. Robert Hughes, 'Labyrinth of Kitsch', in *Theology Today*, Princeton, New Jersey 1975, xxxi, pp. 339–42 (reprinted from *Time*, 4 August 1974, p. 80). In terms of modern art criticism this harsh judgment should be heard and heeded. On the other hand, in terms of religious iconography and exploration of religious themes in art there have been noteworthy exhibitions and collections. For instance, in Assisi, Italy, the lay community Pro Civitate Christiana has assembled a library on Jesus in the Arts with a large collection of photographs and a catalogue, *Jesus in Contemporary Art*, Assisi 1964. (This information is from Dr Hans-Ruedi Weber of the World Council of Churches, Geneva, who has himself studied and interpreted modern art work on Christian themes.)

8. Jack Burnham, *Beyond Modern Sculpture*, Braziller, New York 1968.

9. Nicolas and Elena Calas, *Icons and Images of the Sixties*, Dutton, New York 1971, p. 336.

10. John Berger, *Ways of Seeing*, Penguin Books 1972, p. 32.

11. Ibid., p. 33.

12. Michael Sullivan, *The Meeting of Eastern and Western Art, from the Sixteenth Century to the Present Day*, Thames & Hudson 1973, illustrated.

13. Peter L. Berger, *et al.*, *The Homeless Mind: Modernization and Consciousness*, Penguin Books 1974, ch. 3; Anton C. Zijderveld, *The Abstract Society: A Cultural Analysis of Our Time*, Penguin Books 1974, ch. 5. The basis of these analyses in the Sociology of

Knowledge is expounded by P. L. Berger and T. Luckmann, *The Social Construction of Reality*, Allen Lane, The Penguin Press 1967.

14. Daniel Lerner, *The Passing of Traditional Society; Modernizing the Middle East*, Free Press, Glencoe 1958, ch. 2 on modernizing life styles, the mobile personality, empathy and psychic mobility, pp. 47–54.

15. Robert J. Lifton, 'Protean Man', 1968, reprinted in D. R. Cutler (ed.), *The World Yearbook of Religion: The Religious Situation*, vol. ii, Evans 1970, pp. 812–28.

16. Peter Fingesten, *The Eclipse of Symbolism*, University of South Carolina Press, Columbia 1970.

17. Ibid., p. 10.

18. Carola Giedion-Welcker, *Contemporary Sculpture*, Faber 1956, pp. 112–29; Sidney Geist, *Constantin Brancusi*, Guggenheim Gallery, New York 1969; William Tucker, *The Language of Sculpture*, Thames & Hudson 1974. Ionel Jianou, *Brancusi*, Adam Books 1963, pp. 11–20, 54–66, discusses Brancusi's themes and religious influence. A recent special issue of *Tribuna Romaniei*, Bucharest (no. 79, 15 February 1976), celebrates the centenary of Brancusi's birth with the proud claims: 'A Romanian and universal artist . . . the father of modern sculpture is a Romanian', p. 10.

On the feminine archetype and traditional Mother figure in a modern sculptor's work, see Erich Neumann, *The Archetypal World of Henry Moore*, Routledge & Kegan Paul 1959. Likewise Herbert Read in *Henry Moore: a study of his life and work*, Thames & Hudson 1965, p. 259, describes this artist as 'a maker of images . . . and he is impelled to make these icons by his sense of the forms that are vital to the life of mankind'.

19. Gilbert Cope, *The Birth and Death of Symbols*, (manuscript intended for publication).

20. Rosemary Gordon, 'A Very Private World', in P. W. Sheehan (ed.), *The Function and Nature of Imagery*, Academic Press 1972, p. 63.

21. Berger, *Homeless Mind*, chs 7–10.

22. Jacques Barzun, *The Use and Abuse of Art*, Princeton University Press 1974, p. 149.

23. Barlach's wood-sculpture of 1926, 'Das Wiedersehen' ('The Reunion') depicting the Risen Christ and the apostle Thomas, is shown in Carl D. Carls, *Ernst Barlach*, Pall Mall 1969, plate 84. This is the major book translated into English covering the life and art of Barlach. In addition to Friedrich Schult's definitive illustrated surveys in German (3 vols, Hauswedell, Hamburg 1958ff.) of Barlach's sculptures and drawings, religious aspects are emphasized by Günter Gloede, *Barlach: Gestalt und Gleichnis*, Furche-Verlag, Hamburg 1966. See also: Alfred Werner, *Ernst Barlach*, McGraw-Hill 1966.

Ernst Barlach (1870–1938) is significant for religious iconography because he stands, with other great twentieth-century sculptors (Rodin, Maillol, Brancusi, Henry Moore) in a fruitful tension between tradition and modernity. They follow established sculptural tradition in working with traditional materials such as wood, metal and stone and in dealing predominantly (in the case of Barlach, exclusively) with human form; but they use varying degrees of representationalism on the one hand and non-figurative abstraction on the other. Barlach has been called a 'Nordic expressionist', influenced by medieval wood-carving and the peasant humanity of Russia and his native northern Germany; but his art is much more than this. While rooted in his German heritage his art has a universal appeal. Barlach depicts the human condition in all its variety – the labours and ecstasies, the joys and sufferings of mankind to which he feels committed. While his work includes a number of explicitly religious, Christian and biblical themes it does not follow established canons of iconography. For instance, his powerful 'Entombment' sculpture of 1925 (Carls, op. cit., plate 81) can be interpreted as a Christian 'Pietà' or

simply as a three-figure bereavement group. In some ways parallel to his younger contemporary Brancusi, Barlach evokes spiritual dimensions in the midst of apparently 'secular' phenomena of life. His vision of man as rooted in the soil yet drawn towards infinity might be called a spiritual humanism. For the interpretation of religious images this suggests an eschatological view of the icon: it points beyond our present knowing to what man is yet to become, transformed in the divine presence (I John 3.2).

24. Articles on pictorial representation and meditation are featured under the title 'Bild und Meditation' in the journal of modern Christian art, *Kunst und Kirche,* Linz 1974, no. 4, illustrated.

25. Marshall McLuhan, *Understanding Media,* McGraw-Hill, New York 1965, pp. v and 22–23, ch. 2. An excellent example of this 'cool' medium is seen in the gospel illustrations by the French artist Pillods, in the series 'Images des Evangiles'; just because of their evocative sketchiness and 'low definition', it is easy for people of diverse backgrounds to identify with them.

26. *Kunst und Kirche*, 1974, no. 1, 'Theater, Ritual, Spontaneität, Religion'.

27. Calas, op. cit., pp. 316–23.

28. H. Read (introduction), *Henry Moore: Sculpture and Drawings,* Lund Humphries 1949, plate 219 (colour); John Russell, *Henry Moore,* Penguin Books 1968, 1973, plate 57, p. 117.

29. On the various forms of religion, including both traditional approaches to the holy and more modern humanistic religious orientations, see Frederick J. Streng, *et al., Ways of Being Religious: Readings for a New Approach to Religion*, Prentice-Hall, Englewood Cliffs 1973.

Short Reading List

The following books are recommended for one or more of the following reasons: they have a useful text, are well illustrated and are good value for student purchase.

General Introduction

E. H. Gombrich, *The Story of Art,* Phaidon 1950, 1966, paperback.
Ninian Smart, *The Religious Experience of Mankind,* Scribner's, New York 1969; Collins, Fontana paperback 1971.
G. Parrinder, *Dictionary of Non-Christian Religions,* Hulton Educational Publications 1971.
G. Parrinder (ed.), *Man and his Gods; encyclopaedia of the world's religions,* Hamlyn 1971.
J. G. Davies (ed.), *A Dictionary of Liturgy and Worship,* SCM Press 1972.

Chapter 1 Introduction (Iconography)

G. van der Leeuw, *Sacred and Profane Beauty,* Weidenfeld & Nicolson 1963; Abingdon Press, paperback.
Titus Burckhardt, *Sacred Art in East and West,* Perennial Books 1967.
F. Sierksma, *The Gods as we Shape them,* Routledge & Kegan Paul 1960.
Edwyn Bevan, *Holy Images,* Allen & Unwin 1940.

Chapter 2 Primal Religions

Douglas Fraser, *Primitive Art,* Thames & Hudson 1962.
R. Poignant, *Oceanic Mythology,* Hamlyn 1967.
G. Parrinder, *African Mythology,* Hamlyn 1967.
Charlotte M. Otten (ed.), *Anthropology and Art,* (Readings), Natural History Press, New York, paperback, 1971.

Chapter 3 Ancient Religions

Larousse Encyclopaedia of Mythology, Hamlyn 1959, 1965 paperback.
S. G. F. Brandon, *Religion in Ancient History,* Scribner, New York 1969; Allen & Unwin 1973, paperback.

Chapter 4 The Hindu Tradition

A. L. Basham, *The Wonder that was India,* Sidgwick & Jackson 1954; Grove Press, New York, Evergreen paperback 1959.

Benjamin Rowland, *The Art and Architecture of India,* Penguin Books 1953, 1970, paperback.

Heinrich Zimmer, *Myths and Symbols in Indian Art and Civilization,* Harper 1962, paperback.

Veronica Ions, *Indian Mythology,* Hamlyn 1967.

Philip Rawson, *The Art of Southeast Asia,* Thames & Hudson 1967, paperback.

Chapter 5 Buddhism

Nancy W. Ross, *Hinduism, Buddhism, Zen,* 1968; Faber & Faber 1973, paperback.

Dietrich Seckel, *The Art of Buddhism,* Methuen 1963.

P. M. Lad (ed.), *The Way of the Buddha*, publications division, Ministry of Information and Broadcasting, Delhi, 1956.

Chapter 6 Religions of East Asia

Anthony Christie, *Chinese Mythology,* Hamlyn 1968.

Juliet Piggott, *Japanese Mythology,* Hamlyn 1969.

John Lowry, *Tibetan Art,* Victoria and Albert Museum, HMSO 1973.

Chapter 7 Prophetic Iconoclasm

Ernst Grube, *The World of Islam,* Hamlyn 1966.

Cecil Roth (ed.), *Jewish Art: an illustrated history*, W. H. Allen 1961; New York Graphic Society 1971.

Chapter 8 Christianity

Jane Dillenberger, *Style and Content in Christian Art,* Abingdon Press, Nashville, 1965, paperback.

Walter Lowrie, *Art in the Early Church,* revised edition 1947, Harper & Row 1965, paperback.

G. Ferguson, *Signs and Symbols in Christian Art,* 1954; Oxford University Press 1961, paperback.

Philip Sherrard, *Byzantium,* Time-Life International 1967.

Tamara Talbot Rice, *Russian Icons,* Spring Books 1963.

Émile Mâle, *The Gothic Image*, Collins 1961, Fontana paperback.

Gilbert Cope (ed.), *Christianity and the Visual Arts,* Faith Press 1964.

W. A. Visser't Hooft, *Rembrandt and the Gospel,* SCM Press 1957.

Chapter 9 Conclusion, Modernity

Gilbert Cope, *Symbolism in the Bible and the Church,* SCM Press 1959.

H. R. Rookmaaker, *Modern Art and the death of a Culture,* Inter-Varsity Press 1970, paperback.

John Berger, *Ways of Seeing,* Penguin Books, (with British Broadcasting Corporation) 1972, paperback.

H. Osborne (ed.), *Oxford Companion to Art,* Clarendon Press, Oxford 1970.

Ann Hill (ed.), *A Visual Dictionary of Art*, Heinemann; Secker & Warburg 1974.

H. W. Janson, *A History of Art,* Thames & Hudson 1962.

Heather Child and Dorothy Colles, *Christian Symbols Ancient and Modern: a Handbook for Students,* Bell 1971.

S. G. F. Brandon (ed.), *A Dictionary of Comparative Religion,* Weidenfeld & Nicolson 1970.

More specific bibliographical references are given in the notes relating to each chapter of this book. The student may also be recommended to refer to articles in the many volumes of the *Encyclopaedia of World Art* and the *New Catholic Encyclopedia* (see list of abbreviations).

A most useful source containing annotated bibliographies and lists of journals, addresses and available audio-visual material for study and teaching has been produced by the Shap Working Party: P. Woodward (ed.), *World Religions: Aids for Teachers,* Community Relations Commission (10–12 Russell Square, London WC1) 1972.

Abbreviations

ERE *Encyclopaedia of Religion and Ethics,* ed. James Hastings, 12 vols, T. & T. Clark 1908–21.

EWA *Encyclopaedia of World Art,* 15 vols, McGraw-Hill Book Company 1959–68.

HR *History of Religions,* University of Chicago Press 1961ff.

JAAR *Journal of the American Academy of Religion,* 1932ff.

NCE *New Catholic Encyclopaedia,* 15 vols, McGraw-Hill Book Company 1967.

Index

NOTE This is basically a *subject index* (comprising iconographic themes, images, artists, religions and places). It is designed to help the reader find his way quickly to specific items in the text and pictures, and especially to assist comparisons between topics treated separately in the chapters on the various religions (for instance: Animals, Calligraphy, Eye, Idols, Mother goddess, Nudity, Secular art, Worship and images, Change and development in images). Used in this way, the index may stimulate further thought and research on the part of the reader.

Modern authors and books are not listed in this index. Abundant references are given in the notes, and the reader can best trace the relevant authors by referring to the notes on the areas and themes treated in the text (for instance, ch. 4 on the Hindu Tradition: Daniélou, Rawson, Zimmer).

Page references include illustrations also, since the illustrations are closely linked with the text to which they are adjacent.